Visions of America

Landscape as Metaphor in the Late Twentieth Century

Mel Chin

Lewis deSoto

Richard Misrach

Matt Mullican

Judy Pfaff

Martin Puryear

Edward Ruscha

Ursula von Rydingsvard

Alison Saar

Mark Tansey

James Turrell

Bill Viola

Meg Webster

VISIONS OF AMERICA

LANDSCAPE AS METAPHOR IN THE

PUBLISHED BY THE DENVER ART MUSEUM AND THE COLUMBUS MUSEUM OF ART

LATE TWENTIETH CENTURY

Essays by

MARTIN FRIEDMAN *and*

JOHN BEARDSLEY

LUCINDA FURLONG

NEIL HARRIS

REBECCA SOLNIT

JOHN R. STILGOE

with contributions by

MICHAEL KELLY

MICHAEL TARANTINO

ADAM D. WEINBERG

JOHN YAU

DISTRIBUTED BY HARRY N. ABRAMS, INC., PUBLISHERS

Major support for this book, the exhibition, and its national tour has been provided by the LILA WALLACE-READER'S DIGEST FUND.

Other significant national support has been provided by the ROCKEFELLER FOUNDATION and the BOHEN FOUNDATION, with additional funding from the GRAHAM FOUNDATION FOR ADVANCED STUDIES IN THE FINE ARTS.

Landscape as Metaphor was organized under the auspices of the Denver Art Museum and the Columbus Museum of Art; both museums are pleased to acknowledge the significant contributions of the American Center, Paris, where the project was initiated.

Exhibition Itinerary
Denver Art Museum
14 May to 11 September 1994
Columbus Museum of Art
16 October to 8 January 1995

Editor : Mildred Friedman
Designer : Lorraine Ferguson

Unless otherwise noted, dimensions are in inches; height precedes width precedes depth.

Library of Congress Cataloging-in-Publication Data

Visions of America : landscape as metaphor in the late twentieth century / essays by Martin Friedman . . . [et al.].
p. cm.
Includes bibliographical references and index.
ISBN 0–8109–3925–8
1. Landscape in art. 2. Art, American. 3. Art, modern—20th century—United States.
I. Friedman, Martin

N8214.5U6V58 1994
704.9'43673'097309045—dc20
93–45015

Distributed in 1994 by Harry N. Abrams, Incorporated, New York, A Times Mirror Company.

Printed and bound in Italy.

CONTENTS

FOREWORD

The relationship of humanity to nature is one of art's most compelling subjects; for Americans it holds a special fascination. The awesome scale and variety of the land is bound up with our sense of nationhood. Land is central to the myth and meaning of America.

Before the advent of Europeans and other newcomers, Native Americans celebrated earth and sky in every aspect of their lives, as they do to this day. The artists of the young United States brought along the traditions of a score of other countries, but the vastness and bounty of the new land inspired them to create particularly American vocabularies of form and style.

Landscape continues to have a powerful appeal for many of our most innovative artists. The thirteen who created new works for *Landscape as Metaphor* have turned to this venerable genre as a way of conveying their perceptions and concerns about many aspects of American culture and as a means of expressing ideas that transcend conventional representations of nature.

It is significant that *Landscape as Metaphor* is being presented by the art museums of two regional centers of the United States—Denver and Columbus. Both are inland cities, far from the continent's coasts, and the hundreds of miles that lie between them reflect the grand proportions of the country itself. Although each can be described as midwestern, one lies in the windswept lee of the Rocky Mountains, the other on a green and bountiful plain.

The form and mood of each city are responses to particular environments. The land has shaped these unmistakably American cities more surely than economics or politics. Thus, some of the works for *Landscape as Metaphor* will be reconfigured when they move from one city to the other, reflecting these environmental differences. Perhaps the traveling exhibition is the cultural equivalent of

the odyssey of discovery that lies at the heart of the American myth. In their variety of forms and media, the works of art that constitute the exhibition eloquently express the diversity that is the American landscape.

The experience of discovery that characterizes *Landscape as Metaphor* has been an especially rewarding one for the staffs of the Denver Art Museum and the Columbus Museum of Art. It has been a privilege for us to collaborate with Martin Friedman, the distinguished director emeritus of the Walker Art Center, and to work with thirteen remarkable artists as their ideas developed and materialized. We are indebted to the American Center, Paris, which fostered the exhibition in its early phases.

Special thanks are due the Lila Wallace-Reader's Digest Fund, which has provided primary support for the presentation of *Landscape as Metaphor*. We and many other arts organizations are indebted to the Fund for its commitment to bringing innovative work of American artists to audiences throughout the country. Other generous national support for this exhibition has come from the Rockefeller Foundation and the Bohen Foundation, with additional funding from the Graham Foundation for Advanced Studies in the Fine Arts.

We trust that our enthusiasm for the profound works in this exhibition will be shared by our audiences; in them, we believe, they will rediscover America.

LEWIS INMAN SHARP *Director* Denver Art Museum

JAMES F. WEIDMAN *Acting Director* Columbus Museum of Art

LANDSCAPE IN AMERICAN ART TODAY

Essays by

MARTIN FRIEDMAN

JOHN BEARDSLEY

LUCINDA FURLONG

1 THOMAS COLE **VIEW OF SCHROON MOUNTAIN, ESSEX COUNTY, NEW YORK, AFTER A STORM** 1838, oil on canvas, 39 1/4 x 63 1/4, collection

Cleveland Museum of Art, Cleveland, Ohio: Hinman B. Hurlbut Collection

2 MARTIN JOHNSON HEADE **MARSHFIELD MEADOWS, MASSACHUSETTS** 1870s, oil on canvas, 17 1/8 x 36 1/4, collection Amon Carter Museum, Fort Worth,

Texas

1

2

As Far As the Eye Can See

Martin Friedman

Not that long ago, the American landscape, in all its picture-postcard perfection, seemed the noble embodiment of this country's history and the symbolic expression of its future. How, indeed, could there be any other interpretation of the richly varied natural panorama extending from sea to shining sea, filled with vistas of majestic snow-capped mountains under cloudless blue skies, dense and verdant forests, the awesome expanse of the Grand Canyon, matchless desert sunsets, and rugged coastlines? In sum, a topography of awesome dimensions and limitless natural bounty, singled out for divine blessing, has long been integral to the national consciousness.

Throughout the nineteenth century the vastness and magnificence of the American landscape was extolled not only in literature and music, but by numerous painters and photographers, mesmerized by its beauty. Among these early apotheosizing images of nature were Thomas Cole's *View of Schroon Mountain, Essex County, New York, After a Storm*, a moody 1838 rendition of the Catskills under a turbulent sky, Frederic Church's sumptuous portrayal of Niagara Falls (*Niagara*, 1857), and Martin Johnson Heade's luminous 1870s pastoral *Marshfield Meadows, Massachusetts*.

Coinciding with the movement westward, which gathered momentum by the mid-nineteenth century, were depictions of the new terrain by peripatetic painters in search of exotic subject matter. Returning to their studios, they translated their detailed drawings and color sketches of countless awe-inspiring sites into radiant oil-on-canvas paintings. Among such unabashedly lyrical images of the American West were Albert Bierstadt's spectacularly operatic 1868 *Sunset in the Yosemite Valley* and Thomas Moran's *Cliffs of Green River,* a shimmering, light-saturated 1874 painting of the stark sandstone Wyoming hills. It was largely through such renditions, widely reproduced as color

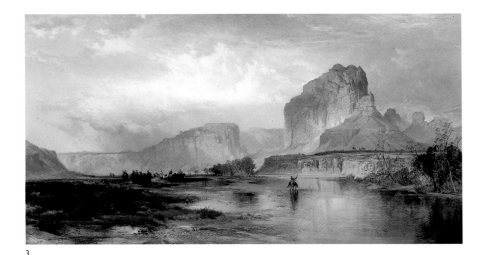

3 4

engravings and illustrations in popular periodicals, that the American frontier assumed quasi-mythological significance for the rest of the country.

But painters were not the only documenters of the West's epic vistas. Lugging their heavy view cameras up perilous slopes, sometimes alongside government surveyors mapping the new lands, the photographers Timothy O'Sullivan, Carleton Watkins, William Henry Jackson, and John Hillers also recorded the virgin continent's compelling beauty. They allowed the landscape's dramatic configurations to materialize slowly on sensitive glass-plate negatives, which registered all of its beguiling details. Jackson's images of Wyoming were influential in convincing Congress to establish Yellowstone National Park in 1872, and Hiller participated in the 1871 exploration of the Colorado River as its official photographer. Eadweard Muybridge, so esteemed today for his pioneering sequential movement studies of humans and animals, explored the landscapes of Yosemite and Alaska through his lens, and in 1869 made a memorable series of cloud photographs.

For inhabitants of America's increasingly industrialized nineteenth-century cities, the dramatic natural prospects, so alluringly described by painters and photographers, were escapist images bordering on the sublime. Yet, even as these were enthralling an urban public, the wilderness they depicted was undergoing inexorable transformation. Untamed nature was beginning to give way

5–7 EADWEARD MUYBRIDGE **CLOUDS** ca. 1869, silver-gelatin prints from 2 ¾ inch square stereographs, collection Bancroft Library, University of California,

Berkeley

5

6

7

to small settlements and farms. The widespread leveling of forests, the ready availability of prairie land for homesteading, the sudden contraction of the continent, accelerated in 1869 by the advent of the transcontinental railroad, mining for gold and silver, were only a few of the many causes of these incursions. So apparently inexhaustible was the supply of land that few questioned the inevitable transformations it was undergoing. Rather, in the spirit of the young nation's Manifest Destiny, the unrestricted, indeed profligate, use of land was deemed every American's inalienable right, especially the right of those with sufficient power and money.

Although idyllic visions of the land, in large measure influenced by its portrayal in nineteenth-century paintings and photographs, have persisted well into our own time, the notion of the immutable vista has been steadily undermined in recent years. And while this country's scenic wonders have not lost their power to stir the imagination, less comforting ideas about the state of its natural resources have seeped into the national consciousness. The accelerated disappearance of wilderness lands and crisis-level environmental concerns have made it impossible to continue to regard the American landscape as absolute and unchanging.

If the American scenic postcard looks less ideal these days, so does the legend of the frontier. Today, the winning of the West is less an epic tale from a rosy Hollywood perspective than a gritty

account grounded in harsh reality. As revisionist history nowadays tells us, the realization of our Manifest Destiny was anything but a totally heroic, high-minded process. Not only was there murderous violence between homesteaders and the indigenous Indian populations, but there were often lethal disagreements among new arrivals over ownership of land and water, and over mining, timber, trapping, and grazing rights. (Today, even Hollywood is on to the latest revisionist thinking; it's been a long ride down the trail from *Shane* (1953) to *Unforgiven* (1992).)

As the twentieth century lurches to fitful conclusion, the assault on nature continues in ever more insidious fashion. Since 1945, when Trinity, the first nuclear device, was exploded near Alamogordo, New Mexico, large areas of that state, as well as vast acreage in Nevada, Utah, Arizona, and California have been testing sites for advanced weaponry, ranging from ballistic missiles to underground nuclear explosions. In much of the Southwest, the landscape is dotted with the rusted remains of these activities. Nor are such insults to nature confined to areas west of the Rockies. The name Three Mile Island, evoking memories of the 1979 Pennsylvania nuclear plant leak, has insinuated itself into our daily vocabulary, along with Love Canal, the benighted upstate New York town, whose subsoil, in 1986, was believed rich in industrial pollutants.

BEYOND WHAT THE EYE CAN SEE

Against this background of troubled awareness, the American landscape assumes particular urgency for many artists today, and is thus a topic ripe for analysis and exposition. As they perceive it, the word landscape refers not just to nature's scenic aspects but to the principles and systems underlying the natural world. Because landscape, in their view, is an all-encompassing theme affected by many aspects of contemporary American culture, it is not just a vehicle for aesthetic exploration. It is, more profoundly, a metaphoric means of eloquently expressing their subjective reactions to contemporary social, psychological, and technological concerns. Such a definition of landscape as a phenomenon beyond the purely descriptive is the premise of the exhibition *Landscape as Metaphor*.

Through conversations and correspondence with the thirteen artists represented in this exhibition, it became clear that their ideas about landscape have little connection to conventional notions about it. Each artist characterizes it as far more than nature viewed through the rectangle of the picture plane. For many, the concepts of landscape and nature are virtually synonymous. While historically there has been a dichotomy between the notions of landscape and nature — with landscape as a picturesque backdrop, a controllable component of the culture that produced it, as opposed to untamed nature — such distinctions no longer apply. Realized in a wide variety of stylistic modes, the reactions of artists today to landscape range from factual renditions to arcane interpretations. Although their imagery is far too diverse in philosophy and style to be described as evidence of a cohesive movement, what these artists have in common is their use of landscape in inventive, frequently provocative, ways.

What soon becomes apparent after seeing the work and hearing the words of artists represented in *Landscape as Metaphor* is that the true landscape is well beyond the illusionistic one so ardently celebrated in the Edenic panoramas of Thomas Cole, Worthington Whittredge, Albert Bierstadt, John Kensett, and other aesthetic forebears. Rather, the landscape, as artists today characterize it, is an elusive concept. For some, it connotes a fragile life-cycle system, of which humankind is inextricably a part. For others, it is a repository of history and myth. Although trees, mountains, rivers, and skies often appear in the work of these artists, these standard components, in their visualizations, take on layers of new meaning. For these artists, the landscape is not only a fertile source of aesthetic exploration but an essential means of responding to many aspects of contemporary existence.

SELF TO NATURE

Some artists represented in *Landscape as Metaphor* think of the landscape not just as a physical manifestation but as an extension of their bodies and psychological states. So intense is their relationship to nature that, for them, the landscape is an indeterminate, constantly changing condition

in which they are wholly absorbed. Expressing this view, the sculptor Judy Pfaff remembers an occasion that ultimately transformed her ideas about what sculpture should be. Although unable to swim well and unfamiliar with the mysteries of the underwater world, she decided to hazard a snorkeling expedition in the Caribbean. So terrified was she to be in such deep water that she forced herself to concentrate on something other than her personal safety. Focusing on her unfamiliar surroundings, she recalls forms and patterns appearing, dissolving, and reappearing in endlessly changing configurations. She was especially fascinated by what she describes as "a nonlinear progression of interrelated opposites forming a unified, self-perpetuating environment in the water . . . subtlety commingled with blatancy, weightlessness with mass, beauty with desolation, and volume with emptiness." [1]

Her watery immersion, as inspiring as it was disorienting, happened during a time when Pfaff says she was "at war with what seemed to be a very limited understanding of sculpture." Until then, she had been conditioned to think of it as something decidedly solid and volumetric. What she encountered in the warm water, however, had none of those absolute qualities. There, she remembers, "You couldn't get a sense of right or wrong if you tried, and the changes seemed more interesting than the axioms of sculpture."

Weightless in the liquid environment, Pfaff regarded herself as both intruder and participant. Soon after this transforming episode, the notion of fluidity began affecting how she thought about sculpture. Whether projecting from the wall or occupying space between the ceiling and floor, her constructions began looking like abstract landscapes in which man-made objects and those borrowed from nature were suspended in airy constellations that energized each other. In these beguiling, free-floating, ever-changing landscapes of the mind, Pfaff began her explorations of the dynamic relationships of mass to void, light to shadow. Within their amorphous confines, junkyard treasures such as rusted bedsprings, screens, glass disks, and old license plates coexist in genial chaos along with levitating tree roots, lengths of raffia, and other fragments of the natural world.

1 All statements by the artists are taken from conversations and/or correspondence with the author in 1992 and 1993, unless otherwise noted.

The interdependence of the realms of humankind and nature is viewed from another perspective by Lewis deSoto, who envisions a reconciliation of ancient beliefs and new scientific ideas about humanity's relationship to the cosmos. In essence, his installations, consisting of unlikely juxtapositions of ancient tribal objects and hi-tech images, are about the enduring relationship between nature and humankind. Reflective of his Cahuilla Indian heritage, his mystical chambers often contain ceremonial objects and rare texts that describe ancient tribal creation myths, along with his filmed images of the desert landscape and recorded ceremonial songs. The very idea of landscape, he notes, is mainly a Western concept, as is the suggestion of a "man/nature" dichotomy: "characteristically, Western conceptual structure is built on a series of discrete polarities: good/evil, heaven/earth, order/chaos, there are thousands. The 'landscape' comes out of an inherent belief that the self exists as separate from some *other*." This *other*, according to deSoto, is a wholly definable entity.

In the traditional Western view, he notes, the landscape has always been an *other*, an entity apart from humankind. But this separatist opinion is being replaced by a broader one that holds the universe to be an elaborate system of discrete, yet interdependent elements, of which humankind is but one. In large measure, he adds, this thinking is attributable to radical new attitudes about the composition of matter, and in support of this opinion, he knowingly refers to such scientific esoterica as quantum mechanics, the Heisenberg uncertainty principle, cosmic strings, and fractal mathematics. Native American societies, along with many other non-Western cultures, he reminds us, have long believed that the spheres of humankind and nature are essentially one and the same. Now, he points out, it appears that Western society, thanks to new ways of perceiving the universe, is beginning to think along parallel lines.

Carved of layered beams of laminated cedar, Ursula von Rydingsvard's raw-edged yet subtly modeled sculptures, darkly toned with graphite, bring to mind an ageless topography. Evocative as they are of primal terrain, she thinks of them as falling "somewhere between human anatomy and man-made objects. Ambiguous forms implying multiple identities especially appeal to her and, she says, "I seem to do best in swinging metaphorically in fluid ways between landscapes (often

mountainous forms), body parts, and objects." Beyond the persistent underlying relationship of the body to all of nature's organic structures, von Rydingsvard says "the most critical landscape to me is the psychological one. This is the landscape Giacometti fills his faces and bodies with." Within its confines, edges between objects are blurred, and forms and shadows are indistinguishable from one another. Absorbed through peripheral vision, this landscape is elusive, constantly evolving, and reminiscent, she feels, of "forms we think we see upon awakening in the middle of the night, still sleepy, negotiating our way toward reality."

Landscape images that most attract her, von Rydingsvard says, are those with "anxious, violent overtones." They can be evoked from many sources, but particularly from objects bearing the imprint of human experience. During a 1988 trip to the Loire Valley she wandered through some less public areas of a few local châteaux, notably their dungeons. Especially vivid impressions of her explorations were the heavily scarred surfaces of the wood doors and window frames of prisoners' cells. These, she remembers, bore incisings from "endless scrapings of a spoon or fingers, over and over, forming many rivulets on the wood surface, creating a powerful psychological landscape."

Many of von Rydingsvard's sculptures, reminiscent of austere terrain, are distilled from memories of objects, places, and events—not from direct observation of nature. Such filtered recollections, however distant and generalized, contribute to her art making process. She says she is overwhelmed by "landscapes with expansive horizontal depth, valley distances like those of canyons, upward distances like those of high mountains." During the summer of 1978, she worked in a studio in the high wooded terrain of Bear Mountain in New York's Harriman State Park. So awesome were these surroundings that she could only gaze at the land through an open doorway, and then, only from well inside the studio. Thus, she recalls, "the landscape was checked on all four sides, curbing its physical and psychological vastness, enabling me to take it in."

Von Rydingsvard still deals with landscape selectively. For example, she has "fantasies of cutting through many layers of earth and simply taking a chunk out." Using excerpts from nature, she feels in control, no longer overwhelmed by nature's immensity.

SURVIVAL AND CONTINUITY

A nagging concern for the planet's endangered ecology underlies much of the imagery of Mel Chin, many of whose sculptures and installations are based on nature under siege. Richard Misrach deals with similar issues in his luminous photographs of imperiled Western lands.

Today's landscape, according to Chin, is not always what it seems to be, and we are frequently deluded by its benign facade. What may seem healthy green expanse can often mask danger below; and we live in a time, he says, when we are increasingly fearful of the landscape we inhabit. Our efforts to deal with the causes of this fear are too often inadequate. He refers not only to chemically polluted, below-ground areas, but also to the questionable effects of current industrial techniques, which, in the name of purging the soil of contaminants, boil and treat it with acids to the point where vital ecosystems involving myriad insects, plant life, and microscopic organisms are destroyed.

Despite such alarmist views, Chin is essentially an optimist about the *real* landscape's prospects for survival. He describes that landscape with impassioned eloquence as "an elusive mass in constant flux, a shape shifting molecular rabble, regurgitating and consuming its thermo effects, chilling and thawing, pressurizing and cracking, serene and unperturbed in some places, unpredictable crystalline storm cloud in others. A cataclysmic construction loosely organized around so-called laws of living and dying, its metaphoric message is interpreted metamorphically and actively by those who sense it."

Through some of his works, Chin posits solutions to ecological crises, in addition to criticizing the social and political conditions that bring these crises about. His sculptures, which frequently allude to nature's forms and principles, are made of wood, stone, earth, and water, in addition to metal and concrete. They vary from relatively small, gallery-scale objects to large outdoor installations, the latter exemplified by his 1991 Minnesota *Revival Field*, which also serves as a laboratory for ecological experimentation.

Art, Chin opines expansively, may even offer society a means of redemption by offering new ways of understanding the landscape as indispensable to daily existence. Noting that great historical

landscape painting has always provided a window onto the ethos of a particular period, he suggests that late-twentieth-century landscape imagery might also offer possible passage into the metaphoric world well beyond this window. And instead of "dramatic vistas of flowers and stone" translated to canvas or photographic film, the landscape, as artists interpret it today, reflects crucial interactions between art and other disciplines—social, psychological, ecological, and technological—concerned with issues of societal survival.

In Richard Misrach's photographs, what initially seem idyllic visions of the Western landscape soon reveal themselves as baleful observations on despoliation of the land. These are disconcertingly beautiful vistas of lands ravaged by man-made catastrophes: a California town is flooded by an ill-conceived irrigation system; a Nevada desert is strewn with the rusted debris of weapons tested by the military. In the Desert Cantos, a memorable series of photonarratives, begun in 1980, that take the form of books and exhibitions, Misrach examines, through elegantly composed images, the ruinous consequences of these ominous events on the land. "The landscape photograph," he writes, "is not an autonomous aesthetic object to be understood on the basis of formal innovation, visceral power, or conceptual insight—it also carries weighty cultural baggage that can no longer be ignored."[2] Misrach's stance is predicated on recognition of indissoluble relationships between contemporary culture and the natural environment. In his words, it is "the inclusion of 'man's intrusion' in every photograph" of the landscape. This statement is expressive of the New Topographics, a contemporary landscape photography movement to whose ideas he subscribes. He characterizes its philosophy as being in direct opposition "to nineteenth-century romanticizations of nature as practiced by the likes of Ansel Adams, Minor White, Paul Caponigro, et al."[3]

According to Misrach, the landscape can be read as text, an opinion that the painter Mark Tansey fully shares, as evidenced by the latter's use of fragments of language in his work. Expounding on the landscape-as-knowledge thesis, Misrach states, "as we hurtle toward the twenty-first century the landscape reveals more closely than history our past, more accurately than media our present, and more precisely than science our future." Even though the landscape's condition may

2 Letter from Richard Misrach to Merry Forresta, 9 December 1990.

3 Ibid.

signify a world in ecological crisis, Misrach, like Chin, believes that "a close reading of the landscape," which suggests an understanding of its increasingly fragile situation, "can help us map our way out of the quagmire."

Considerably less topical than Misrach's and Chin's landscape imagery—indeed, so generalized as to seem timeless—are the organic abstractions of Meg Webster and Martin Puryear. In their sculptures, Webster and Puryear use elemental shapes that sometimes directly, but often indirectly, refer to those found in nature. Through these forms, both artists explore enduring concepts in the natural world such as continuity and metamorphosis, but they do so in distinctly different ways.

For Webster, the landscape has ritualistic significance transcending specific time or place. Her sculptures, which are frequently sited on fields or hills, reflect nature's capacity for constant renewal. Working with masses of earth shaped into monumental conical receptacles and filled with flowering plants, she celebrates the land's life-sustaining power. Because she believes that art should enter into vital physical and social dialogues with the land it occupies, outdoor sculptures should not be merely isolated objects in the landscape, but intrinsically part of it. These earth enclosures, some densely planted with flowering vegetation, blend urban and pastoral components so thoroughly that viewers entering them experience the ground in a strong, elemental way. She speaks of bringing the ground "into play" in these walled sanctuaries, whose mounded and hollowed contours suggest volcanoes, craters, anthills, and other forms from the natural world. To truly sense the earth's weight, texture, and smell, and thus be connected to nature's processes, the visitor, she explains, should spend considerable time in these spaces.

Such Webster sculptures are as much within the spirit of the earthworks movement, pioneered in the 1960s by Robert Smithson, Michael Heizer, Nancy Holt, and Richard Fleischner, as they are in the only slightly older minimalist sculpture tradition. Other determining influences, she acknowledges, range from Cézanne's lucidly defined landscape imagery to her strong ecological and feminist convictions. She characterizes her sculptures as expressions about caring for the earth. The eternal cycle of growth, decay, and renewal is exemplified by flowering plants, grasses, and other vegetation

that thrive within their sheltering womblike interiors. Because a Webster sculpture, with its living vegetation, is in constant flux, varying from day to day and season to season, its maintenance—specifically the care of its plants and condition of its earthen walls—is as much a part of its aesthetic as its form.

Martin Puryear defines landscape as a phenomenon that successive historical cultures have chosen to interpret according to their own world views. Various societies, he observes, have invested the concept of landscape with their own ideas about nature, and we continue to do so today. Therefore, landscape is anything but an absolute; instead, he suggests, it is as much a state of mind as a space-consuming presence. "Landscape is the world under the gaze of man," he writes. "Landscape is not nature. It is a mirror reflecting our fears and fantasies about mankind's place in the world."

While Puryear is essentially a maker of objects, most of which are intended to be shown indoors, several of his major pieces exist within the landscape. Characteristic of Puryear's respectful, almost recessive approach to locating a work within natural surroundings is his 1982 *Bodark Arc* in the Nathan Manilow Sculpture Park, Governors State University, south of Chicago. It is an elegant linear intervention in the semiwild acreage it occupies.

As a rule, landscape elements in Puryear's sculpture are evoked more by their shapes and materials than by large-scale involvement with actual terrain. Whether fabricated of wood, stone, reed, or tar-covered wire mesh, they hint at all manner of biological, botanical, and geological associations—from microscopic organisms to seed pods, boulders, and mountains. But the essence of Puryear's art is well beyond such specific references. It implicitly addresses more universal issues, such as the timeless processes of growth and change in nature.

For all its organic character, Puryear's sculpture is about the interaction and subtle equilibrium between the man-made and organic worlds. This equalibration is convincingly exemplified in *Ampersand,* his 1987–1988 pair of fourteen-foot-high gray granite columns, one the upside-down version of the other, which define the entrance to the Minneapolis Sculpture Garden. Within each granite sentinel there is subtle gradation, from its rough-textured, four-sided base at one end to its

smoothly finished conical form at the other. In addition to implying a harmonious relationship between the spheres of man and nature, these massive stones, which are eloquent expressions of "being" and "becoming," reveal Puryear's fascination with metamorphic processes.

EARTH SPIRITS

While traditional Western attitudes about nature do not embrace the conviction held by tribal societies that powerful animistic forces inhabit it, several artists represented in *Landscape as Metaphor* make direct reference to such forces in their work. Alison Saar, whose richly expressionistic figurative sculptures reflect impulses as varied as African tribal art and Afro-Caribbean folk culture, taps into this belief. Lewis deSoto, influenced by conceptions of humankind's relationship to nature that have long been held by his fellow Native Americans, creates installations through which he aspires to give modern form to these ideas. Bill Viola's installations, many of which incorporate actual as well as videotaped landscape elements, are hauntingly expressive of what he senses to be animistic forces beneath the veneer of everyday reality.

Although raised in a hillside community overlooking Los Angeles, Saar's ideas about the land have little connection to the contemporary urbanscape. Since childhood, she has thought of landscape as filled with history and mythology. Her ideas about it were conditioned by an abiding interest in the lore and imagery of indigenous cultures, an interest greatly encouraged by her mother, the artist Betye Saar, who makes imaginative use of such subject matter in her own work. So fascinated was Alison at an early age with the vivid legends and mythologies of folk cultures that, she says, "I believed that the trees, stones, and even the hills themselves had a life to them. Each element of nature had a personal memory, a history of what it had experienced, survived, and witnessed." And so ingrained in her consciousness is this conviction that it continues to affect her approach to making art.

Even though Saar does not use landscape imagery in conventional ways, it is, nevertheless, subliminally present in her sculpture. Its influence is especially evident in her choice and use of materials. Her wooden figures, although specific characters in her visual narratives, are rough-hewn

tree forms whose origins in the natural world are apparent. Some represent benevolent and demonic spirits based on traditional Afro-Caribbean folk tales, while others derive wholly from her fertile imagination. Some of Saar's rawly carved personages seem to have sprung from the earth, like other burgeoning forms in nature. Perhaps the most arresting of these are the larger than life, carved, painted, and metal-encrusted nude male and female figures that arise from massive tangles of tree roots. These magisterial images, at once benevolent and menacing, read as Saar's powerful statement about humankind's inextricable relationship to the landscape and enduring dependence upon the earth for survival.

In the Cahuilla tradition, Lewis deSoto informs us, certain parts of the landscape are inhabited by powerful spirits, some benign, others with fierce destructive proclivities. The landscape, therefore, is more than an expression of nature's scale and complexity. In Cahuilla culture, he says, the word ʔivaʔa signifies power. Such power, however, is not necessarily recognized as either good or evil, but is capable of actions that can either benefit or adversely affect the people and the land. The figure of Tahquitz, a fearsome spirit said to inhabit the southern California San Jacinto peaks and feed upon the living spirits of humans, says deSoto, is certainly a manifestation of ʔivaʔa. "He does not live on the earth as much as within it; his feeding upon the innocent and helpless is not evil, as it is the condition of his existence. His name is not uttered without caution." From the following account, it is evident that deSoto still shares the traditional Cahuilla respect for the ʔivaʔa of this mountain-dwelling spirit: "Recently, three boys drowned near a waterfall in Murray Canyon, Tahquitz's purview. I knew and understood the idea of an 'accident,' but I did not imagine the forceful interaction with the 'power' of his presence as an explanation for what had happened." The Tahquitz legend is the inspiration for deSoto's *Landscape as Metaphor* project, a room that contains a video-projected image of the San Jacinto mountains, two blocks of melting ice on a steel table representing hapless human victims of that spirit, and a narration of the event in the Cahuillan language.

Bill Viola, like deSoto, inventively uses sophisticated technological means such as video images and multichannel sound in installations that invite the viewer to enter moody psychological

environments where the present becomes the timeless. These darkened chambers are alive with constantly changing projected images in which human forms and those from nature are interrelated. Some of these video installations include borrowings from the natural world, such as the sixteen live sequoia trees in *Sanctuary,* his 1989 work at Capp Street in San Francisco. Embedded well within this tall, indoor forest—not immediately perceptible to viewers—was a large, two-sided screen. On its surfaces were projected images of a woman giving birth. In this latter day primitivistic celebration of the life cycle, the sounds of birth emanated from the sequoia grove. In the *Theater of Memory,* shown in the 1985 Whitney Biennial, the observer was greeted by a massive dead tree, root ball and all, installed diagonally in the gallery and festooned with forty glowing lanterns. In the background, one could hear the fragile, repeated sounds of a wind chime. Projected onto one wall was a succession of blurred recorded images that appeared like unrelated shards of memory, then disintegrated with violent crackling noises. Through landscape imagery Viola obliges us to confront the mysterious reality that exists far below the everyday world's illusionistic surface. In doing so, he invites us to wander the uncharted topography of dreams and myths.

Yet, for all the attraction that the spiritual aspects of traditional cultures hold for him, Viola's video images are more akin to those encountered in dreams than to those immediately associated with indigenous societies. In addition, the mythic aspects of the present intrigue him, to the point where in his pieces, everyday forms such as human figures, room interiors, and landscape images, materialize, dissolve into one another, and, in the process, take on universal resonance. Some critics have characterized him as an artist-shaman who, through the power of his images, enables us to gaze deeply into our ancient shared past and encounter the powerful psychological forces that lurk there.

The "natural landscape," in Viola's interpretation, is not about place but about an all-pervasive psychological condition. As the raw material of the human psyche that provides a link between our inner and outer selves, "its substance," he says, "is as much of mind as it is of body, and we cannot be considered distinct and apart from it anymore than a living cell can be considered

autonomous from the body of its hosts." He makes a strong case for how we perceive the land in atavistic terms: "The dirt under the shops on Main Street *is* our collective unconscious." For all of contemporary society's urbanization, he suggests, the impressions of the human-made environment on the surface of our "collective retina" are miniscule when compared to the vast length of time our species has spent hunting and gathering in the great expanses of the untamed natural world. Consequently, he says, "the accumulations that constitute our inner archaeologies speak more to the kinds of images witnessed today in our national parks than on our downtown streets. They lie beneath each action and thought, like a dark, untouched personal substrata."

DEFINING THE SPACE

In traditional Western paintings of the landscape, whether the Italianate prospects of Claude Lorrain, Corot's soft-edged pastorales, or Monet's chromatic dissolutions of nature's facade, the artist-observer who surveyed the terrain through the rectangular picture plane was the invisible, controlling, but distanced presence. Many artists today, however much they may esteem those earlier idealizations, respond to landscape far differently. As the works in *Landscape as Metaphor* reveal, such longstanding anthropocentric perceptions about our relationship to nature have begun to erode. Because so many artists are interested in nature as more than a phenomenon to be observed from the outside, they pursue new ways of illuminating our complex physical, psychological, and spiritual relationships to it.

Although most of those represented in *Landscape as Metaphor* eschew traditional means of responding to nature, a few use such conventions in dealing with highly subjective issues. In fact, compositional approaches and descriptive techniques, which in other hands might seem dated, even revivalistic, in theirs take on a decidedly contemporary edge. Mark Tansey paints complex landscapes whose detailed imagery evokes places that never were. Also realized in a traditional pictorial manner are Richard Misrach's carefully composed photographs of environmental trouble spots in the Western

landscape. Ed Ruscha's interpretations of the Western landscape, in their smooth-edged abstraction, are harmoniously realized in classical compositional fashion.

Nothing is ever quite what it seems to be in Tansey's enigmatic landscape paintings. On first encounter, these information-filled vistas, like Misrach's photographs, can be misleading. If their composition and subject matter bring to mind nineteenth-century painting and photographs of the American West, Tansey adroitly uses such historical references to address present-day concerns. His paintings explore issues well removed from nature's scenic aspects, ranging from the evolution of language to bafflingly diverse interpretations of reality. Not only are his landscape portrayals commentaries on earlier ways of capturing it, but his attitudes about nature are tantalizingly ambiguous, especially with regard to artists' perceptions of it today. Within these monochromatic representations of sere Western hills, valleys, and canyons, there is a tenuous, not-quite-resolved relationship between traditional "handmade" images and the silk-screened ones of illustrations that Tansey appropriates from art books and other sources of historical subject matter.

The fictional geography of his subjects consists of disparate elements liberally borrowed from sources that include well-thumbed issues of *National Geographic* and *Popular Mechanics*, travel magazines, and assorted current periodicals, including *People* magazine. Tansey is less interested in describing a locale factually than using landscape as a vehicle for ideas that have little to do with conventional notions of the land. As he sees it, "the American landscape is constructed in our minds — the meaning we see in it is through the metaphors we make of it." Because it is a topography of shifting meanings, Tansey says, no absolute truth can be stated about what is observed there, nor can a single metaphor adequately encompass it. The landscape, therefore, is best understood as the combination of interacting, sometimes contending, metaphors that come to life, die, and are replaced by new ones. Each of these metaphors defines it "as something else by adding new meanings, displacing, transforming, and qualifying previous ones." Tansey paints the landscape mainly because, he says, it is an inescapable painting theme. Another reason is that he sees profound similarities between the processes of the growth of language and nature's inexorable processes of evolution. In a

series of "textual landscapes," begun in 1989, he began to render mountainous forms by using layers of text as geological strata. In these paintings, descriptive details, such as mountains and valleys, whose components were actually derived from multiple photographic sources, are represented by textual patterns. He characterizes these diverse interpretations as "a cultural condition akin to 'biological diversity,' where dialogue, hope, and engagement with the complexity of the world is practicable."

Misrach's landscape photographs are deceptively straightforward, to the point of looking like objective documentation of picturesque sites. Unless we know their contexts, it is all too easy to think of them as harmoniously composed, scenic vignettes. Their compelling pictorial qualities at first belie their content, which is precisely Misrach's intention. The doomsday quotient in many of his photographs is often not readily evident. Unless supplied with the facts, how is the viewer to know that a horizontal row of homey looking wooden buildings, under a moody desert sky, is actually chemical bomb and pyrotechnic storage facilities? Or that a vast stretch of crudely bulldozed land in the Nevada desert is full of hastily dug pits containing the carcasses of animals exposed to the toxic groundwater near atomic bomb test sites? His yawning expanses of Western desert resemble abandoned battlefields punctuated with discarded oil drums, twisted remains of tanks and trucks, and spent projectiles. Also dutifully recorded in this battered landscape are huge bomb craters, the shattered remnants of once giant peaks, and half-buried skeletons of livestock that bring to mind the hallucinatory realm of *L'age d'or*, Luis Buñuel's and Salvador Dali's iconic 1928 surrealist film. Misrach's pictures represent an odd fusion of issue-oriented photojournalism and traditional pictorial means of recording handsome vignettes of nature. The result is a gripping hyperclarity that verges on the hallucinatory.

Ruscha's vision of the American landscape draws heavily upon conventional idealizations of it, which he then subtly subverts. It is portrayed in techniques that he casually lifts from the make-believe worlds of advertising and movies, with results that are seductive, disorienting syntheses of romanticism and irony. Vast expanses of open land under dramatic Western skies have long been part of the

Oklahoma-born Ruscha's experience, and, in large degree, his paintings of this theme have been his aestheticization of such emptiness. He approaches the landscape with seeming detachment, almost as an outsider cooly regarding what is before him. In a memorable series of 1960s paintings and silkscreen prints based on a Standard station in Amarillo, Texas—an iconic theme in Ruscha's early work—the landscape is essentially a dominant, limitless sky. In his subsequent variations on this composition, the sky becomes a brilliant blue, black, or chromatically graded backdrop.

In the late 1970s and well into the next decade, Ruscha painted long "skinny landscapes" (his term), some of which extended almost thirteen feet and consisted of elongated, irregular, color washes. The horizon, when it does appear, is visible just above the paintings' lower edges. In some, a string of words, with no connection to the scene depicted, rests on the horizon line; in others, isolated words or images, such as a bamboo pole or the planet earth, float in cloud-streaked skies.

Ruscha talks about such works as paintings about the idea of landscape, rather than naturalistic renditions of it. Their sources, he admits, are many, and include photographs (sometimes his own, but often those he comes across in books and magazines), reproductions of works from art history, and ideas casually lifted from film and television. For all his reliance on secondary sources, he is not without his own feelings about landscape and, for that matter, about nature in general. In fact, he characterizes his personal relationship to nature euphorically. He spends considerable time in California's Joshua Desert area where he has a house and makes drawings and photographs of trees, plants, and other features of these peaceful surroundings.

Still, despite his euphoric feeling about nature, a nagging sense of isolation emanates from Ruscha's recent portrayals of landscape, some so stark as to suggest visions of a nuclear spring. These distillations over the last seven years have barely a hint of color; most range from dark gray to black. Their prominent features are lone trees and shrubs, and houses shrouded in a murky atmosphere. Instead of words, their surfaces include narrow white rectangles of unpainted canvas, reminiscent, in reverse, of the black bars used by censors to block out a telltale word or phrase. However, what exactly is being suppressed, let alone *ex*pressed, in Ruscha's crepuscular idylls is never clear. Do they

represent the dark side of America's arcadian dream at century's end? Are they doomsday images about incipient environmental disaster? Ruscha volunteers no easy answers in conversation, but through this dark phase of his art manages both to beguile and disturb us.

ANONYMOUS SPACE, INFINITE SPACE

For Matt Mullican and James Turrell, landscape is also free of specific time and locale constraints and each, by radically different means, conceives of it as abstract physical and psychological territory. Mullican's conceptual landscapes take many forms, including large-scale floor sculptures whose rigidly ordered, interlocking geometric components bring to mind monumental relief maps of imaginary cities. In marked contrast to Mullican's object-oriented expressions are Turrell's atmospheric, light-saturated rooms through whose volumes the observer moves, as though in a reverie.

Mullican's diagrammatic forms derive from the idiosyncratic, autobiographical, catch-all philosophy that he calls The World. He began developing his cosmology in 1973 as a way of giving symbolic structure to events in his life. The sharply defined geometric areas within its schema bear cryptic appellations such as Subjective, World Framed, World Unframed, the Arts, Language. He expresses this cosmology in a variety of media, including drawings, wall rubbings, banners, posters, incised stone, etched glass, computer-generated video images of fictional cities, and in the floorplans of exhibitions of his own work. Among its other recent manifestations are several large-scale floor sculptures, whose interlocking geometric components bring to mind monumental relief maps of imaginary landscapes. These have been produced in carved stone, cast concrete, and, as exemplified by his work in *Landscape as Metaphor*, *Five into Five*, in shaped plywood.

The bilateral symmetry and compartmentalized areas of Mullican's universe bring to mind the compositions of Buddhist and other Far Eastern depictions of the cosmos, in which successive levels signify man's progression from the netherworld to celestial afterlife. While he is respectful of this iconography, he maintains that his imagery is derived from personal experience alone. Indeed, his

generalized schema allow multiple readings. He regards them not as maps of the physical world but of our interpretation of it. They refer not to actual places but to the indeterminate region beyond reality and imagination.

Like most artists represented in *Landscape as Metaphor,* James Turrell is clear about the inseparability of humankind and nature. "There is no nature unless we enter it," he says, "and it is through art that we can do so and become conscious of this relationship." Today, a massively scaled, all-consuming work by Turrell in the Arizona desert is nothing less than the transformation of a 389,000-year-old crater that he purchased in 1979 and on which he has been working sporadically since that time. Located forty-seven miles northeast of Flagstaff, Arizona, the Roden Crater (named for its previous owner) is becoming a gigantic, evenly shaped earth bowl, from whose depths the sky will seem a vast dome resting lightly on the crater's rim. The prodigious effort to shape its edges to a perfect circle and excavate a series of sky-viewing stations within it, Turrell notes, is a part of his massive artistic intervention into the surrounding landscape that will convert it into a "cultural artifact." Such a cultural artifact, he says, like the concept of time itself, is a man-made construct imposed on nature. The invasive approach to nature exemplified by the Roden Crater, Turrell reminds us, is in diametric opposition to the traditional practice of borrowing nature's images in order to create an art object. In a project of such scale, he says, "art isn't a mark on nature but a condition in which the turning of the earth, and the light of the sun, moon, and stars" bring the work into existence, adding that "on these stage sets of geological time, I want to make spaces that engage celestial events."

Since 1979 the Roden Crater has been a primary focus of his efforts and the most ambitious of his earth projects, but Turrell has continued to make a variety of interior pieces. These include an impressive sequence of light-filled "aperture" installations in many museums, galleries, and alternative spaces here and abroad. At one end of each white-walled minimalistic aperture space, the viewer looks through a rectangular opening into what seems to be luminous infinity. These rooms are based on principles of how we perceive light and form, and within their volumes, dimensionality is a

malleable characteristic. As they contain neither objects nor associative images, all literal and symbolic references are absent in these light-suffused environments and, in Turrell's words, "all there is to see is what you're looking at. These spaces are landscapes because we inhabit them," he says, "but have little connection to outer reality. We don't usually see light this way except in dreams, so these dream landscapes coexist with those of the physical world. We carry within our minds," he says, "visions of interior landscapes assembled over years from memories, imagination, and dreams. On occasion, these can be experienced, fully illuminated, even through closed eyes." Through the power of art, Turrell suggests, we are able to enter the space where these interior and exterior visions of the landscape coincide.

Paradoxically, for all their preoccupation with nature's forms and laws, none of the artists represented in *Landscape as Metaphor* can be characterized as primarily a landscape artist. Yet, if landscape is but one of many ideas that attract them, so vast is its scope that it affords them seemingly limitless possibilities for addressing not only artistic issues, but also psychological, social, and ecological concerns. Through richly diverse imagery, each artist deals with this theme in unique, subjective fashion. Some think of the land atavistically, as the repository of history and myth. For others, apprehensive about the survival of vast areas of the planet, the use of landscape imagery articulates such fears.

Increasingly, contemporary attitudes about landscape are premised on the understanding that all of nature's manifestations, animate and inanimate, material and evanescent—irrespective of scale or locale—are inextricably interrelated and part of its dynamic. In this all-inclusive spirit, some artists are reluctant to make distinctions between the physical landscape and the illusory ones evoked from the worlds of dreams and the unconscious. Finally, many perceive the landscape in terms of their personal relationship to it, regarding it as an extension of their spiritual and physical selves.

What soon becomes clear, even after cursory exposure to the imagery and words of the artists in *Landscape as Metaphor*, is that the landscape theme in American art at the end of the millenium is a

conceptual rather than a descriptive phenomenon, and one rooted in culture rather than topography. In the view of today's artists, the very definition of landscape has undergone drastic modification, to the point where it includes all visible — and myriad invisible — aspects of nature.

It is this concept of the landscape as metaphor that allows — indeed invites — artists to explore, through highly subjective visualizations of the landscape's physical and symbolic attributes, the depth and intensity of their own relationships to nature.

MARTIN FRIEDMAN, director emeritus of Walker Art Center, is the curator of *Landscape as Metaphor*. He was director of Walker Art Center from 1961 through 1990 where he organized numerous exhibitions and authored many catalogues: these include major presentations of work by Claes Oldenburg, George Segal, Louise Nevelson, Isamu Noguchi, and David Hockney, as well as group exhibitions of work by young artists, such as *Works for New Spaces* (1971), *Scale and Environment: 10 Sculptors* (1977), and *Sculpture: Inside/Outside* (1988). He also conceived and developed the Minneapolis Sculpture Garden, which opened in 1988 and is the site of many large-scale outdoor works by American and international artists.

1 WINSLOW HOMER **HUNTSMAN AND DOGS** 1891, oil on canvas, 28 ¹/₄ x 48, collection Philadelphia Museum of Art, Philadelphia, Pennsylvania:

The William L. Elkins Collection

2 THOMAS COLE **RIVER IN THE CATSKILLS** 1843, oil on canvas, 28 ¹/₄ x 41 ¹/₄, collection M & M. Karolik, courtesy Museum of Fine Arts, Boston, Massachusetts

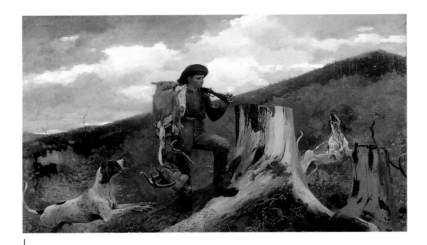

1

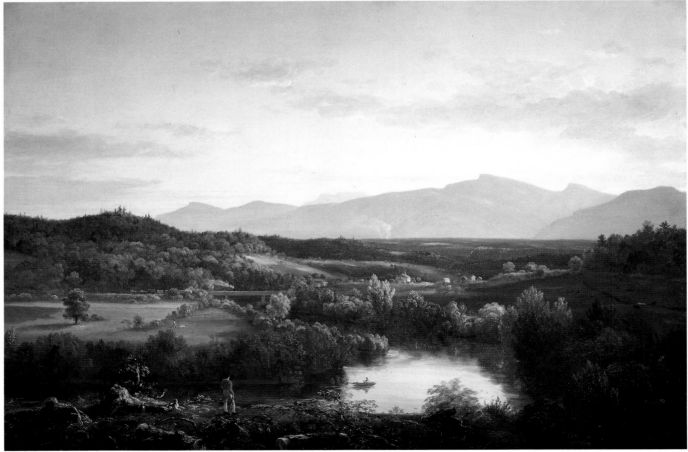

2

GARDENS OF HISTORY, SITES OF TIME

JOHN BEARDSLEY

I

On 30 September 1967, the artist Robert Smithson boarded a bus at the Port Authority terminal at Times Square in Manhattan and, like many an artist-explorer before him, set off in search of America. He sought not, however, like many of his predecessors, to confirm a vision of vast, unsullied nature, either in the sublime fastnesses of the Western mountains or in the awe-inspiring vistas of the Great Plains. Nor was he expecting to ratify, yet again, the myth of America as a pastoral paradise. Instead, he alighted in Passaic, New Jersey, and, armed with an Instamatic 400, set about to chronicle a landscape largely laid to waste.

Although less well-known than the travels of his nineteenth-century forebears—Albert Bierstadt, Frederic Church, or George Catlin—Smithson's "Tour of the Monuments of Passaic, New Jersey" (as he dubbed his journey in a subsequent essay) was hardly less significant.[1] It marked a sea change in artistic perceptions of the American landscape: it was emblematic of the effort of a growing number of artists in the 1960s and beyond to come to terms with the landscape as we actually inhabit it, rather than as we know it from ideology or myth (or from their handmaiden, art). Smithson did not paint a pretty picture. In language both caustic and wry, accompanied by a sequence of purposefully banal snapshots, he detailed a landscape of belching sewer pipes, pumping derricks, used car lots, and unfinished highway construction. The Passaic River looked to him like "an enormous movie film that showed nothing but a continuous blank," while the city was a place of "monumental vacancies that define, without trying, the memory traces of an abandoned set of futures." In all, what he saw was

1 Robert Smithson, "A Tour of the Monuments of Passaic, New Jersey" (1967), in Nancy Holt, ed., *The Writings of Robert Smithson* (New York: New York University Press, 1979), 52–57.

a landscape transformed — and more than a little debased — by an apparently random series of interventions, guided neither by divine plan nor by human reason, but by entropy (the law of thermodynamics that measures the gradual, steady disintegration of a system).

In a subsequent essay, "A Sedimentation of the Mind: Earth Projects," Smithson addressed the fact that the degradation of the landscape undermined the conventions by which it is represented in art.[2] Although he recognized that "the processes of heavy construction have a devastating kind of primordial grandeur," constituting, one concludes, a sort of industrial sublime, he asserted that "the pastoral . . . is outmoded. The gardens of history are being replaced by sites of time," by sites that give evidence of a succession of human and natural disruptions. "The abysmal problem of gardens," he went on, "somehow involves a fall from somewhere or something. The certainty of the absolute garden will never be regained." Our fall from grace with the landscape, Smithson seemed to be saying, effectively precludes the continued representation of America as anything resembling arcadia.

Yet none of this was cause for ecological despair. Smithson refused to see human activities, however disruptive, as inherently bad. While generally supportive of ecological notions, he told a reporter: "The ecology thing has a kind of religious, ethical undertone to it . . . There's a tendency to put man outside of nature, so that what he does is fundamentally unnatural." Instead, Smithson articulated a view in which both man and nature are agents at once of beneficial and detrimental change: "A lot of people have the sentimental idea that nature is all good; they forget about earthquakes and typhoons . . . "[3] What concerned him was not the fact of human intervention in the landscape, but the quality of that intervention. He took it as a challenge to work in areas that were either disrupted by human actions, as in strip mines and quarries, or naturally inhospitable, as in the saline waters of the Great Salt Lake, where he created his most celebrated work, *Spiral Jetty* (1970). He was among the pioneers of the idea that artists might participate in the rehabilitation of industrial landscapes, proposing, shortly before his death in 1973, a series of strip mine reclamation projects to mining companies in Ohio and Colorado. "A bleached and fractured world surrounds the artist," he

2 Robert Smithson, "A Sedimentation of the Mind: Earth Projects," in *The Writings of Robert Smithson* (1968), 82–91.

3 Robert Smithson, quoted in Calvin Tompkins, *The Scene: Reports on Post-Modern Art* (New York: Viking Press, 1976), 144.

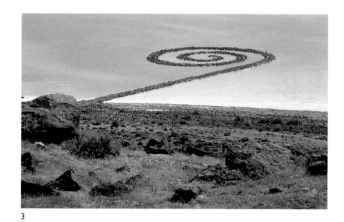

3

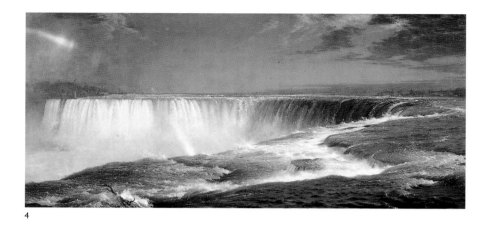

4

wrote. "To organize this mess of corrosion into patterns, grids, and subdivisions is an esthetic process that has scarcely been touched."[4]

Smithson confronted us with the contemporary landscape, one very much of our own making. While he didn't speak for all the artists of his generation—a point to which I will return later—he articulated in his writing and in his art a set of issues crucial to artists concerned with the American landscape in the late twentieth century. He recognized that we are bound to the landscape in both a physical and cultural sense: that the landscape is, in fact, a cultural construct. He also realized that the classic metaphor of the American landscape—the primordial garden—could no longer stand unchallenged, as the landscape bore too many marks of the transformative effects of time. He knew that contemporary artists were challenged to help define a closer, more productive relationship with nature. How others have responded to the same challenge will be the focus of the concluding section of this essay.

II

The landscape Smithson insisted we see—full of "zero panoramas" and "ruins in reverse"—could not have been more different from the various landscapes that have been bequeathed to us by the artists of the nineteenth century. In some measure, the disjunction between Smithson's vision of America and those of his predecessors is an expression of the awesome transformation of the landscape

4 Robert Smithson, "Sedimen-
 taton of the Mind," 82.

itself in the intervening years. But it also tells of the profound gulf in cultural attitudes toward landscape that divides the end of our century from the middle of the last. In our nation's younger years, the landscape was bound up with ideas both theological and nationalistic; it was typically seen as God-given, boundless, and bountiful. As told in Barbara Novak's *Nature and Culture* (1980), it was the Holy Book, open to a chosen people.[5] It was the raw material from which would be crafted the New Jerusalem, a great new nation, the Garden of the World.

As artists fanned out across the landscape in the nineteenth century, these ideas were part of the baggage they carried. Almost inevitably, therefore, their depictions of the landscape spoke of the immanence of God and of the divine promise of America. Church's *Niagara* (1857), for example, is much more than the representation of a waterfall; it is both an icon of the God-given power and beauty of nature and an emblem of nationalism.

As many of our earliest artists were either born or trained in Europe, they also carried with them ideas received from abroad about how to represent the landscape. Their visual formulas were derived from various sources: the notions of the sublime and the beautiful as articulated by the mid-eighteenth-century writers Edmund Burke and Immanuel Kant; late-eighteenth-century English theories of the picturesque; and the nineteenth-century writings of John Ruskin. While sketches and some small-scale works by painters such as Church, Bierstadt, and Moran were often factual representations of observed nature, the landscape in their more operatic works was typically a composite, reconceived and idealized in the studio. When Bierstadt represented the Rocky Mountains, for example, he did so in a way that not only "improved" on nature's compositions, but in a way that intensified a sense of forbidding scale, power, and solitude, provoking in the viewer associations with the sublime.

A more pastoral vision of America can be found in the work of Thomas Cole. Cole was largely responsible for the introduction of the wilderness image into American painting, declaring in his 1835 "Essay on American Scenery" that "the most distinctive, and perhaps the most impressive, characteristic of American scenery is its wildness." But he recognized that wildness would give way to

5 Barbara Novak, *Nature and Culture: American Landscape and Painting, 1825–1875* (New York: Oxford University Press, 1980); see especially the Introduction.

cultivation, and offered, in an optimistic moment, an idyllic vision of what might follow, tellingly contrasted with landscapes of the Old World:

> Seated on a pleasant knoll, look down into the bosom of that secluded valley, begirt
> with wooded hills. . . . You see no ruined tower to tell of outrage—no gorgeous temple
> to speak of ostentation; but freedom's offspring—peace, security, and happiness. . . .
> On the margin of that gentle river the village girls may ramble unmolested—and the
> glad school-boy, with hook and line, pass his bright holiday—those neat dwellings,
> unpretending to magnificence, are the abodes of plenty, virtue, and refinement.
> And in looking over the yet uncultivated scene, the mind's eye may see far into futurity.
> Where the wolf roams, the plow shall glisten; on the gray crag shall rise temple and
> tower—mighty deeds shall be done in the now pathless wilderness; and poets yet unborn
> shall sanctify the soil.[6]

Such language would seem to describe precisely the tone of Cole's *View on the Catskill, Early Autumn* (1837). The painting presents a thoroughly unspoiled scene: a placid river in the foreground, and beyond, extensive forest interrupted here and there by meadows and a panorama of mountains in the distance. A few small figures take their place unobtrusively in the landscape: a mother gathers flowers while her baby plays on a blanket by the stream; a youth chases his horse in the distance; and a hunter slips into the woods behind a rail fence. The view into the landscape is framed by trees, in accordance with a picturesque formula derived from the paintings of Claude Lorrain. It is an altogether arcadian scene, suggesting complete harmony between the new Americans and their land.

Ironically, the painting was something of an elegy for a landscape that was already gone. We know from Cole's journals and from his correspondence that many of the trees along the creek had already been felled, and that a railroad was intruding upon the quiet scene. A walk along the creek the summer before the painting was executed occasioned these private reflections:

> If men were not blind and insensible to the beauty of nature the great works necessary
> for the purpose of commerce might be carried on without destroying it, and at times might
> even contribute to her charms by rendering her more accessible—but it is not so—they
> desecrate whatever they touch—they cut down the forest with a wantonness for which
> there is no excuse, even gain, and leave the herbless rocks to glimmer in the burning sun.[7]

6 Thomas Cole, "Essay on American Scenery" (1835), reprinted in John W. McCoubrey, ed., *American Art 1700–1960* (Englewood Cliffs, N.J.: Prentice-Hall, 1965), 98–110.

7 Thomas Cole, "Thoughts and Occurrences" (1 August 1836), quoted in *American Paradise* (New York: Metropolitan Museum of Art, 1987), 129.

5 THOMAS COLE **VIEW ON THE CATSKILL, EARLY AUTUMN** 1837, oil on canvas, 39 x 63, collection Metropolitan Museum of Art, New York: gift in memory of

Jonathan Sturges by his children, 1895

Similar gloom characterizes much of Cole's contemporaneous writing, both prose and poetry. The "Essay on American Scenery," for example, condemned "meager utilitarianism" and "the ravages of the axe." In 1841 came the poem "Lament of the Forest," in which the wilderness of the New World, speaking through the poet, tells of its destruction at the hands of a greedy people:

> Our doom is near: behold from east to west
> The skies are darkened by ascending smoke;
> Each hill and every valley is become
> An altar unto Mammon, and the gods
> Of man's idolatry — the victims we.[8]

In light of these writings, a late landscape by Cole, *River in the Catskills* (1843), takes on a decidedly melancholy, even moralistic tone. It duplicates very closely the scene of *View on the Catskill, Early Autumn.* But in the later painting, the framing trees are gone, and it is evident that at least one has been chopped down. A stump dominates the left foreground, and the earth is littered with brush. A town is visible to the right; a train cuts across the heart of the landscape. Mother and child are gone, replaced by a solitary man who gazes out over the changed scene. Stump, brush, and train are symbolically charged elements for Cole, as is evident from his writing. What looks at first like another pastoral scene is in fact laced with ambivalence about the transformation of the landscape, in which, as Cole wrote in the "Essay on American Scenery": "the way-side is becoming shadeless. . . . Another generation will behold spots, now rife with beauty, desecrated by what is called improvement; which, as yet, generally destroys Nature's beauty without substituting that of Art."

Cole was not alone in perceiving the gathering conflict between landscape sentiment and economic ambition; anxiety about this conflict is an undercurrent in much nineteenth-century art, and occasionally erupts to the surface. Among the tribes of the upper Missouri River in 1832, George Catlin found himself witness to an epochal struggle between the ostensibly civilizing westward press of commerce and settlement on the one hand and the fragile, preexisting community of human, plant, and animal life on the other. He recognized that the Indians were dependent on the buffalo for food, clothing, and shelter, and that their way of life was threatened by the decimation of the herds,

8 Reprinted in Marshall B. Tymn, ed., *Thomas Cole's Poetry* (York, Pa.: Liberty Cap Books, 1972), 112.

6 TIMOTHY O'SULLIVAN **FIELD WHERE GENERAL REYNOLDS FELL, GETTYSBURG, PENNSYLVANIA, JULY 1863.** FROM **GARDNER'S**

PHOTOGRAPHIC SKETCHBOOK OF THE WAR (1865–1866), albumin silver print from a 7 x 9 glass negative, collection The Museum of Modern Art,

New York: anonymous gift

7 CARLTON E. WATKINS **MALAKOFF DIGGINS, NORTH BLOOMFIELD, NEVADA COUNTY** ca. 1871, albumen print, courtesy Fraenkel Gallery,

San Francisco, California

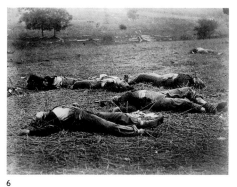

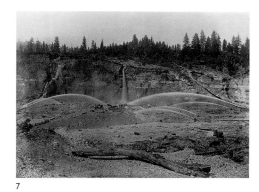

5

6

7

slaughtered to feed an appetite for buffalo robes back East. He saw the Indian and the buffalo as "joint and original tenants of the soil, and fugitives together from the approach of civilized man."[9]

Catlin spent several of the next years trying to preserve on canvas as much as he could of Indian life. He subsequently assembled his paintings and a collection of artifacts into an Indian gallery that he exhibited extensively in the United States and in Europe in the 1830s and 1840s and which he tried repeatedly—and unsuccessfully—to sell to the United States government. (His lack of success is not surprising, given the federal policy of removing Indians from their tribal lands and forcibly resettling them farther and farther west.) While Catlin was trying to support himself and his family through the exhibition and sale of his paintings, he was also hopeful that they might generate some understanding and tolerance of Indian customs, and aid in the effort to secure some official sufferance for the Indians.

As the century progressed, many others bore witness to the degradation of the landscape as it was warred over in sectional conflict or exploited for economic gain. The Civil War produced some of the most harrowing landscapes of the century, by photographers such as Matthew Brady, George Barnard, and Timothy O'Sullivan: the fields of Gettysburg, Pennsylvania, for example, fecund in their harvest of death; the stump-lined and sodden trenches of Petersburg, Virginia, where soldiers

9 George Catlin, *Letters and Notes on the Manners, Customs, and Conditions of the North American Indians* (London: 1841; reprinted, New York: Dover Publications, 1973), 1:260.

lived for months, sometimes waist-deep in water; or the forests of Spotsylvania, Virginia, or New Hope Church, Georgia, witness to such fierce gunfire that both men and trees were felled in the deadly rain. A decade later, the subject was economic conflict. Carleton Watkins and William Henry Jackson, in addition to their respective canonical images of Yosemite valley and of what is now Yellowstone National Park, photographed the effects of hydraulic gold mining in the Western mountains.

Winslow Homer, active in the Adirondacks in the years the preservation of those mountains as a state park was under debate, painted a series of images in which he eulogized forest and wildlife. Among the most powerful is *Huntsman and Dogs* (1891), an image of a young hunter with a deer slung over his shoulder, stepping over a tree stump while traversing the side of a mountain. The colors of the picture are somber—steel gray and brown; it seems devoid of life except for the huntsman and his dogs. All of them are unsympathetically portrayed. As for Cole, the stump for Homer is symbolically charged, an emblem of conflict. So are the hounds and the deer carcass. Although deer are very common now, their numbers were severely reduced in the nineteenth century, and hunting practices—especially the use of dogs—were hotly debated. Significantly, this deer was taken not for food but for sale as a trophy. The hunter carries only the head and pelt of the animal, and the head is carefully wrapped to protect it from damage.

In some important respects, this painting constitutes a coda to the landscapes of the nineteenth century and a prologue to those of the twentieth. It is an image of innocence lost. For the generations before Homer, the landscape was the place where Americans encountered God, where the national character was constructed, and where destiny was resolved. In *Huntsman and Dogs*, however, we encounter only the emblems of a more problematic relationship to landscape: the stump, the hunter, his hounds, and his trophy. Nature, far from being boundless and inviolate, sublime in its sweep or picturesque in detail, is here fragile, vulnerable, and desecrated. It is only in recent years that this image of landscape has come to prevail, but the roots of this attitude go deep into the nineteenth century.

III

Implicit in all these images, whether celebratory or elegiac, is the sense that how American culture defined itself relative to landscape was of central importance to national identity. But this changed by the twentieth century. The landscape was no longer the scene of America's highest ambitions and hopes. The frontier was largely settled, Manifest Destiny—the vision of a nation stretching from sea to shining sea—was resolved, and America's territorial ambitions turned overseas. Moreover, the nation was increasingly urban, cosmopolitan, and technological. In all, the landscape became ever more peripheral to the culture we have come to recognize and venerate as modern.

Something analogous happened to the landscape in art. Its explicit image, especially in heroic dress, was forsaken by most self-consciously modernist artists. But although the landscape was demoted as a subject, it didn't entirely disappear. On the contrary—freed of nationalist and theological overtones, its variations proliferated. America had its Impressionists, painters like Childe Hassam and John Henry Twachtman who, inspired by their French counterparts, probed the landscape for its coloristic and optical effects. It had its more robust realists as well—George Bellows, Edward Hopper, and Rockwell Kent, for example—who celebrated the ordinary if sometimes desolate virtues of the Atlantic seaboard—Bellows in New York, Hopper on Cape Cod, Kent in Maine. Monumental Western scenery also continued to provide fuel for artists well into the century—for many a photographer especially, notably Ansel Adams and Eliot Porter. But it was the urban landscape that commanded the most attention: John Sloan, William Glackens, George Luks, and others of the so-called Ashcan School of painting depicted the street life of various strata of New York society, while photographers like Jacob Riis focused on the ghastly poverty of the immigrants on Manhattan's Lower East Side.

In this welter of landscape images, two starkly contrasting groups deserve particular note. In the second quarter of the century, landscape was both nurturing and nipping at the heels of the modernists. On the one hand, rural America was embraced by regionalist painters such as Thomas Hart Benton, John Steuart Curry, and Grant Wood, almost as a retreat from the pressures of

8 DOROTHEA LANGE **TRACTORED OUT, CHILDRESS COUNTY, TEXAS** 1938, entitled "Power farming displaces tenants from the lands in the western dry

cotton area. Texas panhandle." (FSA–H 162), gelatin silver print, 7 × 9 ¹/₂, collection Library of Congress, Washington, D. C.

9 ARTHUR DOVE **FIELDS OF GRAIN AS SEEN FROM TRAIN** 1931, oil on canvas, 24 × 34 ¹/₈, collection Albright-Knox Gallery, Buffalo, New York: gift of

Seymour H. Knox, 1958

8

9

10

urbanization and poverty and in self-conscious rebellion against the forms and subjects of modernism. In an era of social unrest caused by the depression and by massive southern and eastern European immigration, their America was overwhelmingly a place of industrious white farmers living the good life, a view that was nostalgic at best. Some measure of how selective their depictions of 1930s farm life were can be gleaned from the contemporaneous photographs of abandoned farms and dust bowl sharecroppers — victims of drought and mechanization as well as the depression — by Dorothea Lange and Walker Evans.

At the same time, the landscape was being probed as a source of motifs for the early modernists. Much as it had inspired some of the early experiments in Cubism — Picasso at Horta de Ebro in Spain, for example, or La Rue des Bois in France — the landscape gave rise in America to two particularly vigorous forms of abstraction: the organically derived compositions of Arthur Dove, John Marin, or Georgia O'Keeffe, on the one hand, and the geometric abstractions of artists as disparate as Charles Sheeler and Stuart Davis, on the other. For the most part, those involved in organic abstraction used rural images as their point of departure, while geometric abstractionists were compelled by industrial forms in the landscape or by the disorder, noise, and shifting light of that most urban of landscapes, New York City.

The connection between landscape and modernism has also been discerned in the 1950s paintings of the Abstract Expressionists. In 1961 the art historian Robert Rosenblum articulated a view held by many then and now: the paintings of Mark Rothko, Clyfford Still, Barnett Newman, and Jackson Pollock, among others, evoke a kind of abstract sublime, replicating in a figurative way the awe-inspiring power, solitude, and vastness literally represented in nineteenth-century landscape painting.[10] Rosenblum discerned in the work of Still a vast, abstract geology; in Rothko and Newman intimations of infinity; and in Pollock an image of turbulence and power, all of which resonated with the sublime. Moreover, he recognized the lingering associations between the sublime and the sacred. Before these paintings we stand as "the monk before the sea" or the spectator at the foot of Niagara, "and gasp before something akin to divinity."

IV

If Abstract Expressionism reaffirmed the associations between the sublime and the sacred, then it did so with a difference: these associations were no longer mediated by the landscape, or even by the painted image of landscape, but by paintings themselves—and abstract ones at that. By the 1960s, it seems, the exurban landscape had receded from art and become a pentimento, a memory deep in the national artistic unconscious. Swamped by the major currents of modernism, the landscape image survived primarily in the various eddies of realist painting and rapturous photography.

Given the breach that had opened between landscape and modernism, the work of the late 1960s and early 1970s by environmental or earth artists such as Robert Smithson, Michael Heizer, Walter De Maria, Dennis Oppenheim, Robert Morris, and, somewhat later, Christo, Nancy Holt, James Turrell, Charles Simonds, Ana Mendieta, and literally dozens of others, constituted a major revision in the course of contemporary American art. These artists made the landscape both the subject and the site of their art, using the earth both as a source of meaning and of materials. They were not only returning landscape to a position of preeminence in American art; they were also partaking of an effort to reconfigure our relationship to nature more generally. In the context of the

10 Robert Rosenblum, "The Abstract Sublime," *Art News* (February 1961), 39–41, 56, 57.

environmental movement that emerged in these same years, it seemed that art was once again affirming that landscape was of crucial importance in the expression and evaluation of our cultural identity.

Nascent environmentalism was but one of the sources from which earth art sprang. On a formal level, it owed a debt to the reductive, geometric vocabulary of minimalist sculpture of the mid–1960s. On a theoretical level, it was made possible in part by conceptual art, which "dematerialized" the art object, stressing idea over execution, process over product. Earth art was anything but immaterial—much of it was vast and very palpable—but its existence in distant landscapes was iterated in the form of documentary photographs, drawings, and narratives, all strategies made familiar by conceptual art. Moreover, earth art joined with conceptual art in a critique of the commodity status of art and in a desire to escape the usual nexus of commercial galleries and museums, with their intimations of money and status. "The position of art as malleable barter-exchange item falters as the cumulative economic structure gluts," Heizer wrote in 1969. "The museums and collections are stuffed, the floors are sagging, but the real space still exists."[11]

Heizer found his real space in the Western deserts, where he began in 1967 to create a series of temporary works, geometric shapes drawn on or cut into the ground. Two cuts, each thirty-feet wide and fifty-feet deep, made on opposite sides of a scallop in the escarpment of the Mormon Mesa in southern Nevada, constitute *Double Negative* (1970), his most familiar work. Preeminently about space, it is composed of two voids, the double negatives of the title, in the simple geometric vocabulary that Heizer favors. But in its own size—it is over a quarter of a mile from end to end—and in the great scale of the landscape it occupies, it also addresses itself to particularly American—especially Western American—conceptions of space. *Double Negative,* in fact, provides the experience of aweinspiring vastness, solitude, and silence that has long been associated with the sublime. It does so in a way that again uses landscape to affirm the connection between the sublime and the sacred, as Heizer himself realized. He said he found in the Western deserts "that kind of unraped, peaceful, religious space artists have always tried to put into their work."[12]

11 Michael Heizer, "The Art of Michael Heizer," *Artforum* 8 (December 1969), 34.

12 Michael Heizer, quoted in Howard Junker, "The New Sculpture: Getting Down to the Nitty Gritty," *Saturday Evening Post* (November 1968), 42.

11

12

Double Negative is thus somewhat paradoxical: executed in a contemporary geometric idiom, meant to refute the artistic conventions and escape the economic fate of traditional sculpture, it nevertheless evoked some very familiar metaphors of American landscape. The same paradox applies to Walter De Maria's *The Lightning Field* (1974–1977), a grid of four hundred stainless-steel poles stretched out over a mile on one axis and just over a kilometer on the other in a semi-arid region of west-central New Mexico. Not only do these poles occupy a large space in a vast landscape, they also evoke the image of lethal power that is another hallmark of the sublime. The poles are intended to attract lightning, which occurs with great frequency in this part of the Southwest. The implications of danger are underscored by the artist in a ritual that all visitors to *The Lightning Field* experience. In an office in the nearby town of Quemado, they sign a release that frees the artist and his agents of all liability in the event of an accident; the visitor is then driven to *The Lightning Field* and left there alone—or at most in a small group—for twenty-four hours. "Isolation is the essence of Land Art," the artist tersely insists.[13]

In the context of evolving ecological theory, there is something a little problematic about a work like *Double Negative:* it seems to harken back to a notion of the landscape as a boundless resource, and to suggest a view in which the earth is a surface on which to act rather than a system with which to interact. Other artists, such as Smithson, struggled to reconcile their vision with more current conceptions of landscape, to come to terms with the common, inadvertent, even debased landscapes

13 Walter De Maria, "The Lightning Field," *Artforum* 18 (April 1980), 52.

that actually surround us, and thereby to envision a more cooperative relationship with nature. Photographers such as Robert Adams, Lewis Baltz, and Frank Gohlke, for example, began in the late 1960s to chronicle the contemporary West—not the landscape of monumental scenery, but of uncontrolled development and suburban sprawl. Their books—Adams's *The New West* (1974), and *Denver* (1977), and Baltz's *The New Industrial Parks near Irvine, California* (1974)—revealed the extent to which the myth of the old West was buried in tract houses and industrial development. Adams in particular was determined that we should see the landscape as the product of nature and culture in equal measures, and he made it clear that much was at stake. "Spectacular pictures," he wrote in 1981, "have . . . been widely accepted as a definition of nature, and the implication has been circulated that what is not wild is not natural. . . . Nature photographers particularly need to widen their subject matter if they are to help us find again the affection for life that is the only sure motive for continuing the struggle toward a decent environment." [14] Like Smithson, he insisted that only by acknowledging the landscape we actually inhabit can we begin to take responsibility for it and begin to act conscientiously toward it.

Among sculptors, the effort to reconstruct our relationship with nature has taken various forms. Some favor a modest approach, often executing temporary works with natural materials. Richard Long, an English artist, is especially associated with this approach, but Americans such as Michael Singer pursue it as well. Others use growing plants: Alan Sonfist and, more recently, Meg Webster. Among those who continue to work at a large scale in the landscape, various devices have been used to connect the viewer with the environment: sight lines, for example, as in Nancy Holt's *Sun Tunnels* (1973–1976), where four cylinders are oriented to the locations of the rising and setting sun at the summer and winter solstices, framing views into the Utah desert. James Turrell, in his ambitious, evolving project to create sky viewing chambers in an extinct volcano in Arizona, also focuses on the view out—in his case, into the cosmos.

A sense of place has become one of the most familiar terms with which to describe the effect of earth art and that of a related phenomenon, "sited" sculpture, in which aspects of local terrain, from

14 Robert Adams, *Beauty in Photography: Essays in Defense of Traditional Values* (Millerton, N.Y.: Aperture, 1981), 103.

topography to cultural history, are incorporated into the form or content of the work. This effect was richly explored by Smithson in the *Spiral Jetty:* as he looked at the site on the edge of the Great Salt Lake, he wrote,

> it reverberated out to the horizons only to suggest an immobile cyclone while flickering light made the entire landscape appear to quake. A dormant earthquake spread into the fluttering stillness, into a spinning sensation without movement. This site was a rotary that enclosed itself in an immense roundness. From that gyrating space emerged the possibility of the *Spiral Jetty*.[15]

While the *Spiral Jetty* was thus inspired by the topography of the site, it suggested other connections with the environment as well. Smithson likened his spiral to the structure of the salt crystals that formed on the jetty, and he connected it to an Indian legend in which the Great Salt Lake is said to be linked to the ocean by an enormous whirlpool. At the same time, it was a form that alluded to his fascination with entropy. Turning in upon itself, it leads nowhere in particular; it is, as he put it, "matter collapsing into the lake mirrored in the shape of a spiral."

Others have sought a more personal reconciliation with landscape by suggesting an archaic spiritualism. Both Charles Simonds and Ana Mendieta, for example, created ritual-like work outdoors that explored cultural and emotional connections to the earth. In 1970, in a piece called *Birth,* Simonds buried himself in a clay pit in New Jersey and had himself filmed emerging naked, as if from the primordial ooze. Thereafter, he enacted several versions of a work called *Landscape* ⟷ *Body* ⟷ *Dwelling,* in which he fashioned a clay landscape on his body and then built upon it the simple adobe dwellings of an imaginary race of little people. Multiple metaphors are suggested here: of the body as earth, of earth as a living organism, of building as a growing plant. Numerous cultural observations are offered as well, about the widening gulf between our bodies and nature, and between our architecture and natural systems of growth and decay. Among his recent works are large-scale projects that suggest an architecture determined by natural processes, with cracked-clay floors and brick walls that look like compressed sediments.

15 Robert Smithson, "The Spiral Jetty," in *The Writings of Robert Smithson,* 111.

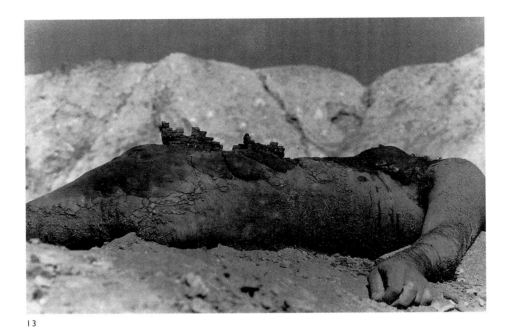

13

Ana Mendieta affirmed some of the same connections between body and earth, but from a more deliberately feminist point of view. Among her provocative and generally temporary works were those in which she formed the life-size image of her own figure, either building it out of mud or cutting it into soft rock. Sometimes the figures were skeletal; at others they were rounded and voluptuous or hollowed out to resemble female genitalia. While they had an archaic quality, evoking ancient female deities of fertility or the earth, they also had an unsettled, even angry, aspect. In some, the figure was pierced with sticks; in others, it was spattered with blood or etched in gunpowder and set on fire. The intimations were to violence — to women, to the earth — perpetrated by a culture that sees both as objects of delectation and exploitation. At the same time, there was something poignant and very personal about these figures. Mendieta, born in Cuba, was sent alone at age thirteen to Iowa, where she was raised — unhappily — in orphanages and foster homes. Some of the first of her figures were made in the Iowa mud, as if to connect herself to the land of her exile. Later, she returned to Cuba, where, in an act of symbolic reconciliation, she inscribed her form in the earth of her native land.

V

Smithson's embarkation for Passaic, I reiterate, was emblematic of a sea change in American art. It was but one venture by one artist into a landscape that was ripe for rediscovery. Smithson's was not the first such journey; neither was it the last. In the decades since, seemingly numberless artists—not only sculptors, but painters, photographers, video and performance artists—have charted new courses across the land. Some, like the original earth artists, continue to work in the landscape itself, creating very palpable sculptures or more ephemeral projects that are documented in film and photography. Still others, as suggested by this book, have returned to making studio works that resonate with images and metaphors of landscape. Together, these artists have restored landscape to a position of cultural importance that it has not held since the middle decades of the last century. And like their nineteenth-century counterparts, they have shown that how we picture the landscape reveals a great deal about who we are.

Earth artists may be said to have established one of the most important legacies in late-twentieth-century art. Some of our most significant new monuments, such as the Vietnam Veteran's Memorial in Washington, are inconceivable without the example of environmental art. From coast to coast, the landscape is blossoming with new public spaces, often designed by sculptors. Artists are now involved in land reclamation, as in Michael Heizer's project to incorporate five huge animal effigy sculptures into a restored Illinois strip mine. Others function as ecological activists, such as Mel Chin, or the team of Newton and Helen Harrison, who document environmental disasters and suggest remedies. Still others perceive landscape in terms of social history, to be told from various points of view: a team of artists including the sculptor Houston Conwill, for example, uses maplike images to recover the neglected narratives of African-American history. In all, the landscape has proved to be a far richer palette than the original earth artists might have imagined. As we approach the end of the century, we face a challenging array of landscape images in which the conflicts of the past are more clearly drawn, in which the ambiguity of the present is richly evident, and in which the prospects for the future are not at all certain.

John Beardsley is a freelance curator and author and an associate curator of *Landscape as Metaphor*. Among his books are *Landscape for Modern Sculpture: The Storm King Art Center* (1985), and *Earthworks and Beyond: Contemporary Art in the Landscape* (1989). His exhibitions include *Black Folk Art in America 1930–1980* (Corcoran Gallery of Art, Washington, D.C., 1981), and *Hispanic Art in the United States: Thirty Contemporary Painters and Sculptors* (Museum of Fine Arts, Houston, Texas, 1987). He has taught in the departments of landscape architecture at Harvard University, the University of Pennsylvania, and the University of Virginia. He is currently writing *Gardens of Revelation*, a book on environments by visionary artists.

Landscape as Cinema: Projecting America

Lucinda Furlong

It is not the least of America's charms that even outside the movie theaters,
the whole country is cinematic. The desert you pass through is like the set of a Western,
the city a screen of signs and formulas.[1]

> — *Jean Baudrillard*

So thoroughly have cinema and other moving-image technologies shaped our experience of the American landscape that the image of the landscape often seems more real than the thing itself. To speak of the American landscape is to speak not just of geography but of a whole host of metaphors. Landscape is a cultural and social construct whose meaning is determined by the ideas, values, and ideologies that individuals project onto it. As photography historians Estelle Jussim and Elizabeth Lindquist-Cock have argued, landscape "construed as the phenomenological world does not exist; landscape can only be symbolic."[2]

How we experience the landscape is shaped not only by factors such as class, gender, race, age, and politics, but by the cultural forms employed to represent it. The geographer D.W. Meinig has pointed out, "Landscape is defined by our vision and interpreted by our minds. It is a panorama which continuously changes as we move along any route."[3]

Meinig's description is particularly apt when considering the construction of landscape in the moving image. Within the conventions of cinematic realism, landscapes immediately evoke more than mere setting. Depending on how they are presented through the length, duration, and mise-en-scène of particular shots, and how those shots are coupled with music, dialogue, or natural sound,

1 Jean Baudrillard, *America,* trans. by Chris Turner (London: Verso, 1988), 56.

2 Estelle Jussim and Elizabeth Lindquist-Cock, *Landscape as Photograph* (New Haven: Yale University Press, 1985), xiv.

3 D.W. Meinig, ed., *The Interpretation of Ordinary Landscapes* (New York: Oxford University Press, 1979), 3.

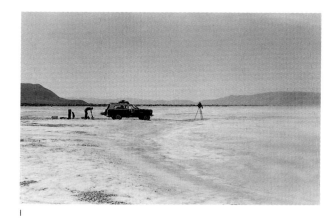

1

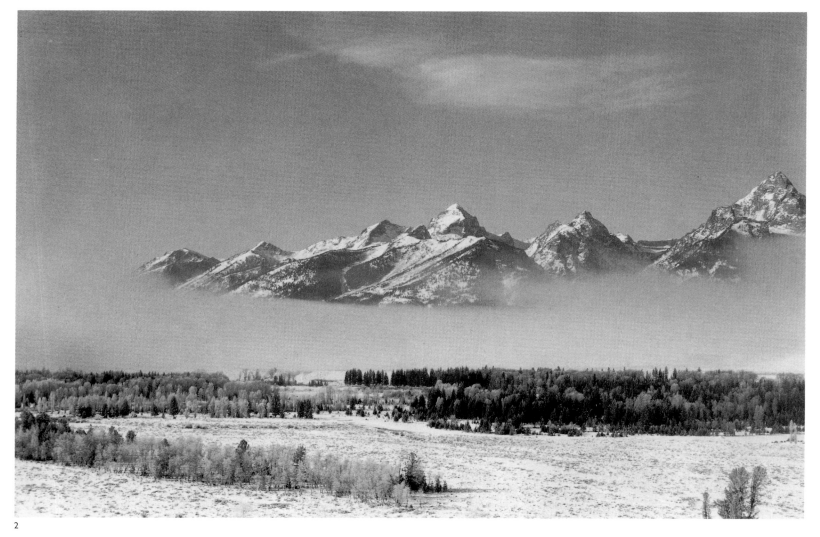

2

landscapes establish a tone, set a plot in motion, or assume metaphorical significance. Methods of encoding the landscape vary, from the evocation of danger lurking around every bend in the river in *Deliverance* (1972), to the way the desert canyons and buttes reinforce the increasing isolation of the two protagonists in *Thelma and Louise* (1991).

But beyond such symbolism, the way landscape is envisioned also provides insights into the American psyche. Films, like all cultural forms, reveal much about the myths and ideological preoccupations of Americans at a given time. While the topic is vast, there are two distinctly American genres—the Western and the road movie—that are particularly relevant in examining the ways landscape has been used to project images of America in cinema.

THE WEST AND THE WESTERN

> SCENE: Long shot of a rocky hill, a wagon train moving toward a valley beyond it.
> Cuts to shot of a family alighting from a covered wagon, then to another of a husband
> and wife surveying the landscape before them.
> HUSBAND: What's the matter, Lucy, don't you like it?
> LUCY *(voice trembling)* : I can't believe it's real. After all we've been through. Think what
> it means: new land, new hope.
>
> —*Frontier Horizon,* 1938

> LOIS WILSON: Death Valley fills you with terror, doesn't it?
> TOM MIX: It's all in how you look at it, I guess. I kinda like it, myself.[4]
>
> —*Rider of Death Valley,* 1932

4 Clive Bush, "Landscape," in Richard Buscombe, ed., *The BFI Companion to the Western* (New York: Atheneum, 1988), 167.

So central is the Western landscape to the Western that it is impossible to think of any film without recalling some arresting landscape image, whether it be a sun-parched desert, a treacherous river, or a verdant valley. And those images are always invested with significance, either explicitly in the film's

dialogue or in the way they are deployed visually as codes of realism. As Hollywood's first and most enduring genre, the Western originated at the conjunction of two turn-of-the-century developments: the emergence of the motion picture as a technological and cultural form and the construction of "the West" as America's most powerful landscape myth. Over seven thousand Westerns have been made since *The Great Train Robbery* (1903), the most influential and popular early Western. By 1910, almost a fourth of all American films were Westerns and this percentage remained remarkably consistent until 1960.[5]

The transformation of the West from geographic to metaphoric space had, of course, begun prior to the development of cinema, during the period of the so-called closing of the Western frontier. As Martha Sandweiss has pointed out, a shift occurred between the 1870s and 1890 in the way Western landscapes were depicted in paintings, photographs, magic lantern shows, and other popular entertainments. While most of the images made before this time were created to transmit factual information about an actual place, those done in subsequent decades were more concerned with imagined or reconstructed visions of a frontier West that had already faded into history. . . . Suddenly the West was less real than ideal.[6]

The substitution of sentimental images for more factual ones stemmed in part from the changing expectations of easterners who had grown increasingly familiar with images of the West through postcards, stereo cards, and magazine reproductions. It was also, as Clive Bush has argued, a necessary ideological antidote to the historical circumstances of the period.

If the "West" died as history and was reborn as myth around 1891, fin-de-siècle American politics played a not insignificant part in the construction of the image. In the historical context of land fraud, farming crisis, appalling frontier social conditions, the economic brutality of the railroads, and acts of genocide against Native Americans, the invention of a "western landscape" was absolutely required. It was an upperclass, eastern, monied consciousness that identified the "West" with American nationalism. . . . Geopolitics required "universal" images of "man" within a "transcendent" landscape.[7]

5 Bush, in the Preface, 13.

6 Martha Sandweiss, "Views and Reviews: Western Art and Western History," in William Cronon, George Miles, and Jay Gitlin, eds., *Under an Open Sky: Rethinking America's Western Past* (New York: W.W. Norton and Co., 1992), 190, 191.

7 Bush, 169.

In early films the construction of a mythology of the West was influenced by a variety of other media. Buffalo Bill Cody's "Wild West" toured internationally for thirty years beginning in 1883. The company, which featured performances by sharpshooters and rodeo riders as well as dramatizations of "heroic" battles with Indians, dazzled audiences with the spectacle of a West fraught with danger and adventure. Charles Russell's paintings of cowboys and Edward Curtis's Indian portraits were steeped in romanticism and a sense of the exotic. And the paintings and sculptures of Frederic Remington and, later, the Western novels of Owen Wister — most notably *The Virginian* (1902) — and Zane Grey, were instrumental in shaping an imaginary Western landscape whose emptiness, brutality, and harsh conditions were inimical to all but the most strong and brave.

At the same time, the enormously popular dime novel proffered a formula of action, spectacle, and frontier stereotypes that influenced the structure and content of Western films. In particular, as Stephen Tatum has pointed out, depictions of the landscape that recur in both dime novels and Westerns as unspoiled lands for the taking or as killing grounds, reflected the period's conflicting utilitarian and primitivistic views of nature. Whereas early novels tended to emphasize "the gleaning of an unused nature's spoils by pioneer settlers [as a] moral and patriotic obligation," those published after 1875 portrayed the landscape as a "badlands whose openness and desolation serve as a visual allegory for the hero's perilous journey."[8]

These action-filled stories primed audiences for Westerns and conditions within the burgeoning film industry were ripe for them. In 1909, the first movie production companies began to relocate to southern California to take advantage of the region's warm climate. An increased demand for product, especially Westerns, necessitated year-round production. But the spectacle of the majestic landscape itself was also key to California's appeal. According to Eileen Bowser:

> While spectacle could be provided with enormous and costly sets, as the Italians did it, in California the landscape itself was ready to perform this function. The extreme long shot became an important element of the spectacle: there was no other way to do justice to the wide-open spaces.[9]

8 Stephen Tatum in Richard Buscombe, ed., *The B.F.I. Companion to the Western* (New York: Da Capo, 1991), 109.

9 Eileen Bowser, *The Transformation of Cinema, 1907–1915* (New York: Charles Scribner's Sons, 1990), 162.

The extreme longshot, of course, is a staple of the Western, used often in film openings, typically showing an expansive view of a desert or plain punctuated by the movement of people through it. So consistent is this visual trope that it can be seen repeatedly in films produced throughout the genre's history: *Straight Shooting* (1917), *Stagecoach* (1939), *Texas* (1941), *My Darling Clementine* (1946), *Red River* (1948), *Rio Grande* (1950), *The Searchers* (1956), *Gunfight at the O.K. Corral* (1957), *Rio Bravo* (1958), *Lonely Are the Brave* (1962), *High Plains Drifter* (1972), and *Pale Rider* (1985).

While not all Westerns are set there, the desert is the genre's archetypal landscape. Noting this in her book, *West of Everything* (1992), Jane Tompkins discusses its metaphorical significance.

> The land revealed in the opening pages or in the opening shot of a Western is a land defined by absence: of trees, of greenery, of houses, of the signs of civilization, above all, absence of water and shade. . . . It is an environment inimical to human beings, where a person is exposed, the sun beats down, and there is no place to hide. But the negations of the physical setting—no shelter, no water, no rest, no comfort—are also its siren song. Be brave.[10]

Thus, the appeal of the desert landscape lay precisely in its promise of deprivation and pain. It became a crucible: "not only a space to be filled," but a "territory to master," in the imaginations of a particular class of American men. "And the openness of the space means that domination can take place virtually through the act of opening one's eyes, through the act, even, of watching a representation on a screen."[11] In Westerns, those aspiring to a masculine ideal of being tough and self-reliant could vicariously exert brute force over other men in a brutal landscape. This is a mythology that is etched into the landscape of Westerns: in the hard edges of the rocks, in the dusty and parched desert, or the dry riverbed.

Tompkins's gendering of the landscape as masculine—a sphere so hostile that only "real men" can triumph over it—assumes a distinctly feminist vantage point. It contrasts with earlier feminist scholarship that has gendered the American landscape as female. For example, in *The Lay of the Land*, Annette Kolodny focuses on what she calls the "pastoral impulse" of the New World settlers who, yearning for solace from their fear of the untamed land, constructed feminine metaphors for their

10 Jane Tompkins, *West of Everything: The Inner Life of Westerns* (New York: Oxford University Press, 1992), 71.

11 Ibid., 74.

3 ARTHUR PENN **LITTLE BIG MAN** 1970, still photograph from the film, collection The Museum of Modern Art Film/Stills Archive, New York

4 JOHN FORD **STAGECOACH** 1939, still photograph from the film, collection The Museum of Modern Art Film/Stills Archive, New York

3 4

interactions with the landscape. Consistently throughout the literature and documents of exploration and settlement of America from the sixteenth to the nineteenth centuries, Kolodny found that the landscape was seen "not only as an object of domination and exploitation, but also as a maternal 'garden' receiving and nurturing human children." [12]

Kolodny cites a highly influential paper on the concept of the West as frontier, delivered in 1893 by the historian Frederick Jackson Turner to argue that the pastoral impulse was also projected onto the West [see pp. 86, 87]. The irrefutable kernel of truth that Turner's vocabulary exposes is that the transition from passively returning to the land as "mother," to exploring it and acting upon it as a repository of wealth, had been repeated from one end of the continent to the other:

> European men, institutions, and ideas were lodged on the American wilderness, and
> this great American West took them to her bosom, taught them a new way of looking upon
> the destiny of the common man . . . she opened new provinces, and dowered new demo-
> cracies in her most distant domains with her material treasures . . . [13]

12 Annette Kolodny, *The Lay of the Land: Metaphor as Experience in American Life and Letters* (Chapel Hill: The University of North Carolina Press, 1975), 5.

13 Kolodny, 137. Reprinted in Marshall B. Tymn, ed., *Thomas Cole's Poetry* (York, Pa.: Liberty Cap Books, 1972), 112.

While Westerns dealing with settlement themes, such as *Frontier Horizon,* were more likely to envision the landscape as feminine, those whose plots unfolded in a Western killing ground were gendered as masculine. But there is at least one film that employs both masculine and feminine metaphors for the landscape. In John Huston's *The Treasure of the Sierra Madre* (1948), three men endure intense heat, dust storms, and bandits in the mountains of Mexico to mine a fortune in gold. To the two novices, the landscape is grueling and harsh, particularly life-threatening for the greedy and paranoid Dobbs (Humphrey Bogart), who disrespects its power. Overcome by his crazed lust for gold, he wastes precious water and is almost killed when a mine collapses over him. It's clear that Dobbs will pay for this attitude with his life.

But for Howard (Walter Huston), who leads the others to the site and teaches them how to extract the gold, the landscape is maternal and generous. Although he is much older than the others, he is never physically overcome by the rigors of climbing the mountains' steep inclines or by the lack of water. He is also the least interested in acquiring wealth, that is, the least invested in exploiting the land. This connection to a maternal landscape is explicitly expressed when he announces: "We've wounded this mountain and it's our duty to close the wound. It's the least we can do to show our gratitude for all the wealth she's given us." Dobbs disgustedly retorts: "You talk about that mountain like it's a real woman." But Howard, who saves the life of an Indian boy, reaps the fruits of his wisdom and generosity by being honored and accepted into the tribe as its medicine man.

Although the conventions of the Western have remained remarkably consistent, thematic changes reflect historical and cultural preoccupations, such as the emergence of greater psychological and moral complexity in the Western's plots and characters in the 1940s, a shift toward adult themes in the 1940s and 1950s, and the transformation of the cowboy to gunfighter in the 1960s. But despite these changes, the Western's audiences declined steadily in the 1960s. Reflecting a political climate that could no longer sustain the mythology of a West riddled with the corpses of its native peoples, Westerns produced in the 1970s deconstructed and parodied that mythology with Arthur Penn's *Little Big Man* (1970), Robert Altman's *McCabe and Mrs. Miller* (1971), Mel Brooks's *Blazing*

Saddles (1974), and Altman's *Buffalo Bill and the Indians, or Sitting Bull's History Lesson* (1976). But despite these attempts to revitalize an increasingly unpopular genre, the spectacular commercial and artistic failure of Michael Cimino's *Heaven's Gate* in 1980 signaled (prematurely) the death of the Western.

A decade later the Western was dusted off, with the success of two films in which the leading actors invested considerable personal and financial capital. Both films, Kevin Costner's *Dances with Wolves* (1990), which sides with the Native Americans against the United States Cavalry, and Clint Eastwood's anti-Western, *Unforgiven* (1992), pointedly critique the moral codes underlying the Western ethos. In each, the landscape is complicit in the revisionist project. In *Unforgiven,* there is no heroism to be found in enduring the landscape's hostility. Eastwood suffers the deprivations of being cold and wet while sleeping outside in a heavy rainstorm. In contrast to the mythology of the traditional Western, whereby Eastwood would have slept under the stars on a clear night, or been impervious to inclement weather, the landscape in *Unforgiven* is merciless. Being merely mortal, Eastwood becomes sick, just as any other human would.

A far less radical reinterpretation of the traditional Western, *Dances with Wolves* nonetheless abolishes any romantic ideas of heroism associated with United States cavalrymen and the march westward. The Sioux are portrayed as morally superior to whites, and this is reflected in their relationship to the land. Unlike the white hunters, for example, who wastefully slaughter buffalo for their skins and tongues, the Sioux use the entire animal for food and warmth. The contrast between the scene of the landscape littered with dead carcasses and that of the Sioux's joyous hunt underscores this difference.

"In Search of . . ." : Road Movies

> Driving is a spectacular form of amnesia.
> Everything is to be discovered, everything to be obliterated.[14]
>
> —*Jean Baudrillard*

The idea of the road as a route to personal transformation is a particularly persistent and rich theme in American popular culture, which resonates in literature, films, and even automobile commercials. As Jussim and Lindquist-Cock have pointed out, taking to the road offers many possibilities: "the search for self, identity, salvation for the metaphysically inclined, the appeal of adventure, freedom from responsibility or restrictions, new opportunities for the experientially minded."[15]

At the same time, the experience of driving for hours on end across a landscape dotted with twenty-four-hour truck stops, cheap motels, and shopping malls—the so-called "vernacular landscape"—can produce a profound sense of alienation. The road film, including Dennis Hopper's *Easy Rider* (1969), Jim Jarmusch's *Stranger than Paradise* (1985), Ross McElwee's *Sherman's March* (1986), Robert Frank and Rudy Wurlitzer's *Candy Mountain* (1987), and Ridley Scott's *Thelma and Louise* (1991), reflects these two visions of the American landscape.

The impulse behind road travel in American culture is rooted in the same ideology of individualism and limitless opportunity found in the Western. The cultural historian Alexander Wilson has shown how driving has transformed our experience of the landscape into a private exercise that taps into a deeply ingrained myth. "The individual hero on the road, pushing back the frontiers and discovering this land for 'himself': this myth has a long and bloody history, particularly in American culture, and the car continues to play a part in it."[16]

Popularized in the 1920s, the automobile was first seen as a means of escape for affluent Americans seeking relief from urban ills. In the 1930s, they took to the newly constructed scenic roads, such as the Merritt and Taconic parkways, which had been specifically designed for visual

14 Baudrillard, 9.

15 Jussim and Lindquist-Cock, 106.

16 Alexander Wilson, *The Culture of Nature: North American Landscape from Disney to the Exxon Valdez* (Cambridge, Mass.: Blackwell Publishers, 1992), 37, 38.

5 DENNIS HOPPER **EASY RIDER** 1969, still photograph from the film, collection The Museum of Modern Art Film/Stills Archive, New York

6 ROSS McELWEE **SHERMAN'S MARCH** 1986, Sheldon Church ruins, still photograph from the film, courtesy the director

5

6

7

consumption of the landscape by car. But the most ambitious road building effort was inaugurated with the passage of the 1944 Defense Highway Act, whose purpose was to assure rapid transport of military vehicles and personnel. Over the next thirty years, the construction of the nation's extensive interstate system made it possible for millions of American families to enjoy the pleasures of the road. While less environmentally destructive and more democratic forms of transport fell victim to the aggressive marketing tactics of the automobile industry, owning a car increasingly became as much a necessity as a dream. Ironically, as Wilson notes, cars were marketed for their "important democratizing role: the idea was that modern highways allowed more people to appreciate the wonders of nature."[17]

If the road promised escape into "nature" for the vacationing American family, it was also a compelling symbol of escape from the restrictive social order the family embodied. Road films derive from this impulse to flee, to discover oneself in the American landscape. This quest is literalized in Dennis Hopper's *Easy Rider* (1969), a film that is the most emblematic, if inauthentic, portrayal of 1960s countercultural values. Taking a cue from Jack Kerouac's iconic 1957 novel of the Beat Generation, *On the Road,* Hopper and Peter Fonda play Billy and Wyatt, two hippies who, flush with money from a big drug deal, embark from Los Angeles on a cross-country motorcycle trip. The film alternates sequences of long shots of the two bikers traversing magnificent landscapes with scenes of their nighttime conversations around a campfire and interactions with people along the way.

17 Wilson, 30.

Throughout the film, each landscape is paired with a 1960s rock or folk song signaling a particular mood or theme. For example, early in the film they ride into the desert to the upbeat sound of a popular anthem to youthful rebellion, Steppenwolf's "Born to Be Wild." By the end of the film, Bob Dylan's brooding "It's All Right Ma (I'm Only Bleeding)" conveys the alienation they feel riding through a sprawling industrial wasteland. This sequence also sets the tone for the final scene, in which they are both shot and killed by a redneck. The landscape thus becomes a projection of Billy and Wyatt's circumstances or state of mind.

But the most powerful evocation of the landscape centers around the countercultural idealization of the land. Early in the film, they stop to fix a flat tire at the house of a hospitable rancher and his Mexican wife. At the dinner table, Wyatt, wistful over the life this couple has made for themselves, says: "It's not every man that can live off the land. You should be proud. Do your own thing in your own time." The film then cuts to Billy and Wyatt doing their own thing: to the Byrds's song, "I Wasn't Born to Follow," they tool down the road through pine forests and mountains illuminated by a soft, warm light.

Wyatt's fascination with living off the land is piqued further when Billy and he visit a commune, where a group of hippy transplants from the city are trying to grow their own food. To Billy's skepticism, he responds, "They're gonna make it." The commitment to the soil Wyatt idealizes implies staying in one place, the antithesis of his life of isolation on the road. But both these choices are rooted in the 1960s ethos, which involves a search for self through engagement with the land.

Unlike *Easy Rider,* which embraces the mythology of the road film, Ross McElwee's *Sherman's March* (1986) is an antiroad film, both a tragicomic catalogue of personal failure and a wry reflection on masculinity. McElwee, a southerner living in Boston, originally set out to make a documentary about the effects of Sherman's March on the South. In 1864, General William T. Sherman swept across the South with 60,000 troops, destroying Atlanta, Georgia, and Columbia, South Carolina, and, as a voice overtells us in the beginning of the film, leaving "a path of destruction sixty miles wide and one hundred miles long before finally forcing a Confederate surrender."

After his girlfriend leaves him, McElwee explains he is too depressed to make the film he had planned. Instead, the film, which is subtitled *A Meditation on the Possibility of Romantic Love in the South in an Age of Nuclear Proliferation*, has a new, though related, purpose—to find the perfect Southern woman. Roughly following Sherman's route, McElwee uses his camera as a diary, traveling from a family reunion in North Carolina, to Atlanta, to South Carolina and then back up to Charlotte, North Carolina. But, despite having met (and slept with) several women, and having rekindled old relationships, McElwee's fruitless trip stands in stark contrast to the signs of Sherman's "success"—the ruins of a church or the numerous battlefields and monuments to the South's losses.

Throughout the film, McElwee articulates the theme of conquest by conflating women with the land. He intercuts scenes in which he ponders the landscapes scarred by Sherman's rape of the land with his discussions with family, friends, and lovers about his inability to sustain a lasting relationship with a woman. Often, the women are seen in nature—in or on the water—swimming, boating, or sunbathing, or surrounded by trees. McElwee humorously makes the woman/nature cliché explicit in one scene with Charleen, a former teacher of Ross's who unsuccessfully tries to matchmake him with a devout Mormon. As they walk through a dark tunnel and emerge through some bushes, Charleen scolds him for being so neurotic and urges him to be more aggressive toward women: "It's like pubic hair. You part the bushes."

But McElwee, who pursues Burt Reynolds (reportedly shooting a film in the area) hoping to discover the key to the actor's appeal to women, isn't the swaggering type. Rather, he is plagued by failure: his car breaks down repeatedly, and at the film's conclusion he is penniless, with only one roll of film left. Less akin to Sherman than to Jefferson Davis, the Confederate President who surrendered in Charlotte, North Carolina, the filmmaker's hometown, he too ends his quest there.[18]

The worst part, McElwee says, is that "I don't seem to have a real life anymore. My real life has fallen in the crack between myself and my film." Indeed, the film's self-conscious, quasi-documentary structure and home-movie style are calculated precisely to make it hard to know what

18 Paul Arthur, "Gilding the Ashes: Toward a Documentary Aesthetics of Failure," *Motion Picture*, vol.4, no.1 (Summer 1991), 24–27.

McElwee's real life is. For even though he presents himself as a hapless loser unworthy of following in Sherman's macho footsteps, McElwee's persona is nonetheless keenly self-aware and ironically self-effacing. In constructing the metaphor of the conquest of landscape/woman, and then humorously dismantling it at his own expense, McElwee's road film becomes a meditation on his own male subjectivity.

<p style="text-align:center">* * *</p>

What we think landscape means is always culturally determined. Meinig reminds us that landscape "lies before our eyes and becomes real only as we become conscious of it." [19] But how landscape becomes real, and for whom, depends on the cultural form used and the conventions governing it.

Like the other films considered so far, *Sherman's March* elaborates a metaphor for landscape that reflects uniquely American myths and obsessions. But unlike those Hollywood films, which fall into easily recognizable genres, the structure, style, and tone of *Sherman's March* deliberately operates outside the traditional conventions of cinematic realism. As a low budget independent film that must be "read" in ways different from standard Hollywood fare, *Sherman's March* makes more demands on the viewer. Thus, it is situated within the field of the independent media arts, which has a rich and diverse history of redefining the expressive potential of the moving image.

There are numerous examples of films and videotapes by artists and independent producers that explore issues of landscape, including not only features, but shorter works in the avant-garde tradition, as well as artists' video, which has its own history and concerns. But three works in particular, two films, Babette Mangolte's *The Sky on Location* (1982), and Jon Jost's *Plain Talk and Common Sense (Uncommon Senses)* (1987), and Steina Vasulka's video *The West* (1985), focus on the Western landscape in order to reinterpret received ideas about this region most associated with the American psyche.

While it is rooted in a moving-image technology, *The West* is a hybrid which deploys video not only as a temporal medium, but as a sculptural form as well. Vasulka, who has lived in New Mexico

19 Meinig, 3.

8 JON JOST **PLAIN TALK AND COMMON SENSE (UNCOMMON SENSES)** 1987, tourists on the four corners, still photograph from the film, collection

Whitney Museum of American Art, New York

8

for the past ten years, creates an eerily paradoxical space in which advanced technology intrudes upon the vast timelessness of the Western landscape. In a darkened room, twenty-six video monitors are stacked in two horizontal rows forming a panoramic band of images. This configuration alludes not only to the wide-open spaces of the West itself, but to wide-screen Westerns, which were ideally suited to the scenic views composed in the nineteenth-century tradition. However, rather than relying on an older pictorial formula, Vasulka replicates the experience of standing in a magnificent, seemingly infinite, landscape by using a lens with a mirrored sphere. With this device, which rotates slowly on a motorized tripod, she is able to obtain a 360-degree pan of the surrounding landscape. The resulting images — including mesas, pueblo dwellings, and the ancient geological formations of Chaco Canyon — are colorized, overlayed, and otherwise fragmented to intensify their effect. This semiabstract imagery, which is divided into two separate channels of video, slowly moves sideways from one monitor to the next, while a low-frequency electronic sound track conjuring up a still, cavernous space, fills the room.

However suggestive of timelessness and ancient culture it may be, this tableau of tranquility is also inhabited by a decidedly modern human invention — the Very Large Array — a vast grouping of giant satellite dishes that are seen periodically in the image cycle. Their slow, rotating movements echo the circular pans of Vasulka's camera, suggesting that their presence is less intrusive than oddly harmonious.

Mangolte's and Jost's films also take the Western landscape as their subject. However, each has a more overtly political quest, searching the landscape for the soul of America — for some symbol of its identity or essence. While both find plenty of fertile ground in the history and ideology of the land, and how it has been represented, each comes up empty-handed.

In *The Sky on Location*, Mangolte starts with the premise that "we confront what we see with what we already know," in order to examine the process of finding meaning in the landscape. Mangolte, a French-born filmmaker and avant-garde cinematographer, who has lived in the United States since the late 1960s, made a series of trips to some of the most beautiful and remote areas of the Far West, including the Colorado Rockies, Yellowstone, the Grand Tetons and Glacier National Park, Yosemite, Mono and Pyramid lakes, Death Valley, the Cascades, Bryce Canyon, Canyon de Chelly, and the Mojave Desert. Her quest: to explore the idea of "wilderness," a concept so ingrained in the American psyche and yet so alien to her as a foreigner — as distinct from nature as scenery. Following a seasonal chronology beginning in the summer of 1980, the seventy-eight-minute film consists primarily of a series of stunning static shots and circular pans, accompanied by a scripted sound track of three voices, including that of Mangolte herself. Except for these voices, who speak about the land's history, ecology, and their personal reactions to it, the film is devoid of people.

This, coupled with a meandering pace, allows for the kind of rumination that traveling inspires. Instead of creating a linear narrative or documentary structure, Mangolte takes a more stream of consciousness approach, freely juxtaposing snippets from immigrants' diaries with musings on the nineteenth-century notion of the sublime in nature, with personal reflections on their inter- actions with the landscape.

Throughout the film, Mangolte interrogates the acquisitive impulse in American culture, the desire to capture the landscape on film in order, somehow, to own it. Implicating herself in this process, she says: "In that same hurry, we take data and document where we are and what we do and what nature is doing. We accumulate photographs and records to compensate for that sense of irremediable loss for the passing traveler." At the film's conclusion, she ponders figuratively and

visually her own position in relation to her subject. As the camera focuses on a swirling river eddy, she says: "In looking at nature, I was tracking down history." Then, in a visual pun on the expression, "can't see the forest for the trees," she cuts from a close-up shot of some trees to the same view from farther away, asking herself: "Have I been too close or back too far?" The camera then zooms out from the eddy and tilts up to reveal a towering mountain in the distance, as she concludes, "Have I really seen?"

As in *The Sky on Location*, Jost's *Plain Talk and Common Sense (Uncommon Senses)* interrogates the representation of landscape to take the pulse of America. In both, the filmmakers use voice-over narration to locate themselves within an American landscape that is both physical and cultural. But where Mangolte's purpose is as philosophical as it is personal, Jost's is more pointedly political—to assay the state of the union in the Reagan era.

To do this, Jost opens the feature-length film with a scene that establishes its central metaphor. Various tourists take turns standing at Four Corners, a slab of stone that serves as a monument to the intersection of the borders of Arizona, New Mexico, Colorado, and Utah. As they photograph one another stepping from one state to the next, marveling at their ability to be in four places at once, Jost's voice-over ruminates on the appeal of attempting to situate oneself both geographically and psychically within a place. "And we Americans come here for that something residing in our landscape—that something we would like to get our grips on, that we would like to understand." Then, standing on the monument himself, he pans his camera to survey the undifferentiated landscape of the four states, and says: "But, looking at us here, one really has to wonder what state we are in."

With this play on words, Jost links a concrete, physical setting with an abstract concept—the broader cultural, social, and political condition of the country in the mid-1980s. In the film's subsequent nine sections, Jost weaves a portrait of America that both draws upon and is victim to various received ideas about and received images of the American landscape. Using quotes from historical documents and speeches about the land; postcards and promotional films reflecting the dual

American obsession with the land as the source of both material and psychic enrichment; current population and income statistics illustrating economic inequities; and a long sequence in which randomly selected Americans step up to the camera and identify themselves, *Plain Talk* is at once a veritable catalogue of ways to represent the physical and social landscape of the country, and a meditation on the impossibility of doing just that.

Jost reinforces this point throughout the film by probing what can be found beneath the surface of any polished image. In a section entitled "Inside/Outside," Jost juxtaposes two disparate images of Colorado Springs. A promotional film describing it as a safe, economically viable community enhanced by the lure of "nature's most varied temptations" is narrated by a syrupy female voice. This is followed by a sequence narrated by an authoritarian male voice describing nearby Cheyenne Mountain, the home of the Strategic Air Command.

Jost's search for the soul of America concludes with a trip to the nation's geographic center. As his camera scans a seemingly empty landscape somewhere on the plains of South Dakota, Jost speculates on the disappointment that tourists, accustomed to monuments and markers, might feel at this anticlimax. "One anticipates a revelation that the metaphysics of nationhood would stand stripped, turned physically palpable . . . something you could get your hands on." Instead, there seems to be nothing there, until Jost reveals that beneath the site lay the underground missile silos of Ellsworth Airforce Base. "It is a terrible irony, as if the spirit of the nation were held hostage to the fates, who, as the chorus of a Greek tragedy, stand ready to announce the fury of the gods."

Jost's preoccupation with picking away at surfaces—at representations that appear to mean one thing and yet, upon further inspection, reveal something else—find their perfect form in his deconstructionist film style. Things are never what they seem to be. And so it is with landscape. Ultimately, Jost argues, it is impossible to discover the significance of the American landscape as a source of American identity. He suggests that we look elsewhere. "The heart of the country lies not over there, or in some imposing symbol. No, rather, the heart of the country lies within ourselves, each of us, in what we really do."

LUCINDA FURLONG is a freelance critic of film and video who was curator of media arts at the American Center in Paris in 1992. As assistant curator of film and video at the Whitney Museum of American Art from 1986–1991, she organized numerous exhibitions including *The Return of Visual Pleasure* (1991), *From Object to Subject: Documents and Documentaries from the Women's Movement* (1991), and *AIDS Media: Counter-Representations* (1989). In 1993, she curated a program of videotapes, *Private Lives/Public Spheres*, for the exhibition *Public Figures* at the Herron Gallery of the Indianapolis Center for Contemporary Art. She has written extensively on the history of independent video.

PERSPECTIVES ON THE AMERICAN LANDSCAPE

Essays by

JOHN R. STILGOE

NEIL HARRIS

REBECCA SOLNIT

ARCHIPELAGO LANDSCAPE

JOHN R. STILGOE

Any exit ramp leads away from the interstate highway corridor, away from that singular American landscape of standardized, franchised, trademarked American space into other landscape, into elsewheres, peculiarities, oddnesses. Long-haul order rules the interstate corridor, an order of chain motels, sanitized gasoline stations, fast-food restaurants, an order of broad median strips, green-painted bridges, well-marked junctions. Inside the mowed lawns, guardrails, and chain-link boundary fences of the interstate corridor, Americans know what to expect. Broad curves, wide shoulders, gentle gradients, a million shield signs gleaming with numbers: I–40, I–95, I–20, I–2–83. Even-numbered routes run east–west; odd-numbered, south–north. But always the capital I stands as prefix, proclaiming interstate federal space, standardized route, announcing the long-haul sameness that infuses motels, gas stations, and restaurants just adjacent, businesses that pander to the traveler in homogeneous space, businesses that accept national credit cards. But beyond the corridor sameness ends. Sameness ends where exit ramp ends.

Beyond the exit ramp, car becomes capsule, spaceship, launched into localism. Away from home turf, every motorist turns explorer, suddenly conscious of interstate landscape left behind, of oddness just ahead. Automobilists glance at gas gauges, and twist around, locking doors. Truckers downshift, test air brakes, then crane forward, checking mirror angles. Everyone slows down, expecting unannounced intersections, unmarked speed limits, potholed roads, narrow bridges, detours, local speed traps. And without warning, maps fail.

Away from smooth interstate space, every road atlas fails. Great national atlases such as the *Rand McNally Road Atlas,* the best-selling annual publication in the United States, aim only at national

audiences, at long-haul drivers.[1] Intended to help drivers travel long distances, they include only the scantest local information, here an exploded map of Los Angeles, there a glimpse of southern Missouri. At the end of the exit ramp, automobilist and truck driver new to an area expect to hesitate, to watch for signs, to ask locals the best way. Everything away from the red, black, and blue lines designating interstate, state, and county highways is only so much blankness to be entered in an exploring state of mind, with doors locked and fuel tank full. Yet at the end of the twentieth century, few Americans explore as the voyageurs did, even on today's rivers of asphalt.

Landscape

"I do not know why the name 'lakes' has been given to these watery deeps of such vast extent," mused Antoine de la Mothe Cadillac in the year 1699. What other explorers of New France called the Great Lakes, he saw as one immense sea. "It will be easily understood that you can readily sail round these lakes for a distance of 1800 leagues, in fresh water and with land all around you, not only with canoes but even with barques and large vessels." An able lieutenant of Governor Louis de Buade Frontenac in the 1690–1697 war against the British and their New World colonists, an explorer and cartographer of the Upper Country, the founder of the city of Detroit in 1701, one of the pioneers of Mobile on the gulf coast of Louisiana, Cadillac ever demonstrated an angle of vision peculiarly French. Precise, convincing, always bold (at one point he argued that all New York colony should fall to the French), he saw North America as an archipelago. "No bottom can be found well out into these lakes, any more than on the high seas; near the land, there are twenty, twenty-five, thirty, forty, or fifty fathoms of water almost everywhere. In Lake Michigan there is a tide, that is, its waters ebb and flow every twenty-four hours, just as in the ocean, and the waves increase and diminish according to the course of the moon." Such a sea demands a marine point of view, for the freshwater sea opens on others, even on the Pacific itself.

"In the country of the Sioux there is a river which is known for 1,000 leagues around," Cadillac concludes near the end of his "Memoir." "Its current is gentle and it would carry a ship

1

1 *Rand McNally Road Atlas* (Chicago: Rand McNally, 1990), 3.

2 3

throughout. It is bordered on both sides by prairies stretching farther than the eye can reach, with a few clumps of trees. Its source is not yet known." But Cadillac has a hunch, a fervent feeling that he knows its source. "It runs from the west and joins the Mississippi, which runs into the Southern Sea. It is my belief that the Western Sea could be discovered by means of this river, for experience shows those who travel in this country that every river takes its rise in some lake situated on a mountain or rise of ground which has two slopes, almost always giving rise to two or more rivers." In a detailed argument mixing fact with surmise, hope with legend, Cadillac makes perfectly clear that the ease with which *coureurs des bois* (trackers) move by boat from the St. Lawrence across the Inland Sea to Chicago, then into the Mississippi tributaries and south to the Southern Sea, will be duplicated in a western route. That route will lead the traveler from the Mississippi west along the river of the Sioux for one hundred days, and eventually to what the Assiniboine tribesmen call the salt sea "beyond which, they say, there is no more land." No Frenchman had found the "grandfather of all lakes" that the Indians located at the headwaters of the Sioux-country river (what Americans now call the Missouri), nor the river flowing west from it to the salt sea, but Cadillac argues eloquently for exploration by water. "It should be observed that one can navigate the interior of the country on fresh water in a ship" already, making only three portages in 2,300 leagues, he observes, and the unexplored western river can only open on the Pacific, offering untold advantage to France.[2]

Seventeenth- and early eighteenth-century cartography makes clear the striking significance of the peculiarly French vision of the New World as archipelago. While British and Dutch settlers

2 Antoine de la Mothe Cadillac, ed., "Memoir," in *The Western Country in the 17th Century*, ed. Milo Milton Quaife (Chicago: Donnelley, 1947), 6–10, 76–77. Still the best for cartographical background, Justin Winsor, *The Mississippi Basin* (Boston: Houghton, 1898), remains a fine narrative history of exploration and settlement.

3 GUILLAUME DELISLE **MER DE L'OUEST** ca. 1770, hand-colored engraving, 17 ¾ x 25, courtesy John Carter Brown Library, Brown University, Providence, Rhode

Island

huddled along the Atlantic shore, Cadillac and other Frenchmen roamed far inland, covering immense distances in canoes, bateaux, and other small craft perfect for exploring promising watercourses. Louis Joliet's map, "Nouvelle découverte de plusieurs Nations dans la Nouvelle France en l'Année 1673 et 1674," offers graphic evidence of the French vision so clear in Cadillac's writing. North America lies almost wholly surrounded by ocean, especially by the Arctic, becoming essentially a giant island. Its Atlantic and gulf coasts exist in the most cursory form imaginable, perhaps not simply because they lie in British or Spanish hands, but because they offer no estuaries or rivers leading far into the interior. What leaps at the viewer, of course, is the vastness of the interior lakes that gives rise to two great river systems, one opening into the Atlantic, the other into the gulf. Despite the crudities of individual details—say the triangular shape of Lake Erie—the overall intention is clear, and repeated in a letter from Joliet strategically placed to cover the unexplored country in the west.[3] The map exists as navigational chart. Viewer and letter-reader alike discover that the river running west from the Mississippi can lead only to the Pacific. Joliet knows North America as an archipelago.

Certainly the Spanish worried about the French vision as much as they worried about French exploration. In 1686, for example, Martin de Echegaray drew a map for Spanish authorities alarmed by news of René Robert Cavelier, Sieur de la Salle's colony at the mouth of the Mississippi. The Spanish naval officer knew the gulf coast and islands well enough, but only hearsay directed his interpretation of the interior. Yet he caught the significance of la Salle's colony as entrepôt to an archipelago undoubtedly connected to the Pacific, along whose coast Spain had already planted missions, and to a vast inland sea, not a chain of great lakes.[4] Quite evidently, de Echegaray understood the importance of a Spanish thrust northward, not overland, but by water, and especially along the rivers running northwest from the gulf. Delay would mean French exploration, and French settlement.

What was it that the Assiniboine told Cadillac, that Joliet heard rumored midway down the Mississippi? Had de Echegaray heard something too about a salt sea, some vast bay of the Pacific or

3 Copy of Joliet's letter in John Carter Brown Library, Brown University, Providence, R.I. Location of original unknown.

4 Original in Archivo General de Indias, Seville, Spain, 61–6–20 (1). On the importance of water in northern New Spain, see Michael C. Meyer, *Water in the Hispanic Southwest: A Social and Legal History* (Tucson: University of Arizona Press, 1984).

some chain of massive lakes like those the French already knew, but salt? In 1752 a version of a map supposedly drawn by cartographer Guillaume Delisle a half century earlier appeared in Paris, a map entitled simply "Mer de l'Ouest." Perhaps the map misuses the name of the late, great cartographer as a way of introducing the geographical theories of his son-in-law, Philippe Buache, its publisher.[5] But perhaps the map reveals the best possible thinking about North American topography around the year 1700, the thinking of Cadillac and other Frenchmen conversant with tribesmen's tales. The map shows an enormous bay unbounded to the north, a sea near the size of Hudson Bay and dwarfing the lakes, a sea clearly salt. Of equal importance, perhaps greater, the map locates a wondrous River of the West, rising in a lake near what Cadillac calls the river of the Sioux country, but titled here the Missouri. Dotted lines reveal the uncertainty of its course, but its importance is unmistakable, indeed awesome. Unlike the ice-bound Northwest Passage luring the British, the great bay and the west running river offer the French a central passage, a route through the center of the North American archipelago.

United States history properly begins with the War for Independence, of course. Before that glimmers mere colonial history, and the seamless "Time Past" of the Indians, an agelessness rammed home by ruins unknown to living tribes. Yet colonial history endures—irksome, embarrassing, seductive, lurking in bits and pieces of wiry landscape. Rural New England families still speak of "the old French wars," as nineteenth-century novelists and historians did. In the 1850s, Nathaniel Hawthorne found something to chew on in the legends distinguishing the Province of New England from the Colony of Massachusetts Bay, and a few decades later Francis Parkman found something even meatier in the struggle between France and Great Britain in North America, the "French and Indian Wars" American schoolbooks now gloss in half a page.[6] Frontenac, Cadillac, Joliet, and de Echegaray belong to "Times Before," to the times when different world views, different angles of vision, clashed for primacy, when North America remained an archipelago, not a chunky continent. As late as the end of the nineteenth century, Times Before perplexed the most acute American novelists and historians.

5 On Philippe Buache see W. P. Cummings, et al., *The Exploration of North America, 1630–1776* (New York: Putnam, 1974), 181.

6 Nathaniel Hawthorne, "Legends of the Province House," *Twice-Told Tales* (1851; reprinted, Boston: Houghton Mifflin, 1882), 272–342. Francis Parkman, *Works* (Boston: Houghton, 1892).

Deep into the nineteenth century, long after independence, United States writers mused continuously on Times Before, on geography, on culture. "Canada was at the very portal of the great interior wilderness. The St. Lawrence and the lakes were the highway to that domain of savage freedom; and thither the disfranchised, half-starved seigneur, and the discouraged habitant who could find no market for his produce, naturally enough betook themselves," argued Francis Parkman in 1874 in his *Old Régime in Canada*, juxtaposing the *coureur de bois* against the "New England man," whose "geographical position cut him off completely from the great wilderness of the interior," whose field of action remained the sea. For Parkman, the *coureurs de bois* knew more deeply than the Anglo-American settlers the great natural wonders of the continental interior, the "gulfs where feathered crags rise like castle walls" or the "stern depths of immemorial forests, dim and silent as a cavern," knew more deeply the depths of emancipation from the restraint of royal edict, "the lounging ease of the campfire, and the license of Indian villages."[7] Author after United States author gnawed the bones of Times Before, authors like James Fenimore Cooper, whose *Last of the Mohicans* (1826) ends in deaths intended only to defuse the force of incipient miscegenation, the miscegenation so easily accepted everywhere in New France and New Spain. But one author alone speaks still of Times Before, of another attitude toward wilderness, of matters beyond the ken of Massachusetts farmers.

Eleven years after Buache published his cryptic map showing a western sea, cities of gold, and a river running west from the Missouri, a French mercantile company set about surveying the streets of St. Louis. United States schoolbooks make much of the westward movement of Anglo-Americans, showing great arrows emerging from the "cultural hearths" of New England, New York, Pennsylvania, and Virginia, and emphasizing the clearing of forest and building of log cabins. But settlement proceeded not by clearing and planting, but by hunting, trapping, and exploring, by the building of trading posts fought over in the Anglo-French wars, by the building of cities. In the western interior, cities came before farms, even after the Treaty of Fontainebleau (1762) and Treaty of Paris (1763) split the West at the Mississippi. Before farmers arrived, the Mississippi basin boasted

7 Francis Parkman, *The Old Régime in Canada* (Boston: Little, Brown, 1874), 312, 313, 399, 400.

small cities dreaming large dreams. Pittsburgh, St. Louis, Louisville, New Orleans, Cincinnati, and other smaller places, such as Ste. Genevieve, nestled against navigable rivers—only Lexington in Kentucky survived as a riverless inland city. At first dependent on trappers and boatmen, early fought over by warring armies, sometimes changing allegiance—usually from French to Spanish to French—these infant cities prospered mightily as ports, trading posts, and jumping-off points. Only tortuous trails at first connected them to the East, or to anywhere. Commerce moved by river.

All nations came by canoe, flatboat, bateau, and later by keelboat and barge. Each city offered a strikingly similar street pattern, a grid of streets crossing at right angles, a grid focused on the waterfront. Anglo-settled cities took their grids from Philadelphia, while St. Louis took its from New Orleans. The grid, the great rectilinear survey Congress authorized after Independence, in time covered the whole West, producing square farms, townships, and fields, the "checkerboard" that air-line travelers discern miles beneath them. Grids emphasize equality—supposedly.[8] Easily extended, replicated, and duplicated in the next city to be, the grid has the sameness of graph paper laid across the wilderness, a sameness belying differences of topography, forest cover, soil fertility, a sameness that silently but eloquently welcomes newcomers. By 1810 the interior of eastern Mississippi basin boasted cities in which all nationalities mingled, while emerging rural landscapes were almost wholly Anglo.

Rural landscape endures as Anglo landscape almost everywhere in the United States. Here and there the explorer-beyond-exit-ramp encounters exceptions—say in the hill country of northern New Mexico, where most farm families descend from seventeenth-century Spanish colonists and fields and villages show traces of Castille. But elsewhere, even where last names tend to be German, as in much of the wheat country of Minnesota and South Dakota, the framework of Federal recti-linear survey orders a mix of barns, fences, and other details scarcely different from those of Anglo-ancestry Kansas and Idaho. State after state, longitude after longitude, the pattern paralyzes most travelers into boredom. Big square farms, each with a farmstead sitting in the midst of square or rect-angular fields, reach toward the horizon, interrupted now and then by a tiny small town, a handful of cross-hatched streets, one the Main Street of stores, post office, and farm-supply businesses, one or two others

8 Richard C. Wade, *The Urban Frontier: The Rise of Western Cities, 1790–1830* (Cambridge, Mass.: Harvard University Press, 1959), 1–71. On river commerce, see Robert Capot-Rey, *Geographie de la circulation sur les continents* (Paris: Gallimard, 1946), 192–214.

essentially residential, perhaps one more fronting a railroad track, rusted and disused or polished, well-ballasted, and busy. Now and then emerges a larger town, the "county seat" with its courthouse square a duplicate of some other farther east, a grandiose courthouse, more stores and houses than usual, and a consolidated high school, its giant gymnasium announcing a passion for basketball and other wintertime indoor sports. Contemporary travelers find the vastnesses of rural America essentially British, certainly white, what Englishman Jonathan Raban, exploring the Mississippi River headwaters in a small boat, discovers as a "vast white ghetto."[9] Secure, quiet, even dull, rural America endures between prosperity and destitution, remarkably crime free, smog free, news free. Only in the rural South, in the territory of the Old Confederacy scarcely touched by the rectilinear survey, does the traveler encounter black families who give cause for wonderment.

Away from the seaboard Southern states, inland from the museumlike plantation houses, rural landscape reflects the subtle infusions of non-Anglo thinking, the continuing longevity of Times Before. Now out-of-favor authors caught in the 1870s—and later—the knowledge of something old, something haunting the landscape. Today, dismissed in their own nation as racist, as crudely local colorist, as second-rate, Southern authors like George Washington Cable stirred the ashes of the Confederacy to find sparks of something deeper. "The original grantee was Count . . . , assume the name to be De Charleu; the old Creoles never forgive a public mention," begins one of his short stories, "Belles Demoiselles Plantation." "He was the French king's commissary. One day, called to France to explain the lucky accident of the commissariat having burned down with his account books inside, he left his wife, a Choctaw Comptesse, behind." Cable understood that the plantation landscape of the western South developed from a culture other than British, even other than African. His stories about New Orleans society, about marriage between ethnic groups, between races, depend in part on their physical and temporal setting, their evocation of African dance on a summer night in the Place Congo, their understanding of Creoles, of a city known as French, Spanish, American, Confederate, and Federal.[10]

9 Jonathan Raban, *Old Glory: An American Voyage* (New York: Simon and Schuster, 1981), 152, 153.

10 George Washington Cable, *Old Creole Days: A Story of Creole Life* (1879; reprinted, New York: Scribner's, 1916), 121. See also Cable, "The Dance in Place Congo," *Century* 31 (February 1886), 517–523, for his understanding of racial energy in New Orleans.

4 GEORGE CALEB BINGHAM **FUR TRADERS DESCENDING THE MISSOURI** ca. 1845, oil on canvas, 29 x 36 ¹/₂, courtesy The Metropolitan Museum of Art,

New York: Jesup Fund, 1933

4

William Faulkner's *Absalom, Absalom!* of 1936 rammed home the message of Cable, and others, the message that the western Southern landscape reflects more than the simple westward movement of Anglos and enslaved blacks. The novel is not so much about the era before the Confederacy as it is about Times Before, when a settler named Sutpen arrives from nowhere, buys—using Spanish gold coin—"a hundred square miles of some of the best virgin bottom land in the country" from Chief Ikkemotubbe through the Chickasaw Indian agent, then vanishes, only to return with a covered wagon filled with slaves, and carrying an architect on its one seat. The last, "a small, alertly resigned man with a grim, harried Latin face, in a frock coat and a flowered waistcoat and a hat which would have created no furore on a Paris boulevard," has come "all the way from Martinique" to disappear into the woods for two years to direct Sutpen in building his great house with the help of naked, French-speaking island slaves.[11] Building in the wilderness forms one great theme of the novel, as it does in others Faulkner wrote as he explored the twisted themes so evident in Southern landscape.

Cable, Faulkner, and other Southern writers know what so many east- and west-coast Anglo intellectuals try to hide: the landscapes of Mississippi, Arkansas, Louisiana, even Florida, Missouri, and Michigan still reflect a richer, more shadowed past than that reflected by the rural landscapes of Massachusetts, Pennsylvania, even Virginia, perhaps even by coastal cities like Boston, New York, Seattle, and San Francisco. The first cities of the Mississippi basin attracted the trappers, hunters,

11 William Faulkner, *Absalom, Absalom!* (reprinted, New York: Random House, 1964), 34, 35, *passim*.

watermen of several cultures, the men who knew the savagery and the freedom that repulsed and attracted Anglo historians like Francis Parkman. In the great multicultural stew of the lakes and rivers seaming the archipelago, only the rural regions stood aloof, secure, almost smug in their Anglo-generated agricultural order. But where the field ended and the creek or ravine began, the creek or ravine crowded with rank, luxuriant forest, with roaming predators, escaped slaves, renegade Indians, drifters, and tramps, agricultural order ended and the old order of the *coureurs des bois* obtained.[12] Always at the edge of the field, near the riverbank, up the hillside lurks the forest, lurks something of Times Before.

Many urban intellectuals squirm when the name Faulkner rises in conversation. No local colorist he, but no city dweller either, he of the Nobel Prize. His works linger like landscape, refuse to vanish, always point the way—the channel—back to the last attack on urban intellectuals and manufactured "national culture," the attack from the depression-era rural South. Southern writers knew the legacy of pre-Civil War sectionalism, and the desperation and poverty of postwar Reconstruction. They knew a landscape not only of burned-out plantation houses and grown-over cotton fields, of charred towns and steamboat piers, but a ragged backcountry of pine-board shacks, sharecropper cabins, and gullied roads. But they knew too the South as a specific, identifiable region, one of several such in the nation. "The United States are culturally and economically divided—not like Gaul into three—but into five parts," opined Allen Tate and John Peale Bishop in 1942, casually using "United States" as a plural noun demanding a plural verb. "Each has had its special history; each has a somewhat special way of life. There are New England, the South, the Middle West, the Southwest, and the West Coast." In their thinking, as in the thinking of so many other authors then—and now—dismissed as regionalists or local colorists, New York and its environs are not properly a "part" or region. "New York is the city where books and magazines (but not all of them and not always the best) are published;" it is the city where "writers go to make a living" using energy that "has derived some substance from the sidewalks of New York" but whose "origin is to be sought in the New England village, the Ohio factory town, the Wisconsin farm, the

12 Forrest Carter, *The Education of Little Tree* (New York: Delacorte, 1976).

Southern plantation, the dry plains of New Mexico."[13] New York is the manufacturer and wholesaler of a "national culture," a sort of veneer flung over regional identities, something exported overseas. Just as its skyscrapers, wharves, and great avenues are new, without anything remaining from the deep Dutch past, so its broadcast culture is new, divorced from specific pasts, landscapes, and depths.[14] Tate and Bishop suggest that New York-style culture appeals only to Americans who know nothing of the deep pasts of specific regions and landscapes—or else know those pasts so well that they recoil in terror toward something safer.

Others wondered too. The philosopher John Dewey, as early as 1920, mused that the great New York-based magazines "have to eliminate the local" in order to have national audiences, and find in the traveling public their best readers. "They subsist for those who are going from one place and haven't as yet arrived at another," he remarks of magazines sold by the hundreds of thousands in railroad-terminal kiosks. But underlying his argument is a deeper one, one playing on the notion of a traveling readership, a public en route. He implies that the people who absorb the national magazine culture are people not yet in place, people as anxious to be Americanized as any newly landed immigrant. "The country is a spread of localities, while the nation is something that exists in Washington and other seats of government," Dewey decides before remarking that "the defeat of secession diversified the South even more than the North." In using the word *country* in its older sense, in the way Henry James used it in 1886 in *The Bostonians* when he introduces a Southern Civil War veteran as an immigrant in Boston—"He came in fact from Mississippi, and he spoke very perceptibly with the accent of that country"—Dewey slices deeply into the lingering difference between *country* and *nation*.[15]

The difference fascinated dozens of Americans, especially T. S. Eliot, who fourteen years later published "Tradition and Orthodoxy." His willingness to carve the nation into countries jars any contemporary reader, while his remarks about borders and frontiers elicit only smiles. Who now believes that "to cross into Virginia is as definite an experience as to cross from England to Wales, almost as definite as to cross the English Channel?" Who reads, without squirming, his remarks

13 Allen Tate and John Peale Bishop, *American Harvest* (Garden City, N.Y.: Garden City Publishers, 1942), 11.

14 Jan Morris, *Manhattan 45* (New York: Oxford, 1987); E.B.White, *Here Is New York* (New York: Harper, 1949).

15 John Dewey, "Americanism and Localism," *The Dial* 68 (June, 1920), 684–688. Henry James, *The Bostonians* (Boston: Houghton, 1886), 36. See also J. B. Priestly, *Midnight on the Desert: Being an Excursion into Auto-biography During a Winter in America 1935–1936* (New York: Harper, 1937).

about "the foreign races" invading New York and other cities, and swamping "native culture?" In context, however, precisely bracketed by Dewey and George Davidson, Eliot becomes seer, a poet gifted with landscape vision. "I had previously been led to wonder, in traveling from Boston to New York, at what point Connecticut ceases to be a New England state and is transformed into a New York suburb," he remarks at the train window, scrutinizing what is so evident aboard Amtrak expresses today. He savors "the sordor of the half-dead mill towns of southern New Hampshire and Massachusetts," the mysteries of abandoned farms grown up in forest. Eliot, like Davidson and Dewey, sees local landscape as something descried against a national veneer, as something whose past foreshadows future. In another essay, when he remarks that "we have not given enough attention to the ecology of cultures," Eliot makes clear that "if the other cultures of the British Isles were wholly superseded by English culture, English culture would disappear too." In his 1948 "Notes Towards the Definition of Culture," Eliot demonstrates that his earlier likening of the crossing of the Potomac to the crossing of the English-Welsh frontier was not at all frivolous, but critical in any understanding of British or American culture.[16] Without specific regions, without specific local landscape, the veneer of national culture, the skim coat of national, interstate highway landscape can only warp and twist, for *nothing backs it*.

Almost no one listened to Davidson, Dewey, Eliot, and the others, the last partisans of tradition, of localism, of parochialism, the last measurers of Times Before, the last scrutinizers of local landscape. To be sure, throughout the 1920s and 1930s a handful of intrepid travelers retraced the routes of explorers, finding along the rivers an America already out of the reach of long-distance automobilists. Lewis R. Freeman, for example, took his outboard-motor-powered skiff from Milwaukee to New York City, from Pittsburgh to New Orleans, following the voyageurs, and publishing wonderful books like *By Waterways to Gotham* and *Waterways of Westward Wandering*, books that discover disquieting changes beneath the veneer of radio-broadcast national culture.[17]

After World War II, after television especially, regional culture like regional landscape became essentially local color, something haphazardly preserved — or pickled — in museums, tourist

16 T. S. Eliot, "Tradition and Orthodoxy," *American Review* II (March 1934), 513–528, esp. 513–514; and, "Notes Towards the Definition of Culture," *Christianity and Culture* (New York: Harcourt, 1949), 130–131, *passim*.

17 Lewis R. Freeman, *By Waterways to Gotham* (New York: Dodd, Mead, 1926), see especially his remarks on the voyageurs, 71–75; and *Waterways of Westward Wandering* (New York: Dodd, Mead, 1927).

5 **POPULATION DISTRIBUTION OF THE UNITED STATES, 1980** flashlight map, 29 x 40, courtesy Geography Division, Bureau of the Census, with the

assistance of National Ocean Service, National Oceanic and Atmospheric Administration, Washington, D.C.

5

brochures, and fast-food restaurant paper placemats. Airline travel only speeded what the post-Sputnik, public-school systems began with the substitution of physics for geography, the gradual discomfort of Americans with maps, the creeping disorientation of Americans confronting long-distance travel. The vast central part of the continent, an expanse encompassing the whole Mississippi watershed, the High Plains, even the eastern slope of the Rocky Mountains, became what airline travelers now dismiss as "Fly-Over Land." A nation anxious to be a world power turned to the world, and so emphasized its coasts, the one fronting an ever-changing Europe, the other facing a transformed Pacific Rim. In the year 2,000, predicts the United States Bureau of the Census, over half the American population will live within fifty miles of the sea, and over three-quarters will live within seventy-five miles.

Forgetting its localities, its regions, its depopulated landscapes whispering of Times Before, above all forgetting that colonization continues, its purveyors of national and world culture ignore the continuing settlement of America. In the great blocks of Anglo-dominated rural landscape, little changes, not even after massive farm mechanization. But elsewhere, in cities especially, everything changes, as group after group of newly arrived immigrants mark off their turfs, their zones bordered by frontiers as indistinguishable and as important as any between England and Wales; as long-time residents move to suburbs focused on stasis; as gigantic shifts in population stress and overstress extant

natural and built ecosystems, infrastructure fabrics, landscapes. Now Cadillac and Joliet are proven right, for twisting among the blocks of Anglo-settled, Anglo-dominated landscape come threads of something different, something of Times Before, something of Times to Come.

Much of the American continent is utterly foreign to most Americans now, not only unvisited, but almost unimaginable. Americans no longer know the immensity of scale—and depth of detail— that transfixed Parkman, that made him sneer at the New England man with his face to the sea, the man surprised at the *chemin du Canada*. Only recently have they begun to imagine the racially mixed populations that entranced Cadillac and Joliet, that terrified Cooper, that fascinated Cable and Faulkner. Americans, especially educated Americans of wealth, influence, and energy, fly over their nation en route to Europe, Asia, or Yucatán, dismissing the immensities the voyageurs so laboriously mapped. But that vast territory, that "great white ghetto" penetrated by Raban in his Mississippi voyaging motorboat, stands now as dense as any African jungle imagined in Joseph Conrad's *Heart of Darkness* (1902). All the arguments now about racial, religious, ethnic, and class diversity demand some nod, however slight, to the contests of Times Before—and to the great landscape theaters in which they occurred.

Landscape speaks still to anyone thoughtful enough, scrupulous enough to listen, to scrutinize, to realize. Today's artists know and use its power to thrust contemporary Americans into Times Before.

Beyond

So the motorist drives warily to the end of the exit ramp, shifts gears perhaps, or merely glances right and left before joining the local road bordered by local landscape. Geographers merely catalogue the thousands of discrete, named landscapes temporarily corralled by the borders of the United States. Only those who probe those landscapes learn their power, see in them the gulfs and immensities of Times Before, the gulfs and immensities of Times to Come. Only those who leave the interstate highway see.

JOHN R. STILGOE is professor of visual and environmental studies and the history of landscape at Harvard University. He is the author for Yale University Press of *Borderland: Origins of the American Suburb, 1820–1939* (1988), *Metropolitan Corridor: Railroads and the American Scene* (1983), and *Common Landscape of America: 1580–1845* (1982). In addition, Professor Stilgoe has published numerous articles in the periodicals *Places*, *Landscape Architecture*, and *The Journal of Architectural Education*.

THE PASSING OF THE GREAT SPACE

NEIL HARRIS

As this millennium nears its end, Americans confront two environmental crises: the first emergency involves the status of our natural landscape, more particularly what we have done to it; the second concerns our built landscape and what it is doing to us. Dirges for our damaged sense of place and the destruction of cherished landmarks are jostled by new indictments of our social setting: increasingly divisive, inaccessible, and manipulated, its public, civic, common areas are seen to be collapsing before a system of pervasive partitioning that caters to class, power, and privilege. The crisis seems all-inclusive. "America's experiences are under siege," one critic charges.[1] The "contemporary spectator in quest of public urban spaces increasingly must stroll through recycled and revalued territories," transformed into "gentrified, historicized, commodified, and privatized places," another puts it.[2] This dispiriting vision challenges planners, critics, artists, scholars, and indeed all who seek to understand our place in the landscape.

Apocalyptic sentiments about our ecosystem and our immediate setting are not new. It was in Chicago, one hundred years ago, that Frederick Jackson Turner delivered his fabled address on the passing of the frontier. In what was probably the most influential American academic paper of the century, Turner helped recast historical literature and, without necessarily intending to do so, prepared the way for a ferocious environmental debate.

The meaning of the Turner thesis has been hotly debated and its conventionalized argument endlessly revised; generations of historians and geographers have struggled to define its terms and offered models by which to measure interacting social structures, governmental systems, and patterns of physical settlement. But whatever the specific revisions, popular perceptions continue to link

1 Tony Hiss, *The Experience of Place* (New York: Knopf, 1990), xviii.

2 M. Christine Boyer, "Cities for Sale: Merchandising History at South Street Seaport," in Michael Sorkin, ed., *Variations on a Theme Park. The New American City and the End of Public Space* (New York: Hill and Wang, 1992), 204.

1

some kind of fundamental national character (a heady brew of individualism, energy, aggressive expansionism, and egalitarianism) to the physical challenge of wilderness survival. Demographic dispersion, the proximity of a redemptive nature, the need for social cooperation in the face of danger, the absence of a historically determined, unequally distributed pattern of land ownership, and the absence, as well, of marks of privilege and domination by church and state: all were claimed as significant allies in the march of democracy across the continent. Turner put the case succinctly. It was "to the frontier the American intellect owes its striking characteristics," he wrote, "that coarseness and strength combined with acuteness and inquisitiveness; that practical, inventive turn of mind, quick to find experiments; that masterful grasp of material things, lacking in the artistic but powerful to effect great ends; that restless nervous energy, that dominant individualism, working for good and for evil, and withal that buoyancy and exuberance which comes with freedom . . . "[3] Thus, the inexorable expansion of settlement could be charged with sapping the rudimentary vigor of American society itself and the diluted physical challenge portended drastic shifts in political behavior.

Sentimental, overstated, xenophobic, anti-urban: all these epithets have assailed the Turner thesis. But its capture of a fin-de-siècle anxiety about social density and natural destruction made its imaging a palpable political and intellectual force.

3 The Turner paper was read before the meeting of the American Historical Association held in Chicago in 1893. It has been reprinted many times. One convenient reprinting, in which it is supplemented by an introduction and seven commentaries, is George Rogers Taylor, ed., "The Turner Thesis Concerning the Role of the Frontier in American History," rev. ed., *Problems in American Civilization* (Boston: D.C. Heath, 1956).

4 Morton and Lucia White, *The Intellectual Versus the City from Thomas Jefferson to Frank Lloyd Wright* (New York: New American Library, 1964), remains a useful summary of anti-urban traditions. For a more recent study that qualifies this view, among other things, see James L. Machor, *Pastoral Cities. Urban Ideals and the Symbolic Vision of America* (Madison, Wisconsin: University of Wisconsin Press, 1987).

5 Among the classic analyses are R. W. B. Lewis, *The American Adam: Innocence, Tragedy, and Tradition in the Nineteenth Century* (Chicago: University of Chicago Press, 1955); Leo Marx, *The Machine in the Garden: Technology and the Pastoral Ideal in America* (New York: Oxford University Press, 1964); and Henry Nash Smith, *Virgin Land: The American West as Symbol and Myth* (Cambridge, Mass.: Harvard University Press, 1950).

6 Among the many texts and catalogues examining this subject see Robert Rosenblum, et al., *The Landscape in Twentieth Century Art. Selections from the Metropolitan Museum of Art* (New York: Rizzoli, 1991); and Bryan Jay Wolf, *Romantic Re-Vision: Culture and Consciousness in Nineteenth Century American Painting and Literature* (Chicago: University of Chicago Press, 1982).

The succeeding century and, more particularly, the last several decades have only sharpened the crisis of environmental confidence that Turner's generation experienced. The emergence of an urban society within a national tradition of skepticism about city life and city institutions (nurtured both by religious puritanism and enlightenment rationalism) set the ground rules for the angry debates about social policy and behavior that subsequently developed.[4]

Many of the dominant landscape images of our own age can be traced back to this persistent tension between a repudiated heritage of naturalism and the march of industrial and urban development. Captured by a succession of tropes—the machine in the garden, the earthly paradise, nature's nation, God's country—the paradoxical dream of simultaneously mastering and preserving a divine landscape in virgin splendor set the stage for a whole series of nineteenth-century American epics.[5] It was a master theme for ambitious writers eager to create great poems, plays, and novels. Natural wonders also engaged the attention of several generations of American painters and photographers—Thomas Cole, Frederic Church, Albert Bierstadt, Thomas Moran, William Henry Jackson—many of them finding in the scale, grandeur, and innocence of the North American landscape a set of scriptural messages.[6]

From such heights only descent is possible. For twentieth-century Americans the tradition of wilderness worship has served mainly as a kind of mournful memory bank from which deposits can still occasionally be drawn, but which suffers from a permanently declining balance.

Jeremiads, polemics, and exposures have long focused popular attention on our uneasy relationship with nature. The wastefulness of uncontrolled exploitation and the dangerous loss of permanent wilderness enclaves were favorite Progressive themes and enjoyed vigorous promotion in the Theodore Roosevelt era. Avarice, foolishness, enervated morality, and inherent human sinfulness were made to share blame for the declension. The expansion of national parks and forests, the endangered species campaigns, dress reform, summer camps and personal invigoration movements, demands for pollution control and development limits, literally dozens of movements expressed concern.[7] Some villains were easy to identify, charged with illicit designs upon the national heritage:

7 Many of these campaigns are described in Peter J. Schmitt, *Back to Nature: The Arcadian Myth in Urban America* (New York: Oxford University Press, 1969).

8 An enormous literature has developed describing the documentary work done in the 1930s and 1940s. See the relevant portions in, among others, James Curtis, *Mind's Eye, Mind's Truth: FSA Photography Reconsidered* (Philadelphia: Temple University Press, 1989); Pete Daniel, et al., *Official Images: New Deal Photography* (Washington: Smithsonian Institution Press, 1987); Alan Trachtenberg, *Reading American Photographs: Images as History, Mathew Brady to Walker Evans* (New York: Hill and Wang, 1989); Alan Trachtenberg, "Walker Evans's America: A Documentary Invention," David Featherstone, ed., *Observations: Essays on Documentary Photography* (Carmel, California: Friends of Photography, 1984).

9 Rachel Carson's text was originally published in 1962 by Houghton Mifflin Co.; a silver-anniversary edition was published by the same firm in 1987.

oil companies, timber interests, electric utilities, mine owners, simultaneously increasing living costs, endangering life and happiness, and corrupting public officials. Scandals in the 1920s, natural disasters, and federal projects in the 1930s and 1940s highlighted the damaged landscape. Documentary filmmakers, photographers, back-to-the-land crusaders, novelists, unemployment relief programs, helped direct national consciousness toward the accumulated insults to nature that were now vexing the nation.[8]

Not all the denunciations and documentaries singled out predatory interests as their target; some had softer, less defined ambitions. But the broader tradition is polemical, and the images of many photographers and painters conjure up tangled desperations: oil boom towns gone bad, eroded Southwestern landscapes, flooded river valleys, mining towns, and auto junkyards.

The most visible and obvious degradations of the landscape were succeeded as subjects by covert, slow-acting, more insidious assaults resulting from massive industrialization and technological aggression. The landscape as dump, polluting station, end ground for chemicals, plastics, atomic fuel, toxic agents that promised, at one point in their existence, to increase production levels, these became the topics of the post–World War II years. *Silent Spring* (1962) remains the best known and most influential indictment of the new exposure genre, but the examples in Rachel Carson's work have been overshadowed by even more ominous events as well as by spectacular criminal prosecutions.[9]

The tradition of breast-beating, guilt, and targeting anger boasts, then, a lengthy pedigree. But alongside it has emerged a newer but parallel strain of righteous indignation. Focusing upon the built landscape, it also possesses a prehistory. For many years it was the congested and rhetorically repudiated ground of American cities that aroused most resentment. They have been regarded with suspicion on many grounds—their immigrant populations, their clear testimony to economic ambitions, their challenge to established religious and social controls, their violence, their political corruption, their contrast of living standards, their filth and disease. The Turner frontier argument contained a reluctant acknowledgment of the growing dominance of cities.

2

But it was economic and demographic dominance, not rhetorical or cultural. Urban landscapes were admitted only reluctantly into the hierarchy of artistic subject matter, and were soon associated with a subversive modernist sensibility, offering their own challenges to traditions of representation and narrative. And as subjects for historical scholarship, they were a long time in achieving respectability.

Between the naturalist and urban landscapes, of course, lay a middle vision that for some enshrined a truer ideal. Suburban developers tried to capture some of this appeal. And as sprawl grew in the middle third of the century, the range of residential enclaves—some of them more woodsy, more isolated, more nature friendly than others—meant that Americans confronted a tripartite menu of landscape possibilities. Like depleted wilderness and alien city, however, the suburb was soon supplying its own negations. Multiplication, growth, and repetition made it a complicit agent in both the destruction of nature and the reproduction of urbanism.

Through the middle of this century these three landscape types possessed, at a minimum, a certain conceptual, even iconic integrity. Despite many hybrids and confusions, overlaps and borrowings, imagery and experience separated them with some clarity. Various forms of popular culture—

3

film, musical comedy, soap opera, comics, children's literature, magazine fiction—generically distinguished wilderness-frontier, city-big town, and suburb-small town in the staple stage sets and fictional dramas they supported. Genres were built around the domestic arrangements associated with each environment, and the life-styles each seemed to demand. Advertisers deployed versions of these types in their sales pitches and product lines (and nomenclatures) invoked their ideal form.

Such clear levels of separation are no longer convincing; their erosion may have helped set the terms of the current malaise. For both development schemes and some of the assaults upon them reflect what has become an ongoing abrasion of traditional boundaries. Many of the more recent popular spatial manipulations are in part attempts to redress the lost contrasts and disappearing juxtapositions.

For the collapse of American space, its apparently infinite permeability and extended infiltrations have challenged conceptions of historic time and political sovereignty. Developmental subversion is charged not only with threatening rivers, mountains, deserts, forests, architectural monuments, and popular landmarks; it is, some argue, in its deployment of mythic vocabularies (the frontier among them), a menace to consciousness, an interruption of historic living patterns, an

10 Michael Sorkin, "Introduction," *Variations on a Theme Park*, xii. The eight essays in this book are the latest expressions of this critical vision. Other treatments of urban space, commodification, civic visions, and packaged landscapes, some of them quite different in ideology and intention, can be found in texts like Jane Jacobs, *The Death and Life of Great American Cities* (New York: Random House, 1961); William H. Whyte, *The Last Landscape* (Garden City, N.Y.: Anchor, 1968); William H. Whyte, *The Social Life of Small Urban Spaces* (Washington, D.C., The Conservation Fund, 1980); William H. Whyte, *City Rediscovering the Center* (New York: Doubleday, 1988); Richard Sennett, *The Fall of Public Man* (New York: Knopf, 1977); a number of the essays in Nathan Glazer and Mark Lilla, *The Public Face of Architecture. Civic Culture and Public Spaces* (New York and London: Free Press and Collier Macmillan, 1987); and several essays in Richard Martin, ed., *The New Urban Landscape* (New York: Olympia and York, 1989).

11 The most elegant and comprehensive recent critique of the changing status of nature in the landscape is Alexander Wilson, *The Culture of Nature: North American Landscape from Disney to the Exxon Valdez* (Cambridge, Mass. and Oxford, England: Blackwell, 1992).

enemy to human variety and idiosyncrasy. In certain respects there are echoes of Turner in the new critique.

But it is not the frontier's disappearance that forms the target for many contemporary critics; it is the destruction of public spaces and the civic ideals they embody, together with the loss of landscape particularity, its reflection of region or specific location. Several decades ago, particularly in the writings of Jane Jacobs, indignation focused upon planning megalomania and many of the most misplaced ideals of urban renewal. Now it is tackling the merchandised landscape of shopping centers, theme parks, historic preservation sites, golf courses, vacation resorts, sealed-off (and armed) residential enclaves, corporate campuses, gentrified inner-city neighborhoods, along with their promises of physical security, selective togetherness, sanitized diversion, instruction, information, and evocation in various combinations and intensities. The spector stalking the landscape is the shadow of what a recent critic has called one "vast, virtually undifferentiated territory—stretching from Fairfax County, Virginia, to Orange County, California—homes, offices, factories and shopping malls," which "float" in a setting that has discarded the structure that once gave cities life.[10]

This setting has also been losing most of its non-urban features. In the wake of our redecorated zoos, botanical gardens, facility-laden national parks, and marine land theaters, the natural landscape, always itself a function of some larger rhetoric, now threatens to degenerate into little more than the ward of the developer or promoter-impresario, a protected and filtered asylum for flora and fauna, exhibited on sufferance and for purposes of diversion and entertainment.[11] Nature, in short, has become a dependent variable. In the theme parks, the urban landscape, now fondly remembered for just the congestion, street life, and natural disorder that once made it a target for moralists, is little more than the exotic (if diluted) background for music and dance. And the middle landscape emerges as eclectic re-creation of historic time. Main Street sets are patriotic simulacra designed to reenact historic deeds or repeat famous messages.

The great Satan in this most recent fall from grace is, of course, Walt Disney, his Land, his World, his Epcot, and their numerous offshoots and imitations, bearing with them an apparently

4

unstoppable momentum. That the Disney version developed in southern California and flourishes in Orange County, amid a blend of Hollywood-mediated, midwestern dreams of fantasy and opulence, and within a natural landscape containing some of the continent's most extraordinary contrasts, does not seem accidental. The theme park, with its clustered divisions—landscapes that testify to historic memories, collective dreams, media thrills, and fictional characters—engages the rage of those who find its syntheses devastating, its values undemocratic, its impact dehumanizing.

Below Disney, perhaps, as lieutenant villain in the hierarchy of environmental demonology, stands James Rouse, the celebrated and successful developer-preservationist of Baltimore's Inner Harbor, St. Louis' Union Station, Boston's Quincy Market, and other multi-use shrines of patriotism, commerce, transport, tourism, and entertainment. Marrying old and often decaying settings with merchandising opportunities, sometimes turning former public spaces into private, for-profit ones, the Rouse approach shares many of the features that have made the Disney pattern so popular.

In fact, efforts to re-create landscapes of love, fear, loyalty, and concord reflect just those levels of technological mastery and social anomie that have made the classic tripartite landscape division no longer persuasive as a standard for policymaking or the basis for ideals. Today, little is either clear or uncontested about any aspect of the landscape. Property rights, the legal basis for

sovereignty, are called into question by lawsuits over Indian treaties and legislative remorse for earlier rituals of conquest. Monuments, as expressions of territorial patriotism and statements of historic identity, are sources of controversy in a society angry about gendered, racial, and class claims to authority and prepared to find in any visual code or set of symbols insinuations of ill-gotten hegemony. Public sculptures arouse vehement confrontation as violations of taste, morals, convenience, and intelligence. Elaborate gardens, park topiary, and manicured lawns are taken for revelations of gender division and semi-militarized domination of terrain. Courts and legislatures are embattled by struggles to define the physical range of freedom of expression, as privatized and sometimes even fortified spaces replace favorite assembly points and nodes of discussion. Graffiti and street murals are variously defended as authentic aesthetic and political forms of expression, or attacked as defacing and degrading markings of antisocial deviants bent on exposing the commnunity's lack of physical control. Simultaneously policed and dangerous, monotonous and threatening, crowded and deserted, the public landscape is paraded as a badge of shame and a confession of social failure. It is not surprising that packaged asylums, organized for profit as well as for protection, should be doing so well.

Although the language of criticism is new, the pith of the controversy is not. America has long contained clashing ethnic spatial visions and dramatic contrasts of spatial consumption. In some measure space has always been a contested commodity. Sharing it, despite nostalgic efforts to the contrary, has often been strictly delimited, and economic ambitions have long been imperial. "Will it be believed by orderly and respectable people outside of New York," waxed *The New York Times* ironically 110 years ago, "that, in spite of the obvious insufficiency of sidewalk room which now exists, people will insist upon walking on the sidewalks, and thus still further interfering with their usefulness." Indignant merchants complained that pedestrians clung to them "as if the sidewalks were meant for their use," instead of for unloading goods.[12] "I can blame nothing so much . . . as the rapacity of the land-owner," William Dean Howells commented at about the same time, who "keeps the street, mean and poor. . . . "

12 *The New York Times* (5 December 1881), 4.

It was not only economic competition that posed the issue. Dreams of classlessness and social homogeneity were threatened by actual experiences of indiscriminate mixing. The great urban parks of the nineteenth century, for example, many developed by Frederick Law Olmsted and his followers, touched off angry struggles among various groups for differing levels of access and exclusion. Museums, libraries, amusement parks, all occasioned conflicts about appearance, deportment and, in some cases, race. Several of this country's fiercest race riots were incited by encounters at bathing beaches. For a century, local ordinances or informal practices enforced racial separation at theaters, restaurants, and auditoriums. Municipal policemen, publicly, not privately paid, patrolled neighborhoods on the lookout for those whose dress or physiognomies indicated they didn't reside nearby. Reformers such as Olmsted, anticipating and welcoming heterogeneity, also insisted on the active presence of specially trained patrol forces, to keep the parks safe, clean, and orderly. Gates, fences, hedges, walls, and armed mercenaries are not newly invented instruments to define and defend territories.

Like Frederick Jackson Turner one hundred years ago, the new frontiersmen have captured some truths and sentimentalized others. American public spaces were rarely as lavish or as welcoming as their counterparts in Europe. The "animated, populated piazza with rich material, pattern and pigeons, fountains and sculpture, sidewalk cafés and bouquets of trees," has remained "obdurately continental," Ian McHarg writes, "and the pale shadows that have been realized in the United States are arid, contrived, self-conscious, and often empty. . . ."[13] Our most inviting environments have generally been linked to profit-making enterprises. A society with so insistent an emphasis upon accumulation has encouraged mixing where buying and selling take place, and has legitimated intelligent planning and finished display in their interest. The hotel lobbies, banks, and department stores of several generations ago were no less manipulative than their successor shopping malls and, like the malls, were frequently heterogeneous and inclusive in their clientage. Hence the presence of the floorwalker, the house detective, and the bank dick, precursors, in some measure, of the armed security guards who currently patrol so many commercial centers.

13 Ian McHarg, *Design with Nature* (Garden City, N.Y.: Doubleday, 1969).

In America, the commercial landscape has not only been a more effective social mixer than the cultural or political world, it has also been a more effective marker of history. Fashion, advertising, and consumption are often better at evoking the past than courthouses, legislatures, town halls, or museums. One demonstration is the nostalgia binge of the last few decades, driven and supported as it has been by a taste for the mundane and the merchandised. Curio markets and collector fairs trade in the daily commodities of an older era: home appliances, trade catalogues, ration books, menus, matchbooks, costume jewelry, sheet music, ashtrays. In the case of the landscape, historic preservation groups, spearheaded by associations like the Society for Commercial Archaeology, have organized to save electric signs, cinemas, restaurants, telephone booths, traffic lamps, fast-food outlets, gas stations, motels, and other remnants of collective daily experience. Logos become escutcheons and promotional slogans grow into memorable quotations. These are the landscapes produced by (and for) the picture postcard, souvenirs created in order to memorialize a visit or activity. As specimens of "hyper-reality" or "decorated sheds" or "postmodern signs" intended for self-advertisement, these packages now have defined stylistic phases of their own, as students of Googie coffeehouses or early McDonald's design can testify. Historicized and idealized, the pop vernacular helps shape collective memory.[14]

But it also is anarchically invasive. Roadside landscapes, urban franchises, and country stores wander happily across one another's natural habitats, until traditional distinctions make no sense at all and confused tourists hie to the safety of controlled variety. This is the theme park's stock in trade, after all. Movement must be made efficient if it is to be profitable. Long lines, hassles, disappointments, congestion, are solved by authority. Depending on circumstances, such control suggests the ideal cities of some utopian socialists, the grand duchies and enlarged estates of European tourism, or the regimented obsessions of totalitarianism. But the popularity of these well-policed settings reveals a taste for order that is unsatisfied by the levels of security maintained by public authority.

14 See, among others, Alan Hess, *Googie: Fifties Coffee Shop Architecture* (San Francisco: Chronicle, 1985); Thomas Hine, *Populuxe* (New York: Knopf, 1986); Paul Hirshorn and Steven Izenour, *White Towers* (Cambridge, Mass.: MIT Press, 1979); Philip Langdon, *Orange Roofs, Golden Arches: The Architecture of American Chain Restaurants* (New York: Knopf, 1986); and Chester H. Liebs, *Main Street to Miracle Mile: American Roadside Architecture* (Boston: Little, Brown, 1985).

In fact, some public spaces work quite well, given their quantity of use and physical pressure. Air corridors and highways handle enormous quantities of travelers, and do so by combining public subsidy and regulation with private exploitation. Like some other contemporary activities, the traveler's landscape is a totalizing one, meeting many needs simultaneously and influencing the design ideals of other parts of the landscape. Institutions built around the airplane and the automobile—from garages and shopping centers to airports and restaurants—must define their surrounding territories broadly, evaluating their transfer methods and ways of interacting with hotels, restaurants, and sports arenas.

Many other large commercial settings can claim to meet a broad spectrum of needs, spiritual and physical. "We are better off than we suppose," J. B. Jackson wrote just a few years ago. "Our landscape has an undreamed of potential for public spaces of infinite variety." Sports arenas, flea markets, amusement parks host diverse groupings of people. When we perceive "the urban public space not simply in esthetic or environmental terms, but in terms of history," Jackson goes on, "all sorts of unnoticed public squares become discoverable." [15]

But the mixed breeds have spread across the larger landscape, and make broad and unconvincing claims. Shopping centers are invested with religious significance, festival places for unifying multiplicities. Corporate lawns and courtyards sport commissioned sculpture as do university campuses, airports, and hospitals. Artworks are popular marketing tools. Urban office buildings demonstrate transcendence of climate and topography by creating high-rise winter gardens for the delectation of employees and customers.

These landscapes on demand are complemented by Hollywood's apocalyptic cityscapes, the urban disaster areas conjured up by films like *Robocop, Darkman, Batman, Escape from New York, Planet of the Apes,* and the archetypal *Blade Runner.* These horrific settings, redolent of atomic disaster or criminal triumph, have become the correlatives of the soiled and depleted forests, deserts, rivers, and oceans that environmentalists have been championing. For they are similar confessions of failed policies, social greed, group conflict, political corruption, and technomania. Once the badge of

15 J. B. Jackson, "Forum Follows Function," Glazer and Lilla eds., *The Public Face of Architecture,* 122. This essay was published by Jackson in *Discovering the Vernacular Landscape* in 1984.

prelapsarian, Edenic innocence, the theater of divine injunctions, the American landscape is now, for many artists, filmmakers, photographers, novelists, an emblem of collapsed and despairing hopes, regimented, segmented, despoiled, a vast wasteland filled with the garbage of an overindulgent, contradictory society. Those returning with reports of promise, or rhapsodizing about natural wonders still untouched (or built developments that are humane, inspiring, and inclusive) are greeted with incredulity and accused of unacceptably comprehensive and naive optimism. Such was the sad fate of many realist landscapists of the last several decades, whose canvases demonstrate the continuing capacity of artists to respond with enthusiasm and delight to the natural wonders they can still discover.[16]

From one standpoint, the new pessimism belongs to a far more massive fall of American exceptionalism, our lost exemption from conventional evils. Politicians, historians, clergymen, and editorialists long draped a mantle of unique invulnerability over the American polity that explained its prosperity, political stability, and apparent freedom from the terrible afflictions associated with distant regions of the earth. Epochal disasters—a Vesuvius, a Mount Pelée, a Turkish earthquake, or Bengali flood—have revealed an angrier nature than any Americans have known, including even Hurricane Andrew. Our costliest single natural catastrophe in the last 150 years, at least in terms of human casualties, the Johnstown Flood, remains a minor episode in the lengthy annals of worldwide natural disaster.

But national boundaries and oceanic barriers no longer defend against the planetary perils that scientists almost weekly unveil: ozone holes, melting ice caps, Amazon deforestation, rising temperatures, acid rain. Military accidents and earthquakes are not the sole sources for new fears of flooded cities, burned out farmlands, or collapsed skyscrapers. These can be achieved through slower, less dramatic processes. Secret powers of destruction, such as the hidden past of chemical poisoning, invest the most innocent looking setting with diabolic potential.

The American landscape, its historic divisions blurred and confused, its centers of social contact removed or subdivided, its old immunities sapped by new and wily enemies, its national

16 I am thinking of a number of the artists treated in John Arthur, *Spirit of Place. Contemporary Landscape Painting & the American Tradition* (Boston: Little, Brown, 1990), including among others, Robert Jordan, Sarah Supplee, Russell Chatham, Jack Beal, Richard Chiriani, James Butler, Daniel Chard, and Adele Alsop.

boundaries invaded or defied by broader natural processes, its resources plundered, its secrets violated, its pleasures profiteered, seems best described in medical metaphors. The patient lies in critical condition, wounds untreatable except by the most drastic remedies. Attending physicians murmur about controlled development, reduced pollution, extension of the commons, income redistribution, regional planning, a new ethic for public spaces. The relatives are suitably depressed.

Too much crepe may indeed have been hung around the bedside. Contemporary spatial criticism can often be apocalyptic in its rhetoric, demonic in its targeting, selective, and inconsistent. The landscape has long been a screen on which to project larger anxieties and animosities; its enemies and friends are identified according to rigid formulas.

But fears about the disappearance of common ground tap currents of thought and feeling as powerful as any enlisted by Turner's jeremiad of a century ago. And they require response. There is no obvious single action to be taken, although some critics, such as William H. Whyte and Alexander White, offer helpfully specific words of advice. Rather the fragmenting and colliding spaces reflect the problems of our social constituencies, our economic organization, our political process. And where nature once offered contrast, there is now continuity. That fertile field of cosmic dreams, that alternate vision of Eden, that transforming realm of spirit that made the New World new, now threatens to grow nightmarish, mocking the liberating vision it once inspired.

The path ahead is hard, and so tangled that only artists may be persuasive. Planners, promoters, and politicians have had their chance; we may now be ready for different drummers to lead us out of a different wilderness.

NEIL HARRIS is currently the Preston and Sterling Morton Professor of History at the University of Chicago where he has taught since 1969. He holds degrees from Columbia, Cambridge, and Harvard universities and writes on the cultural history of the United States. His most recent book is *Cultural Excursions: Marketing Appetites and Cultural Tastes in Modern America* (University of Chicago Press, 1990). Earlier writings include *Humbug: The Art of P. T. Barnum* (Little Brown, 1973) and *The Artist in American Society: The Formative Years, 1790–1860* (George Braziller, 1966).

Elements of a New Landscape

Rebecca Solnit

Begin, though, not with a continent or a country or a house, but with the geography closest in—the body. Theory—the seeing of patterns, showing the forest as well as the trees—theory can be a dew that rises from the earth and collects in the rain cloud and returns to earth over and over. But if it doesn't smell of the earth, it isn't good for the earth.

—Adrienne Rich

Perspective

Landscape was not significant in modern art, but it has become increasingly significant in recent strains of art that are not part of modernism. Rather than doing something so simple as stepping backward into unchanged territory, however, artists and other thinkers are reinventing our relationship to the land, transforming it from a divinely irrelevant idyll into one of the principal intellectual battlefields of our time. Some aspects of this new view were generated by feminist and ecological

The oracular voice is to writing as seven-league boots are to travel: in order to cover the distance I set myself here, I've been more sweeping, more telescopic than I would be in the magnifying-glass voice of scholarship. Proposing relationships between distant phenomena has been my task; closer observations of these phenomena can be found in the texts cited below.

1 Classic landscape composition from Claude Lorrain to Ansel Adams features an open expanse at center framed by coulisses of foliage or hills to make a theatrical space—the space initially occupied by the Virgin and Child or other human figures in Western painting. The figures diminish in Claude, which is why we consider him a landscape rather than a history painter; they disappear altogether in some romantic and much American art; in the latter, the stage is empty because the actors have yet to appear or because looking has become the only remaining action in response to the landscape.

Landscape: my problem is not with the land but with the scape. The compound term has come to mean an expanse, a certain kind of composition. Scape is far from the only way to represent land, and the conventions of landscape have come to be stifling. Most artists who are still working within the landscape tradition are wrestling to reinvent it in one way or another, either broadening the scope of its subject matter or its formal rules or taking it into new media.

1

theory; some of them coalesced into the body of attitudes called postmodernism. There is considerable diversity and disagreement within and between each of these arenas, but it is the areas of concordance that seem richest to me, and that are the subject of this essay.

The word landscape itself is problematic now: landscape describes the natural world as an aesthetic phenomenon, a department of visual representation; landscape is scenery, scenery is stage decoration, and stage decorations are static backdrops for a drama that is human.[1] The passive landscape and the supine woman are linked in Western painting as objects for a subject that identifies women with nature and the body, men with culture and the mind.[2] The odalisque and the pleasure-ground are acted upon rather than actors, sites for the imposition rather than generation of meaning,

2 The implications of these associated binary metaphors —women/nature, senses/ body, and men/culture, mind/spirit—have been addressed by many thinkers. Hélène Cixous and Catherine Clement in *The Newly Born Woman* (Minneapolis: University of Minnesota Press, 1986), write, "Always the same metaphor: we follow it, it carries us, beneath all its figures, wherever discourse is organized.... Thought has always worked through opposition, through dual, hierarchical oppositions." Among the oppositions they cite, "Activity/Passivity, Culture/Nature, Man/ Woman, Head/Heart." See also, John Phillips, *Eve: The History of an Idea* (New York: Harper & Row, 1985), and the Gerburg Treusch-Dieter essay "The Beginning of the End: On the History of Radiation from Plato to Chernobyl" in *Looking Back on the End of the World* (New York: Semiotext(e), 1989). Both of these deal with the relation between creativity, paternity, and the association of women with the earth. See also, Carolyn Merchant, *The Death of Nature* (San Francisco: Harper & Row, 1982).

and both are positioned for consumption by the viewer within works of art that are themselves consumable properties.

Modernism from Manet to the Beats was part of urban culture, and the problems modernism addressed were social problems. In the 1930s, the French photographer Henri Cartier-Bresson said of the progenitors of Group f64 and American art photography, bemoaning their irrelevancy, "The world is falling to pieces, and Adams and Weston are photographing rocks!"[3] The nation briefly recognized in the dust bowl the interconnections between a human problem and the natural world—a world that was literally falling to pieces and blowing away. Still Ansel Adams and Edward Weston were not part of the great regionalist-socialist experiment of the 1930s, which addressed working landscapes and rural lives: their photographs of rocks did not have much to do with social problems— they did not even have much to do with rocks.

In making landscape art, contemporary artists recognize landscape not as scenery but as the spaces and systems we inhabit, systems our lives depend upon. Thus, there was no need to return to a landscape that had never been far from anything but our thoughts: it was the thoughts that had to change. The landscape is now thought of as ubiquitous—as the environment, which includes politics and economics, the microcosmic as well as the macrocosmic, the cultural as an extension of the natural, our bodies as natural systems that pattern our thought, and our thoughts as structured around metaphors drawn from nature. To arrive at this understanding involved altering basic cultural patterns. Changes come from many directions and move into many others; it is the network formed by those elements that constitutes the territory my narrow paths traverse.

TIME

Landscape's most crucial condition is space, but its deepest theme is time. Landscape is identified with the past in Western tradition: humanity originated in—and lost—a garden, and natural landscape continues to represent a place in which change has not yet happened, the original condition of the earth, origin itself. Much of our landscape tradition comes out of the classical pastoral mode that

3 Cited in Estelle Jussim and Elizabeth Lindquist-Cock, *Landscape as Photograph*, 140.

celebrates the purity of the rural in contrast to the corruption of the urban, of primitive culture, of simple lives, and does so in a mood of deep nostalgia and longing. For the ideal world of the pastoral is always in the past, and has its parallels in Eden, the lost golden age, the landscape yet undiscovered, and the irrecoverable world of childhood experience. Representation of the earth as maternal reinforces this last element.

This mood of nostalgic nature loving, however, has always been subordinated to the optimistic narrative of progress.[4] Progress and the avant-garde postulate an open-ended journey upward and forward, unfolding in linear rather than cyclical time. They suggest humanity moving in a single direction led by the avant-garde. (The rise of diverse voices has made this unity impossible.) The same cosmology that began with Creation by an unmoved mover marched toward an ideal of transcendence of that same Creation — transcendence of the body, of mortality, of the sensible material world, of the entire territory designated as female, an ascent toward purity. Perhaps the earliest and most powerful version of this is Plato's allegory of the cave, which postulates sensory knowledge as deception and proposes a transcendent rise toward pure light as an escape from the bonds of the senses and the body; this escape from the cave is clearly birth from a womb. Thus, Plato's ascent implies a journey from the maternal realm of the sensible and material into the masculine territory of intelligible forms.[5]

4 Regarding progress, see Thomas McEvilley, *The Case of Julian Schnabel* (catalogue for 1984 retrospective at San Francisco Museum of Modern Art): "What is called the transition to Post-Modernism occurred at the moment when significant numbers of people realized with surprise that they no longer could believe in the inherent force of progress, the exalted mission of history, and the inevitability of its accomplishment." Also see William Leiss, *The Domination of Nature* (New York: George Braziller, 1972). J.B. Bury, *The Idea of Progress: An Inquiry into Its Growth and Origin* (New York: Macmillan Co., 1987): "Cartesianism affirmed the two positive axioms of the supremacy of reason, and the invariability of the laws of nature; and its instrument was a new rigorous analytical method which was applicable to history as well as to physical knowledge. The axioms had destructive corollaries. The immutability of the processes of nature collided with the theory of an active Providence. The supremacy of reason shook the thrones from which authority and tradition had tyrannized over the brains of men. Cartesianism was equivalent to a declaration of the Independence of Man. It was in the atmosphere of the Cartesian spirit that a theory of Progress was to take shape."

5 See Hélèn Cixous, *Speculum of the Other Woman* (Ithaca, N.Y.: Cornell University Press, 1985), and Treusch-Dieter, (cited above) on Plato. And for the continuation of this body of metaphors, see Sigmund Freud, *Moses and Monotheism* (New York: Vintage Books, 1955): "This turning from the mother to the father signifies, above all, a victory of the spirit over the senses — that is to say, a step forward in culture."

The change I want to trace in the relationship between landscape and time is the loss of faith in progress and the subsequent about-face toward nature as an ideal—a goal—rather than merely as a starting point for artistic representation. In 1979, Kim Levin wrote, "Modern art was scientific. . . . It longed for perfection and demanded purity, clarity, order. And it denied everything else, especially the past: idealistic, ideological, and optimistic, modernism was predicated on the glorious future, the new and improved."[6] Slowly, as it became more difficult to sustain the metaphors of nature and matter as other, the culture would begin to withdraw faith from its own myths of progress toward a future made possible by the control of nature.

And so the past has become the future: as the vision of organic harmony becomes not the raw material upon which technology imposes its will, but the necessary terms of our life on earth, linear time bends into a circle. Landscape comes to the fore, no longer the territory of nostalgia but the circumference of possibility, the conditions of survival. Consequently, many artists who are documenting the expanding environmental crisis are asking questions not only about our past, but about our beliefs and our future.

6 Kim Levin, "Farewell to Modernism," *Arts Magazine* (October 1979). See also Helen Mayer Harrison and Newton Harrison: "We see modernism as the successive division into smaller and smaller categories of all human knowledge: the operant belief being that the establishment of micro-categorization permits a clear perception of individual phenomena and therefore, deeper understanding. . . .

We feel that to know more and more about something out of context leads to less and less understanding of the something, since everything exists in context. We have so much information and yet so little understanding. Indeed, modernism reflects the condition that separates people from the ground they stand on." Interview with Michael Auping, Grey Art Gallery, New York.

7 See Morris Berman, *The Reenchantment of the World* (Ithaca, N.Y.: Cornell University Press, 1981); Thomas Berry, *The Dream of the Earth* (San Francisco: Sierra Club Books, 1988); Werner Heisenberg, *Physics and Philosophy* (New York: Harper & Brothers, 1958); Carolyn Merchant, *The Death of Nature* (San Francisco: Harper & Row, 1982); and William Leiss, *The Domina-tion of Nature* (New York: George Braziller, 1972). This commentary upon the effect of Bacon and Descartes has been given by many scholars as an explanation of the roots of our environmental crises and of an alienation from nature that begins as an alienation from the body. Lynn White in his famous 1967 essay, "The Historical Roots of Our Ecologic Crisis," sees this crisis as rooted in Christian dogma; Phillips (see note 2) connects this to the cosmology of Genesis itself; Paul Shepard, in many marvelous books from *Man in the Landscape* to *Nature and Madness,* traces nature-hating to the desert fathers of the Old Testament, and to nomadic pastoralist sky-god worshippers, a point of view many feminists agree with (see Merlin Stone, *When God Was a Woman* (New York: Doiset Press, 1990), and Riane Eisler, *The Chalice and the*

SUBSTANCE

The test of the first atomic bomb, on the morning of 16 July 1945, in New Mexico, can serve to represent the consummation and destruction of progressive modernism: the modernism of science as launched by Francis Bacon and René Descartes in the seventeenth century.[7] In different ways they established the mentality that would become modern science: Bacon's empiricist model of vexing nature to force out her secrets (he spoke of nature as female) postulated an imposition from without that had much in common with Descartes's model of analytical reason as the supreme mode of knowledge and his assertion of the absolute separation of the mind from the material world and the body—with the self located in the nowhere of the mind. The immaterial mind imposes its will on inanimate matter in a model of control from without that pictured the universe as a machine— which may have been only a logical extension of Genesis's portrait of God as the unmoved mover, the clock maker who sets the world in motion, a model modern scientists and artists followed in their creative work.[8]

When the bomb exploded, two traditions of thought collided: the world of dead fragments of Descartes and Bacon and the world of interconnected systems of quantum physics, ecology, and later, postmodern theory.[9] The bomb changed everything: the notion of human scale—scientists had made

Blade (Cambridge, Mass.: Harper & Row, 1987). Interestingly, these feminists tend to cele-brate the matriarchal agri-culturalists of the Near East who were replaced by patriarchal cultures; Shepard locates our paradise lost earlier, in the more pantheis-tic, less hierarchical world of hunter-gatherers.

8 Genesis itself, recent scholar-ship suggests, is a political

tract that revised earlier accounts of Creation, which included an active female earth or procreative God-dess. As creating became wholly masculine, the crea-tion became wholly Other, and a schism opened up between subject and object, mind and matter, with repercussions on the status of women. So it may be that rather than representing a philosophical departure from earlier metaphors for the

earth, modern science only fully realized ideas which had been implicit for millenia.

9 See Donald Worster, *Nature's Economy: A History of Ecological Ideas* (Cambridge: At the University Press, 1977), 317. And see Werner Heisenberg, *Physics and Philosophy*, 79–81: "The influence of the Cartesian division on human thought in the following centuries can hardly be

overestimated, but it is just this division which we have to criticize later from the development of physics in our time. It has been pointed out before that in the Copenhagen interpretation of quantum theory we can indeed proceed without mentioning ourselves as individuals, but we cannot disregard the fact that natural science is formed by men. Natural science does not simply describe and

explain nature; it is a part of the interplay between nature and ourselves; it describes nature as exposed to our method of questioning. This was a possibility of which Descartes could not have thought, but it makes the sharp separation between the world and the I impossible."

something too small and too vast to understand, brighter than the sun and deadly for half a million years; the possibility of a morally neutral science; the nature of nature itself, with the generation of a deadly, unnatural element, splitting of the atom, and radiation's insidious effects on genes and health. Most significantly, the bomb seemed to close a lot of the divides that had organized the modern Western worldview: between observer and observed, between creative work and political impact, and between war and peace. Finally, the potential effects of the bomb were so pervasive over time and space that notions of containment and separation collapsed.

The radiation of the bomb and the herbicides and pesticides developed from chemical warfare research were the first clear warnings that the world could no longer be regarded as a collection of inanimate objects, but must be seen as a network of intricately balanced systems. The substances themselves first spoke out against the inadequacy of the modernist worldview, and with *Silent Spring* (1962), Rachel Carson first gave them a voice: "In this now universal contamination of the environment, chemicals are the sinister and little-recognized partners of radiation in changing the very nature of the world—the very nature of its life. Strontium 90, released through nuclear explosions into the air, comes to earth in rain or drifts down as fallout, lodges in oil, enters into the grass or corn or wheat grown there, and in time takes up its abode in the bones of a human being. . . . As Albert Schweitzer has said, 'Man can hardly even recognize the devils of his own creation.'" [10]

Ecological problems are invariably described in terms of the relation between substances and systems: the makeup of the atmosphere, the effects of toxins, the loss of topsoil, desertification, oil spills, water pollution, the extinctions of species. Attention to systems and substances rather than scenes as manifestations of nature unravels assertions about alienation from nature. [11] In this worldview, the landscape is never absent, only the ability to understand its languages, a lack that artists have addressed in works that speak in terms of substances and systems.

10 Rachel Carson, *Silent Spring* (New York: Houghton Mifflin, 1962), 16, 17.

GENDER

As a social movement with specific social goals, feminism sought to acquire rights and representation

for women as other social justice movements before it had sought them for hitherto marginalized classes, religions, and races of men; as an analysis of entrenched structures of belief, feminism reached far deeper to disrupt the binary relationships around which the culture organized itself. The subject-object relations of modern art and science I've been describing align a number of beliefs: the gap between subject and object, observer and observed, creator and creation; the essential immateriality of mind and mindlessness of matter; and the association of men with energy, form, mind, and women with substance, nature, and earth.

I've suggested the beginning of the end of this cosmology at the Trinity site in 1945. In 1963, one year after the publication of Carson's *Silent Spring*, Betty Friedan's *The Feminine Mystique* announced that women were not content to be relegated to the margins of cultural participation. There is a strange consonance between the two books: for our purposes they can be read as elegies to the odalisque and pleasure-ground of painting, of women and nature as sites for the imposition rather than the generation of meaning. Postmodern theory provided ideological rigor to the rising desire for a more equitable distribution of value and power and the loss of faith in universalizing, authoritative voices. The authoritative voice was one that spoke objectively, from nowhere, disembodied: postmodern theories attempt to locate rather than dislocate voice, to embody it. Here body and locale unite as the incontrovertible circumstances of expression.[12]

11 The artist Mary Lucier, whose videos deal with the representational traditions of the landscape, once told a San Francisco audience, "You don't understand—for us on the East Coast, nature is in the past tense." A New Yorker who declares her alienation from nature might consider, while having morning coffee, that the city's water comes from an Adirondacks watershed—one of the world's first large nature preserves, that the source of the milk in an outlying dairy farm and the coffee's more distant genesis in third-world tropical highlands, might in fact recognize that the cup of coffee is a link to sublime, pastoral, and exotic landscapes in which the drinker participates, if only as an unwitting consumer, should recognize that the cup of coffee is as potent a representation of— and more material a tie to— absent landscapes as images could be.

12 See, for example, Susan Bordo, "Feminism, Post-modernism, and Gender-Scepticism" in *Feminism/Postmodernism* (New York: Routledge, 1990), 137 and 143, 144: "That uncovering first occurred, not in the course of philosophical conversation, but in political practice. Its agents were the liberation movements of the sixties and seventies, emerg-ing not only to make a claim to the legitimacy of margina-lized cultures, unheard voices, suppressed narratives, but also to expose the per-spectivity and partiality of the official accounts. Now those accounts could no longer claim to descend from the heavens of pure rationality or to reflect the inevitable and progressive logic of intellectual or scientific discovery. They had to be seen, rather, as the products of historically situated individuals with very particular class, race, and gender interests. The body, accordingly, is reconceived. No longer an obstacle to knowledge . . . the body is seen instead as the vehicle of the human making and end-less remaking of the world."

METAPHOR

The dichotomizing metaphors we've inherited are themselves questionable: nature and culture, for example, suggest an opposition that in turn implies an approximate equality—but culture considered as an aspect or aberration of nature can be seen as a small arena within the broad compass of nature.

Metaphors of basic truths assume a substructural, foundational truth rather than an interdependent network—the truth of dissection rather than conversation. Metaphors of dominance, competition, and waste postulate an open-ended system with an out—a somewhere else that has turned out to be nowhere in a shrinking earth ("utopia" means no place, unattainable perfection). In the new metaphorical landscape, however, observation—witness—becomes a form of involvement rather than detachment; all positions are political; there is no outside, objective position from which to observe. The viewer is part of the landscape. Feminism asserts, "The personal is political," which transplants the idea of politics, the contest of meaning in the arenas of power, . . . from a public region to every interstice of experience. "The truth is local," the postmodern philosopher Jean-François Lyotard observes.[13] We find ourselves in a psychic landscape without the partitions and exits that defined the Judeo-Christian landscape. We find ourselves in a landscape that is an ecology of systemic interconnection, of relationship, of locality. And, if all the metaphors are about land, the changes resonate between the psychic and geographical landscape, inform each other, cross over: how we inhabit the landscape is determined by our metaphors.

There are a number of parallel shifts that constitute a huge gesture that reverses modernism's upward movement out of Plato's cave—a retraction of that gesture of purity and transcendence against the body, the senses, the maternal, against origins, mutability, ambiguity, a

13 Jean-François Lyotard, *The Postmodern Condition* (Minneapolis: University of Minnesota Press, 1984). Nancy Fraser and Linda J. Nicholson, in *Feminism/Post-modernism* (cited above), comment, "The postmodern condition is one in which 'grand narratives of legitimation' are no longer credible. Lyotard argues that meta-narratives, whether philosophies of history or nonnarrative foundational philosophies, are merely modern and *dépassé*. We can no longer believe, he claims, in the availability of a privileged metadiscourse capable of capturing once and for all the truth of every first order discourse. . . . In the postmodern era legitimation becomes plural, local, and immanent."

gesture of absolutes and universals. This counter gesture celebrates the sensory, the tangible, the feminine, the complex, the impure, the contextual, the local, the specific, the contingent, the fecund, mutable, shifting, ambiguous, immanent (generating what would have once been a contradiction: a spirituality that emphasizes the bodily, the mortal, and the material). This gesture constitutes a shift from the Cartesian view of the world as a collection of discrete inanimate objects to that of Ludwig Wittgenstein, Claude Levi-Strauss, Jacques Lacan, and Jean-François Lyotard, a worldview in which language provides the primary metaphor of relatedness and contextual truth, of a systemic, syntactic world of relations rather than a stable one of things. Ecological theory, feminist social theory, and postmodernism all embrace some version of this systemic worldview, which is reflected in temporally unstable, site-specific, performative, bodily, and process art, as well as in photography, installation art, and other more familiar genres. Ecology, which emerged as a discipline long before it emerged as an influence outside science, is peculiarly significant as a subject without an object—that is, as a discipline whose focus is on systems and relationships rather than on objects.

ART MAKING

In the art world, body is manifested as performance, locale as site: performance and site artists will begin to create oeuvres that are temporal, inextricable from their circumstances. In a cosmology that no longer presumes that nature is something out there, apart, landscape—space—is joined by animals and the human body as a manifestation of the natural. Indeed, the emphasis on the body is an emphasis on the subject as object, the cultural as natural, the maker as within the territory of work. Here the works of Dennis Oppenheim and Carolee Schneemann come to mind as early examples. In Oppenheim's early performances, his body was acted upon by natural forces, such as the sun, rather than his acting upon them. Schneemann's performances, such as *More than Meat Joy* and *Eye Body* (1963), used her own body as the site from which she addressed ideas of fertility, eroticism, transgression, and archetypes.

2–4 DENNIS OPPENHEIM **ROCKED HAND** 1970, film stills, courtesy M. Knoedler & Co., New York

5 ANA MENDIETA **SERIE ARBOL DE LA VIDA (TREE OF LIFE SERIES)** 1987, photograph of earth-body work with tree and mud executed at Old Man's

Creek, Iowa City, Iowa, 20 × 13 ¼, collection Ignacio C. Mendieta

2 3 4

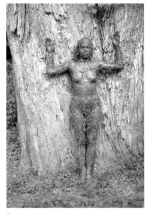

5

In the 1970s, photographers began to make landscape images again. One notable difference was the plethora of women making landscape images by the early 1980s: Judy Dater, Linda Connor, Meridel Rubenstein, Wanda Hammerbeck, Masumi Hayashi, and many others. Their photography is distinct from that made by most men during this time, from the deadpan bitterness of the New Topographers of the mid-1970s (Robert Adams, Lewis Baltz, Joe Deal) to the more idealistically ecological documentary works of the 1980s, by such photographers as Robert Dawson and Greenpeace's Sam Kittner. Men usually represented the landscape as either pure or tainted. The misanthropic implication is that people don't belong in the landscape, that there is no middle ground between untouched and ravaged. In photographing ravaged landscapes, they are supplying the Other to the images of pristine wilderness by Ansel Adams, Robert Glenn Ketchum, Eliot Porter. The work by women concentrates instead on intimate, inhabited landscapes; people become a part of the landscape in their work in a way they haven't been before; the natural and the cultural aren't dualized. In the work of such artists as Judy Dater, Ana Mendieta, and Mary Beth Edelson, the artist herself occupies the landscape, breaking down boundaries between spectator and spectacle, and between photography and performance. The question of whether the photograph is a document of a

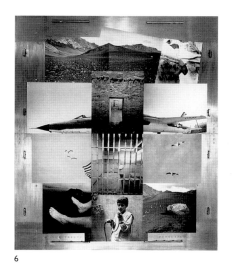

6 7

performance or sculpture or whether the performance/sculpture was staged for the camera is unanswerable, and perhaps inappropriate: the work is grounded at both ends.

In some respects photography remains a conventional genre, a genre of discrete image making in which the divide between image and spectator is absolute. In another respect, it always has been modernism's unloved stepchild for its lack of autonomy: photographers, unlike painters and sculptors, need to engage with the world out there, have a relationship with their subject matter that entails greater negotiation with and responsibility to that which they represent. There are formal shifts in landscape photography that are also significant, however; the aforementioned melding of photography with genres such as earth art and performance, and the transition from conventional pictorial space—the photograph as window—to another kind of image in which the photograph serves as sample. Here I am thinking of the many photographs by Richard Misrach, Linda Connor, Lewis Baltz, and others, in which foliage, or rubble, or lava, or dirt crowds the foreground of the image. Again, nature without landscape, without scenery, without liberating prospects, vistas, views, distances—nature in your face.

8 JOSEPH BEUYS **SAVE THE WOODS** 1973, photo offset print, edition of 200, 19 $\frac{3}{8}$ x 19 $\frac{3}{8}$, courtesy Ronald Feldman Fine Arts, New York

9 NANCY HOLT **SUN TUNNELS** 1973–1976, photograph of tunnels at the Great Basin Desert in northwestern Utah, concrete, tunnels 9 x 18 feet,

total length 86 feet, courtesy John Weber Gallery, New York

8

9

10

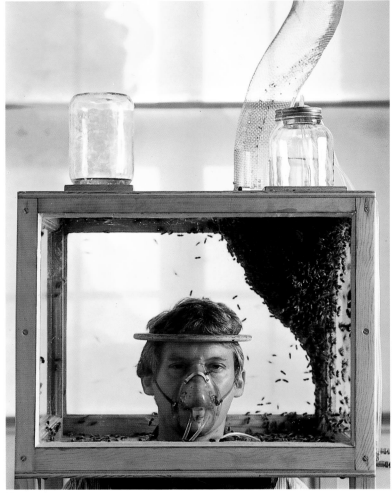

11

10 HELEN AND NEWTON HARRISON **THAT IDIOT THESEUS DID IN THE MINOTAUR** 1982, (sketch for the Seventh Lagoon, Buffalo Wallow), photographic painting on shaped canvas, Buffalo panel: 97 x 121; Tractor panel: 97 x 119, courtesy Ronald Feldman Fine Arts, New York

11 MARK THOMPSON **A HOUSE DIVIDED** 1989, photograph of installation/performance with honey bees, courtesy the artist

In such works, nature is present as substance rather than form. When the natural world ceases to be perceived as the scenery out there and becomes the systems and substances all around, we've moved from a mechanical to an ecological worldview, one that is implicit in many artists' installations dealing with substance. In concentrating on substance rather than form as the bearer of meaning, artists assert the decisive significance of substance, rather than regarding it as neutral matter that takes on meaning as it is given form. The very notion of giving meaning to something is premised on a cosmology in which things don't have it yet, in which form is to content as spirit is to matter, men to women, God to nature. Substance suggests that meaning is inherent in the world, rather than needs to be inscribed upon it, and it proposes meanings that can be read in the world itself—the world as language. It replaces representation with presentation, and much as representation is about what is absent, about lack, substance as vehicle of meaning is about what is present, about presence.

Joseph Beuys is, of course, the great progenitor of this way of working: his sculptures and performances rely on the meanings inherent in their substances—fat, felt, honey, gold, copper, animal corpses, stones, and so on. American artists of the 1960s began to think of materials as significant: Walter De Maria, Robert Morris, Hans Haacke, Dennis Oppenheim, Terry Fox, Carolee Schneemann, Robert Smithson, Alan Sonfist, Mierle Laderman-Ukeles; then in the 1970s Helen Mayer Harrison and Newton Harrison, and Mark Thompson; and by the 1980s, a whole generation. Like the substance works, site-works often call attention to what already exists rather than supplementing it. Nancy Holt's *Sun Tunnels* (1973–1976) and subsequent projects come out of her work as a photographer: the works function not as photographs but as cameras, as ways of framing and calling attention to views. Much as Walter De Maria's *Earth Room* (1977–ongoing) calls attention to the complex sensuality of earth itself, *The Lightning Field* (1974–ongoing) is less about the formal arrangement of steel poles than about luring lightning from the New Mexico thunderclouds. Robert Morris's first major earthwork is called *Observatory* (1971). Here the works become means to experience

12 ANN HAMILTON **PRIVATION & EXCESSES** 1989, element from installation at the Capp Street Project, San Francisco; 750,000 pennies, honey, sheep,

two mortar and pestles, teeth, felt hat, a gesture and hands wrung in honey, courtesy Sean Kelly, Inc.

 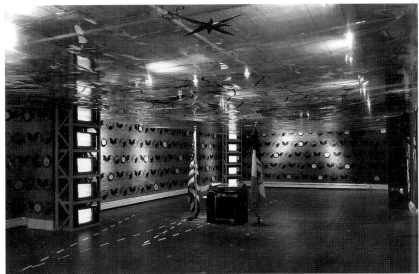

12　　　　　　　　　　　　　　　　　　　　13

existing landscapes rather than objects of contemplation in themselves. The subject of the work of art becomes the world that surrounds it: the picture is always being made by the viewer rather than premade by the artist. Creation shifts from fait accompli to present tense as the artist becomes a collaborator in a world that is alive, is creating itself.

Installation art brings many of these issues inside, into environments that are responses to their sites and sometimes metaphorical constructs of the world. The world here isn't represented in images of what is absent, but present in microcosm. Here, too, the viewer enters into the work, literally, geographically. The work may speak to the whole body, may have temperature, sensation underfoot, smell, sound, tactility, as well as sights. Installation art could be described as an attempt to speak to the mind in the languages of the body. (Ann Hamilton is certainly the most significant artist in this regard.) These sensual installations diverge from the dystopian view of much postmodern art; they move toward an arcadian realm of the senses: they arise from a faith in the wisdom of the body and the authenticity of sensory experience, which goes against the grain of poststructuralist credos of the infinite malleability of truth, of the manipulated nature of all experience. They propose a direct

REBECCA SOLNIT is an essayist, critic, and activist based in San Francisco. Her writing has been widely published in art magazines, including *Art Issues*, *New Art Examiner*, and *Aperture*, as well as in anthologies, and museum catalogues. Her books include *Secret Exhibition: Six California Artists of the Cold War Era* (San Francisco: City Lights, 1991), *Kingdoms*, a collaboration with Lewis deSoto (California Museum of Photography, 1993), and a volume on landscape and land politics in the American West to be published by Sierra Club Books in 1994. She is a member of the Association Internationale des Critiques d'Art, and the recipient of a 1993 National Endowment for the Arts Fellowship in Literature.

experience without proposing an absolute one, a local truth in Plato's cave. And of course, in our aligned metaphors, to return to the senses is to return to the body, to the feminine, the natural, the maternal, the earth—so although landscape as such is not to be found in many of these works, they nonetheless subsume the issues and desires that were once the territory of landscape art into a broad new lexicon.

A further manifestation of this idealism is the involvement of artists in actual ecological work, rather than work about it (another shift away from the representational, and from art as a removed discourse). Mel Chin has included the regeneration of a toxic site in his work *Revival Field* (1991–ongoing); Peter Richards has transformed a Palo Alto landfill into a public park; and Michael Heizer's strip mine regenerative earthworks are among the better-known examples of artist as ecologist. At the other end of the spectrum, groups such as Earth First! and Greenpeace have used creative visual means to give ecological catastrophes greater recognition. Certainly Mierle Laderman-Ukeles and Helen Mayer Harrison and Newton Harrison have been among the most distinguished artists in this respect. Laderman-Ukeles deals with nature without dealing with landscape, focusing on substances and systems rather than on spaces. She concentrates on the forces and sectors that maintain the material world, those the ideological world depends upon, and ignores. For decades, she has worked as the artist in residence at the New York Sanitation Department where she has designed one of its waste transfer facilities as a public museum of waste and redemption. The Harrisons' work begins with visits to sites that are troubled, goes on to reflect on the metaphors and narratives from which the site's problems arise—arbitrary boundaries in the pollution of the great lakes, for example—and generates artwork that is many-faceted. There are lyrical proposals that exist both as written displays with images (maps, photographs, drawings) and as spoken performances— conversations between these two who have made conversation their basic metaphor. The work may exist only as a postulate of alternative possibilities, or more and more often, it may be put into effect as environmental reclamation. Either way, it recognizes that the crucial changes in the landscape begin with changes in the way we think about it—begin in the mind.

Profiles of the Artists

I MEL CHIN **THE EXTRACTION OF PLENTY FROM WHAT REMAINS: 1823–** 1988–1989, plaster, whitewash, wood, steel, mahogany, banana tree, coffee,

mud, blood, 144 × 105 × 68, courtesy the artist

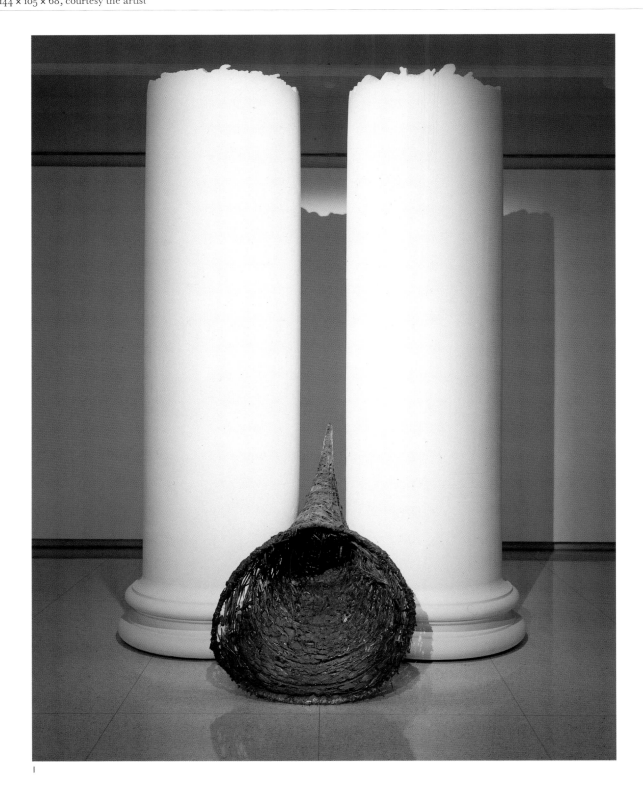

I

MEL CHIN

JOHN BEARDSLEY

MEL CHIN (b. 1951, lives in
New York City) has had solo
exhibitions at the Hirshhorn
Museum and Sculpture
Garden, Washington, D. C.,
in 1989 (*Directions: Mel Chin*)
and at the Walker Art
Center, Minneapolis,
Minnesota, in 1990
(*Viewpoints: Mel Chin*), which
traveled nationally. Using
natural materials, such as
wood, stone, earth, and
water, Chin makes works that
vary from discreet objects
to large environmental instal-
lations. His 1991-ongoing
Revival Field earth sculpture in
St. Paul, Minnesota is a
minimalistic configuration of
concentric circles planted
with vegetation that extracts
pollutants from the soil.
Created in collaboration with
a leading agronomist, this
work is also an outdoor
laboratory for scientific study.

1 Unless otherwise noted, all
quotations are from conver-
sations with the author or
unpublished writings of the
artist.

2 Mel Chin, quoted in Peter
Boswell, *Viewpoints: Mel Chin*
(Minneapolis: Walker Art
Center, 1990), unpaginated.

On the face of it, the various manifestations of Mel Chin's work
would seem to bear little relation to each other. During the latter
half of the 1980s he was probably best known as the maker of
elegant, enigmatic sculptures that were handcrafted from wood,
plaster, asphalt, mud, animal skins, and a variety of even more
unorthodox materials. A sculpture such as *The Extraction of Plenty
from What Remains: 1823–* (1988–1989) may be taken as typical
of this aspect of his work. It is composed of two 12-foot-tall
truncated plaster Ionic columns that compress the narrow end
of a horn, which is made of banana-tree fibers woven on an
armature of mahogany branches and coated with mud, coffee, and
dried blood. It is a work of simple beauty and quiet power that
functions, as Chin rightly puts it, as a "visual, aesthetic, and
conceptual snare."[1]

"It doesn't suffice for me just to make beautiful objects,"
Chin says, "the sculpture must be loaded with information.
Its beauty acts like a Venus flytrap. . . . I think that you have to use
a lure to get the message across, and that there should always be
a disturbing or precarious edge to that message."[2] The message in
the case of *The Extraction of Plenty* is a geopolitical one; it concerns
the intervention of the United States in the affairs of Central
America, something that dates back to the Monroe Doctrine of
1823. The columns are direct copies in size and style of those at the
White House; the horn alludes both to the literal shape of Central
America and to a cornucopia—the horn of plenty. Taken
together, they are a metaphor for the power of the United States
over the political and economic life of Central America, whose
bountiful harvests of fruit, coffee, and mahogany are largely
consumed by the United States and other first-world nations.

By comparison to such visually direct if ideologically complex
sculptures, Chin has also created a number of room-size indoor
installations. For a traveling exhibition in 1990–1991, for exam-
ple, he fabricated several versions of a piece called *Landscape*. On
the plasterboard walls of a typical museum space, Chin hung three
paintings he executed in the manner of different Eastern and
Western traditions: thirteenth-century Taoist, fourteenth-century
Mazdean, and nineteenth-century Western romantic. Material
from local landfills was loaded into the walls, and seeped onto
the floor through small horizontal openings at the bottom
edges of the walls. These openings conformed to a scaled

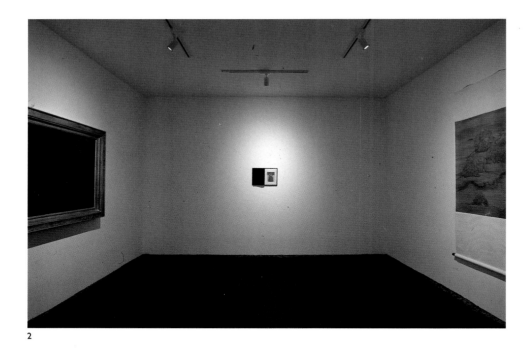

2

topographic section of the thirtieth parallel, which circles the globe through China and the United States.

By juxtaposing a mock exhibition of landscape painting with a large quantity of hidden waste, Chin was raising questions about the way in which we celebrate the aesthetic dimension of landscape while trying to obscure its social and ecological aspects. Through the comparison of Eastern and Western landscape traditions and through the device of the thirtieth parallel, Chin was also suggesting that this is a problem of global proportions. "The piece isn't simply about landscape art or about pollution," Chin says, "but about the psychological space between those things."

Meanwhile, in St. Paul, Minnesota, Chin has been involved in a long-term project with few of the outward characteristics of the typical work of art. The end product of *Revival Field* (1991–ongoing), as the project is called, is neither sculpture nor installation, but the restored ecological health of a contaminated site. As Chin puts it, "I am sculpting a site's ecology." The project had its beginnings in an article that he happened to see in the late 1980s about plants that function as "hyperaccumulators," selectively absorbing and containing large concentrations of heavy metals. The idea that these plants might aid in the reclamation of

hazardous waste sites had been apparent to scientists for some time, but no field tests had yet been tried. "I saw the poetic nature of the idea," Chin remembers, "and decided to investigate its practicality."

Chin recognized that art might provide the needed catalyst to bring polluters, scientists, public agencies, and the necessary capital together. "I'm using sociology as a sculpting tool," Chin explains. With the help of a research agronomist at the United States Department of Agriculture, Dr. Rufus Chaney, Chin acquired sufficient expertise to spearhead the field test. Financial support came from the National Endowment for the Arts after a funding flap that propelled Chin into the national news (the grant was temporarily held up by the Endowment's chairman, John Frohnmeyer, who questioned the project's artistic aims). And in the wake of an exhibition of Chin's work at the Walker Art Center in Minneapolis in 1990, a site was found in St. Paul— Pig's Eye Landfill, a receptacle for Twin Cities' waste until 1972, and a place with dangerous concentrations of cadmium, which has been designated a State Superfund site.

In the summer of 1991, a fenced circle of ground at the landfill was planted with some hyperaccumulators, including varieties of

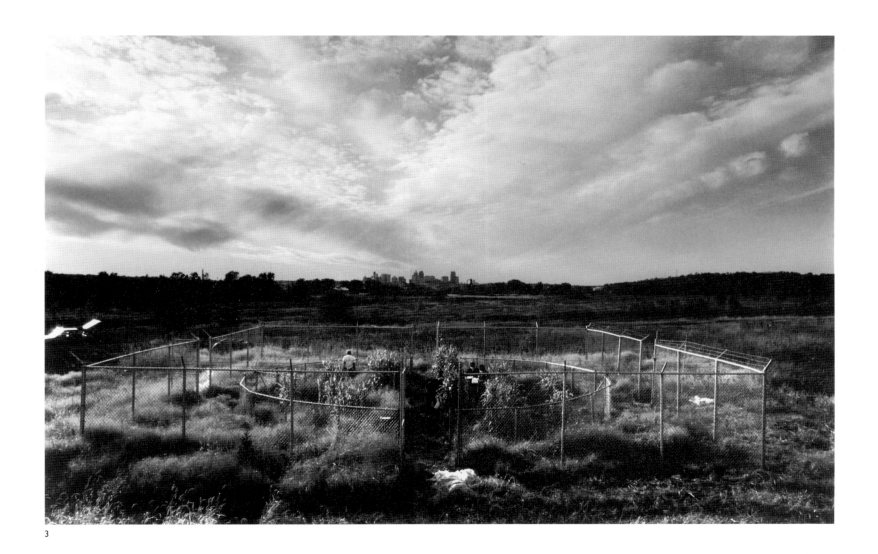

3

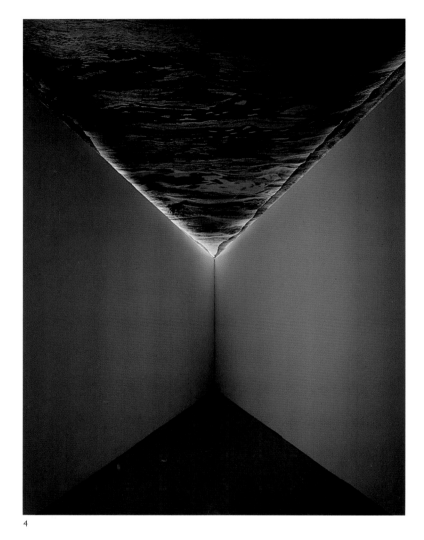

4

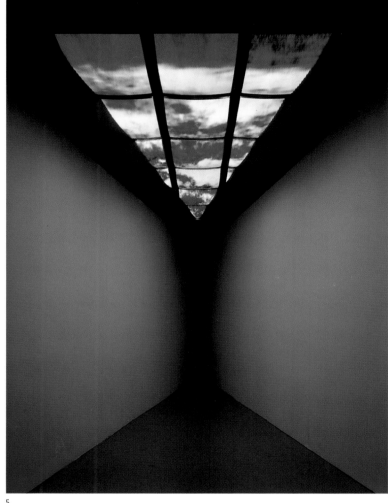

5

6

alpine penny thrift, dwarf corn, and bladder campion. Around the circle, a fenced square served as a control, seeded with nonaccumulating plants. Yearly, for three years, the plants were harvested and sent to Chaney for analysis, which demonstrated that, indeed, the plants within the circle were collecting significant quantities of cadmium. Chin's project has attracted both national and international attention. A similar project is now being planted in Holland, and a smelting firm in control of a National Priority Superfund site in Palmerton, Pennsylvania has approached Chin about testing another revival field there.

Chin acknowledges the impact that the art and writings of Robert Smithson and Marcel Duchamp have had on the development of his ideas for *Revival Field.* Smithson emphasized a geologic consciousness of time, allowing Chin to think in terms of work that would be completed after his lifetime. Duchamp provided a bridge, with his allusion to alchemy, which allowed Chin to consider *Revival Field* as a modern alchemical/metallurgical project. Michael Heizer, Robert Morris, Alan Sonfist, and others, were preparing the way for a work such as *Revival Field* by working in and on the landscape. But he notes a difference between their work and his: "In their reclamation earthworks, Heizer, Morris, and Sonfist worked outwardly. They altered despoiled landscapes by physically pushing the earth into thoughtful formal configurations. My intent is to alter the earth from within, to heal and return its potential to sustain life." And Chin is well aware of the irony in the fact that the preliminary formal aspects of the work of art will disappear as the soil is remediated, to be replaced by a normal, healthy ecosystem. "The artwork is completed, but a technology is born," he observes, a technology with both ecological and economic implications. The harvested plants can be incinerated, and the metals extracted and sold.

If Chin's sculptures, installations, and environmental works would seem to have little outward connection, they are nevertheless united by a rigorous method. Chin insists on seeing landscapes in the most complete and complex terms possible— as products of nature and culture acting together and as expressions of both creative and destructive impulses. This method results in works of great variety, all of which convey, in their particular ways, a subtle awareness of the various political, economic, and ecological forces that shape the contemporary landscape. "Some of my work takes difficult political and ecological dilemmas and expresses such topics in symbolic forms," Chin explains. "*Revival Field* is a major departure though not disconnected from the impulse driving this body of work. Rather than making a metaphorical work to express a problem, it is a work employing the same creative urge to tackle a problem head on. As an art form, it extends the notion of art beyond the familiar object or commodity into the realm of process and public service."

Chin's recent work continues to explore landscape as both a physical entity and a cultural construct, as a space with political, economic, and ecological dimensions. One of his most ambitious current projects is called *State of Heaven* (1991–ongoing). He is again working with scientists, this time asking them to develop a computer model to mathematically articulate the dynamics of the earth's atmosphere. An image of the heavens derived from this model will be woven into an enormous, hand-knotted carpet; patches in this carpet will be unwoven and rewoven to record fluctuations in the atmospheric ozone layer. These openings in the rug will be scaled to actual ozone depletion.

Chin's sculptural project for *Landscape as Metaphor, Spirit* (1994), is another of his visual, aesthetic, and conceptual snares. It is, he says, "a portrait of a landscape on the line." A large barrel balances on a thin rope woven from native prairie grasses of the Great Plains, like a distended tightrope walker in imminent danger of falling. The cask has numerous connotations: it is a common measure of production for oil, alcohol, and various solid commodities, and alludes to the etymology of the word "ton" (from Old English "tunne," large cask). The rope suggests a landscape reduced to a slender trace under the strain of production. The use of indigenous prairie grasses specifies that reference. It is a reminder of the virtual extinction of a whole grasslands ecosystem put under the plow in an expression of the pioneering spirit. Imploding walls surrounding the expanding barrel create a psychological tension: "pressure" from without and "pressure" from within metaphorically connect the work to current consumerism and continuing ecological concerns. The piece also alludes to the enormous and devastating consequences that followed after white settlers introduced alcohol to Native American populations. With the most simple means, Chin is again suggesting the complexities of the contemporary landscape; with an image so imbalanced, he raises the specter of economic and ecological collapse.

As revealed by both *State of Heaven* and *Spirit*, Chin continues to be loyal to his notion of "poetic entrapment." Whether his work takes the form of sculpture, installation, or environmental art, he persists, as he says, "in bearing sculptural witness to ecological and political tragedies."

1–4 LEWIS deSOTO **TAHUALTAPA PROJECT** (SERIES) 1983–1988, collection Seattle Art Museum, Seattle, Washington

1 **HILL OF THE RAVENS,** black and white photograph, feathers, wood, 32 × 32

2 **LITTLE MOUNTAIN THAT STANDS ALONE,** black and white photograph, feathers, cement, marble, wood, 32 × 32

3 **MARBLE MOUNTAIN,** black and white photograph, marble, wood, 32 × 32

4 **MOUNT SLOVER,** black and white photograph, cement, wood, 32 × 32

1

2

3

4

LEWIS deSOTO

REBECCA SOLNIT

LEWIS deSOTO (b.1954, lives in San Francisco) draws upon the legends of the Cahuilla Indians of southern California for his conceptual sound and projection installations. Images of mountain and desert lands revered by this ancient culture figure prominently in these projects. Through his highly conceptual evocative art, deSoto seeks to reconcile long held tribal beliefs, central to Cahuilla heritage, and higly complex scientific theories about humankind's relationship to the universe. His recent solo exhibitions include *Pé Túkmiyat, Pé Túkmiyat (Darkness, Darkness)* San Jose Museum of Art, California (1991), *The Language of Paradise*, Artist's Space, New York, New York (1991), *Tahualtapa Project and Video Room*, Moderna Museet, Stockholm, Sweden (1993), and *Falling*, Christopher Grimes Gallery, Santa Monica, California (1994).

Within all the diversity of landscape art, we seldom see the constants. One of the most deeply buried and most constant elements of Euro-American landscape art is its dependence on the cosmology of Genesis. Because most viewers are also permeated with beliefs framed in Genesis, this specific condition is often mistaken for a universal when it is noticed at all; most often it remains invisible, and the more invisible a bond, the harder it is to liberate oneself from it. Genesis is a ceiling often mistaken for the sky.

Lewis deSoto's work is important for many reasons, perhaps most of all for the glimpse it gives us of how the world might look if Genesis had never been written, or if we had never read it. This is a vastly original accomplishment, one that distinguishes his work from almost everything else in the landscape field. I am not proposing deSoto here as an untutored child of nature; his is a perspective not determined but complicated and liberated by his Native American ancestry and early exposure to the traditions of his father's people, the Cahuilla Indians of California's southern deserts. His understanding of landscape is not simply a traditional one, but a synthetic one, wrought as well from readings of Taoist, Buddhist, and phenomenological texts.

Genesis is a story of creation that describes a relationship between creator and creation and the nature of the creation. Both of these aspects have determined a great deal about Western art. The creative relationship is less of engenderment, of procreation — extension of self—than of manufacture, of the creation of "notself" by an act of volition. (Genesis is an altered account of an earlier procreation by a male and female deity; the oneness and maleness of the Judeo-Christian God required the suppression of the collaborative, engendering nature of creation in the earlier story.) God makes the world, but remains separate from it; and the world lacks divinity. A kind of binary schism has already entered the picture.

Secondly, the creation is first static, then flawed. Another schism has entered the picture: the evolving, the mutable, the temporal, the unstable are imperfect, and perfection is a standard against which all things are measured—and fall short. Thus, the flawed, sublunar world of medieval theology is a blighted way station between the Fall and the Last Judgment. Much of what seems to be radical thinking in landscape art is, in fact, deeply rooted in this binarism. Contemporary landscape photography, for example, often works in terms of the before/after, virgin/

5

whore, pure/polluted in representing the landscape; central to this dualism is the belief that nature exists or ought to exist in a static state and that humanity is distinct from nature-creation, an intruder. All that has changed here is that Paradise Lost has been updated from before the Fall to before the first footstep or last century. Readings of the landscape of the American West as a raw, blank arena—an escape from culture and from the cultural mediation of meaning—is one of the most problematic aspects of a worldview that tends to be Eastern and urban.

The Cahuilla creation myth begins with a miscarriage out of the primordial darkness, goes on to a drawn-out creation involving two brothers distinguishable by the quality of their workmanship, and doesn't have a clear endpoint: the gods create tools as well as creatures, and the creatures create and destroy as well. There is a continuum of change without a fall from grace; imperfection is original to the world, and creation is never finished. Culture and nature are not useful categories here. DeSoto's installation for *Landscape as Metaphor, Tahquitz*, most clearly operates outside of all the givens of landscape. However, I want to frame it in the context of the work that came before.

DeSoto's oeuvre begins with *Botanica* (1980), a series of photographs of flowers that abandon the rules for landscape photography. The arcadian nostalgia of the genre is a monumental irony, given that all photography depends upon modern machinery and chemistry. DeSoto's flower photographs, however, explored the affinities between the camera and the flower. Because both flowers and cameras are light-responsive, he organized the image making around that responsiveness: a slow exposure allowed the camera to receive the flower's light, and a flash gave it back. In this version, flowers become somewhat less romantic, the camera more so—in fact it becomes possible to see the camera as a kind of mechanical flower, with its petal-like, irislike aperture. Again, the organic and the mechanical cease to be opposed to each other, but instead, the one emerges as a metaphorical echo of the other. Rather than traditional subject/object, viewer/scenery relationships, *Botanica* establishes a reciprocity, insists on the responsive sentience of the landscape. The mechanical becomes not a violation of the natural order but an echo of it, a later wave of an ongoing creation.

Too, the *Botanica* images are less about photography as a means of composing images than as a performance, a process: the blurred, crowded images are only documents of an encounter between camera and plant. The subsequent *Projects* (1983) series of photographs were documents of sculptural events and site-specific installations. The next major photographic project, *Tahualtapa* (1983–1988), would begin to eliminate the photographic mediation of these elements. *Tahualtapa* is basically a multimedia work centered around a mountain the Cahuilla call Tahualtapa in San Bernardino County (not far from the mountain that is the site for *Tahquitz;* both are part of what has long been Cahuilla country). The work was instigated by a friend's remark to the effect that it was too bad the mountain wasn't there anymore. The leveling of the mountain had been so gradual, deSoto himself hadn't realized it was going on. *Tahualtapa* made that history visible. The four photographs relate to four chapters of that history: *Tahualtapa*, or Hill of the Ravens, for its original cultural status; *El Cerrito Solo*, the Little Hill that Stands Alone, or its renaming by the violently evangelical Spanish; *Marble Mountain* for its earlier Anglo history as a marble mine; and *Mt. Slover*, for its current phase as a cement quarry. The images have their titles inscribed on them, props set in the foreground of the photographs, and frames as much a part of each work as the photograph. The frames are filled with materials relating to the mountain's role: feathers, feathers and marble dust, marble slabs, cement.

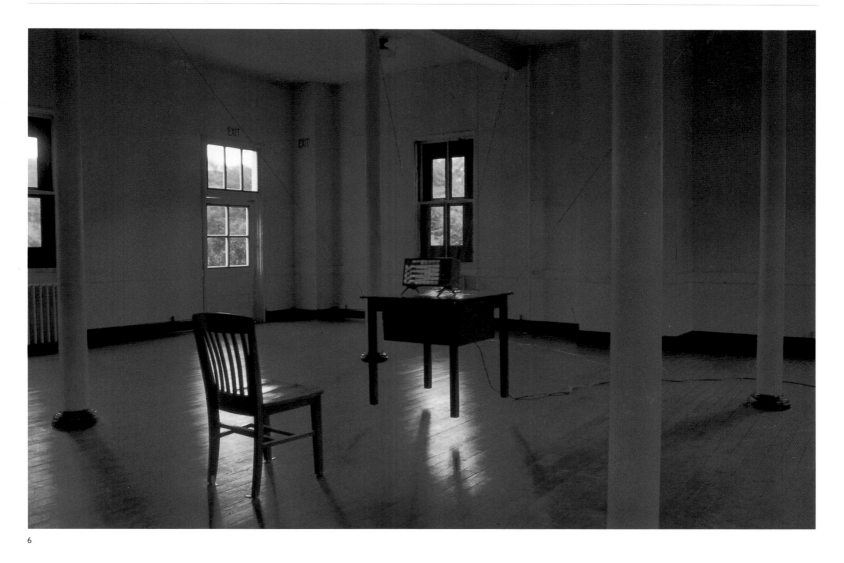

6

Regarding these substances as much a part of the mountain's essence as its form gives a different emphasis to its metamorphosis. *Tahualtapa* is not a mourning for what has been so much as a chronicle of what has become, and a recovery of both lost history and lost material. Further aspects of the project position the mountain in its surroundings and extend the territory of the artwork to that of the mountain. In *Slover Compass* (1988), a cross of topographical maps and photographs document the artist's distance markings on cement sidewalks made from the nearby mountain. In the cement relief of *Slover Quadrant*, the mountain's materials are extended into the exhibition space. Clearly, the evolution from the

sacred hill of the ravens to a cement quarry is not a paean to progress, but the loss recuperated by the project is as much the knowledge of where so much of the cement in the region comes from as where the mountain went. The mountain is never seen independent of the three cultures that named and valued/devalued it (and the artist's interpretation becomes a fourth, memory-restoring layer of evaluation). The piece is as much about the metamorphoses of perceptions of the mountain as of the mountain's own metamorphosis—it is subjecthood that is the object. Under the diminishing gaze of these subject-states the mountain itself disappears. As the artist remarked recently, understanding the

7 LEWIS deSOTO **PÉ TÚKMIYAT PÉ TÚKMIYAT (DARKNESS, DARKNESS)** 1991, mixed media installation at the San Jose Museum of Art, San Jose, California, courtesy Christopher Grimes Gallery, Santa Monica, California

8 LEWIS deSOTO **AVIARY** 1990–1991, mixed media installation at the Headlands Center for the Arts, Sausalito, California, courtesy Christopher Grimes Gallery, Santa Monica, California

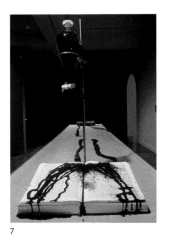

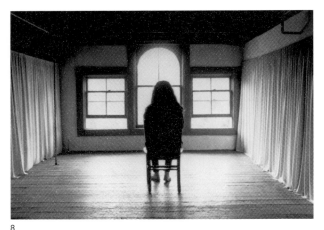

7 8 9

history of the mountain and the source of the material meant that you could be in the landscape while driving on the freeway—not a devaluation of nature, but a revaluation of culture, and so finally not a mountain that disappears, but an already absent mountain that is made manifest.

Tahualtapa and three subsequent installations, *Háypatak, Witness, Kansatsusha* (1990), *The Language of Paradise* (1991), and *Pé Túkmiyat, Pé Túkmiyat (Darkness, Darkness)* (1991), all deal with indigenous California points of view—the latter two specifically with Cahuilla creation mythology. Together they can be seen as a midrash of the less referential works, from *Botanica* to *Office* (1992) and *Observatory* (1993), the last dealing with the cosmic origins of static and the possibility of searching it for meaning.

Another category deSoto dismisses is that of the banal: he points out that his paternal tongue has no word for sacred. In the same way that Genesis slices time into a dreamtime and a fallen aftermath, the notion of sacredness localizes certain kinds of power or value and relegates everything not sacred to the status of the profane. Increasingly, his installations rely upon quotidian objects—most often, furniture and machines, the objects appropriate to rooms for living and making, rather than looking at. The results seem intensifications of the everyday world rather than a realm apart from it. The wintertime installation *Edison Song (Tesla Sings for a Deaf Edison)*, (1990), for example, consisted of a heater miked to an amplifier, a table hovering above the

floor, and a chair. Resting on the table at the far end of a long, multi-windowed room at the Headlands Center for the Arts, the heater vibrated as its wires glowed red. The amplifier turned the humming wires into a more audible music, and the viewer gravitated toward the chair set before the heater, the source of both sound and warmth in the chilly, blue-tinted space (it can be considered a landscape defined and occupied by luminosity, temperature, and sound vibrations rather than by more conventional visual objects of scenery). Offered up as an object for contemplation, the heater became alluring, fascinating.

Even the opulent installation *Pé Túkmiyat, Pé Túkmiyat (Darkness, Darkness)*, at the San Jose Museum of Art, consisted of, in addition to a range of light and sound zones, two tables, a fan and a tiny video monitor, so that the Cahuilla creation was represented as a domestic interior, a made world within the created world. It is easy to describe *Edison Song* as dealing with a different body of concerns than the mythologically generated works, but it is also possible to see it as a parallel exploration of spaces, energies, and transformations. Similarly, installations such as *Aviary* (1990) and *Air* (1990) translated outside phenomena into palpable indoor sounds, addressing the landscape not as a visual composition of a specific locale but as a pervasive field of sound and motion.

The *Witness* (1990) installation was organized around the viewer's position in the piece. A darkened room with a wooden

9 LEWIS DeSOTO **HÁYPATAK, WITNESS, KANSATSUSHA** 1990, mixed media installation at the San Francisco Arts Commission Gallery, San Francisco,

California, courtesy Christopher Grimes Gallery, Santa Monica, California

decklike floor over a bed of stones was organized around a video projection of the landscape around Drake's Bay in Marin County; the flooring extended as a kind of spit almost to the screen, and as the viewer watched from this position, his/her own shadow became part of the projection. The terrain was shot in three styles: close-ups, sweeping views, skyscapes. The title's three words referred to three cultures of the region: the Miwok, the Asiatic, and the imperial English. Composition became a means of reiterating consciousness. Like the mountain in *Tahualtapa*, the bay in *Witness* served as a checkpoint for cultural shift rather than landscape as a given. In the same way, the viewer's shadow on the screen established that we were seeing ways of seeing nature, not nature itself, and a tiny monitor atop the projector showed a figure standing within the landscape on the screen. Spectatorship becomes a mode of participation rather than the detached state asserted by most Western image-making traditions, and the subject becomes an object of contemplation. This is one of the areas of concern that installation opened up for deSoto: photographs operate within certain assumptions about the act of viewing, while his installations make the viewer into a reader, a sitter, a shadow, a palpable participant in the work under consideration, and part of the whole rather than outside it. The examination of premises and assumptions that has been part of his work is more available in a medium with so few premises of its own.

Further, a photograph is a completed act, a finished creation. In deSoto's installations, things are unfolding in real time, incomplete, part of the mutable world rather than a comment on it. The artist has described his installations as being akin to camera obscuras—in that sense, the works bring together the objects that make the image, but put us amidst that image as it is in the perpetual present tense of being made, rather than freezing and representing it. They transform the act of representation from one of commentary on the past to a constant conjuration into the present, shifting the tense of creation into the now.

Tahquitz is both an installation about a Cahuilla myth and a symbolic reenactment of the myth, bringing the viewer into a narrative that is unfolding within a room to be read. Most unemphatically, it presents the kind of Western landscape that is most often read as raw, new, virginal, and uninhabited in terms of the folklore that has in fact accumulated around many such places in the region. As in earlier pieces, the landscape is viewed not as

itself, as the respite of the romantics, but as an experience modulated by the layers of inherited experience and the means of perception.

The artist describes the event that the installation regenerates: "Tahquitz is an ancient creature who lives in icy caves atop the San Jacinto peaks. He kidnaps, enslaves, then feeds on the souls/spirits of humans. One day he seizes a pretty young maiden . . . enslaves her and commands her to feed on souls as well. Eventually he pities her and allows her to return to her village. He forbids her to speak of her experience. She returns after a few days, but sees that years have passed. She is badgered by the village people to tell her secret. At the moment of her telling, she is struck dead." The story bears a great deal of resemblance to nineteenth-century gothic literature, from *The Legend of Sleepy Hollow* (in which Rip Van Winkle sleeps for many years) to *Dracula* and *Frankenstein*, particularly in the sense of the mountains as numinous, sublime, and dangerous places. It doesn't have much to do with contemporary readings of landscape as refuge, as paradise, as good in contrast to the evil that is culture, nor does it with further conventional association of the female with the natural, the male with the cultural. One could also read it against Plato's allegory of the cave, for here the scene is not the territory of the limitations of the sensory aligned with the vaginal space of the dark cave, but is a dangerously luminous cave beyond the realm of the familiar, in which ascent to the heights imparts a knowledge that is death rather than deliverance. Implied within the story is a contentment with the ordinary sphere of human activities, rather than endorsement of a restless desire to cross its circumference.

The installation seems to propose two readings of the story: the ice melts under the light as though knowledge annihilates the fear that is Tahquitz and his ice cave. The reading of the story within the ominous environment, however, proposes an act of communication that is ongoing, incomplete, and liable to be fatally interrupted at any juncture—for the stories may not be completed, the voices may be those of the dead as recorded voices often, uneventfully, are. *Tahquitz* establishes a moment of tremendous tension in a conceptual landscape that is far from an escape and presents us with the profound risks of any act of communication.

I RICHARD MISRACH **THE WORLD'S FASTEST MOBILE HOME, BONNEVILLE SALT FLATS, UTAH** 1992, dye-coupler print, 40 x 50, courtesy the

Robert Mann Gallery, New York

I

RICHARD MISRACH

REBECCA SOLNIT

Richard Misrach (b.1949, lives in Emeryville, California) has been photographing the American desert landscape since the mid-1970s. He has focused on sites which have undergone extensive despoliation through natural and man-made catastrophes. In Misrach's photographs, what at first seem idyllic visions of nature in all its primal grandeur emerge, on closer view, as rueful meditations on wanton destruction of the land. In one series of pictures, a California town has been suddenly flooded by an ill-conceived irrigation system; in another, vast acres of the Nevada desert, used to test the latest military ordinance, are strewn with the debris of deadly hardware. His collection of photographs available as books include *Desert Cantos* (1987), *Bravo 20: The Bombing of the American West* (1990), and *Violent Legacies: Three Cantos* (1992). Misrach has had several national and international traveling solo exhibitions, his photographs have been shown at the *1981 Whitney Biennial*, Whitney Museum of American Art, New York, New York, and his work was included in *Between Heaven and Home: Contemporary American Landscape Photography*, National Museum of American Art, Washington, D.C. (1992).

Perhaps the most distinctive sensation of being in the desert is the awareness of oneself as a solitary vertical element in a vast expanse. Richard Misrach's ongoing Desert Cantos series seems to occupy a similar isolated position in the contemporary art world: there is simply nothing else that does what they do. The possibilities of art are often described as isolated from each other, as though one must choose the theoretical or the visceral, the urgencies of politics or the meditations of philosophy, formalist or documentary modes. In his huge color photographs, Misrach seems to have found a forgotten road that leads to where they all converge. That simile of a road may have its real counterpart in the highways leading into the Mojave and Great Basin deserts.

Untouched by any formal art training, Misrach's photographic career began in 1974 with the publication of the book *Telegraph at 3am*, black-and-white images of the street people of Telegraph Avenue in Berkeley. The artist himself speaks of his naive disappointment when this documentary work failed to have any social impact, and like many others on the waning edge of that era of uprisings, he retreated to the apolitical and to the land. It's interesting, in light of his later work, that at that early juncture, politics and landscape appeared as distinct spheres: a decade-and-a-half later—in 1989, in Colorado—Misrach would help organize a kind of summit for artists on the subject called "The Political Landscape."

After the black-and-white images of people came pictures of exotic landscapes. Among the memorable ones are those of Stonehenge by night—the stones spectral and strange in the sudden flash of light—and a series of pictures of the Hawaiian rainforest, also at night. In these, the flash reveals an intricate tangle of greenery that has nothing to do with classic landscape composition. Rather than a landscape of form, these pictures reveal a landscape of stuff—lush, confusing, and disorderly. But by the end of the 1970s Misrach had found the spaces that have preoccupied him ever since: deserts—not the famous picturesque deserts of Utah's and Arizona's canyon country or the pristine sand dunes of Death Valley, but the subtler, lesser-known territories of southeastern California, Nevada, and northwestern Utah.

This terrain is the land almost nobody settled (though it had superbly adapted indigenous populations), nobody admired, and nobody realized was there. It is also, not coincidentally, home base for some of the United States military's most devastating and

2 RICHARD MISRACH **CAMOUFLAGED SOLDIER, EDWARD'S AIRFORCE BASE, MOJAVE DESERT, CALIFORNIA** 1983, dye-coupler print, 40 x 50,

courtesy Robert Mann Gallery, New York

2

secretive practices. Twenty percent of the military land is in Nevada alone: radioactive, toxic, shattered by bombs, scattered with tanks and ordinance, fenced off, and patrolled. The people in this place live in widely scattered oases, tumbleweed-and-neon respites of banality from the vast sublimity of the surrounding land. This contrast drove many of Misrach's earliest images.

All his work in this region has been organized into thematic groupings he calls cantos. One of the cantos from the early 1980s is titled *The Event* (1983). Its images depict the citizenry who came to a dry lake in southern California to watch a space shuttle land. The motor homes, the jungle-camouflaged soldier, the clusters of pastel portable toilets, all stand in contrast to the perfect starkness of the lake bed and the overwhelming blue sky, as though the work was a kind of meditation on the vanity of human pastimes. A famous image of folly from around the same time depicts an empty swimming pool, diving board over dry concrete, in the midst of a flooded desert—*Diving Board, Salton Sea* (1983)—part of a canto on a man-made flood. It is possible to trace the increasing politicization of the artist through the cantos, and the course of the work suggests that the land itself educated him. All of these works trace human effects on the land, beginning with the relative neutrality of train tracks (though even his head-on *Train Tracks* (1984) recalls Theodor Kaufmann's 1867 painting of American

Indians lying in wait for a distant train, *Westward the Star of Empire)*, continuing through the disasters of fires and floods, and then homing in on the military for many series: on the Nevada [nuclear] test site, the Bravo 20 bombing range, Wendover Air Force Base.

There was a time when history painting was considered the loftiest type, and the lowest, the least noble, landscape. The distinction was based on the old European-Virgilian idea that landscape serves as a respite from history, a place in which nothing happens—a pastoral idyll or a rustic interlude. Somewhere in the ennoblement of landscape painting in the late eighteenth and early nineteenth centuries, history painting began to fade, and in the twentieth century it has survived only as a symbol in works like Picasso's *Guernica* (1937), or as disjunctive irony in works like Larry Rivers's *Washington Crossing the Delaware* (1953). One of the most interesting things about Misrach's work is the way it seems to revive history painting—revive it as landscape photography. It is in part that the meaning of landscape has changed; the fate of the earth is our current political crisis and so landscape is no longer escapist. Misrach's work is photography as history painting rather than documentary because of its aesthetic—nobody ever chose a view camera to shoot action pictures, and such heroic skies and subtle tints have little to do with the documentary tradition—and because of its emblematic, exhortatory nature. The many pictures of military effects and environmental problems pose questions to a national conscience.

The American landscape has always been represented as a place before history—the problematic term is virgin—by both the lineages of photography and painting, by the Eastern painters Thomas Cole, Frederic Church, Albert Bierstadt, and by the California photographers Carleton Watkins, Eadweard Muybridge, and Ansel Adams. In Misrach's work, the landscape is after history. That is to say, history has impressed itself upon these grounds, as bomb craters, airplane hangars, dead animals, and contaminated state parks. These are subjects that would conventionally be represented in the small black-and-white images of photojournalism, which see virgin landscapes as beautiful and contaminated landscapes as ugly. But Misrach's pictures are huge Ektacolor prints, unfailingly beautiful, and almost as often, disturbing.

3 RICHARD MISRACH **TRAIN TRACKS, COLORADO DESERT, CALIFORNIA** 1984, dye-coupler print, 40 x 50, courtesy Robert Mann Gallery, New York

4 RICHARD MISRACH **DIVING BOARD, SALTON SEA, CALIFORNIA** 1983, dye-coupler print, 40 x 50, courtesy Robert Mann Gallery, New York

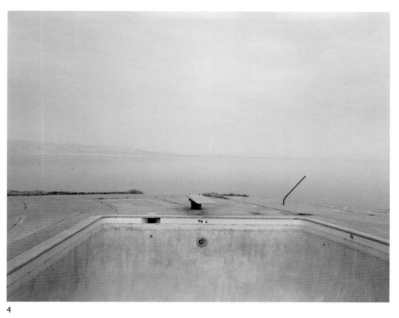

3

4

And as photojournalism, they would have been images of people, of history being acted out. Instead, the images are of the land that history has acted upon, a past tense that deemphasizes the human figure. The extensive canto on the Bravo 20 bombing range, for example, has much to do with the activists who tried to prevent the navy from continuing its unauthorized bombing of public land in central Nevada, but the images are largely of the bombed land: not the bustle of causes, but the aftermath of effects. This project evolved from one of documentation to become a proposal to turn the place into Bravo 20 National Park. In using photography of the inaccessible as a vehicle for national park lobbying, Misrach was also emulating the uses to which William Henry Jackson and Ansel Adams put their images of Yellowstone and Kings Canyon. In turning a photographic series into a subversive proposal for the Department of the Interior, he was turning his medium into meta-public art.

In the canto *The Pit* (1987–1989), the subject is a dead livestock dump in central Nevada. The specific causes of the animals' deaths are unknown, and they are often paired with a text about livestock deaths caused by nuclear fallout in the 1950s: a visible event without explanation coupled with an invisible event with explanation. And here it becomes hard to label all the work landscape. These are elements swallowed up in the open secrecy of

the Nevada landscape, but it is fauna, not flora or terrain that dominates—perhaps they might be called instead, environmental photographs, with the overall concern that term suggests. Most of the pictures are claustrophobic, horizonless, and the colors are warm and muted, the colors of earth and hide and dried blood. The great swelling or dessicated forms looming up in the picture plane begin to resemble the bodies of tableau paintings: it is as though *The Peaceable Kingdom* has become *The Raft of the "Medusa."* It is, too, a nature we are less inclined to think of: nature as mortality and corruption, fellow creatures as food and chattels, ourselves perhaps present in the marks where bulldozers have been burying the evidence.

Because these images were beautiful, many people found them deeply disturbing; some compared *The Pit* to Lee Miller's allegedly aestheticized images of World War II's liberated concentration camps (though few of those offended proposed to investigate the site or lobby to shut down the livestock industry). It seems that what really disturbed them was a mixing of languages, the language of visual pleasure and of that of compassion: the subject would have been acceptable if the images had been ugly, and the beauty would have been acceptable if the subject were neutral. In some of the outcries there seemed almost a demand that only the good look beautiful, that artists thus make our

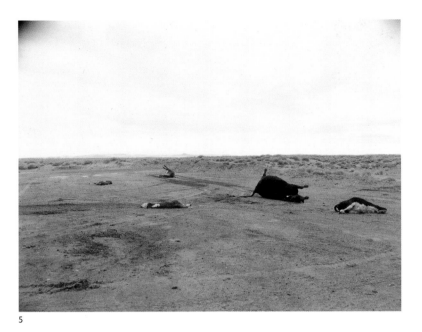

5

morality easier. Misrach's work suggests instead that the relationship between the good and the beautiful and between appearances and values is nebulous. This very nebulousness constitutes the ethical core of Misrach's work: the wrongs he documents are almost always either invisible or inspiring, and they question the adequacy of our categories and our responses. Often an environmental disaster is invisible to everyone but statisticians counting mortalities or deformities, and the landscape looks as before. The sins of the military, on the other hand, are often glorious, stirring displays of power. Sometimes only a title in a Misrach photograph gives away the secret that something is wrong: for example, the radiant light in a photograph of thunderclouds becomes ominous when the title explains that this is the Nevada Test Site.

The loose category of beauty only problemizes the images; the tauter meaning of the sublime suggests something of their power and their morality. Among the qualities Edmund Burke enumerated in his 1751 treatise on the sublime are terror, obscurity, power, privation, vastness, magnificence, light, the cries of animals, pain, darkness, solitude, and silence—a list that transfers readily to Misrach's oeuvre. The sublime—as the word was used in the eighteenth and nineteenth centuries—is the aesthetic of the overwhelming and terrifying, an important and

neglected category in the discussion of landscape, and a means of explaining why images of disaster can be so stirring.

The Bonneville Salt Flats images unite many of the issues in Misrach's previous work. It was in the Salt Flats that the Donner party fell behind schedule and so only arrived in the Sierra in time for the first blizzard of the season; and it is now in the Salt Flats that the world's land speed records are set. The two events—the tragic slowness and the ecstatic speed—seem between them to bracket an American attitude toward the landscape: a concern with speed, conquest, progress, escape, and power. In light of the place's history, the cars speeding at hundreds of miles an hour to nowhere in particular seem driven by a repetition-compulsion, a desire to overcome human vulnerability to the vast arid space of the desert. Before Manifest Destiny and the war with Mexico, the entire West was conceived of as the Great American Desert, a barrier to civilization and national expansion. The Great American Desert shrank to the outlines of the Great Basin and Mojave afterward, and geographers carved away at it until by 1900 nothing remained of it but this flat expanse west of another great, the Great Salt Lake. This, the remains of the prehistoric Lake Bonneville, is one of the flattest, most unvaried regions in America's West, a minimalism that only ends at the mountains on the horizon.

Misrach's images of this place have, rather than the blurred speed of action photography, a monumental stillness: the race car images seem almost descendants of the country gentleman's painted portraits of racehorses and prize bulls posed standing still, held by their halters. They suggest once again the incongruity of the American West: the ephemeral, reckless bent of its culture overshadowed by the forbidding majesty of its stony landscapes. They are not, however, pictures made to condemn hot-rod culture, but to consider it as a manifestation of the responses to the lay of the land—the desire to outdistance it, to overcome it, to not be subject to it, the desire to speed up into the supernatural. They are, too, art about art, for the cars are not only feats of engineering, but conscious works of art corresponding to the aesthetic norms of the subculture. As such, the cars are sculptures, and as sculptures, they are monuments to the continuing desires that transformed the West. For viewers of the photographs they are sculptures in a landscape, however stark. But for the drivers, the already abstract landscape of the Salt Flats

6

blurs into nonexistence at their stupendous speeds; the cars annihilate distance — the thing that devastated the Donner party — and in annihilating distance and space, they erase landscape itself.

Landscape is often thought of as being primarily about space, but the nature of time is an equally crucial concern, and the relationship between the two is questioned in these images. Here, the linear time of Manifest Destiny and world's speed records are mocked by the cyclical time of the natural world, and the images of perfectly straight lines stretching into the distance seem to be about a futile euclidian desire to transcend it. Every fall this expanse of the Great American Desert becomes a lake in which even the racetrack disappears, and every spring the land reemerges as though newly created, an extraordinary expanse of pure salt, an unearthly earth.

MATT MULLICAN

MICHAEL TARANTINO

MATT MULLICAN (b.1951, lives in New York City) earned an international reputation for banners and posters emblazoned with a complex, pictographic, "sign language." Among his current projects are large concrete relief sculptures that suggest a depopulated, densely urban environment. These visions of anonymous model cityscapes are based on Mullican's idiosyncratic cosmology; they are mappings more of his imagination than of any real or even hypothetical urban space. He has had solo exhibitions at the Everson Museum of Art, Syracuse, New York (1986); the Dallas Museum of Art, Texas (1987); the Museum of Modern Art, New York, New York (1989); the Hirshhorn Museum and Sculpture Garden, Washington, D.C. (1989); the List Art Center, Massachusetts Institute of Technology, Cambridge, Massachusetts (1990); the Rijksmuseum Kröller-Müller, Otterlo, The Netherlands (1991); and, the Kunstmuseum Luzern, Switzerland (1993).

1 Oliver Sacks in "The Landscape of His Dreams" *The New Yorker* (27 July 1992), 59.

2 Sigmund Freud in *The Interpretation of Dreams* (Penguin Books, 1991), 176; originally published in 1900.

The Force of Revelation

Hughlings Jackson speaks of the "doubling of consciousness" that tends to occur in such seizures. And this is how it is with Franco: when he is seized by a vision, a waking dream, a reminiscence of Pontito, he is transported—he is, in a sense, there. His reminiscences come suddenly, unannounced, with the force of revelation. Though he has learned over the years to control them to some extent, to invoke them or conjure them up—as indeed all artists learn to do—they remain essentially involuntary.[1]
—*Oliver Sacks*

What is in question, evidently, is the establishment of a psychical state which, in its distribution of psychical energy (that is, of mobile attention), bears some analogy to the state before falling asleep—and no doubt also to hypnosis. As we fall asleep, "involuntary ideas" emerge, owing to the relaxation of a certain deliberate (and no doubt also critical) activity which we allow to influence the course of our ideas while we are awake. (We usually attribute this relaxation to "fatigue.") As the involuntary ideas emerge they change into visual and acoustic images.[2]
—*Sigmund Freud*

"Details of a Fictional Life," "Death Pulling the Soul Out of the Dead Man," "Entering the Picture," "The Demon and the Angel Fighting Over the Dead Man's Soul," "Performing: Acting Under Hypnosis": these are a few of the titles given by Matt Mullican to performances he gave under hypnosis in 1979 and 1982. While they refer, on one level, to a metaphorical clash of emotions and concepts (fiction/life, death/afterlife, good/evil, performance/hypnosis) that were articulated by the artist on stage, they also predicted Mullican's eventual concerns with questions of architecture, landscape, and the environment. In fact, the title, "Entering the Picture," may describe almost all of Mullican's subsequent activity, from the low-tech series of stick figures on paper to the recent work with virtual reality. In these, the spectator is literally projected into another space and the parameters of that space are regulated by the apparatus each participant must wear. Both physically and intellectually, Mullican's use of hypnosis functions as an approximation of the viewer's position within a picture—the limits of which are set by the artist himself.

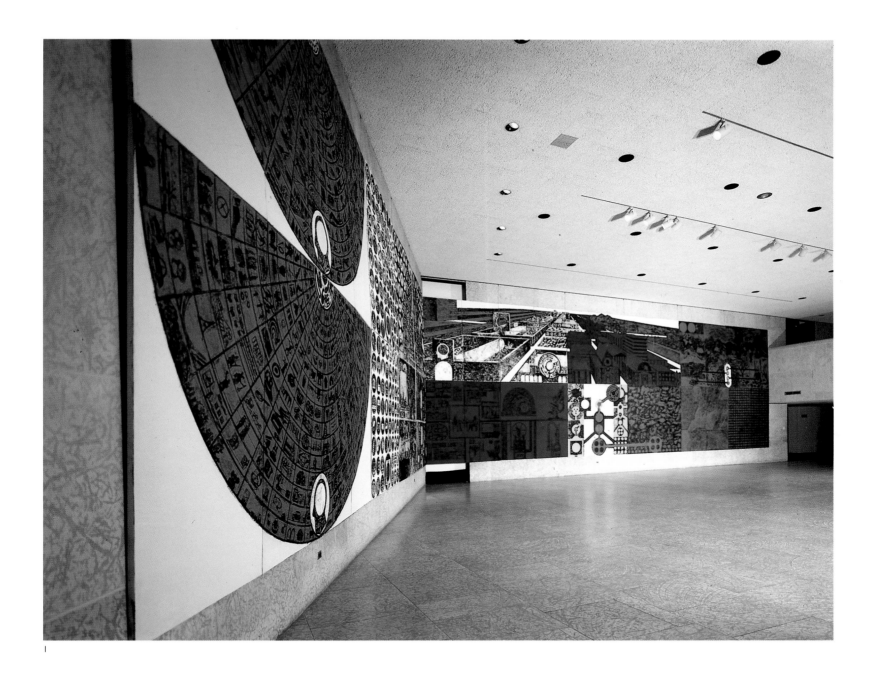

I

The citation above from Oliver Sacks is taken from his account of the incredible life of Franco Magnani, an Italian painter living in San Francisco who, over the course of the past thirty years, has produced a series of minutely detailed paintings of the town of Pontito, in Tuscany, where he was born in 1934. What makes the production of these paintings so remarkable is that Magnani has not been in Pontito since 1943. Thus, the works are painted from memory, a memory with photographic detail of such refinement that these paintings have become an obsession. Magnani's landscapes bear witness to the relationship between repetition and similarity: the more he re-creates the views, the more his position in relationship to them becomes both closer and more distant. The "involuntary seizures" that transport Magnani to the site of his paintings share many of the characteristics of hypnosis. He is "entering the picture," i.e., the village of Pontito, trying repeatedly to re-create what has become, in retrospect, the idyllic period of his childhood.

Oftentimes, in Mullican's hypnosis/performances, he would supply himself with props—paper backdrop, paints, and various other supplies that would serve as additional means to illustrate his interior voyage.[3] Thus, in one performance at the Institute of Contemporary Art in Boston in 1983, he produced a series of drawings based upon the various stages of the character that he was "living," from birth to death. Like Magnani's landscapes (and like Freud's state of presleep), these works challenge our understanding of the categories "subjective" and "objective."

City as Concept

> There is at the back of every artist's mind something like a pattern or a type of architecture. It is a thing like the landscape of his dreams; the sort of world he would wish to make or in which he would wish to wander, the strange flora and fauna of his own secret planet.[4]
> —*G.K. Chesterton*

The shift between these subjective and objective states takes place within the activity of entering the picture. For Mullican, the importance of this play of opposites on the field of landscape is particularly evident in *The Dallas Project* (1987), his first large-scale representation of a city (or, as the artist puts it, "a model of a city").[5] The first eight panels of the work relate directly to the hypnosis performances, representing the spiritual world and the artist's place within it. They include specific references to heaven, God, life, fate, demons and angels, death and hell.[6] Additional sections designate other areas of Mullican's "world": "History," "Language and Symbols," "Arts/ The World Framed," "The World Unframed/The City." It is in the latter section that Mullican's strategy for entering (and picturing) a three-dimensional space becomes apparent.

The vantage point that Mullican adopts for this city is a kind of bird's-eye view of an industrial landscape. Yet, for all of its specificity — churches, office buildings, and other recognizable building types appear — this city is more generic than specific. Above all, the notion of a shifting vision is of foremost significance. This city is both recognizable and impossible to locate. Appropriately enough, in this representation, the living units and public spaces are situated beneath the city, taking part in the organic life above, yet physically separated from it.

The Viewer and the City: A Cinematic Diversion

One way of analyzing Mullican's representation of space is to compare it to that of the cinema. Two examples will suffice to illustrate the shared notion of entering into a picture: In his essay, "The Primal Scene of the Cinema: Four Fragments from the Mistress of Atlantis (1932)," Karl Sierek draws attention to a curious shifting of points of view in this G. W. Pabst film.[7] He describes a scene that begins with the hero looking through a barred window, watching an encounter between the woman he loves and his rival. As the spectator looks through the bars, the shot is clearly positioned as a point of view. Yet, at a certain

3 Bob Riley. Program notes for a performance by Matt Mullican at the Institute of Contemporary Art, Boston, 1983.

4 G. K. Chesterton, in Sacks, 64.

5 Interview with the author, July 1989.

6 Descriptions of the panels are drawn from conversations with the artist, the Dallas Museum of Art brochure, and Nancy Princenthal's catalogue essay that accompanied the exhibition of the second version of this work in the United States.

7 From Eric Rentschler, ed., *The Films of G. W. Pabst: An Extraterritorial Cinema* (New Jersey: Rutgers University Press, 1990).

2

3

4

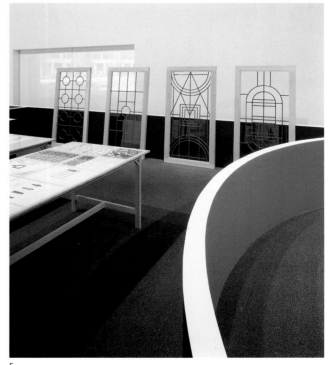

5

moment, the rival leaves the room (and the frame), and the hero enters, thus becoming the object of his own gaze.

What occurs in this sequence is a literal passing from subjective to objective, as the viewer/subject steps out of his own point of view and into the frame of reference he has defined. In addition, beside the literal acting out of stepping into the picture, the sequence bears an uncanny resemblance to a state of hypnosis (and analysis), where the subject may also be called upon to look at himself. Freud's combination of the involuntary and the deliberate also comes into play, in the attempt to both establish and abdicate an omniscient view.

A second, more general, example may be found in the films of Yasujiro Ozu, which are characterized by a consistent movement through space without the benefit of a moving camera. Ozu's films often open with, and are interspersed with, static shots of the urban landscape. These shots both frame and expand the narrative that drives the film. Taken together with the way the director uses perfectly matched cuts to move through domestic interiors, they posit motion and difference as subjective processes. Ozu's films seem incredibly fluid. Examined more closely, they are an elaborate series of fixed points.

A Spatial Inventory

Filmic conceptions of space and position, sleep and dreams, hypnosis, memory — all are methods of "entering the picture." And all are valid ways of describing Mullican's conception of the city and the inner landscape. In *The MIT Project* (1990), it is the process of description itself, played out within a three-dimensional, walk-through version of the artist's five worlds, which informs the piece. Encompassing a virtual inventory of personal and objective references, the work is "an attempt to do what the Dallas piece did — to talk about the concerns of my work, from the material to the symbolic, to the subjective, to the cosmological — but to do it all via a real place."[8]

Each of the five areas, except for that colored red and designated as "history," is filled with objects that refer to the personal world of the artist and the outside world he is trying to describe. Yet, there is a disjunction in the choice of objects assembled here: the use of the name MULLICAN; the integration of personal objects, such as clothing and bulletin board photos; the self-referentiality of certain works. All of these point to the individual's attempt to construct a picture, a space. Yet other objects clearly represent a more distanced view, an attempt to describe this environment through certain properties: bones and eggs collected from a local museum, generators, reproductions from encyclopedias, and more. This three-dimensional landscape, which one literally walks through, is based on a continual realignment of the spectator's vantage point.

If this is the "world in which the artist would like to wander" (Chesterton), it is one that is extremely malleable. It is not surprising that this project would lead Mullican to the world of computer imaging and virtual reality, where the notions of control and lack of control substitute for the realms of the subjective and objective.

A Model Project

> Whoever reflects on four things, it were better he had never been born: that which is above, that which is below, that which is before, and that which is after.[9]
> —*Mishnah, Hagigah 2:1*

Mullican's project for *Landscape as Metaphor* is a plywood structure that, like *The Dallas Project* and *The MIT Project*, functions as a model that the spectator can physically traverse. Yet, while those two pieces invited the viewer to distinguish between Mullican's various "worlds," the current project takes on many more physical characteristics. Like the concrete model he exhibited in 1990 at Le Magasin in Grenoble, it is, according to the artist, "a map in space." Here, Mullican extends the notion of entering into a space by making the various zones and their interdependence tangible and tactile.

In a sense, the wooden model brings the artist's concern with landscape full circle. In *The Dallas Project*, an interior landscape was represented from a distance, from a vantage point that

8 Interview with the author, July 1989.

9 Quoted in Umberto Eco, *Foucault's Pendulum* (Harcourt, Brace, Jovanovich, 1989), 235.

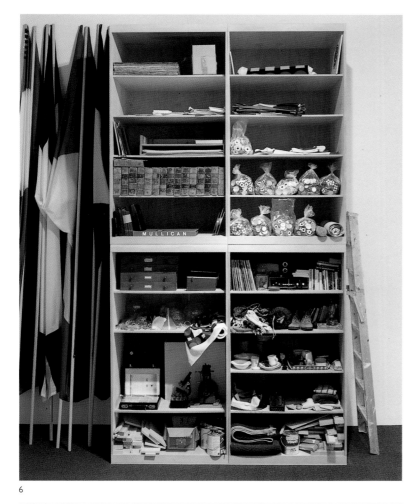

6

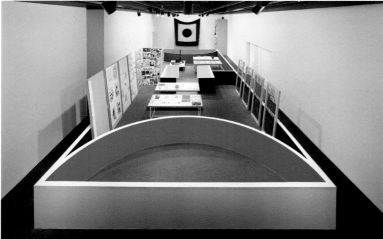

7

seemed intent on reproducing that space for an objective viewer. The fact that the individual panels were rubbings, literally taken from another image, further emphasized the notion of reproduction.

Once the artist moved to a more sculptural, three-dimensional space, however, the distant, objective tone of the work was replaced by a move toward a tangible reality. In these models—both concrete and wood—we inhabit the space, making its abstract surface into a real place, corresponding to the artist's worlds. This is where Mullican's conception of landscape seems most striking: mapping out a world, element by element, through an extraordinary succession of media, he has succeeded in translating that space into recognizable spheres. Now that we know the parameters, now that the map is firmly in hand, we are free to explore what is inside. These works are not just models of representation. They are models of perception as well. Mullican dares to reflect on elements of space that we take for granted — above, below, before, and after — and invites us to do the same.

MICHAEL TARANTINO is an independent curator and writer living in Brussels. From 1982–1988, while living in Boston, he was the director of the New Works Program for the Massachusetts Council for the Arts. Among recent exhibitions he has curated are *Repetition/Transformation* for the Centro Reina Sofia, Madrid (1992) and, a selection of paintings by Julião Sarmento for the Centro de Arte Moderna, Lisbon (1993). He is currently preparing an exhibition of the work of Jenny Holzer, Matt Mullican, and Lawrence Weiner for the Lenbachhaus Städtische Galerie in Munich and the Castello di Rivoli outside Turin. Mr. Tarantino contributes regularly to *Artforum*.

JUDY PFAFF

JOHN YAU

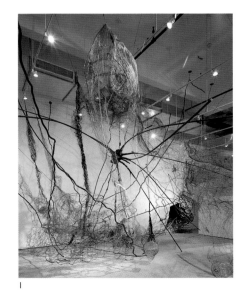

1

Judy Pfaff first hit her stride in the mid- to late-1970s, a period of abundant innovation in which artists as diverse as Gordon Matta-Clark, Lynda Benglis, and Richard Tuttle successfully broke through the constraints of minimalism and redefined existing artistic practices. While Pfaff is one of the artists who found a way to challenge the austerities and literalism associated with minimalism and conceptual art, what distinguishes her from her peers is that, of them all, she is the most difficult to categorize. Pfaff is neither painter nor sculptor, but an inclusive artist who uses materials and processes associated with both. She is an artist whose work has ranged from temporary site-specific installations to large, expansive pieces that are permanently attached to a wall. Finally, unlike many artists of the post-minimalist generation, Pfaff has never settled into the use of a particular material or process. One doesn't think of her as working only in fiberglass or bronze, for example. One doesn't even think of her work as falling into a particular period when she worked in a single material or utilized only one process. Instead, she is an artist whose work slips in and out of every category, making such distinctions irrelevant.

Thus, Pfaff is a postmodern artist, someone whose work challenges the convenient modernist categories as definitively as did Jasper Johns when he made his "flags" and "targets" in the late 1950s. Pfaff's and Johns's differences are generational. Johns emerged in the shadow of the Abstract Expressionists. His elusive work, impossible to categorize, temporarily halted the calcification that had started to set into painting, particularly after Jackson Pollock's untimely death in 1956 and the increasing prominence of formalist critics such as Clement Greenberg and his followers, Michael Fried and Rosalind Krauss. Pfaff's work became known after minimalist sculpture and painting, much of which was based on a misreading of Johns's work, as well as on the formalists' puritanical encoding of the work of such Abstract Expressionists as Barnett Newman, Mark Rothko, and Ad Reinhardt. As in the mid-1950s, the art world of the 1970s had started to implode, and art making had been reduced to a few predictable possibilities. Thus, the parallel that may be drawn between Johns and Pfaff is that they defined their approaches to the making of art at times when much of the art world and its practices had been influenced by the proscriptive attitudes of critics.

1 JUDY PFAFF **CORPO ONBROSO** 1993, installation at the Rotunda Gallery, Brooklyn, New York, steel, wood, fiberglass, glass, tar, plaster, cables and pulleys, variable dimensions, 30 x 20 x 18 feet, courtesy the artist

2 JUDY PFAFF **DEEPWATER** 1980, installation at the Holly Solomon Gallery, wood, rattan, oil and acrylic paint, woven wire, plastic, 60 x 25 x 12 feet, courtesy the

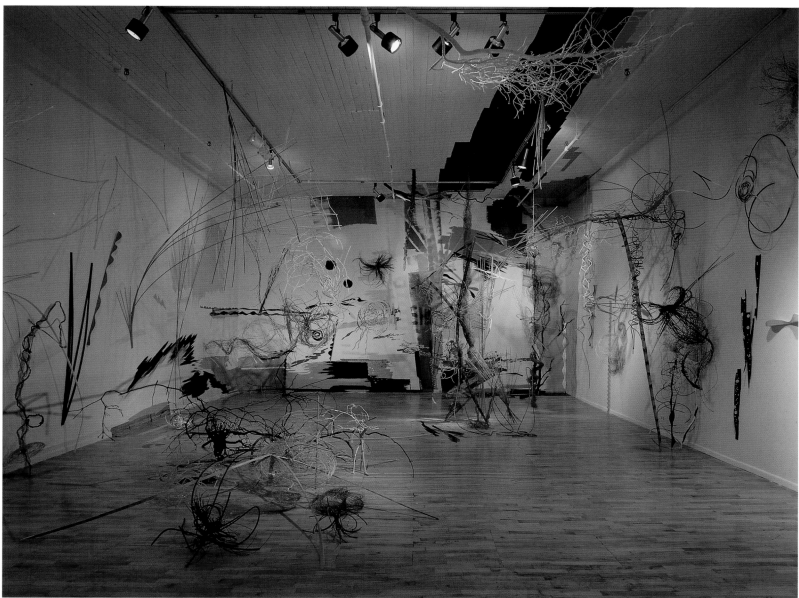

2

3

4

In *Deepwater* (1980), one of Pfaff's early important installations, the artist turned the large white rectangular box of Holly Solomon's downtown gallery into a cacophonous environment—reminiscent of Kurt Schwitters's series Hanover Merzbau (1923–1943)—that permitted the viewer to move through, in and around, while surrounded by diverse shapes and bright colors. The thin sticklike forms, which seemed to be turning somersaults from the wall, were warm pink, pale lemon yellow, and bright red. A dense mesh hung in midair, in apparent defiance of gravity. Other elements and clusters rose up from the floor or cascaded from the ceiling. The walls were streaked with thick strokes of red, blue, and black paint. In contrast to much of the art of an earlier generation, the viewer neither stood and looked at a monochrome or brightly striped surface nor walked around and examined a mysterious or obdurate object. Rather, one moved through a room; one became immersed. As Pfaff herself said later, "*Deepwater* was not planned from one position; one of the pleasures of doing the piece was that I had to work all around. The piece only works if there is not one view or focus that is the 'right' one; you have to experience it."

Deepwater disoriented the viewer, and evoked the sensation of being underwater and, at the same time, of walking on city streets. It was as if two worlds had merged, bringing together the pleasure of skin diving or snorkeling and the bracing visual assault of a complex urban center. This duality is one of the central features of Pfaff's work. It makes the viewer feel simultaneously calm and perplexed. This state, at once sensual and disquieting, is underscored by Pfaff's ability to shift the visual and physical markers we associate with gravity. In this work, all kinds of things seemed to be floating, rising, sinking, and cantilevering through the air.

From *Deepwater* through recent works such as *Corpo Onbroso* (1993), Pfaff has consistently demonstrated an interest in landscape as a realm of conflicting and contrasting experiences, rather than as a stable and secure place. Pfaff's works embody fluidity, interacting realities where no single point of view, thing, or language, dominates. And in doing so, they parallel as well as evoke the different interconnected layers of perception that astronomers, biologists, and physicists have utilized in order to construct inclusive models of the universe we inhabit. One could say that for Pfaff, as well as for these theoretical scientists, no one

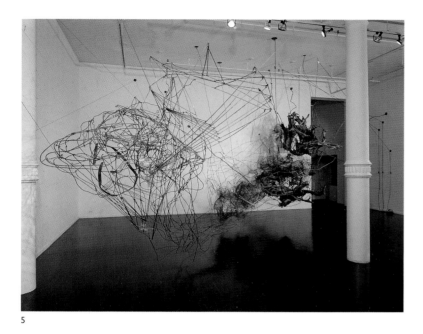

5

language or code supersedes all others. The complexity of our constantly changing world demands an intricate, yet useful and efficient, language that can simultaneously conjure and explain its variousness.

In the mid-1980s, Pfaff redefined her working method, and moved from making temporary, site-specific installations to constructing permanent pieces that are affixed to walls. This move may have been prompted in part by Pfaff's awareness that the materials she used in her installations were ultimately thrown away. Pfaff's decision to change her practice and make permanent pieces undoubtedly resulted in part from her concerns about the effects of waste on the environment. The issue of waste and plenitude, particularly in a society dedicated to the production of the new, is one of the subjects Pfaff began tackling in her work during the mid-1980s, a decade notable for its material greed and dissipation. Typically, things such as garden chairs, street signs, wire and metal rods of different thicknesses, plastic reflectors and hollow tubes, are thought to be replaceable items; they are impermanent, manufactured things, meant to serve a temporary function. However, if Pfaff had continued to use such things in ephemeral installations, she would, in effect, have been contributing to the cycle of needless waste that characterizes our post-industrial society.

Between 1984, when Pfaff made *Badlands (Frio)* and *Badlands (Caldo)*, and 1992, when she made *Flusso é Riflusso*, both her work and thinking seemed to migrate between poles of abundance and asceticism, and between evocations of place and abstract models of a reality invisible to the naked eye. Further, the viewer no longer moved in and through the work. For Pfaff, who had expressed her desire to make works in which no single point of view is dominant, this change meant that she had to create works that in their stillness implied both jarring and fluid movements.

In *The Snail* (1990), for example, Pfaff used rods and wire to construct an undulating horizontal tunnel-like form made of sections that fit smoothly together, like the mollusk's spiral shell. Within this hollow, three-dimensional structure, Pfaff placed different abstract forms, such as striped metal disks, semi-transparent plastic disks, and ribbonlike pieces of metal. These pieces echo the circularity of the hollow structure, as well as interrupt its curving, linear flow.

At one end of *The Snail*, protruding three-dimensional cones, made of metal rods, recall a snail's feelers. And yet, while the viewer may make this association, *The Snail* is not a visual replication of a mollusk. Rather, *The Snail* embodies various phenomena of sight and physicality that the viewer can connect to the actual experience of a snail, and more. For example, circles and spirals, forms that have long been central to Pfaff's lexicon, are inherent in many of nature's forms and in planetary orbits. Thus, one suspects that for Pfaff, the snail was simply a departure point. Its physical form provoked an investigation into a variety of realms of perception, experience, and memory.

The spiral and circle suggest both constant movement and perfect stillness; and in Pfaff's works, they often function as both physical presences and visual stimuli. They can be planar metal disks or lines effortlessly unfolding through space. A curving loop, which might be defined as a distorted or distended spiral, may seem like a liquid form that sight has stilled, like something whose motion has been frozen by a high-speed photograph. Underlying all of these abstract forms and suggestions of movement is the artist's recognition that the world is undergoing constant change.

Philosophically, Pfaff is a descendant of Heraclitus, who believed the world is in constant flux, rather than of either Plato, who proposed that there are ideal forms that exist beyond the realm of our perception, or of Aristotle, who believed the world

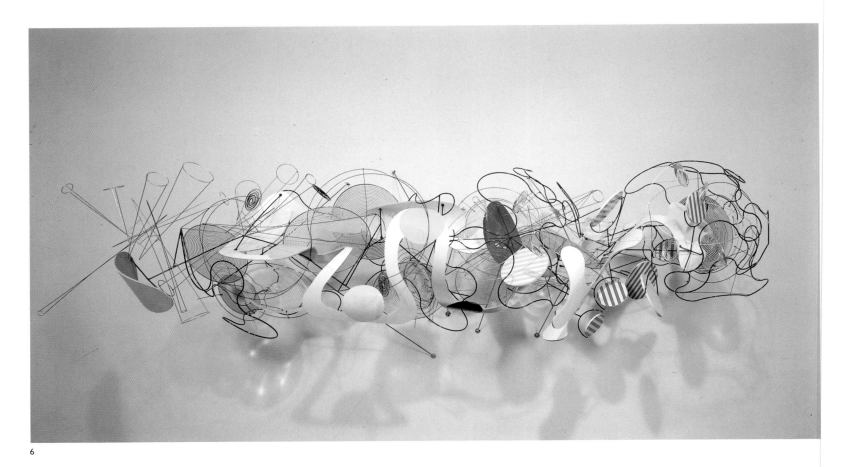

6

could be divided into discrete groups or classifications. Pfaff's decidedly nonidealizing, nontypifying understanding of experience explains in part why her work defies categorization. Once again we might recall the work of Jasper Johns, who said that he chose objects because they were "things which are seen, but not looked at, not examined."

There is a current of optimism that informs all of Pfaff's work, and in this regard it can be seen as very American. In works such as *N.Y.C.–B.Q.E.* (1987), the artist incorporated a wide range of things (black-and-yellow striped metal circles, letters, numbers, and a faux-brick wall, among others) to evoke a highway going through various neighborhoods and industrial zones of Brooklyn and Queens. In contrast to *Deepwater,* which evoked a natural and self-replenishing realm, *N.Y.C.–B.Q.E.* conveyed the speed with which a commuter can see the world flashing by, as well as a

decaying urban landscape, a place of constant waste.

By incorporating things we associate with this specific area of passage, Pfaff reminds us that we don't actually experience them as physical and visual objects. Rather, the letters, numbers, and traffic fixtures are signs to be decoded and obeyed. We decipher the world we inhabit rather than participate in it. And as decipherers, we are outside the world instead of in it. As in *Deepwater,* in *N.Y.C.–B.Q.E.,* the artist attempts to immerse viewers in experience, to make them aware of it as something more engaging than a set of signs and codes. Like a passionate lover, Pfaff offers us the possibility that the world is both pleasurable and disorienting, that it is constantly seen and experienced anew.

Pfaff's ability to convey a vision of a world that is continually metamorphosing connects her not only to Jasper Johns, but also to someone who influenced him: John Cage. In *4′33″,* perhaps his

most notorious composition, Cage wrote a score made up of various lengths of silence. Even though the piece is meant to occur within a period of four minutes and thirty-three seconds, it always takes longer than that to be played. Although *4′33″* is silent, the listener doesn't hear silence. Rather, the audience hears itself hearing the place it inhabits, the place where "silence" is being played. *4′33″* is a piece that can never be heard the same way twice. It neither adheres to an ideal nor can there be an ideal presentation of it. It turns our attention to the world we inhabit and makes us hear it anew; it re-presents sound. It points us to that which is constant and changing about the world. This is what Pfaff does in her art; she makes us redirect our attention.

In *Deepwater* and in *Corpo Onbroso*, which, like *Deepwater,* was a temporary site-specific installation, Pfaff evokes strong associations with the ocean floor. Among other things, *Corpo Onbroso* is made of metal pipe, wire mesh, and blown glass. Installed in the public space of the Rotunda Gallery in Brooklyn—a high-ceilinged room with a balcony walkway—the viewer was able to see *Corpo Onbroso* from above as well as walk through it. In this work, industrial detritus merged with the world beneath the ocean. However, the place we entered was a metaphor for our consciousness, rather than a literal presentation of an actual place—where we must go inside ourselves to get rid of our habits and experience. Pfaff now possesses a far wider range of formal possibilities than she did in the late 1970s and early 1980s. *Corpo Onbroso* was a three-dimensional drawing, a sculptural object, and an environment. As in much of her work since the mid-1980s, it included found objects, prefabricated objects, and elements made specifically for it. This blending of diverse materials echoed both natural and constructed landscapes, and reminded us that there is no pure or untainted place in the world. Pfaff understands that when we look at the world, we are constructing it. This is a key aspect of her interaction with her materials and her environment. One senses in her embrace of diverse materials and processes her desire that human beings not only learn to see the world anew, but that they also consider other ways to use and reuse what is around them.

Although some critics might see Pfaff as returning to an earlier mode, it is also possible to see this recent, site-specific installation as fitting into the cycle of migration that characterizes her career, her ongoing movement between the poles of seemingly

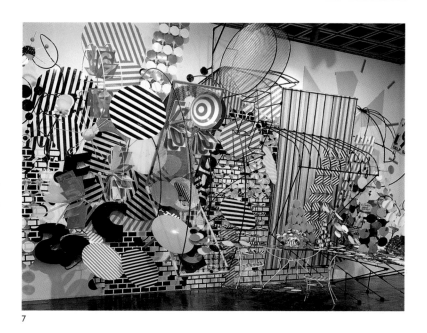

7

abstract and seemingly representational works, and between sensual excess and cool austerity.

There is no telling exactly what Pfaff will do next, only that she will continue to excite her viewers' imaginations, as well as challenge their habits of perception and understanding. Certainly a work such as *Corpo Onbroso* suggests that Pfaff has picked up a thread running through her work: a temporary installation and the possibility of pieces that change each time they are installed.

JOHN YAU is a poet, critic, and curator. His recent books include, *A.R. Penck* (Abrams, 1993), *In the Realm of Appearances: The Art of Andy Warhol* (Ecco Press, 1993), and *Edificio Sayonara* (Black Sparrow Press, 1992). He is currently organizing a retrospective exhibition of paintings by Ed Moses, for the Museum of Contemporary Art, Los Angeles.

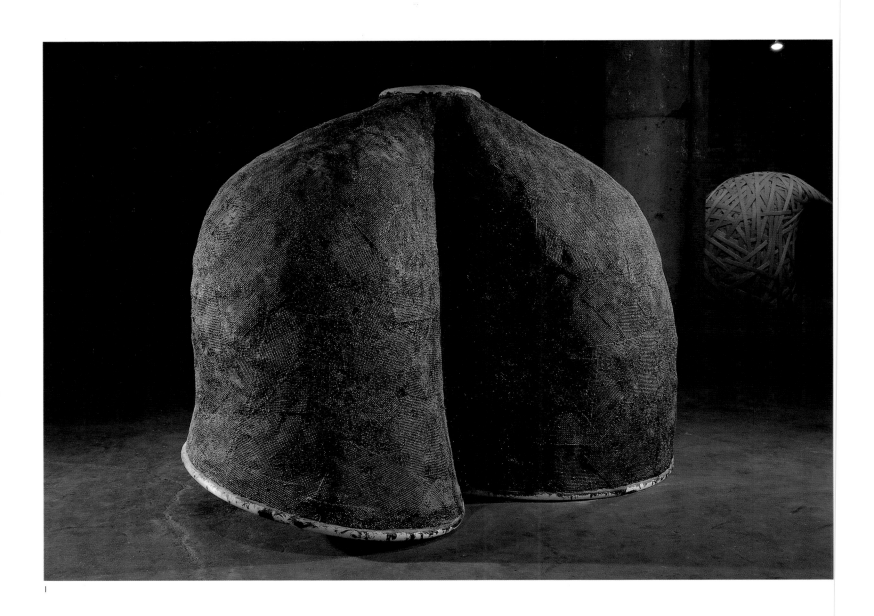

1

MARTIN PURYEAR

ADAM D. WEINBERG

Leaves are not more shed from the trees,
or trees from the earth,
than they are shed out of you.
　　　　　—Walt Whitman

1　E.L.D. Seymour, ed., *The New Garden Encyclopedia* (New York: Wm. H. Wise and Company, 1946), 1242.

2　Interview with the author, 29 January 1993.

MARTIN PURYEAR (b. 1941, lives in Accord, New York) draws heavily upon natural forms, such as trees, seed pods, rocks, mountains, and other land forms to create sculpture strongly evocative of nature's evolutionary processes. His imagery is a subjective synthesis of organic shapes. In addition, many of his works are related to tribal and folk architecture. His ambiguous forms simultaneously allude to both the man-made world and nature, and such subthemes as metamorphosis and transformation echo throughout his sculptures. Puryear has had one-person exhibitions at the Corcoran Gallery of Art, Washington, D.C. (1977); the Museum of Contemporary Art, Chicago, Illinois (1980); the Joslyn Art Museum, Omaha, Nebraska (1980); the Museum of Fine Arts, Boston, Massachusetts (1990); and the Art Institute of Chicago, Illinois (1991). His sculpures have been included in *Sculpture Inside Outside* (1988), Walker Art Center, Minneapolis, Minnesota; *1989 Whitney Biennial*, Whitney Museum of American Art, New York, New York; and, *Dokumenta 1992*, Kassel, Germany.

A small deciduous tree is cut down. The tree, perhaps twenty feet tall, is suspended upside down from a giant bipod structure, so that the network of branches approach the ground. People can freely circulate around this natural anomaly to examine the delicate, leafless stalks. As they move around the branches, their first thought might be that they are looking at the root structure of a tree that has been uprooted. The experience is a rather vertiginous one. We expect roots to be below ground and the branches to be above, yet these roots are at eye level, emphasizing the zone in which one moves and interacts. The branch system is in a netherworld, between zones, creating a sense of limbo.

One walks *through* a forest, *by* a grove of trees. Trunks are objects, poles as it were, easily ignored unless they are massive or have remarkable form. One unthinkingly treads *over* the roots of trees and looks up at branches. What typically signifies "tree" is its most spectacular aspect, the form made by its branches. For a tree, as it is defined "in a strict sense, is a woody plant with a single stem or trunk, usually to a height of ten feet but crowned at the top with spreading branches."[1] The artist, Martin Puryear, has placed the tree in our path so that we can't avoid being confronted by the part of the tree that is its glory.

When one looks at a tree one is cognizant of a series of relationships: the branch system to the trunk, the leaves to the branches, the intervals between branches, the branches and leaves to the sky. There is also the viewer's relationship to the tree's height and girth. These relationships themselves are always changing depending on the viewer's position in relation to the tree. Martin Puryear's work for *Landscape as Metaphor* plays on these deceptively simple relationships in order to heighten our experience of and encourage our reconsideration of the concept of "tree." It questions our experience of a tree in nature, its correspondence to an archetypal, platonic notion of "treeness" in its ideal form. The piece also causes a shift in our perception of nature and most significantly a change in the perception of ourselves.

This work, addressing the idea of landscape, is atypical for Puryear. The artist has said, "my work is not about landscape as such. I am an object maker."[2] In fact, although his works are largely made from a variety of woods and other natural materials and call to mind a range of associations with nature, from falcons

2

m.P.

to whales to gourds, they do not directly deal with the notion of landscape. His sculptures, by and large, are discrete entities that sit on the floor or hang and lean on the wall. They are not views, nor for the most part do they propose them. Puryear's sculptures are typically ambiguous metaphorical objects that suggest culturally derived artifacts, from baskets to boats to burial mounds, which are as specific in their sources as they are in their forms. Puryear, who has spent extended periods in Sierra Leone, Sweden, and France, as well as various regions of North America, is purposely, but intuitively, eclectic. The work for this exhibition, however, is an artifact with few, if any, cultural associations.

Yet, in certain of Puryear's objects the sense of landscape does intrude. Over the years he has created what may be described as a series of shelters, among them *Cedar Lodge* (1977), *Sanctum* (1985), and *Where the Heart Is* (1990). These works suggest the idea of protection from the elements and also imply landscape, in that they are based on yurts (structures used by nomadic cultures in central Asia). With such temporary structures there is the allusion to movement over terrain and the mental association with the idea of landscape. Another early work, *Some Tales* (1975–1977), consists of a group of seven linear wooden elements arranged horizontally on the wall. They support, among other readings, in both visual and symbolic terms, a variety of

horizon lines. These calligraphic elements can be seen as shorthand notations for various types of terrain: valleys, ridges, plains, and water. Puryear's *Some Lines for Jim Beckwourth* (1978), a twenty-three-foot-long piece, consists of seven parallel, equidistantly spaced lines of twisted rawhide affixed horizontally to the wall. This piece, as well as a later version entitled *Equation for Jim Beckwourth* (1980), which includes the additional elements of a rawhide cone, several saplings, and a cone made of earth, pitch pine, and oak, visually connote a landscape. The above mentioned works, however, merely propose landscape in an abstract manner and not in a physical and visceral sense, as in the current work.

It is Puryear's several outdoor works that set the precedent for his installation in *Landscape as Metaphor*. Foremost among these is *Bodark Arc* (1982), his most literal transcription of landscape. The primary feature of this work, created at the Nathan Manilow Sculpture Park, is a 392–foot semicircular foot path in the shape of a bow. (Its form is only discernible from a bird's-eye view.) The work includes two other relatively simple and unassuming elements: a wooden arch fashioned from two upright posts and a bowed lintel, and a bronze chair (its shape derived from a West African chieftain's chair) with a similar, bow-shaped back support. The gate is placed at the head of a radial path bisecting the arc at ninety degrees, and the chair is sited at the far end, at what would be the center of the circle.

Bodark Arc, in the tradition of 1960s minimalism, realigns the relation between viewer and work by emphasizing the creation of an experience as opposed to a sculptural object. (Even the chair and arch are functional objects and not sculpture in the traditional sense.) The surrounding landscape, which is a microcosmic ecosystem, including a swamp, a pond, and a woods, has only been slightly modified. *Bodark Arc* treads the middle ground between nature trail and aesthetic experience. The movement and positioning of the viewer is the essence of the piece. Puryear reaffirms the viewer's ground-level relationship to nature. He has prescribed a directional path through nature over the flat surface of a modest landscape, lacking dramatic lookouts or precipices. He has created a continuous series of viewpoints subtly and unobtrusively determined by the geometry of the path. *Bodark Arc* is a meditation on the nature of, and distinction between, sculpture and space, sight and experience. It places the viewer in

3 MARTIN PURYEAR **BODARK ARC** 1982, wood, asphalt and bronze, 196 foot radius, collection Nathan Manilow Sculpture Park, Governors State University, University Park, Illinois

4 MARTIN PURYEAR **PAVILION IN THE TREES** 1993, Western red cedar, white oak, and redwood, 35 feet high, walkway 60 feet long, platform 16 feet square, 24 feet above ground plane, courtesy Fairmont Park Art Association, collection Lansdown Glen, Horticulture Center, Philadelphia, Pennsylvania

3

4

the role of reenacting and—almost in a ritualistic manner—re-creating the work.

Pavilion in the Trees is a recently completed project that was proposed for a Philadelphia park in 1981. Its design consists of a long wood ramp leading to a gazebolike form elevated on stilts, reminiscent of a shelter such as *Home Is Where the Heart Is.* As the title suggests, the pavilion is in the trees, situated among the branches. Similar to *Bodark Arc,* the work defines a course. The process of climbing up the ramp and moving over the ground affirms the idea of landscape, that is, the viewer's relationship to that essential feature of the landscape—the horizon. One is in and looking at the landscape simultaneously. Such a structure, in the spirit of a nineteenth-century architectural folly, is a diversionary work; the ramp is to be strolled on in a leisurely fashion and one is supposed to linger in the pavilion. Thus, as one ascends the ramp, gazing out over the railings and looking down through the cracks between the boards, one's connection to the ground is gradually shifted.

As with the work in *Landscape as Metaphor,* the artist is changing the viewer's position in relation to the trees. In *Pavilion,* however, the viewer is in quite the opposite position from the current work. The trees are unmodified, as they exist in nature. The changes that occur are those that might happen naturally, created by the season, weather, or time of day. The viewer has been literally elevated to provide a shift of perspective. In the current work, the artist, with a light-hearted twist, has conjured an impossible sight, a sight from below ground, such as one might find in a natural history museum diorama (minus soil, animals, and insects). Nonetheless, in *Pavilion,* Puryear means to create a similar distortion, albeit in a different way. The gazebolike form is intended to be set in a bowl-like hollow so that the platform, from a distance, would appear to be at ground level.

In this manner, the artist places the viewer/participant simultaneously on the ground—as seen from a distance by another person—and above it. This equivocal space is similar to the ambiguity posed by the current work. A tension is created by actual experience, and the abstract mental knowledge of where one imagines oneself to be. The landscape of *Pavilion* is the landscape itself. The landscape of the work in *Landscape as Metaphor*

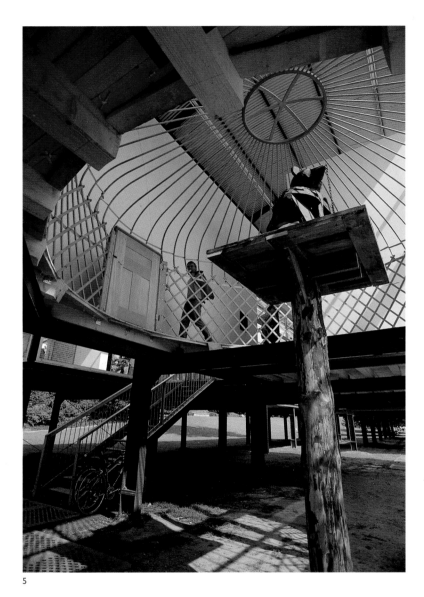

5

3 *Documenta IX,* 13 June–20
September 1992 (Stuttgart:
Edition Cantz; in association
with Harry N. Abrams, Inc.),
442.

is situated somewhere between those works that are more strictly speaking objects, and *Bodark Arc* and *Pavilion*, which present landscape as movement through space.

In this discussion, Puryear's recent installation for *Documenta IX* (1992) is particularly pertinent. As described by the artist: "The work consisted of a yurt frame enclosing a wooden platform mounted on a pole. The pole was set into the earth beneath the pavilion extending up into the yurt so that the platform was about 50 centimeters above the pavilion floor. A wooden sculpture sat on the platform. I needed to have the pavilion floor cut away inside the yurt . . . so that the yurt enclosed 'outdoor space,' and one could look down through the yurt frame and see the earth below." [3] As with his work for *Landscape as Metaphor* the literal relationship between figure and ground is all important. Inside the *Documenta* pavilion, the viewer saw the sculpture from a narrow walkway around a raised platform. It was this viewing level that seemed to establish the ground level. Yet seeing the earth below from the platform, in combination with the precariousness of the viewing space, was a rather disorienting experience that distorted one's sense of the "true" ground level. The viewer was neither indoors nor outdoors, neither on the first story nor on the ground. This work, like *Bodark Arc* and *Pavilion*, was as prescriptive as it was descriptive. It prescribed *how* one has the experience as much as it described *what* one sees.

Oddly enough it is one of Puryear's first outdoor sculptures, *Box and Pole* (1977), a temporary installation created for New York State's Artpark, which perhaps has the most instructive relationship to the work in this exhibition. That work and the current one alone in Puryear's oeuvre maintain the basic form of the tree. However, the current work is essentially the crown of a tree without much of a trunk, while the pole element of *Box and Pole* is primarily trunk (in fact two trunks fitted together) without crown. *Box and Pole* consisted of two elements isolated in an empty field: a 100-foot-high southern yellow pine, shorn of limbs and bark, situated next to a compact fifty-four-square-inch box made of carefully fitted wooden beams. As with the sawhorse form in the current work, the artist contrasts the natural form of the tree with a constructed form—the box. Also, by stripping the piece—literally and figuratively—down to essential forms, he has made of the pole and box objects that cannot be casually passed by. Despite their similarities, *Box and Pole* emphasizes

6

everything that the current work does not: its geometry, its linearity, and its height. In searching for the crown of the tree, one sees only trunk extending into space. Yet, the trunk (pole), so easily ignored as one passes by a tree, cannot be disregarded here. Both works, almost twenty years apart, are ruminations on "treeness," on wood, its origins and uses. The questions these works pose are crucial because so much of Puryear's work is made of wood and, for him, the confrontation and communion with material represents a confrontation with self (as a 1978 sculpture bearing the title *Self* attests).

* * *

The work in *Landscape as Metaphor* can also support another, more narrative, reading. The tree suspended helplessly upside down (uprooted or cut down depending on how one looks at it) is like a hapless animal caught, killed, and displayed like a trophy. The scaffold suggests a gallows. Instead of a person hanging, it's a tree. The tree, out of its natural habitat—safely under the ground or

majestically above it—is a specimen that has been collected. It suggests humankind's capacity to control and dominate nature. However, the tree's exquisite natural form alludes to nature's persistent power in real and symbolic terms despite the potential interventions, natural or man-made, that might occur.

Puryear's work, nevertheless, does not simply posit a dualistic opposition to nature. In his art there is a triadic relationship between the artist as an individual creative force, culture as it is manifested in the artifacts and structures he fashions, and nature as it affects and is modified by both. Puryear's work acknowledges and hearkens back to early industrial forms—levers, gears, pulleys, wheels, and scaffolds—not nostalgically, but as a way of hinting at a more organic, symbiotic relationship between nature and technology. His art seems to suggest that in present-day society something has been lost, not only in terms of skills and craft, but in terms of understanding and solving problems. Merely seeing things in binary opposites is limiting, not enlarging. His works defy simplistic contradictions and suggest that we are only constrained by our lack of imagination and inventiveness. And in order to expand the field of possibilities, which are restricted artificially by marketplace and standardization, one must return to nature (without denying the technological), and rely on one's own creative process. To quote Brancusi, "nothing can grow in the shadow of great trees."[4]

4 Sidney Geist, *Brancusi: A Study of the Sculpture* (New York: Grossman Publishers, 1968), 2.

ADAM D. WEINBERG is Curator of the Permanent Collection at the Whitney Museum of American Art, New York, and an associate curator of *Landscape as Metaphor*. He was formerly artistic and program director of the American Center, Paris, from 1990–1993. From 1989–1990 he was director of the Whitney Museum of American Art at the Equitable Center, New York, where he curated such exhibitions as *Contingent Realms: Four Sculptors* and *Aldo Crommelynck: Master Prints with American Artists*. From 1981–1989, Mr. Weinberg was director of education and assistant curator at the Walker Art Center, Minneapolis. While there he organized several exhibitions of photography, including: *Vanishing Presence* (1989), *Cross References: Sculpture into Photography* (1987), and *On the Line: The New Color Photojournalism* (1986).

EDWARD RUSCHA

JOHN BEARDSLEY

ED RUSCHA (b.1937, lives in Venice, California). Although he began his career in the early 1960s with posteresque, deadpan evocations of Americana, ranging from highway gas stations to other icons of instant urban culture, his paintings in recent years have undergone drastic change. His recent landscapes, in particular, are about the anonymity and isolation of much of America today. They often consist of somber, silhouetted images of houses and trees, in which even suburbia takes on a brooding, ominous cast. Ruscha's work has been included in many group exhibitions and he has had numerous solo exhibitions, among them are those recently organized by the Williams College Museum of Art, Williamstown, Massachusetts (1988); Tokyo Museum of Contemporary Art, Japan (1989); the Musée National d'Art Moderne, Centre Georges Pompidou, Paris, France (1990); Fundacio Caixa de Pensions, Barcelona, Spain (1990); Whitney Museum of American Art, New York, New York (1990); and, The Museum of Contemporary Art, Los Angeles, California (1991).

Pick a painting, any painting, from the past decade by Ed Ruscha and try to describe what you see. On the face of it, this should be a simple task: typically, you see a word or a group of words floating against a square or horizontal field, which is often divided laterally to suggest a horizon. But look a little longer and your confidence begins to wane. Things are never quite what they seem in Ruscha's work. The words aren't always there and, when they are, they are often the source of an arresting paradox: they are immediately legible, but their precise meanings are not always comprehensible. Simple words become ciphers. The visual field can be equally perplexing. It might be ground or sky, but it might also be some indeterminate, shadowy place; it may or may not seem to have any connection to the superimposed legend. Neither description nor interpretation, you quickly realize, will be as easy as you first imagined.

I'll select *Where Are You Going, Man? (For Sam Doyle)* (1985), and wrestle with it for a moment. A dark field is divided by horizontal bands of white spots that cluster especially along a couple of diagonals. One might be looking from the air at night down onto the gridded lights of a sprawling city. Above this image float the words "Wass a guin mon? U dig me?" The words were lifted from a painting by Sam Doyle, a self-taught, African-American artist who lived on St. Helena Island off the coast of South Carolina. They are in Gullah, an African-inflected dialect still heard in isolated communities on the Carolina sea islands. Translated by the artist as "where are you going, man?," they were chosen, Ruscha says, because he was "fascinated by the lingo." Paired with the image of a city at night, they raise all kinds of metaphorical possibilities. What have we wrought?, the artist might be asking us. Where are we going as a culture, as a nation? What unimaginable arc connects Gullah life with that of the late-twentieth-century metropolis? But then, again, Ruscha is a cunning artist. He might not be asking us anything of the kind. Maybe these are just words, confusing in their own right, and with no particular relevance to the image behind them. Perhaps they are simply put there for visual effect and to confuse the unwary. I'll bet on both. I'll bet the painting is both powerful metaphor and meaningless juxtaposition of image and text. Such is the slippery character of language, and Ruscha seems determined to test its capacities to describe and explain. U dig me?

1 EDWARD RUSCHA **WHERE ARE YOU GOING, MAN? DO YOU DIG ME? (FOR SAM DOYLE, FOLK ARTIST)** 1985, oil and enamel on canvas, 60 x 78 ½, collection the artist

2 EDWARD RUSCHA **ANNIE** 1962, oil on canvas, 67 x 72, private collection

1

2

But I'm exaggerating, it might be argued. I've chosen an anomalous painting, one in which the words are more perplexing than usual because they're in an unfamiliar dialect. Most of Ruscha's paintings that involve language use plain, unidiomatic, English words. And at the outset of Ruscha's painting career, they were often drawn from commercial sources and carried somewhat more obvious associations with popular culture. There was *Annie* (1962), for example, the name taken from the cartoon character and rendered in its signature typographic style; *Large Trademark with Eight Spotlights*, the emblem of the Twentieth-Century-Fox Film Corporation set off by searchlights; or *Hollywood* (1968), a rendition of the landmark sign in the eponymous hills, silhouetted against a vivid sundown sky. In their appropriation of the emblems of mass culture and in their assault on the distinctions between high and low, these paintings suggested a link to New York Pop Art, as in the work of Warhol or Lichtenstein. But they were rooted in the environment of Los Angeles, its particular architecture and commerce, and they were deeply literate. Even these paintings suggested the limbo between words and meanings: their names were just names, but they also managed to resonate with the dangerous allure of mass-marketed myths of success and glamour, of life at the end of the rainbow.

Of late, Ruscha has managed to demonstrate how elusive and arcane even unidiomatic speech can be. Take *Industrial Chemical* (1987), for instance, in which the abbreviations for these terms, rendered in orange, bracket a cross-hatched image that resembles the shadow of a mullioned window falling on a brilliant red surface. The terms themselves are anything but neutral. They put me in mind of Dwight Eisenhower's parting admonition to beware the power of the military-industrial complex. The lines between them are slightly splayed, as if cast by a raking light. Is this another disturbing metaphor, a suggestion of the long shadow that chemicals and industry, along with their potent and toxic by-products, cast over our lives? Ruscha acknowledges that, despite a "luscious base, yes, it's threatening." But he cautions against over interpretation. He was motivated here, at least in part, by "pictorial possibilities. It's not instructive." So is it a painting about compositional structure or about the dark side of the American dream? "It may be all or none of those things," Ruscha says enigmatically.

Ruscha has also played on the importance of words by signaling their absence. *Name, Address, Phone* (1986), for example,

3

shows a tree-lined suburban street with three white bands of diminishing size in front of three more-or-less identical houses. You could be anywhere—fill in the blanks, and you're in Short Hills or Shaker Heights. The dark, airbrushed silhouettes convey an idea of hollowness or banality but, again, don't assume you've got it figured out. "I don't share the attitude about the bleak suburb," Ruscha maintains. "I wanted to make black paintings. I wanted to get rid of brushstrokes. The silhouettes work as an image of fog, blackness, darkness. They're another way of putting the image on the surface."

Name, Address, Phone is just one of an increasing number of wordless pictures that Ruscha has been producing in recent years. Is the linguistic philosopher abandoning language? Maybe yes, maybe no. Although perhaps less well known than his word paintings, Ruscha has been creating such wordless compositions intermittently throughout his career. The celebrated image of the *Los Angeles County Museum on Fire*, (1965–1968) for example, or the 1977 painting of logs blazing in a red-brick fireplace floating in a brown field, called *No End to the Things Made out of Human Talk*. But even these pertained to discourse in their own ways: the one

perhaps an expression of ambiguous feelings about the authority of museums to construct and preserve our notions of culture; the other an allusion to the role of language in the creation of ideas about hearth and home.

Not withstanding the fact that there seem to be few certainties in Ruscha's painting, it is safe to say that landscape is important to him, especially as a formal device. "Most of my proportions are affected by the concept of the panorama," he told an interviewer.[1] "Like I say, I'm a victim of the horizontal line, and the landscape, which is almost one and the same to me." "The concept of the horizontal is basic to my work," he recently confirmed. "My eyes are horizontal, words and sentences are horizontal, my brushstrokes often have a horizontal pattern. So you can see landscape not only in works with an obvious ground line. You see it in all phases."

Ruscha's evocation of the panorama relates his work not only to the grand tradition of American landscape painting but to the popular precursor to the motion picture as well: the scroll paintings of the nineteenth century that depicted natural wonders such as scenery along the Mississippi River, which were gradually unrolled in front of a paying audience. The sweep of these panoramas was absorbed into the language of landscape cinematography, which provides perhaps a closer relative to Ruscha's imagery than nineteenth-century painting. Indeed, allusions to film abound in Ruscha's work. The paintings with words suggest opening titles and credits, while the duskiness of the black and white paintings recalls the atmosphere of *film noir*.

1 Ed Ruscha, in an interview with Bernard Blistene, et al., *Ed Ruscha : Paintings* (Rotterdam : Museum Boymans-van Beuningen and Los Angeles: Museum of Contemporary Art, 1990), 140. All other quotations are from an interview with the author, March 1993.

But Ruscha doesn't simply use landscape as a formal device. He plays on its epic associations as well. Whether in the silhouette of a covered wagon or in a technicolor sunset, his paintings often suggest a restless nation heading west toward the promised land. He acknowledges some element of autobiography in this. Born in Nebraska in 1937, he grew up in Oklahoma City. At age eighteen he struck out for California, hoping to become a cartoonist or commercial artist; he studied graphic design and commercial art at Chouinard Art Institute, Los Angeles, before deciding to become a painter. Because he knew the migratory experience from the inside, he could challenge its mythic proportions. In 1963 he created the first of fifteen photographic books (which he still considers among his most important creations); called *Twenty Six Gasoline Stations 1962,* it documented filling stations along the road between Oklahoma City and Los Angeles, a subject that would subsequently figure prominently in his painting as well. He followed this first book with *Some Los Angeles Apartments* (1965) and *Every Building on the Sunset Strip* (1966); these were decidedly unheroic pictures of commonplace but iconic structures, as representative of American life as any monument of civic or ecclesiastical architecture. Their deadpan style provided a precedent for conceptual art; it also found a parallel in Robert Smithson's similarly banal snapshots of the mundane environment of Passaic, New Jersey, ironically presented in his essay "A Tour of the Monuments of Passaic," in 1968.

Ruscha is as resolutely vague about the future directions of his work as he is about its past meanings. He talks about doing a series of works based on his experience of the desert of southern California, where he spends a good part of his time. He may or may not continue to use words, though one can hardly imagine that even without them he will drift far from the riddles of signification. And, he says, "I won't necessarily address world problems in my paintings," as if he could escape what has otherwise seemed to be his destiny. From landscape to language, Ruscha has traversed a great deal of important terrain in the course of exploring how the notions of culture are created and conveyed.

4

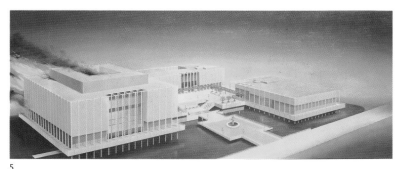

5

6

URSULA VON RYDINGSVARD

ADAM D. WEINBERG

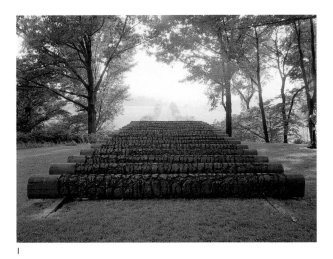

1

URSULA VON RYDINGSVARD (b.1942, lives in New York City) carves jagged, mountainous forms out of thick layers of laminated cedar that evoke primal landscapes and geological strata. The resulting wood forms, toned with graphite, evoke an ageless topography. Although she was born in Germany, the artist is descended from generations of Polish farmers, and in her first eight years her large family was moved from one detention camp to another. The impact of that experience left a powerful psychological imprint. At the same time, her ritualized working method reflects the spiritual underpinnings of her agrarian ancestry. Recently von Rydingsvard has had one-person exhibitions at the Cranbrook Academy of Art Museum, Bloomfield Hills, Michigan (1989); Capp Street Project, San Francisco, California (1990); The List Art Center, Brown University, Providence, Rhode Island (1991); and, Storm King Art Center, Mountainville, New York (1992).

At first glance one might assume that Ursula von Rydingsvard's sculptures, made exclusively of cedar and often suggesting natural forms, have everything to do with landscape. The works frequently resemble rock formations, canyons, and forests, and many bear titles such as *Lace Mountains* (1989) and *Land Rollers* (1992). The surfaces of her sculptures allude to the processes of nature, the action of climate—rain, heat, wind, and cold—and the intervention of insects, mammals, and birds that burrow, scratch, gnaw, and peck. Yet, the connection of von Rydingsvard's sculpture to landscape is, in fact, subtler than it may appear on the surface.

The cedar von Rydingsvard uses is delivered to her Brooklyn studio as 4×4s in lengths of fourteen, sixteen, and eighteen feet. For her, the wood is simply raw material, a malleable substance that can be assembled, hacked, and ground to yield a desired form. She is not interested in cedar for its own sake, its origin as a majestic tree in the Northwest, or its distinct fragrance. Nor does she discuss her use of cedar with fetishistic reverence. What appeals to von Rydingsvard about milled cedar, in addition to its pliability, is its relative neutrality, its unitary form, and its conceptual possibilities.

Land Rollers (1992), a site-specific work made for the Storm King Art Center in upstate New York, consists of seventeen loglike forms, each more than fourteen feet in length, loosely incised with concentric striations, and laid parallel to one another on a hilltop so as to create the effect of a platform extending into space. This work exemplifies how far removed, in the artist's mind, the lumber is from its source as a tree. Each of the beams in this piece could have more readily and simply been made using actual cedar trees shorn of their limbs and bark; instead, the artist chose to glue together sixteen 4 × 4s which she then shaped into logs. It is not the love of traditional craft nor the need to begin from scratch that inspires her, as most of her work is accomplished with power tools. True to her roots in minimalism, she is uninterested in imitation or illusion per se; the viewer never forgets that the markings on the sculptures are those that the artist has made with saws and grinders and not those of nature. As the above example demonstrates, von Rydingsvard's work is not about using the stuff of nature to mirror or reveal nature. Her sculptures are the result of nature yielding to culture, that is, in an agrarian sense, as a field yields crops.

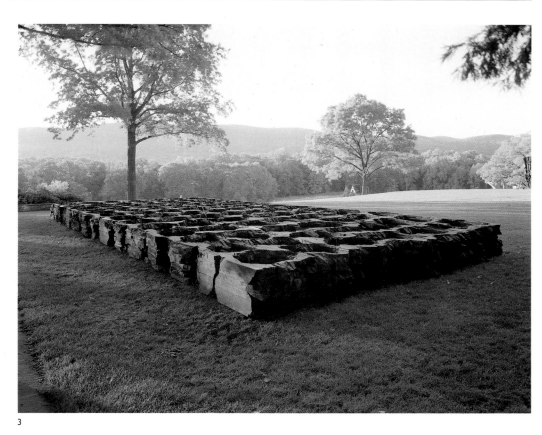

2

3

Von Rydingsvard's sculpture recalls nature because her art is a cultivation process. Her purpose is to coax and augment her raw material, not to dominate or make a complete break with it. For the artist, there is no inherent struggle between the forces of nature and human endeavors; the processes of nature include the activities of human beings. Her work is ecological in the sense that it is about the transactions of living creatures with their environments.

Von Rydingsvard descends from generations of farmers — back to ancestors in her native Poland. Her most vivid memories of her father pertain to his skills as a farmer and woodcutter. One sees evidence of von Rydingsvard's agrarian upbringing and sensibility in the shovels and other implements she has created, among them *Paul's Shovel* (1987), *Schwitters's Shovel* (1988), and *Untitled* (1988), a work that has the appearance of an oversized meat-tenderizing mallet. While each of these sculptural totems proffers diverse visual allusions, each is a simplified, well-worn

tool honoring the activity of work. The way in which many of her sculptures are "planted" on a site further implies agricultural connections. For example, the 180 twelve-foot-high beams of *Song of a Saint (Eulalia)* (1979) that were distributed across a hillside — facing north so as to register the sun's shadows — resembles a reforestation project. Or, her work *Ene Due Rabe* (1990), with its rows of craters, suggests furrows made ready for planting. Further evidence of the artist as cultivator is the relationship of certain sculptural forms to those of plants: the podlike elements of *Song of a Saint*, or the large-scale shootlike posts contained in *Tunnels on the Levee* (1983).

More subtly connected to this agrarian sensibility is von Rydingsvard's awareness of natural rhythms and the ways in which they form the basis of her work. Her consciousness of rhythms begins with those of her own body — breathing and heartbeat — and connects to those of human, animal, and plant cycles of growth and decay, and extends to diurnal, annual, and

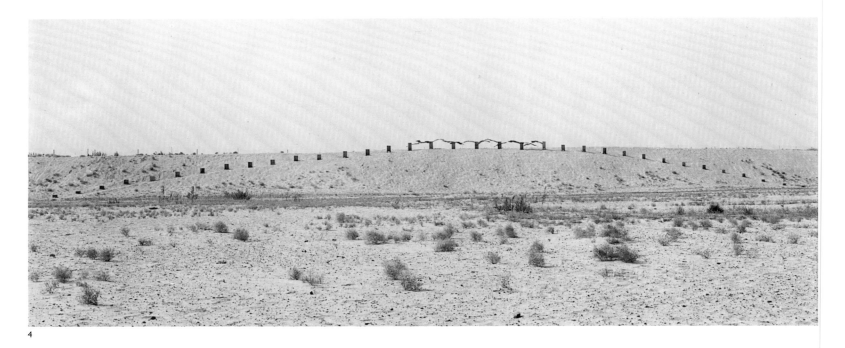

4

even geological cycles. Von Rydingsvard follows a consistent and rigorously self-disciplined daily schedule. Invariably she wakes each day at 5 A.M., swims for an hour, goes to her studio at 8 A.M. and works until 7 P.M. This regimen is integral to her art, from the way she carries out mindless tasks such as washing the floor to ready herself for work, to the manner in which she assembles and layers the units of the sculpture. The artist begins the process with a loosely fashioned template that is the first layer and foundation of her rhythmic structure. Each succeeding layer is a response to the previous one. The sculpture reveals itself one step at a time, moving toward some unknown teleological end. Countless repetitions are built into every phase of the construction from the cutting and gluing, to the labor intensive stripping of excess glue, to the arduous task of rubbing on stain and graphite. These processes give von Rydingsvard confidence, a confidence that belies her fear of knowing that no two sets of repetitions are exactly alike and that the outcome isn't assured. Like a farmer preparing to plant crops, the artist has the assurance of having undergone the cycle before, knowing how to cultivate, sow, and harvest, how to judge the climate and the seasons. But the weather can play tricks, and there are always personal and economic variables that may have an impact on the results. It is this adverse

aspect of chance and variability that endows her work with tension and an element of surprise.

The rhythms and repetitions reveal yet another aspect of von Rydingsvard's work: a marriage of the sacred and the secular. In his classic work, *Technics and Civilization*, Lewis Mumford attributes the development of the clock (i.e., the regular measurement of time) to the routine of the monastery. He asks: "Was it by reason of the collective Christian desire to provide for the welfare of souls in eternity by regular prayers and devotions that time-keeping and the habits of temporal order took hold of men's minds?"[1] Implicit in what Mumford writes is the idea that the religious and the industrial have a common point of departure in the element of time and ritual. This is also true for von Rydingsvard, and no doubt stems from the key role religion played in her life in the post-World War II German refugee camps she lived in until age nine. She recounts: "The churches we went to were barracks much like the one we lived in. . . . The church was just a bigger barracks with a cross on it. But inside, rituals occurred like nowhere else. There was something wonderful about the kind of rhythm, the way women lined up with their heads covered bowing up and down. . . . What happened was full of quietness, respect, and dignity. There was a repetitive rhythm in

the songs, the litanies, the repetitions of the priest and congregation."[2]

While many of her works both in subject and title allude to religious themes, from *St. Martin's Dream* (1980) and *Stations for Santa Clara* (1982), to *Confessor's Chair* (1989), the more important point here is that von Rydingsvard does not separate the spiritual and the industrial, the life of the mind and the labor of one's hands. Her approach is non-Manichaean. In her work she locates a common ground, a protoreligious, prechronometric space. She does so through the exercise of order, repetition, and ritual in creating each work. In her childhood, ritual provided a counteraction to the dislocation and alienation of camp life. Today, it remains a means of survival, a way to forge a bond between her daily life and her art.

A sculpture such as *Ene Due Rabe* is especially revelatory of the intricate web of repetitions in her work. The title itself is based on a rhyme remembered from childhood, although she no longer recalls its specific meaning. The continuous repetition of such a song has a mesmerizing quality that for her suggests a subject with no beginning and no end. The work itself also seems to extend infinitely as it blankets a space more than forty feet long and seventeen feet wide. It is a two-dimensional surface laid out in three dimensions, difficult to see except from a bird's-eye view. It consists of ninety-eight chasmlike units, similar to one another yet each wholly unique. The abundant strata are both vertical and horizontal. From the relatively minute, etchlike, repeated lines created by the circular saws, to the chopped raw facets of the beams, the overall effect is of an undulating silver-bronze surface, a visual conundrum in which viewers may lose themselves. The work is built up of a mass of repetitions from the micro to the macrocosmic.

Von Rydingsvard is fond of listening to the meditative sounds of Gregorian plain chants, the unison liturgical works of the Catholic church composed during the Middle Ages. In these works "the melody has no leading or keynote but has the character

of a free undulating oscillation about a central note and a free rhythm which is not fettered by regular beats but is the rhythm of prose speech."[3] So it is with *Ene Due Rabe* as it is with so many of her works: unpretentious as prose, but focused on a loosely articulated, rhythmic surface that appears massive and inert yet seems to oscillate.

The connections to monastic order and discipline seem to inform her working methods as well. In creating large-scale works the artist gathers around her a community of apprentices and assistants who undertake extraordinary tasks and devote enormous amounts of time and effort. With *Ene Due Rabe*, for example, she had six assistants working full time and one hundred fifty part-time volunteers; frequently they labored around the clock in order to finish the piece on time. However, it was not only the effort, but rather the working rhythm established among artist, assistant, and volunteer that made such a work possible. It is no coincidence, when reflecting on this piece, that she remembered "once seeing a moving maze of tiny insects surrounding a rock [and the] easy movement of separations and linkages that felt like the movement of the surface of the ocean."[4] What the artist describes here is the conflation of an intricate, clearly defined working system with the imagery of the sculpture itself, its complexity and richness subservient to a grand plan.

Just as von Rydingsvard's sculptures are mediations between the sacred and the secular and her working methods a union of process with object, so are the siting of her outdoor pieces about a reconciliation between the works and their locations. They are situated on the ground, above the ground, and in the ground. There are, however, many ways to be "on," "above," or "in." Like animate creatures of diverse species, her works variably hover, stand, rest, sit, roll, and crawl. An early outdoor piece, *Koszarawa* (1979) is a series of crisscrossed oarlike forms reminiscent of early American zigzag rail fences that loll lazily on a hillside. In this work the earth is as much a part of the substance of the sculpture as the wood itself. Another early work, *St. Martin's*

1 Lewis Mumford, *Technics and Civilization* (New York: Harcourt Brace Jovanovich, 1963), 14. Reprint of 1934 edition.

2 Ursula von Rydingsvard in "Ursula von Rydingsvard: Interview," in *Judith Murray: Painting, Ursula von Rydingsvard: Sculpture* (Greenvale, New York: Long Island University, C.W. Post Campus, 1985), 44.

3 *World of Music, an Illustrated Encyclopedia* (New York: Abradale Press, 1963), s.v. "plainsong."

4 Ursula von Rydingsvard in *Capp Street Project 1989–1990* (San Francisco: Capp Street Project, 1990), 24.

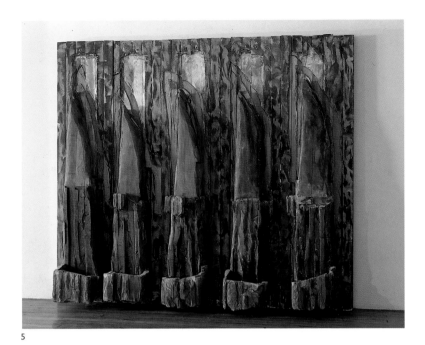

5

Dream (1980), consists of a 280-foot line of more than thirty posts planted in a sand dune. The posts, set apart equidistantly, increase in size as they form an arc leading to the summit of the dune. The tallest and highest of these are surmounted by enormous winglike constructions, poised as if ready for takeoff. Here the work forms a junction between the horizon and the dune itself.

Some objects, such as the recurrent bowls and tubs, hint at anthropomorphic interpretations. *Five Cones* (1990–1992) calls to mind a group of ambulatory figures in formation. The sculpture is at once anchored and "light of step." Von Rydingsvard's sculptures often appear to be archetypal, not entirely individuated forms that bridge the abyss between the living and the inanimate, the synthetic and the natural, the object and the site.

The artist's works, despite their sturdy construction, formidable appearance, and seeming timelessness, have a vulnerability about them. The surfaces of her work sometimes resemble peeled, cracked, or scarified skin. *Orvieto* (1989) and *Dreadful Sorry* (1987–1988), exquisite as their textures are, seem to bear the signs of punitive, and perhaps as the latter title suggests,

penitent lacerations and mortifications. Nonetheless, such surfaces are as delicate as they are tough. Marks left by heavy-duty equipment may, paradoxically, have the ephemerality of traces left by a tree branch on the snow when it stirs in the wind, or of disturbances made by a breeze on the water.

In creating site-specific outdoor installations, the artist often looks for enclosed, visually framed, or relatively protected spaces such as gulleys, clearings, hollows, and hillocks. She has said, "A part of me shies away from nature and the spectacular. [I am] overwhelmed by what nature is capable of."[5] For this reason, when she creates a piece she never contemplates the idea of nature. Her works are often reactions to the power of nature. *Tunnels on the Levee* consists of three partially buried shelters, each 3 ½ × 3 × 14 feet, probably a reference to the barracks of the refugee camps. In each of the three there is a collection of vaguely anthropomorphic, minimally carved beams, crowded into one end, as if in hiding. Another work, *Iggy's Pride* (1990–1991), consists of nine 17-foot-high escarpment shapes dug into the side of a hill. Despite the solidity of these craggy formations, they seem defenseless and appear to be attempting to take cover.

This suggestion of vulnerability does not represent a retreat from the world, although von Rydingsvard's monastic tendencies and connections to preindustrial agrarian modes might indicate otherwise. One can't help but wonder, however, what relevance this approach has today, in a world where pollution is prevalent, rainforests are destroyed, and agriculture is increasingly controlled by genetic engineering and the exploitation of multi-national agribusiness. For von Rydingsvard, her work has an ethical dimension. Her concerns are for an economy of means, not a sentimental celebration of simplicity for its own sake, but an understanding of simplicity as a means of survival. The basis of her work is interdependence: how all elements relate, modify, and coexist with one another. Her art, often created by communal effort, ultimately addresses the necessity for accommodation and individual responsibility.

5 Interview with the artist,
26 September 1992.

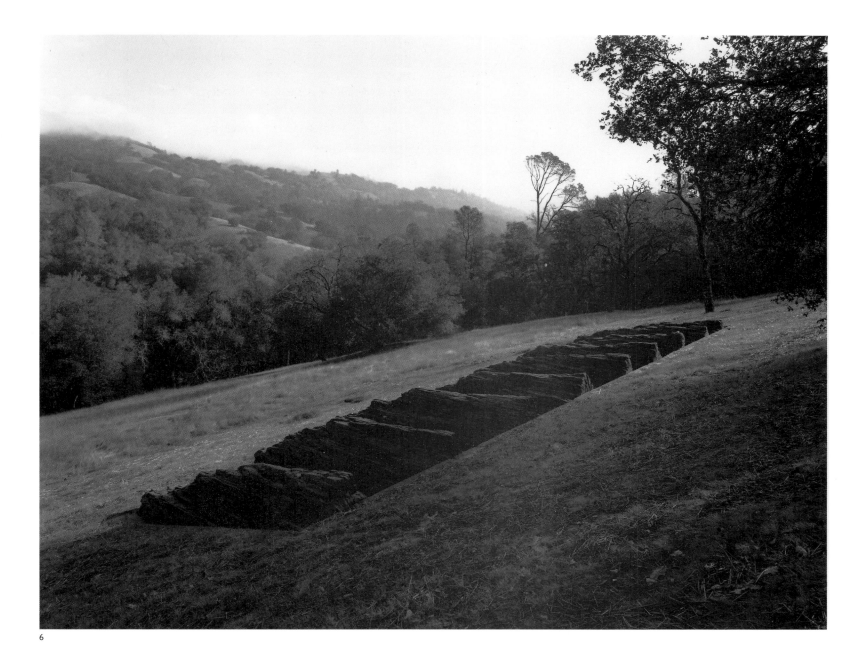

6

ALISON SAAR

JOHN BEARDSLEY

1 Unless otherwise noted,
quotations are from
conversations with the artist,
February 1993.

ALISON SAAR (b. 1956, lives in New York City) bases her sculpture upon African and Caribbean religious beliefs and folktales. Central to her work is the idea that ancestral spirits inhabit the elements of landscape: earth, water, and plants. Some of Saar's polychromed wood figures literally grow out of tree roots, while others are covered with branches. Such works are an eloquent synthesis of body and landscape. Recent solo exhibitions of her work have been organized by the Bellevue Art Museum, Washington (1992), the Neuberger Museum, Purchase, New York (1992), the Hirshhorn Museum and Sculpture Garden, Washington, D.C. (1993), and the High Museum, Atlanta, Georgia (1993). She has been included in group exhibitions such as *The Decade Show* organized in 1990 by the New Museum of Contemporary Art, the Studio Museum in Harlem, and the Museum of Contemporary Hispanic Art, New York, New York.

Alison Saar may be seen to sum up many of the complexities of recent American art. Both in her person and in her art, she is a combination of a bewildering array of influences, a rich fusion of the many streams that feed the river of American life and thought. Yet, like anyone who springs from multiple traditions, she is privileged to bear a particular burden. To be of several worlds is to have special access to the idioms and values of many different cultures, but it is also to risk being entirely of none. For our notions of cultural identity, art, and race are typically constructed around dualities rather than complex mixtures. We are more prone to see things as black *or* white, folk *or* fine, traditional *or* avant-garde, rather than as amalgams of both. Saar is one of those artists who bravely challenges us to replace *or* with *and,* to embrace complexity and even ambiguity as the more truthful construction of identity.

Saar grew up, as she has often said, "floating between two worlds," but that doesn't begin to do justice to the many traditions to which she is heir. Her father is white and was a painter before becoming an art conservator. She worked for him on a part-time basis through her high school and college years, and thereby gained a first-hand experience with materials and techniques of art from around the globe, including Chinese frescoes, Russian icons, and pre-Columbian and African sculpture. Saar's mother, the artist Betye Saar, is of African and European descent, and moved comfortably between the worlds of academic and unofficial art. She was an instructor at Otis Art Institute in Los Angeles, where Alison received her M.F.A. in 1981. But when Alison was a child, her mother took her to the *Watts Towers,* fabulous constructions of steel rod coated with concrete and embedded with broken pottery, tiles, and shells, built beginning in the 1920s by an artistically untutored Italian immigrant named Simon Rodia. Here the young Saar learned about the imaginative juxtaposition of found objects, which would subsequently figure so importantly in her own work. "This is where I first became an artist," she says. "I was impressed by the resourcefulness—the making of something out of nothing."[1] Saar's college education reinforced these multiple exposures. As an undergraduate, she studied art history and studio art at Scripps College, where her course work included African, Haitian, and Afro-Cuban art; she ultimately wrote her senior thesis on Afro-American folk art.

1 ALISON SAAR **SUBWAY PREACHER** 1984, tin, wood, convas, and mixed media, 89 x 56 x 31, collection The Nelson-Atkins Museum of Art, Kansas City, Missouri

2 ALISON SAAR **CONKERIN' JOHN** 1988, wood, nails, tin, mixed media, 81 x 15 x 31, collection Wendy and Alan Hart

3 SIMON RODIA **WATTS TOWERS** 1921–1954, glass, shells, pottery, cement, wire, steel rods, two 90-foot-tall towers in a 150-foot-long triangular site, Los Angeles, California

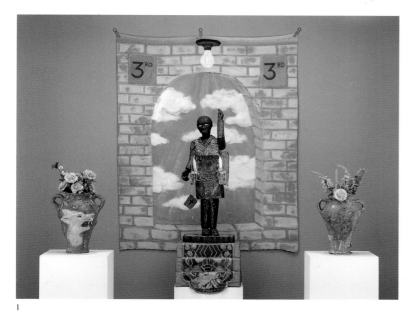

1

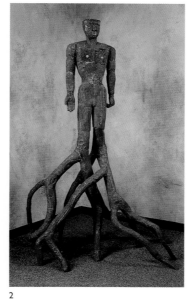

2

Saar's art reflects this rich inheritance. She consciously explores the boundaries between high and low art, utilizing the subjects and materials of both fine- and folk-art traditions, drawing on official and vernacular sources. Though technically sophisticated, she has the untutored artist's appreciation for the magical properties of found objects and junk materials, and for the expressive power of a raw, rough surface. At the same time, she dwells on the boundary between races, exploring the historical constructions of difference and some of its contemporary manifestations.

2 For an examination of the cross-cultural aspects of the Lazarus character, see Judith Wilson, "Down to the Crossroads: The Art of Alison Saar," *Callaloo* 14 (1991), 17. Wilson is a particularly good source for a wider under-standing of the African and Afro-American inflections in Saar's art.

3

Many of Saar's subjects come directly from Afro-American history and folklore. *Conkerin' John* (1988), one of her classic tree-figure combinations, alludes to the folk-art practice of making sculptures out of tree roots. But it also refers to the tremendous powers believed to be conveyed by High John the Conqueror, a root that is a frequent ingredient in voodoo potions. As such, the sculpture is an image of the strength and resilience of black American culture. At the other extreme is a piece like *Travelin' Light* (1983), a figure covered in hammered lead that hangs upside down from a frayed rope. Here we are confronted with some of the horrible social repercussions of race. The inevitable allusion is to lynching, but Saar also speaks of the piece in terms of the way negative attitudes are internalized by the victim, hobbling him. "It expresses the cost of allowing yourself to be defeated," she says. At times, her subjects from black American life are married with those of European traditions; she has carved a variation on Michelangelo's *Dying Slave* as an African, and done two versions of the biblical Lazarus, the patron saint of mendicants and lepers who also figures prominently in the New World African-inflected religions.[2]

4 ALISON SAAR **TRAVELIN' LIGHT** 1983, wood, lead, mixed media, 29 x 6 x 4, collection Merry Norris

5 ALISON SAAR **SWEET DADDY GOOD LIFE** 1985, wood, tin, painted canvas, 101 x 24 x 16, collection The Newark Museum, New Jersey

4 5 6

Some of Saar's other subjects are drawn from urban street culture. Characteristic of this work are *Sweet Daddy Good Life* (1985), a sculpture of a dazzling huckster perched on top of a miniature Cadillac, and the nearly life-sized drawing *Ju Ju Eugene* (1985). These are morally ambiguous figures, urban outlaws who are both fearsome and tempting. *Sweet Daddy* is all white tin with a gold leaf hand and a gold tooth inset with a rhinestone; he seduces with impossible promises. But Saar wanted "to turn around his negative image—hope is sometimes better than nothing." *Ju Ju Eugene* is clearly a person of magic; *ju ju* is an African word for a charm. He appears against a cloud, martini glass and hat floating above him, with the long fingernails and toenails of the man "who never has to work." He wears sunglasses and cornrows —signs of the nonconformist—and hovers above an angry female dog, suggesting anger and abusive power. These figures are conscious challenges to some of our social stereotypes, suggesting that the extreme separation of good and evil is another questionable duality.

If these characters embody some of the ambiguities of good and evil, then a sculpture like *Subway Preacher* (1984) expresses the complexities of inward and outward life. A trench-coated figure covered in embossed ceiling tin, *Subway Preacher* was based on a panhandler Saar encountered every morning in the New York City subway during her residency at the Studio Museum in Harlem. "I would give him money," Saar remembers, "but he would never look me in the eye. He just had this serene dignity about him—like, you know, he had to do this to survive, but . . . ". Saar created an image of this inward strength: his coat opens to reveal a small reliquary in his chest, containing candles, a heart, and various found objects, as if the beggar's clothing hid "some sort of glory inside him."[3] A chest cavity, which doubles as an altar or shrine, is a frequent device in Saar's work; it is one of

3 Saar, quoted in an interview with Judith Wilson in *Secrets, Dialogues, and Revelations: The Art of Betye Saar and Alison* *Saar* (Los Angeles: Wight Gallery at the University of California at Los Angeles, 1990), 42.

6 ALISON SAAR **JU JU EUGENE** 1985, mixed media, 98 × 50, courtesy the Jan Baum Gallery, Los Angeles, California

7 ALISON SAAR **CROSSROADS** 1989, mixed media installation, 15 × 15 × 18 feet, various elements in three collections: Virginia Museum of Fine Arts, Richmond

Virginia; Walker Art Center, Minneapolis, Minnesota; and Thomas Barry Fine Arts, Minneapolis, Minnesota

her several conscious debts to African sculpture. It is loosely based on a similar phenomenon found in *nkisi* figures of the Bakongo people of Zaire, in which medicinal herbs and objects with magical properties are encased in a covered cavity, endowing the figure with spiritual power.

Saar has recently created several installations that challenge still other, typically hierarchical, oppositions. *Crossroads* (1989), for example, questions dualities of heaven and earth, body and spirit. The installation was organized around a large, clay-colored plaster cross, with a figure at the terminus of each of its three arms and a pool of water at the fourth. To the left stood a tin-covered female figure, her legs emerging from tree roots, an arm folded behind her head in a variation on an arabesque pose. Her body bore several small cavities covered with transparent plastic, which contained plastic roses. She expressed sexuality and regeneration in a carnal sense; she was literally rooted in nature. Across from her stood a male figure who played culture to her nature; he was reminiscent of African nail fetishes, votive figures in which nails are set to seal contracts or appeal for justice. As such, the figure was an image of ritual and accumulated power, but suggested an ambivalence about authority; he held an iron bullwhip, like a slave overseer, and at his feet lay the dross of industrial production. At the head of the cross was a phoenixlike male figure suggesting resurrection; encased in ceiling tin from a burned building, he emerged from carved smoke and flames. Doors in his chest opened to reveal a flickering light. Across from him was fire's opposite—water.

On one level, then, *Crossroads* represented the meeting place of nature and culture, fire and water. But other meetings were also implied. In the four corners of the installation stood piles of stones, suggestive at once of trail markers and grave sites. Over the cross hung a ladder, a reminder that crossroads represent not only choices on earth, but also the transit between earth and heaven. The cross itself is a symbol of almost universal significance—a Christian, African, and Afro-Caribbean emblem; it resonates with the death and resurrection of Christ, but also with the spirit of Baron Samedi, the Haitian voodoo deity of graveyards, of life and death. In all, *Crossroads* was a cross-cultural meditation on physical and spiritual regeneration, on the concurrent lives of the flesh and the spirit, and on the transition between life and

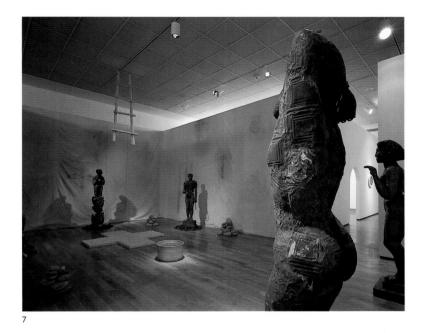

7

death. It conveyed the idea that body and spirit, life and death, are not dualities, but in some way coexistent, or at least contiguous: they might meet down at the crossroads.

Implicit in *Crossroads* was a conception of landscape as a sacred space, hallowed by its connections with fertility, spirituality, and death. The installation conveyed a sense of landscape as inhabited by alternately protective and dangerous forces, and by the spirits of the deceased. This conception of landscape is also explored in the figures in *Landscape as Metaphor*. Massive variations on Saar's body-tree constructions, these figures reiterate the animistic principle that spirits inhabit all the significant components of our world. But they allude to numerous historical connections between body and tree as well: trees as witnesses to numberless lynchings and lashings, for example, or as refuges for runaway slaves. Saar especially connects these sculptures with the fate of escaped slaves in Florida; they hid in the roots of mangrove trees on their way to a life of freedom in the subtropical swamps. Embedded in knotholes in these tree figures are small reliquaries containing enigmatic objects. We are invited to experience these sculptures in a ritualistic sense: to take shelter within their roots as did the escaping slaves, and explore them for their hidden charms.

MARK TANSEY

MICHAEL KELLY

I

On the uninhabited side of Aruba is a "natural bridge" of volcanic rock sculpted by the Caribbean Sea over thousands of years. It is not only a marvelous sight, but also the only bridge on a solitary road along this precipitous coastline. Because of continuous erosion, cars are no longer permitted. Visitors can still walk over it, but they do not actually use it as a bridge, since they have to return to their parked cars. So the natural bridge, a landscape, has become a metaphor for a bridge—a "landscape as metaphor."

One of Mark Tansey's paintings, *Bridge over the Cartesian Gap* (1990), is remarkably similar to the natural bridge, even down to the details of its crevices, color, and people. But in his painting the people are not tourists toting cameras, but everyday folk carrying various objects—a ladder, a person, a canoe, even the kitchen sink—over a gap. Each of these object-bearing figures constitutes a different image of the etymological origin of the word "metaphor": transfer or carry over. Each image is thus a metaphor for metaphor. So, although Tansey's painting is like the natural bridge, it is not a picture of a bridge. Rather, it is a landscape comprised of metaphors about metaphor, and even about the "dangers of uncontrolled metaphors," as these words in the lower right-hand corner caution us. It is a perfect example of "metaphor as landscape."

So an Aruban landscape that is also a metaphor is comparable to a painting filled with metaphors that is also a landscape. Such a comparison should not be surprising. After all, the word

MARK TANSEY (b.1949, lives in New York City) paints large, monochromatic panoramas based on American landscape imagery in which historical and contemporary images are freely juxtaposed. On first viewing, these appear to be reminiscent of late nineteenth-century paintings and photographs that celebrated similar themes. On closer observation, however, such similarities end. The artist's point is soon apparent: in many works the richly variegated strata of his monochromatically rendered canyons and mountains consist of dense layerings of text; a metaphor, on the one hand, for the accretion of knowledge, and on the other, for the evolution of civiliza-tion itself. Tansey's paintings have been selected for group exhibitions such as *10 + 10: Contemporary Soviet and American Painters* (1989), Modern Art Museum of Fort Worth, Texas, *Image World: Art and Media Culture* (1989), Whitney Museum of American Art, New York, New York, *Harmony and Discord: American Landscape Painting Today* (1990), Virginia Museum of Fine Arts, Richmond, and the *1991 Whitney Biennial*, Whitney Museum of American Art, New York, New York. Recent one-person exhibitions include *Mark Tansey: Art and Source* (1991), the Seattle Art Museum, Washington and *Mark Tansey* (1993), the Los Angeles County Museum of Art, California.

1 MARK TANSEY **BRIDGE OVER THE CARTESIAN GAP** 1990, oil on canvas, 87 × 108, private collection

2 MARK TANSEY **CONSTRUCTING THE GRAND CANYON** 1990, oil on canvas, 85 × 126 ½, collection Walker Art Center, Minneapolis, Minnesota

1

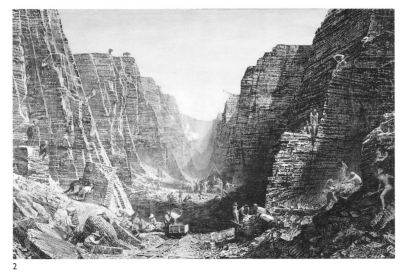

2

1 Friedrich Nietzsche, "On Truth and Lies in a Non-moral Sense," in *Philosophy and Truth: Selections from Nietzsche's Notebooks of the Early 1870s*, D. Brezeale, trans. (Atlantic Highlands, N.J.: Humanities Press, 1979), 84.

2 Cf. the catalog to the 1992 show, *Sketching at Home and Abroad: British Landscape Drawings, 1750–1850*, at the Pierpont Morgan Library in New York.

"landscape" can mean either an actual landscape or a representation of one, and the title of this exhibition implies that landscape is metaphorical. Some of Tansey's paintings can be seen as explorations of this implication.

II

Nietzsche regarded truth as a "movable host of metaphors . . . illusions of which one has forgotten that they are illusions."[1] To speak of landscape as metaphor is also to remind us of something we know but have forgotten. Yet there is an important difference here. Whereas truth for Nietzsche is deflated once it is recognized as metaphor, landscape painting first comes into its own once it is seen as metaphor.

Historically, landscape painting seems most naturalistic in the seventeenth century (in works by such artists as Claude Lorrain) as it was becoming an autonomous genre; in fact, it became autonomous, in part, by *pretending* to be true to nature. For example, while professing that their purpose was to represent nature faithfully, the earliest British landscape painters were also surprisingly candid in recognizing that they were "cooking nature."[2] So landscape art began as an illusion of an illusion. By now, judging by its modern history culminating in twentieth-century conceptualism, we have cast off this second-order illusion. We acknowledge that landscape is a metaphor in roughly the sense that the verb "to landscape" means to make a plot of ground more attractive or, in Ralph Waldo Emerson's words, to depict "a fairer creation than we know." While Tansey's paintings may appear in style and subject matter to belong to illusionism, they are in inspiration and content very much part of the twentieth century, where one of their roles has been to problematize the history of landscape painting becoming metaphor.

In particular, Tansey's painting *Constructing the Grand Canyon* (1990) makes it perspicuous that landscape is metaphor, though only if we see beyond its appearance as an illusionistic landscape. The witty title alone begins the story: while it seems folly to think that humans could construct something as sublime as the Grand Canyon, it is also clear that landscape painters attempt just that. Of course, it is not the physical reality of the Grand Canyon that they construct, only its meaning as something we experience in nature and, in this case, in painting.

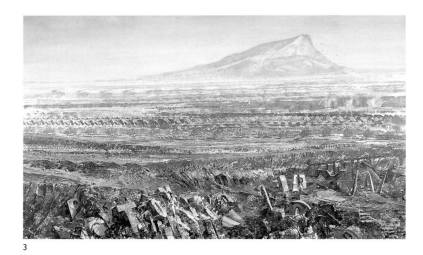

3

To articulate and interpret this meaning, we need discourse. We may not select the discourse of the Yale School (Paul de Man, Harold Bloom, and Geoffrey Hartman in alliance with Jacques Derrida's deconstruction) or the archaeological discourse of Michel Foucault out of which Tansey's painting is literally constructed.[3] But we must choose one of many other theoretical discourses. Otherwise, our experience of the Grand Canyon—qua nature or painting—will not only remain ineffable, which some people would likely prefer, but also be rendered unintelligible; ineffability and intelligibility (in this case achieved through the senses) are not incompatible. We know the Grand Canyon has meaning, many meanings in fact, making our only task their articulation. Meaning is lavishly there, if at times difficult to identify, so there is no reason to suppose, as the deconstructionists often do, that meaning is radically indeterminate just because there are multiple meanings. If the painting had no determinate meaning at all, how could people "read" it, as they do, as a landscape painting, an inversion of deconstruction, or whatever? The painting, like the Grand Canyon, is of course more than any of these readings/meanings.

Tansey's *Valley of Doubt* (1990) reveals just how deeply landscape is embedded with meaning. As we look into the horizon through the avant-garde binoculars in the left forefront of the image, we see a full array of modes of signification—letters, numbers, footprints, rubber stamps, and direct imprints of tools —all the way up to Cézanne's *Mont Sainte-Victoire* (1904–1906), the arch symbol of modern landscape painting. Although at first we

may think the modes of signification are just debris scattered about the landscape, we soon realize that they actually comprise —construct—it. They are as much a part of the landscape as the stones with which we perceptually confuse them. At the same time, *Valley of Doubt* is a metaphor for the last century of the genre of landscape art, marked on the one end by pre-Cubist form and on the other by postmodernist, textual content.

Try as we may, we cannot avoid meaning and discourse in landscape unless, of course, it were possible to purge landscape of them.[4] This very possibility is explored in Tansey's *Robbe-Grillet Cleansing Every Object in Sight* (1981), where the figure is trying to cleanse the landscape of every remnant of meaning, whether pictorial or discursive, ancient or modern. Is this feasible? The picture answers its own question. In the far-right corner there is a small replica of Robbe-Grillet in the cleansing posture. So for him to succeed he would have to cleanse himself and thus the very act of cleansing, which is impossible. The reason he could not do so is not only that it would be paradoxical, but that the act of cleansing meaning unveils new meaning. Moreover, this unveiling is an act of meaning, just as deconstruction (especially when it critiques representation) is a method of construction (since it, too, is a representational act). As we saw in *Constructing the Grand Canyon,* meaning proliferates within painting even under the watchful eye of the postmodernist.

While Tansey's paintings first read as illusionistic landscape pictures and then as illustrations of the role of discourse in landscape, their ultimate strength lies in their multiple levels of pictorial metaphor. Yet for all their metaphors, they do not stop being landscapes: they are metaphors as landscapes, paintings that are as meaningful as they are about meaning.

III

Now, if it is true that landscape is "cooked" by discursive meaning, does that really mean that landscape is a discursive metaphor taking pictorial form? Some readers, emphasizing that landscapes are after all metaphors of nature, will undoubtedly insist that there must be a sense in which landscape painting is natural or real. What would that mean? And who should judge? Tansey addresses these questions in *The Innocent Eye Test* (1981) and *Purity Test* (1982). The first painting depicts a cow guided into a museum to inspect Paulus Potter's *The Young Bull* (1647), as if an

4 MARK TANSEY **PURITY TEST** 1982, oil on canvas, 72 x 96, collection Chase Manhattan Bank, N.A.

5 MARK TANSEY **ROBBE-GRILLET CLEANSING EVERY OBJECT IN SIGHT** 1981, oil on canvas, 72 x 72, collection The Museum of Modern Art, New York:

gift of Mr. and Mrs. Warren Brandt, 1982

innocent animal would be best qualified to judge the realism of a human representation of nature. But is this cow not just another creation of the artist? Not only is landscape a construct, but we— not nature—are the judges of it, and we are by no means innocent.

A related point is reflected in *Purity Test*, where a band of Native Americans on horseback is looking down from a hill onto Robert Smithson's earth piece, *Spiral Jetty* (1970), which itself is a metaphor for the prospect of returning to nature. Such a return would be possible here only if the Native Americans could be thought of as primeval representatives of nature who could judge what nature was like before the onset of entropy or human intervention. The "natives" cannot play this role in Tansey's picture for the simple reason that they are modeled on Frederic Remington's portraits of Native Americans. If they judge at all, they do so only as art-historical constructs. *Purity Test* once again confirms landscape as metaphor.

Yet for some viewers the Native Americans in Tansey's picture may nevertheless represent a distant past when, it is believed, we were closer to pristine nature. In yet another painting, "*a*" (1990), which is Tansey's first treatment of the deconstructivist notion of "the world as text," he suggests that there was never such a time. An androgynous nude figure stands before a stone wall on which its shadow is cast. The wall is not only inscribed with text but comprised of it (again, literally), as is the entire landscape. Her experience of the landscape, as well as her very existence in it, is textually mediated. So, despite the nudity and cavelike setting, both of which conjure up an original state of innocence and purity, she discovers that "in the beginning there was text." This is not intended as an affirmation of the deconstructionist credo, but rather as a critical reflection on the search for origin, unveiled here as a futile diversion from the construction of meaning.

4

5

3 The texture of the painting is comprised of texts by these authors that are transferred to the canvas through silk screening. In a related painting, *Mont Sainte-Victoire*, the agents of discourse— Jacques Derrida, Roland Barthes, François Lyotard, et al.—mediate between Mont Sainte-Victoire and the viewers, as well as between the cave in the foreground and the mountain in the background.

4 Even in the Swiss Alps, perhaps the closest Europe gets to pristine nature, Paul de Man and Jacques Derrida are mischievously present (see *Derrida Queries de Man*, 1990).

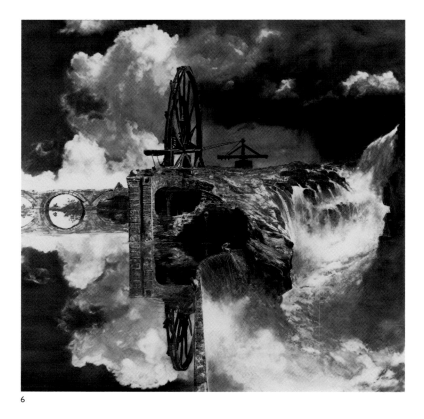

6

What, then, does the figure in "*a*" draw? Ignoring the voice of mimesis calling out from her shadow, she draws the outline of a figure that is not her own. It is a metaphor for her or, better, for her predicament—drawing on a textual wall. Instead of drawing facial features to mark the identity of her representation, she draws an "*a*," as if to show us that she realizes the textuality of her act of drawing as well as of her surroundings. That an "*a*" is what she would draw is implied by the word "ibid," which stands near her foot and between her, her shadow, and the wall. She seems bound to repeat, to imitate—not nature but text, not mimesis but metaphor. So the "original" act of drawing incorporates a recognition of the textuality of drawing.[5] This means that art's relationship to text (discourse) is internal, having to do with the creation of the meaning of landscape through metaphor.

IV

Tansey continues his investigation of "landscape as metaphor" in the three 1994 paintings for this exhibition. In *Library of Babylon,*

where he portrays the genetic structure of organic nature, he seems to offer hope to those who believe that because the gene is organic nature's microcosmic level, we can finally say with some confidence that we have got nature right. These same people might then argue that even if landscape is a discursive construct, surely nature itself is outside the clutches of metaphor and textuality. Unfortunately, part of what we learn about nature when we reach its genetic level is that it remains somewhat concealed, perhaps forever. So *Library of Babylon* is just a new metaphor for landscape. For this reason, because it depicts the history of the development of the genetic structure as represented on a computer, as well as because of its Borgesian title, it supports rather than contradicts the idea of nature as metaphor.

If this conclusion is discouraging news for people who expected genetics to resuscitate realism about landscape painting, if not also about nature, *Library of Babylon* offers some consolation: genetic structure is a new metaphor for the sublime since nature is sublime only so long as it is beyond our grasp. In light of this,

illusionistic landscape painting, in its attempt to capture the real, is not only a chimera but an undesirable goal, as its success would signify the end of the sublime (and of itself for that matter). Yet another metaphor encoded in *Library of Babylon* is that the diversity reflected in DNA, the structure of which may be the very source of life's fecundity, is a metaphor for the variety of metaphors we witnessed in Tansey's earlier paintings. If we cannot grasp nature through pictures, perhaps they can at least help us better understand its metaphors, as well as painting's own.

Water Lilies is emphatically about diversity. By exploring the phenomenal surface to which Monet reduces all content in search of a perceptual sublime, Tansey reveals the richness beneath the shadows on the pictorial surface.[6] He minimizes color—Monet's main aestheticizing device—in order to unmask diversity on other levels, such as content, subject matter, and modes of signification. The pictorial metaphor here is both biological—given the contrast between the water lilies thriving on the sunlit surface and the many life-forms flourishing below the shadows of the trees—and nuclear—for the tranquil reflections on the surface may on closer examination be those of a nuclear explosion. Such a dangerous prospect, caused perhaps by the fact that Monet painted over so many species, may signal that the nuclear sublime has supplanted the perceptual sublime. If so, then nature asserts itself in landscape painting after all; it may be that the cause of the explosion among the water lilies is the very diversity of life and metaphors Tansey advocates.

The last painting, *Landscape,* touches on some of these same themes. Here, various icons of meaning present in *Robbe-Grillet Cleansing Every Object in Sight,* plus many additional ones from world history (Mayan heads, Roman and Greek statesmen, Hitler, Washington, Lincoln, Lenin, and Stalin), have been inflated and chaotically combined into the shape of a pyramid. Since the cleansing act is now out of the picture frame, the icons surge forth with meaning and demand our interpretive attention. Perhaps they are inflated because they have consumed so many interpretive acts already. In any case, the colossal heads and remains of statuary are insisting that we make choices between interpretations, meanings, and histories. Which ones should be preserved, which destroyed? Who should decide and according to what criteria? These questions are urgent in *Landscape* given the monumental size of the ruins, which, as metaphors, echo similar questions facing us around the globe.

So, rather than represent a nonmetaphorical nature, Tansey's earlier and present paintings generate a plethora of new metaphors about landscape, nature, the sublime, and painting itself. At the same time, he not only thematizes the multiplicity of pictorial content, he creates paintings with it.

V

In Tansey's *Bridge over the Cartesian Gap,* the bridge accomplishes more for the viewers of the painting than the natural bridge does for Aruba's tourists. By uniting text on the right with image on the left, it actually serves as a bridge. Of course, the text here has become the texture of a landscape, and the image is of metaphors of metaphor that we typically see as textual. So the two sides already permeate one another, minimizing the need for a bridge. But then the painting as a whole is the bridge. It carries us from text to image, image to text, the intersection of which is one of the structures of content that generate paintings. In this particular picture and in general, Tansey's achievement is not just his deft illustration of pictorial problems, his ingenious transformation of text into texture, or his ironic reflection on the predicament of contemporary painting. Rather, while exploring the structures of content on which painting depends, he has created metaphors as landscapes that are as sublime as Aruba's natural bridge.

5 The game of drawing is to be played on the parceled land represented in Tansey's *Chess Game* (1982).

6 Cf. Tansey's *Myth of Depth* (1984).

Michael Kelly is managing editor of *The Journal of Philosophy* and adjunct professor of philosophy at Columbia University. He is editor of *Hermeneutics and Critical Theory in Ethics and Politics* (MIT Press, 1990); *Critique and Power: Recasting the* *Foucault/Habermas Debate* (MIT Press, 1993); and *The Encyclopedia of Aesthetics* (Garland Press, forthcoming 1995). He has also published numerous articles on critical theory, ethics, and aesthetics in art periodicals and catalogues.

I | JAMES TURRELL **RODEN CRATER, SITE PLAN WITH SURVEY NET AND ALIGNMENTS** 1992, mylar, beeswax, emulsion, ink, liquitex, wax pastel,

42 × 90 ³/4, courtesy the artist

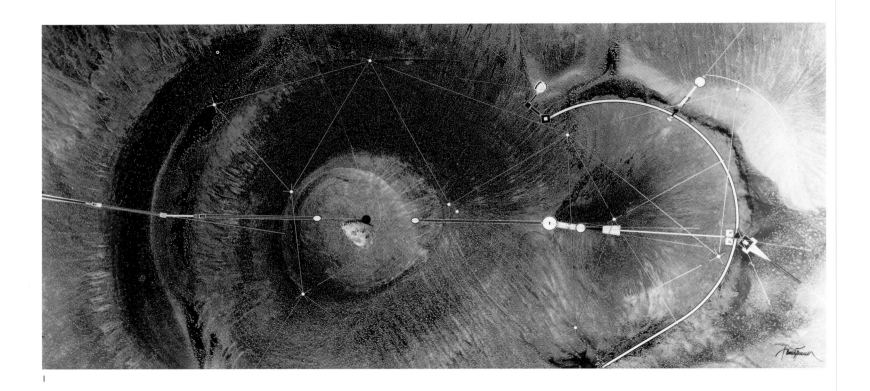

I

JAMES TURRELL

JOHN BEARDSLEY

1 Turrell in an interview with
Julia Brown, published in
Occluded Front: James Turrell
(Los Angeles: Fellows of
Contemporary Art and
Larkspur Landing: Lapis
Press, 1985), 25.

2 Ibid., 22.

JAMES TURRELL (b. 1943, lives in Flagstaff, Arizona) creates highly controlled architectural environments using light and volume to generate a sense of indeterminate, even infinite, space. Not only do his gallery installations utilize rectangular formats that allude to traditional pictorial compositions, but so do his idiosyncratic architectural structures in which natural light is the primary ingredient. In these luminous presentations distinctions between actual and illusionistic space are utterly dissolved. Thus, the landscape becomes infinite space in Turrell's poetic essays about perception. He has had a number of solo exhibitions including those at the Whitney Museum of American Art, New York, New York (1980), The Museum of Contemporary Art, Los Angeles, California (1985), and the Henry Art Gallery, University of Washington, Seattle, Washington (1992). Since 1974 Turrell has been working on a monumental permanent outdoor installation, a natural observatory, to be created at the Roden Crater in northern Arizona; it will be in progress into the next decade.

James Turrell's art explores the frontiers of perception. Its effect is virtually subliminal; it enables us to see things that are not there, and causes us not to see things that are. It makes light palpable; it dissolves the logical constructions of space. It is, to paraphrase the artist, about seeing ourselves see. "My work is about space and the light that inhabits it," he says. "It is about how you confront that space and plumb it. It is about your seeing."[1] Turrell allows us to experience the subtle complexities of our seeing, enabling us to explore its physiological, psychological, and temporal dimensions.

In a series of indoor installations called Wedgeworks, for example, that began in 1969, Turrell created suspended veils of light that seemed almost tangible. In each case he constructed a partition wall part way across a room, and gave the terminating edge an angled surface. He positioned a hidden source of fluorescent light behind the wall. The light raked across the angled end of the wall as it was cast into the viewer's space, bisecting it diagonally. This line of light read as a skin or scrim, at once opaque and diaphanous; it concentrated attention on itself while simultaneously allowing viewers to experience the atmospheric volume of incandescent space beyond it.

In another series of indoor works dating from 1976, called Space Division Constructions, viewers entered a rectangular room, with tungsten light directed against its side walls. The facing wall carried a seemingly flat gray rectangle, as if painted on the surface. On closer inspection, this solid form dissolved into space, revealing itself to be an aperture into another chamber. Sometimes this second space was lit from behind the wall; at others, it was filled with a mist of ambient light from the viewer's space. In either case, the perimeters of the room were barely discernible, and one seemed to be looking into limitless dusk.

In both series of works, the effect was utterly disorienting. For as long as it took to decipher what was going on, the all-too-automatic process of visual perception was arrested. We witnessed our own faculties at work. "My desire is to set up a situation to which I take you and let you see," he says. "It becomes your experience."[2] His inclination to structure but not to interpret experience is underscored by his series titles, which describe only the formats of his works—wedges or space divisions—and not their effects. Yet these effects are carefully orchestrated to produce an experience of perception that is at once intuitive and

2 JAMES TURRELL **DANAë** 1983, installation at the Mattress Factory, Pittsburgh, Pennsylvania, tungsten and ultraviolet light, 11 feet 7 $^1\!/_2$ inches x 16 feet

3 $^1\!/_2$ inches x 33 feet; aperture: 5 feet 6 inches x 9 feet 4 inches, collection Barbara Luderowski

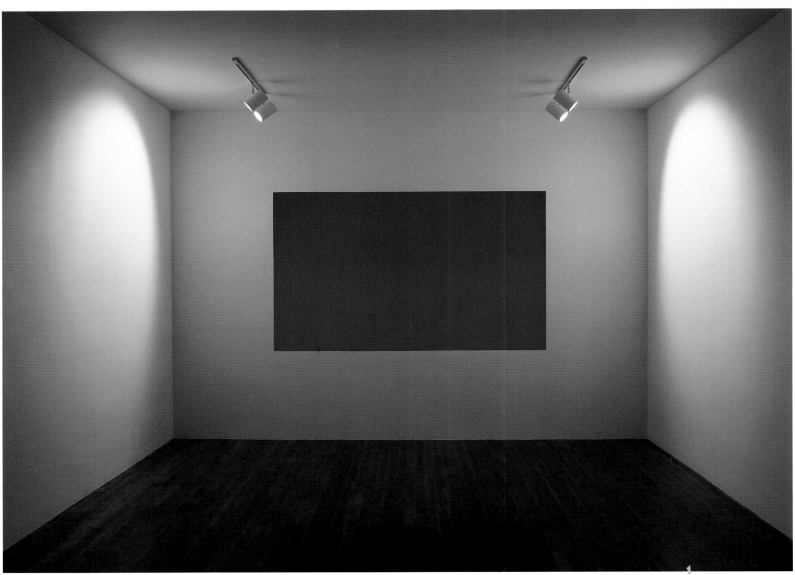

3 JAMES TURRELL **SOLITARY** (FROM **SOFT CELL SERIES**) 1992, aluminum, fiber honeycomb, rubber foam pyramids, incandescent lights,

base: 9 feet 8 ¹/₂ inches x 8 feet ¹/₂ inch; pedestal: 20 feet 3 ¹/₄ inches x 14 feet 2 inches, collection the artist

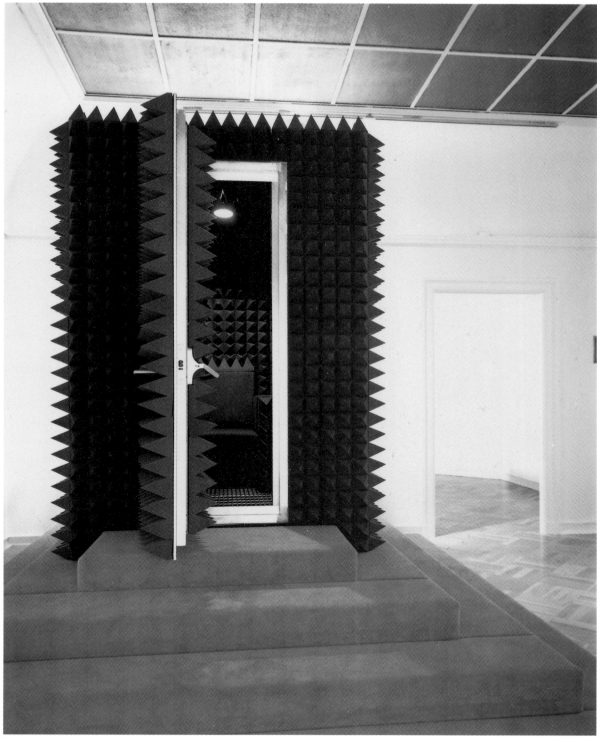

3

4 JAMES TURRELL **SKISPACE** (FROM **SPACE THAT SEES SERIES**) 1992, marble, concrete, fluorescent light with two dimmers, interior room: 23 x 32 x 32 feet,

collection Billy Rose Art Garden, The Israel Museum, Jerusalem, Israel: gift of Hannelore and Ruda Schulhof to the American Friends of The Israel Museum

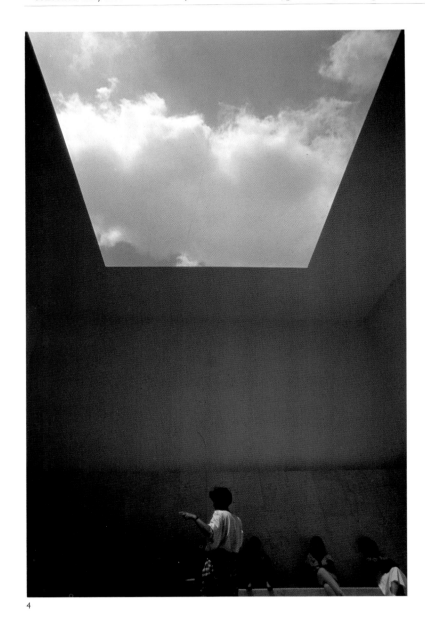

4

cognitive, physiological and psychological. "It's very important to me that you see (a piece) one way at first, and then it reveals itself as something else. Then you go back and see that initial way again. . . . And yet having done that doesn't steal its magic."[3]

Turrell's ideas about perception had their foundation in academic studies. He received a degree in perceptual psychology from Pomona College in Claremont, California, in 1965. His subsequent interest in light and space as media for art was in some measure reinforced by the artistic climate of Los Angeles in those years. His initial experiments paralleled investigations by such artists as Robert Irwin, Maria Nordman, and Doug Wheeler. His perceptual focus was sharpened by research he conducted in the late 1960s as part of the Art and Technology program of the Los Angeles County Museum of Art. Turrell worked with Irwin and the psychologist Edward Wortz, investigating such perceptual anomalies as *Ganzfelds* (completely uniform visual fields) and anechoic or sensory deprivation chambers, in which external light and sound are all but eliminated. These experiences can be discerned in several of Turrell's recent sculptures, particularly those known as Perceptual Cells. *Close Call* (1992), for example, resembles a phone booth. You enter, shut the door, and put your head in a light-filled dome that creates a *Ganzfeld* in which depth perception is particularly difficult. Turrell compares the effect of this sculpture to the experience of seeing under water. *Solitary* (1992), from a series called Soft Cell, more closely resembles an anechoic chamber. It is coated inside and out with black sound-proofing foam. A door opens to reveal a seat. With the door closed, you are isolated in a realm with no sounds except those of your own breathing and heartbeat. Taking the seat shuts off the light inside the chamber. Only after a period of time do the eyes adjust enough to see a faint beam of light on an interior wall.

Much of Turrell's early work was executed in a studio at the Mendota Hotel in Ocean Park, California. He lost this studio—and all the spaces he had created in it—in 1974, but fortuitously received a Guggenheim Fellowship the same year. Turrell decided to use the funds to search the Western United States for a landscape site in which to make his art. Turrell had been flying since he was sixteen, and had become attuned to perceptual phenomena experienced from the air; for example, different qualities of light and atmosphere, the limpid sky of winter in the Western deserts, and the blindness of fog over the ocean. He had

3 Turrell in an interview with Richard Andrews, published in *James Turrell: Four Light Installations* (Seattle: Real Comet Press, 1982), 10.

4 Turrell in an interview with Richard Andrews, published in *James Turrell: Sensing Space* (Seattle: Henry Gallery Association, 1992), 51.

also come to know the phenomenon called celestial vaulting, in which the sky seems like a perfect arch overhead, and the earth's surface has a corresponding appearance of concavity. His fascination with heavenly light and deep space led him to construct a number of Skyspaces beginning in the early 1970s — small chambers with overhead openings — in which people might experience these phenomena in especially vivid ways. It also led to his most ambitious undertaking to date, the Roden Crater project, which is planned for completion near the turn of the century.

As Turrell describes the Roden Crater project, "the idea is to take this artifice, this cultural activity we call art, and bring it into nature." To achieve the optimal sky-viewing effects in the landscape, Turrell knew he needed a site free of air pollution, and a butte or cone that rose at least five hundred feet above a surrounding plain, at an elevation over five thousand feet. After searching for seven months by air, he found his way to the Roden Crater, an extinct volcano near Flagstaff, Arizona. At present, Turrell anticipates creating a series of chambers in and around this cinder cone, which will function variously as *Ganzfelds* and as naked-eye observatories. Four spaces will be oriented to the cardinal directions and reveal the changing qualities of solar light in the course of a day, as well as its seasonal variations. Others will be oriented to lunar or celestial events; some will gather the light of stars millions of light years away. "I am working the earth into the sky, the sky into the earth," he explains, noting that some of the spaces will function like a camera obscura. In others, the light will be altered by its reflection off the black sand of the cinder cone, or off the surface of pools of water he will create in the ground.

Perhaps the central experience of the Roden Crater project, however, will be the perception of celestial vaulting. A tunnel will lead the visitor to the bottom of the inside of the cinder cone, the rim of which Turrell is already reshaping to form a level and perfectly regular ellipsoidal shape. From the inside of a space at the base of the crater, the sky will appear as a thin skin or membrane stretched flat across an opening at the top of the chamber. Climbing outside into the crater itself, the visitor will experience the sky in a completely different way — as a great, deep vault overhead. If the visitor then climbs to the rim of the cone, the sky will appear as a shallow inverted dish curving gently from horizon to horizon, while the earth will seem to be concave.

At first blush, this might sound like a project of megalomaniacal proportions. But based on Turrell's work to date, we can trust that the final product will be both subtle and absolutely magical. Despite its scale, it should have very little impact on the landscape itself. Turrell is replanting the cone with indigenous vegetation to efface all traces of his alterations to the crater's shape. The Roden Crater project may prove, in fact, to be an exercise in humility. Located in an area of exposed geology, it will remind us that the life of the earth extends far back before our time. And like the observatories of ancient peoples — especially Native Americans — to which it bears some conscious resemblance, the project is intended to affirm our connections to solar and lunar cycles, and to suggest conceptions of time infinitely greater than our own.

Once completed, the Roden Crater project will probably have few rivals in its combination of ambition and immateriality. At the same time, it brings to mind other large-scale landscape projects, especially those of Michael Heizer and Walter De Maria, who were also California-born. While the Roden Crater project is bound to feel much less like a mark on the landscape than, for example, Heizer's *Double Negative* (1969–1970), Turrell does seem to share an expansive sense of space and an attitude of virtually limitless possibilities with Heizer and De Maria. Like their works, his display a deeply ambiguous attitude toward art history; they are unlike anything we have seen in art before, yet they resonate with some very traditional and abiding feelings about landscape. In particular, Turrell's Roden Crater project evokes eighteenth-century notions of the sublime, which in their own way were attempts to describe the perceptual and psychological experience of vast space and solitude. The sublime associated the infinite with feelings of awe and even terror; it was conventionally linked with an experience of the divine. Turrell uses the word in a more restricted sense: "I am working for pure visual delight and sensation," he says. "And when I say delight I mean in the sense of the sublime."[4] That is, he is not explicitly evoking either the religious or the terrible aspects of the sublime — although his visitors may experience the Roden Crater project in those terms. He is intent instead on evoking the sense of the wondrous — the mysterious encounter with the infinite available to each of us when we lift our eyes to the heavens.

BILL VIOLA

LUCINDA FURLONG

1 Raymond Bellour, "An Interview with Bill Viola," 34 *October* (Fall 1985), 91–119.

BILL VIOLA (b. 1951, lives in Long Beach, California) creates complex, psychologically probing video installations, many of which are based on past and current cultures and their relationship to the land. His travels have taken him to North Africa, the South Pacific, and to sites throughout the American Southwest in search of subject matters that stress humankind's relationship to the land. Combining video monitors and projections on walls of a room, he uses landscape imagery to explore various levels of reality, especially the psychological terrain between the everyday world and that of dreams and myth. He has had solo exhibitions at a number of institutions including The Museum of Modern Art, New York, New York (1987), the Contemporary Arts Museum, Houston, Texas (1988), the Fondation Cartier pour l'Art Contemporain, Jouy-en-Josas, France (1990), and the Centro Reina Sofia, Madrid, Spain (1993). Since 1977 Viola's work has been regularly included in the *Whitney Biennial*, Whitney Museum of Art, New York, New York and *Dokumenta*, Kassel, Germany.

Bill Viola is not, by any traditional definition, a landscape artist. Landscape has been the exclusive subject of only one of the numerous videotapes and installations he has made over the past twenty years. And yet, landscape, for Viola, remains a central preoccupation, a means of symbolically rendering the workings of his mind.

Viola's use of landscape as a way of plumbing consciousness has evolved from early tapes that explored the phenomenology of the viewing experience. Like many artists who began experimenting with newly available portable video technology in the early 1970s, Viola initially became fascinated with video's plasticity as a medium. While a student at Syracuse University, Viola studied electronic music that, like video, is constructed from electrical energy organized as voltages and frequencies. Unlike film — a photographic process in which the image is recorded onto a light-sensitive emulsion — the video signal is composed of electronic waveforms that can be shaped and processed as temporal events.

This preoccupation with the signal itself is shared by many artists, such as Steina and Woody Vasulka, who pioneered the idea of "playing" various electronic devices like musical instruments — signal generators, synthesizers, switchers, etc. — in order to discover their parameters. Viola's earliest tape, *Information* (1973), was produced in this spirit of experimentation: in it he mistakenly routed a signal from a video recorder back to itself. The resulting chaos of images and sounds, considered abnormal according to broadcast engineering standards, nonetheless opened up new image-making possibilities.

Unlike his colleagues, however, Viola became less interested in the abstraction produced by image processing than in issues of human-perception and how the viewer interacts with the representational image. "Up until that point I thought that the raw material in video was the technology, and then I realized that was wrong, or only half the issue. The other half was the human perception system. I began to realize that I needed to know not only how the camera works, but how the eye functions, and the ear, how the brain processes information."[1]

Viola's dual obsession with the technical capabilities of the medium and the perceptual process is rooted in the same impulse that inspired structural filmmakers of the late 1960s, such as Michael Snow and Paul Sharits, whose films reduced the

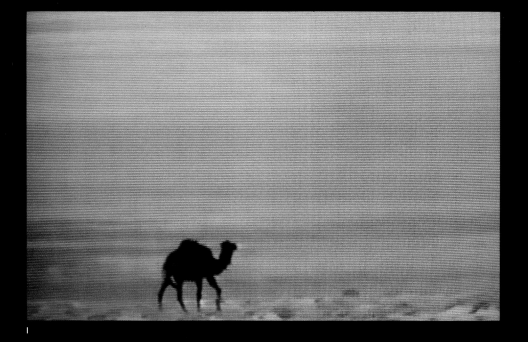

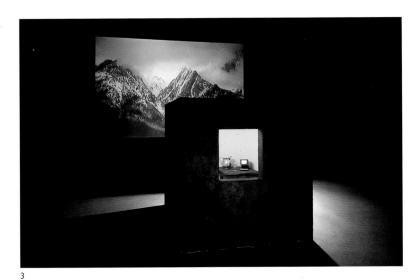

3

4

cinematic viewing experience to its most minimal elements. Unlike these filmmakers, who focused exclusively on the material and temporal properties of celluloid, Viola has always been interested in metaphor. This explains the apparent paradox between the painstaking technical precision of his work and his subject matter. Thus, while his early tapes, such as *Red Tape* (1975), *Four Songs* (1976), and *The Reflecting Pool* (1977–1980), were exercises in which Viola taught himself the vocabulary of video, they also represent his initial forays into the realm of the symbolic. For example, the five short tapes that constitute *The Reflecting Pool* deal with issues of time, duration, and light (the stuff of structural filmmaking) while addressing primal themes such as birth, consciousness, and renewal.

With his 1979 tape, *Chott el-Djerid (A Portrait in Light and Heat)*, Viola focuses on a natural phenomenon—the bending of light rays—to blur the boundary between reality and illusion, between physical and mental landscapes. In *Chott el-Djerid*, Viola makes visually perceptible the effects of the extremes of frigid cold and intense desert heat on the landscape. In constructing a tape in which the duration and composition of each shot challenged the viewer to figure out what one is seeing, Viola suggests that perception is governed as much by psychological processes as by physical phenomena. The tape consists of a series of carefully composed stationary shots of two landscapes with opposite climatic conditions—the snowy plains of central Illinois and Saskatchewan in winter, and the seemingly endless expanse of the hot Tunisian Sahara desert.

Chott el-Djerid opens with what looks like a blank white screen. Slowly, however, it is revealed to be a snowy landscape. As the camera zooms out, a lone tree, barely perceptible in the distance, is reduced to an even tinier speck. This is followed by a sequence of equally minimal shots, all matched to the same horizon line, in which the camera zooms into or out from isolated farmhouses, trees, and utility poles. The falling snow reduces visibility, creating a shaky image that is further distorted by the heat of a camp stove held under the lens. Finally, we see another snowy expanse, marked only by a speck in the distance. As we strain our eyes to decipher it, the speck is revealed to be a person (Viola) slowly moving toward the camera.

The cumulative effect of this exercise is to direct our attention to the perceptual process. For what initially seems to be an empty

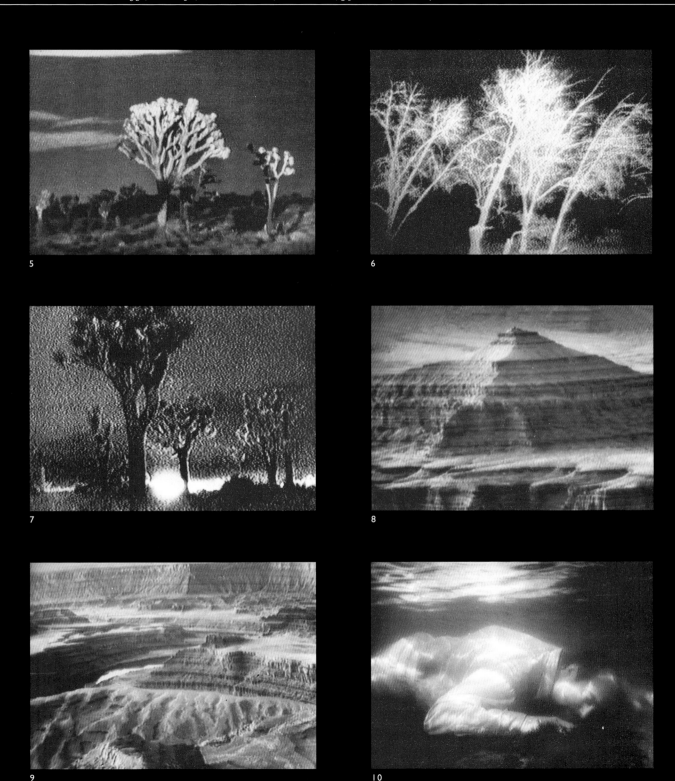

5

6

7

8

9

10

landscape, devoid of all but the most minimal information, is actually filled with numerous visual cues and small events to be deciphered. From this disorienting prelude comes an even more hallucinatory sensory experience derived from desert mirages.

As the monotone snowfields give way to a colorful landscape of sand and intense blue sky, Viola is seen throwing a rock into a bright red-hot spring. The scene dissolves from the scalding water to an arid desert vista. Viola uses telephoto lenses to capture the visual distortions produced when the heat becomes so intense that it actually bends light rays to create a mirage. The result is hypnotic: billowing currents of air and clouds suspended over a desert punctuated by undulating images of an occasional camel, human, vehicle, or palm tree. The landscape and the minimal movement within it seem to mysteriously appear and then dematerialize before our eyes, creating a perception so unstable that it's hard to tell if it's real or a figment of the imagination. Viola has continually probed the disorientation produced by this marriage of physical phenomena and mental processes. But his intense interest in focusing the viewer's attention has always been directed toward prompting us to ask, not only, "How did he do that?" but, "What does it mean?" A central aspect of Viola's symbolism is the way he often uses the most simple images and sounds to great effect, as in the installation *Room for St. John of the Cross* (1983). The piece is based on the experience of a sixteenth-century mystic, St. John of the Cross, who, imprisoned and tortured for his religious views, wrote numerous ecstatic poems. Dominating one wall of a dark room is a large-scale video projection of snow-covered mountains. Shot in black and white from a moving car, the tape's shaky quality is accentuated by the loud sound of the violently blowing wind and white noise that fills the space. In the center of the room stands a small cubicle into which one can peer through a window. The cell, dimly illuminated, contains a pitcher, a glass of water, and a small video monitor. Playing on the monitor is realtime footage of a snow-capped mountain. Audible inside the cell is a voice reciting, in Spanish, St. John's poems, which tell of love, humility, spiritual ecstasy, and flying over walls and mountains.

The obsessive, repetitive quality of the voice reveals a person whose mind and spirit—and possibly sanity—are being tested by the extreme conditions of confinement and torture. By focusing his mind on his recitations, Viola seems to suggest, the mystic was able to keep the roaring noise of impending insanity at bay. Landscape is central to the construction of this metaphor. Viola sets up a series of stark contrasts—between the tiny claustrophobic cell and the space outside, and the large jittery landscape image vs. the small tranquil one—that point to the interior life as a source of strength. The mountains, traditionally a symbol of strength, offer the possibility of freedom, if not from physical constraint, from mental anguish.

The importance of landscape as a source of spiritual transcendence and escape from the confines of the physical is also central to Viola's videotape, *The Passing* (1992). Structured like a recurring dream filled with vivid and unsettling images, *The Passing* is Viola's meditation on the death of his mother, Wynne Lee Viola. Viola's studied use of many of the same formal devices seen in earlier tapes—slow motion, stationary shots, slow pans, and zooms—establishes a dilatory tone well suited to the tape's theme. This is underscored by the fact that the tape was shot in black and white with a sound track dominated by rhythmic breathing.

The Passing opens in total darkness. Three dim points of light and the sound of crickets and cars passing in the distance provide the only clue that we are outside. Viola then cuts to an extreme close-up shot of his face with one eye open. To the sound of steady breathing, he closes his eye, thereby initiating a dream sequence. Here again darkness fills the screen, out of which first emerges a grainy, barely perceptible image of a murky landscape, followed by images of a dead body submerged in water. As if to escape the nightmare, the camera quickly pans up from this dark underworld to the bright sunny surface where a toddler is seen playfully running out of the shallow water across a beach.

These juxtapositions—of light and darkness, of the dream and the waking state, of the realm of the dead under water and that of the living above—are repeated in variations throughout the tape. As in a dream, they assume symbolic significance. But clearly, the most powerful product of Viola's disturbed psyche is the image of the drowned body, which reappears in different forms every time Viola closes his eyes.

Early in the tape, we see the source of the disturbance— Viola's dying mother, who lies sleeping, suspended between life and death. The only indication that she is still alive is the steady

sound of breathing. When she stops breathing at the tape's conclusion, Viola himself is seen lying drowned on the sandy bottom.

Interwoven into the dream sequences is footage of the Western landscape Viola shot at Bonneville Salt Flats, Death Valley, and Joshua Tree National Monument, among others. Throughout the tape, landscape plays a significant role as the place where the passage from life to death occurs. Viola creates this otherworldly symbolism through the selection of images signifying isolation and vastness—cacti, barren boulder fields, mesas carved by centuries of geologic instability, and starkly silhouetted mountains rising sharply from the desert floor. But what most contributes to the landscape's strangeness is the quality of light achieved by shooting in black and white, primarily under low light conditions. The resulting images, which are sometimes grainy, murky, and gray, or else pushed to extreme contrasts of bright light and total darkness, produce an effect markedly different from the rest of the tape, which is sharper and within normal contrast range.

Several sequences in particular suggest landscape's intermediary role between life and death. About halfway through the tape, Viola cuts from a close-up shot of his mother near death, supported by a respirator, to a series of eerily beautiful night shots of Joshua trees. They are illuminated only by the moon or by passing car headlamps. To nineteenth-century Mormon settlers, the Joshua tree was like a Biblical prophet, its branches resembling limbs that pointed the way for travelers seeking the Promised Land.

Viola's metaphor extends to the headlamps as well, which serve as beacons pointing the way to eternal life. He repeats this trope toward the end of the tape at the moment of his mother's death. Wynne Viola is seen in her hospital bed, no longer in close-up. No breathing sound accompanies the image this time. She is dead. The camera fades to black. A beacon of light—perhaps beckoning her to the afterlife—fills the screen, followed by a series of shots of multiple headlights etching the black, nighttime landscape. Viola then pans away from the lights, across a murky gray landscape, and then comes to rest at a tranquil mountain whose crystal clear reflection is seen in a lake below.

Bill Viola has fine tuned his ability to isolate an image, action, or phenomenon and transform it, often through the subtle use of a video effect, into images that are both visually striking and emotionally resonant. In *The Passing*, as in other works, the idea of landscape as a site where spiritual or psychic renewal is possible is articulated through deceptively simple images and sounds. And yet, the clarity and precision with which they are deployed are what make his metaphoric project so unique.

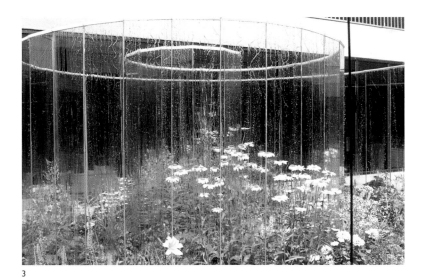

3

4

Ontogeny recapitulates phylogeny, we are taught. So Webster's growth as an individual artist recapitulates something of the history of recent sculpture. From relatively small discrete forms she moved to ever more complex environments that acknowledge the interconnectedness of all the parts of cultural and ecological systems. Several recent projects demonstrate how elaborate the systems in Webster's own work have become, while revealing the persistence of familiar themes: nurture, for example, and the sensory basis of perception. I am thinking here of the two pieces involving falling water alluded to above, one outdoors for the Carnegie Museum in Pittsburgh (1991), the other indoors for the Brooklyn Museum (1992). The former, called *Stream*, was an artificial cascade falling through a bed of river stones over a rubber lining in the museum courtyard; when the water reached the bottom, a visible pump and pipes returned water to the top of the stream. The piece suggested the ways in which technology is ever more implicated in nature, or conversely that nature is increasingly a cultural construct, existing and given form through human agency. *Running*, the piece for the Brooklyn Museum, similarly employed pump and pipes; they sprayed water on a rubber sheet draped over a random arrangement of construction materials. Here again, landscape was an artifice, in this case, moreover, something both attractive and seemingly derelict. A small glass house, like a gazebo, stood beside the stream, and contained books on ecology and the cultivation of plants.

For the Laumier Sculpture Park in St. Louis, Webster has been planning and planting since 1991, a piece she describes as "an interface between garden and park," a one-and-a-half acre environment that includes open meadows and dense groupings of plants that will provide habitat for animals. Called *Pass*, the environment includes a reforested area planted in the form of a pair of lungs; a watercourse and bird- and egg-shaped ponds; a conical depression planted with flowers and a corresponding knoll planted with clover. The overall intention of the project, she says, is "to demonstrate and further natural abundance, ecological principles, the joining of man and nature, the cultivated and the wild."

Perhaps Webster's most complex project to date, however, is a study for a park and community garden for downtown Atlanta,

sound of breathing. When she stops breathing at the tape's conclusion, Viola himself is seen lying drowned on the sandy bottom.

Interwoven into the dream sequences is footage of the Western landscape Viola shot at Bonneville Salt Flats, Death Valley, and Joshua Tree National Monument, among others. Throughout the tape, landscape plays a significant role as the place where the passage from life to death occurs. Viola creates this otherworldly symbolism through the selection of images signifying isolation and vastness—cacti, barren boulder fields, mesas carved by centuries of geologic instability, and starkly silhouetted mountains rising sharply from the desert floor. But what most contributes to the landscape's strangeness is the quality of light achieved by shooting in black and white, primarily under low light conditions. The resulting images, which are sometimes grainy, murky, and gray, or else pushed to extreme contrasts of bright light and total darkness, produce an effect markedly different from the rest of the tape, which is sharper and within normal contrast range.

Several sequences in particular suggest landscape's intermediary role between life and death. About halfway through the tape, Viola cuts from a close-up shot of his mother near death, supported by a respirator, to a series of eerily beautiful night shots of Joshua trees. They are illuminated only by the moon or by passing car headlamps. To nineteenth-century Mormon settlers, the Joshua tree was like a Biblical prophet, its branches resembling limbs that pointed the way for travelers seeking the Promised Land.

Viola's metaphor extends to the headlamps as well, which serve as beacons pointing the way to eternal life. He repeats this trope toward the end of the tape at the moment of his mother's death. Wynne Viola is seen in her hospital bed, no longer in close-up. No breathing sound accompanies the image this time. She is dead. The camera fades to black. A beacon of light—perhaps beckoning her to the afterlife—fills the screen, followed by a series of shots of multiple headlights etching the black, nighttime landscape. Viola then pans away from the lights, across a murky gray landscape, and then comes to rest at a tranquil mountain whose crystal clear reflection is seen in a lake below.

Bill Viola has fine tuned his ability to isolate an image, action, or phenomenon and transform it, often through the subtle use of a video effect, into images that are both visually striking and emotionally resonant. In *The Passing*, as in other works, the idea of landscape as a site where spiritual or psychic renewal is possible is articulated through deceptively simple images and sounds. And yet, the clarity and precision with which they are deployed are what make his metaphoric project so unique.

MEG WEBSTER

JOHN BEARDSLEY

1 All quotations are from conversations and correspondence with the artist, January 1993.

MEG WEBSTER (b. 1944, lives in New York City) uses natural materials with which she often creates simple geometric forms. She has also made a number of monumental conical receptacles filled with flowering plants, through which she celebrates the land's fecundity and capacity for renewal. For her, landscape has ritualistic significance that transcends time and locale, a significance evoked through the actual growth and decay of plants. Webster's installations, such as *Glen* at the Minneapolis Sculpture Garden (1988), *Stream* at the Carnegie Museum of Art (1991), Pittsburgh, Pennsylvania, and *Running* at the Brooklyn Museum (1992), Brooklyn, New York, bring ideas of growth and continuity into the realm of aesthetics. Her work has been included in a number of major exhibitions including *Aperto* at the *Venice Biennale*, Italy (1988), the *1989 Whitney Biennial*, Whitney Museum of American Art, New York, New York, and *El Jardin Salaje* (1991, Fundación Caja de Pensiones, Madrid, Spain). In 1992 the Contemporary Arts Museum, Houston, Texas organized a solo exhibition of her work titled *Meg Webster : Garden and Sculpture.*

It is through a particular strength of Meg Webster's sculpture that we see the elemental components of our world as if for the first time. She works with a repertory of simple shapes—cubes, cones, spheres, spirals—fashioned from soil, salt, water, hay, and sometimes living plants. She has made cones of salt, beds of earth and moss, chambers of hay, caverns of flowers, and glass cubes containing water. Nothing could sound more prosaic. Yet Webster manages to wrest a subtle poetry from these modest means.

To experience Webster's sculpture is first of all to reencounter one's own senses: the olfactory, the tactile, and the auditory, no less than the visual. As one might expect, the visual predominates as we register the shadings of light on a breastlike swelling of earth or the refraction through a column of water, the subtle bloom of delicate green algae on a ball of dirt or a riot of color in a cone of flowers. But the impulse to touch registers almost as quickly. The cone of salt has been packed by hand; we see traces of the artist's touch and want to add our own. The column of water invites the plunge of our hand; the rectangle of earth topped by a layer of living moss—as high as a bed and as wide and as long as our bodies—is teasingly titled *Volume for Lying on Flat* (1989). Before long, we grow aware of the scent of damp earth. Approaching a pyramid of hay, we smell fecundity and incipient rot. Aural stimulus has become a feature of Webster's recent work, with water cascading down fabricated falls and pumped back up again.

Our sensory connection with Webster's art is deepened by the fact that many of her sculptures are meant to be entered. "I want to give people the chance to go within the work. The primary experience is of material, then form. Then you experience your presence within it."[1] Several of her early projects were like simple dwellings. The hay pyramid was entered by means of a ladder, a wooden box—for a 1984 installation at the Mattress Factory in Pittsburgh—by a ramp that led to a small chamber containing two facing seats and just enough room to sit knee to knee. Two of her larger commissions—*Hollow* (1984–1985) for the Nassau County Museum, New York, and *Glen* (1988) for the Minneapolis Sculpture Garden at the Walker Art Center—involved entering an essentially circular space that embraced one in an environment of earth and plants. This notion of enclosure animated two more recent projects as well, the *Soil Ball in a Glass Enclosure* (1989–1990) and *Glass Spiral* (1990). Both were micro-environments, the former indoors and the latter on the terrace of

1 MEG WEBSTER **VOLUME FOR LYING ON FLAT** 1989, peat moss, steel wire, earth, 31 x 81 x 24, courtesy the artist

2 MEG WEBSTER **GLEN** 1988, earth, steel, plants, and fieldstone, 142 x 504 x 510, commissioned with Lannan Foundation support for the Walker Art Center exhibition

Sculpture Inside Outside, at the Minneapolis Sculpture Garden, courtesy the artist

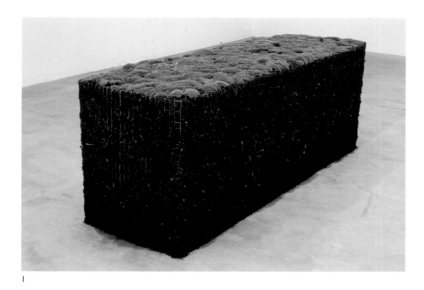

1

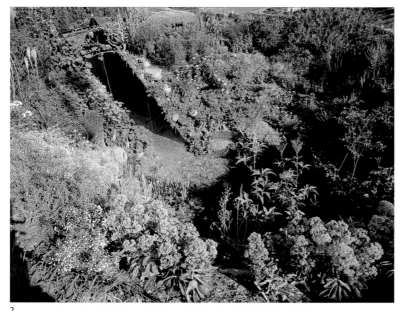

2

2 Jonathan Schell, *The Fate of the Earth* (New York: Alfred A. Knopf, 1982); first published as a series of essays in *The New Yorker* (1, 8, and 15 February 1982).

the Milwaukee Art Museum. *Glass Enclosure* was some eight feet tall and twelve feet square; entered through a door, its humid interior allowed the growth of algae on the soil ball. *Glass Spiral* was composed of a transparent wall set in a mound of earth, which curved in upon itself several times; from its top, water slowly seeped down the glass to nurture plants growing in the soil below.

The notion of enclosure is not meant simply to be salutatory. Neither is the material quality of Webster's sculpture intended only to provide an experience of sensory perception for its own sake. Both are expressions of Webster's determination to make us see our place in the world — to recognize earth as *our* earth, water as *our* water, plants as nourishment to *our* bodies and *our* souls. Dichotomies between inside and outside, nature and culture, city and country, are "horrible and false," Webster insists. Sometimes her determination to connect us with our surroundings is very pointed. *Water from a Dead Lake* (1989) was a container of polluted water, an indictment of the damage we have already inflicted on our environment. More often, however, the tone is more hopeful. Earthen beds, for example, are meant to resonate with ideas of sexuality and nest-building. Planted pieces, she says, "are about caring for nature. Plants make the space, but I am not really interested in composing plants the way a landscape architect would. The plants express enterprise and caring. They connect people to the earth and to growth."

Webster has worked with natural materials since her earliest days as an artist in the late 1970s, when she created small sculptures in sand inspired in part by environmental artists such as Michael Heizer and Robert Smithson. The phenomenological basis of her work—the way in which it focuses attention on our physical existence, on our acts of sensory perception—took shape at the same time, absorbed somewhat intuitively from Minimalist sculpture along with its simple geometric language. Her commitment to landscape was quickened, she says, when she read Jonathan Schell's *New Yorker* essay on nuclear annihilation, "The Fate of the Earth," while a graduate student at Yale in the early 1980s.[2] "It made me wonder," she remembers, "why are we on the edge of destroying the earth?" Thereafter, more and more of her sculptures were literally alive, miniature ecosystems that required careful nurturing.

3 MEG WEBSTER **GLASS SPIRAL** 1990, installation at the Milwaukee Art Museum, Wisconsin, earth, plants, and glass, 86 x 180 x 240, courtesy the artist

4 MEG WEBSTER **RUNNING** 1992, installation at The Brooklyn Museum, New York, water, Butyl rubber, wood, electric pump, cinder blocks, sand bags, wire mesh,

glass windows, books, and computers, 20 x 45 x 80 feet, courtesy the artist

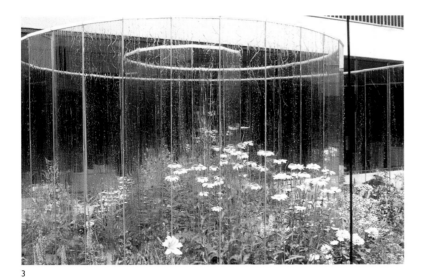

3

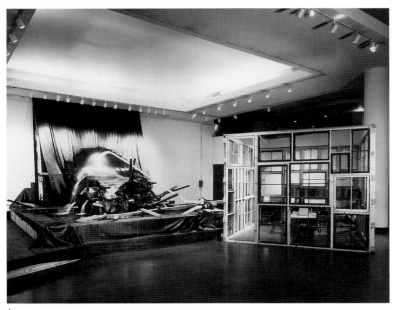

4

Ontogeny recapitulates phylogeny, we are taught. So Webster's growth as an individual artist recapitulates something of the history of recent sculpture. From relatively small discrete forms she moved to ever more complex environments that acknowledge the interconnectedness of all the parts of cultural and ecological systems. Several recent projects demonstrate how elaborate the systems in Webster's own work have become, while revealing the persistence of familiar themes: nurture, for example, and the sensory basis of perception. I am thinking here of the two pieces involving falling water alluded to above, one outdoors for the Carnegie Museum in Pittsburgh (1991), the other indoors for the Brooklyn Museum (1992). The former, called *Stream*, was an artificial cascade falling through a bed of river stones over a rubber lining in the museum courtyard; when the water reached the bottom, a visible pump and pipes returned water to the top of the stream. The piece suggested the ways in which technology is ever more implicated in nature, or conversely that nature is increasingly a cultural construct, existing and given form through human agency. *Running*, the piece for the Brooklyn Museum, similarly employed pump and pipes; they sprayed water on a rubber sheet draped over a random arrangement of construction materials. Here again, landscape was an artifice, in this case, moreover, something both attractive and seemingly derelict. A small glass house, like a gazebo, stood beside the stream, and contained books on ecology and the cultivation of plants.

For the Laumier Sculpture Park in St. Louis, Webster has been planning and planting since 1991, a piece she describes as "an interface between garden and park," a one-and-a-half acre environment that includes open meadows and dense groupings of plants that will provide habitat for animals. Called *Pass*, the environment includes a reforested area planted in the form of a pair of lungs; a watercourse and bird- and egg-shaped ponds; a conical depression planted with flowers and a corresponding knoll planted with clover. The overall intention of the project, she says, is "to demonstrate and further natural abundance, ecological principles, the joining of man and nature, the cultivated and the wild."

Perhaps Webster's most complex project to date, however, is a study for a park and community garden for downtown Atlanta,

5–8 MEG WEBSTER AND PHILIP PARKER MODELS FOR **ATLANTA GARDEN** 1992, proposal for a garden sponsored by Liz Claiborne, Inc. with Park Pride

Atlanta and Y-Core, Atlanta, Georgia, courtesy the artist/architect

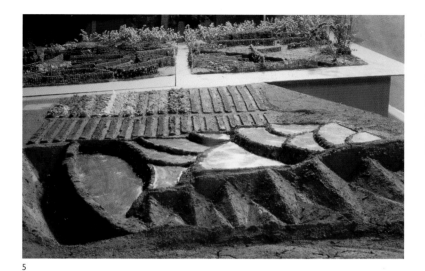

5

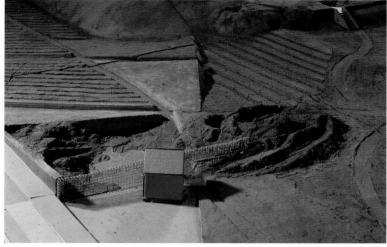

6

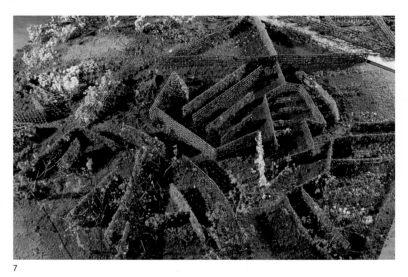

7

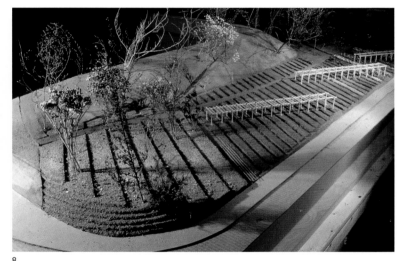

8

developed in collaboration with the architect Philip Parker. To a great extent, the form of the proposal was derived from a reading of the urban context. The site straddles the line between institutional Atlanta, exemplified by the Civic Center, and a typically modest inner-city neighborhood. The park would include earth sculptures, flower and vegetable gardens, orchards, vine-covered trellises, and an environmental education center. A place for both passive and active recreation, it would also be an economic resource for the neighborhood, with produce sold on the site.

Something has been gained and something lost in Webster's recent works. They have grown in scale and they reveal a far deeper understanding than her earlier sculptures of both ecological systems and the social constructions of landscape. But such ambitious environmental projects inevitably depart from the elegant, elemental simplicity of the salt cone or the moss bed. It may be that the enduring strength of Webster's sculpture will be found in the splendid reconciliation of these two seemingly disparate tendencies.

COMMISSIONED WORKS FOR
LANDSCAPE AS METAPHOR

MEL CHIN

LEWIS DESOTO

RICHARD MISRACH

MATT MULLICAN

JUDY PFAFF

MARTIN PURYEAR

EDWARD RUSCHA

URSULA VON RYDINGSVARD

ALISON SAAR

MARK TANSEY

JAMES TURRELL

BILL VIOLA

MEG WEBSTER

MEL CHIN SPIRIT

Pressed against the ceiling of a fifty-foot-long white corridor is a monumental oaken barrel, nine feet in diameter. This swollen form appears precariously balanced on a taut, scorched rope attached to the ceiling at both ends of the corridor. The gargantuan barrel, encircled by giant steel hoops, its staves darkened by its mysterious contents, recalls the casks common to American frontier life. Everyday necessities essential to the survival of early settlers, such as grain, pork, oil, alcoholic spirits, and gunpowder, were transported and stored in these casks.

In those days, the increasing demands of agriculture, industry, and commerce set into motion the inexorable process of redefining the American landscape. An unhappy consequence of this transformation, which began with a vengeance during post-Civil War westward expansion, was the reduction of the indigenous ecosystem to, in Chin's words, "a thin green line." *Spirit* is his meditation on the Tall Grass Prairie, a lost American landscape that once extended from Minnesota southward to Texas and Oklahoma. The rope, composed of prairie grasses acquired by Chin from a national preserve,* suggests not only the vestigial green line but the ragged horizon of a disquieting psychological landscape. Symbolic of man's aggressive interventions in the landscape, the giant barrel is a mesmeric, potentially explosive presence.

* Big Bluestem and other vanishing species of indigenous grasses used in Chin's rope were collected for *Spirit* with the permission of the Nature Conservancy, Kansas City Field Office, Topeka, Kansas.

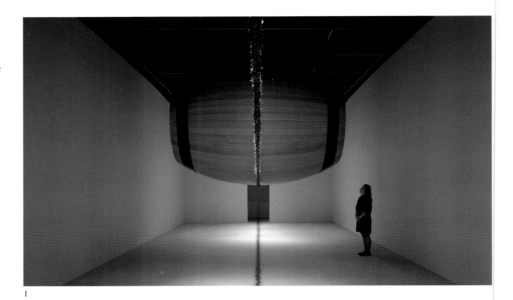

1

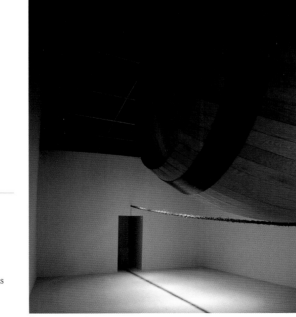

2

1–3 MEL CHIN **SPIRIT** 1994, white oak, mixed Tall Grass Prairie plants, steel, industrial patina, sheetrock, paint; Room : 13 feet 9 inches x 20 x 50 feet;

Barrel: 12 feet long, 9 foot diameter; Assistants: Art Bernal, Barron Brown, Bill Durrua, Keith Grenoble, Gordon Harrod, Tam Miller, Jerry Murphy, Doug Warnock, and the Special Problems Workshop (University of Kansas at Lawrence)

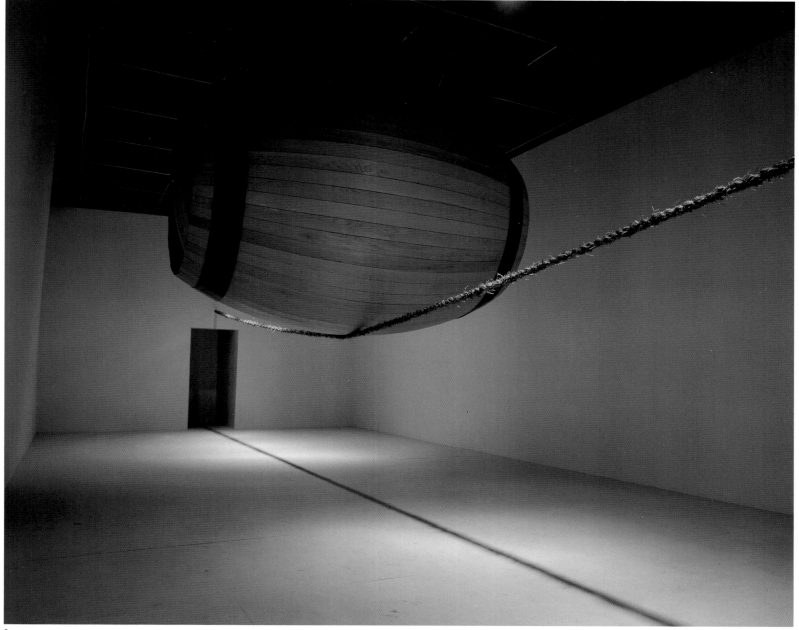

3

4–6 Mel Chin and assistants gathering grasses on the Kansas prairie for the *Spirit* installation at the Denver Art Museum

7 *Spirit* (detail of braided rope)

4

5

6

7

8

9

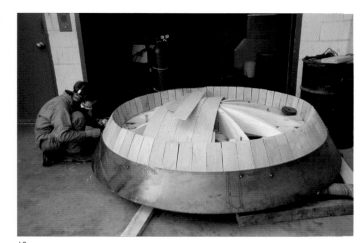

10

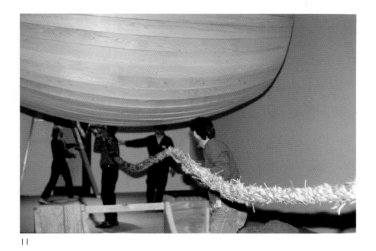

11

1, 2 **LEWIS** De**SOTO** TAHQUITZ 1994, two video monitors, six-channel speaker system, galvanized steel table, ice, two ceramic ollas, automated light table and map with text; 13 feet 9 inches x 28 x 32 feet; Assistants: Jordan Biren, Lisa Galli, Stephen Galloway, Fernando Mariscal, John Roloff, Alvino Siva, Dan Stingle

3 *Tahquitz* under construction at the Denver Art Museum

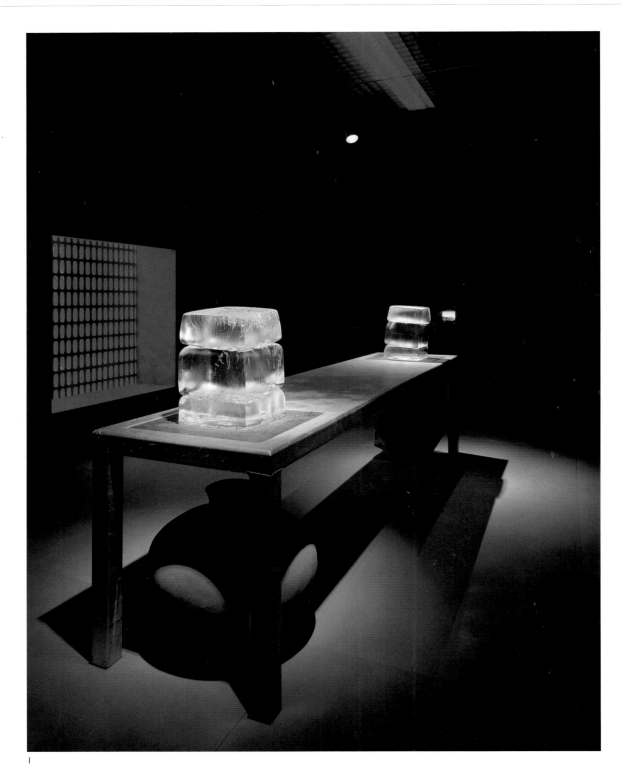

1

LEWIS deSOTO TAHQUITZ

Lewis deSoto's moody, austere installations, such as *Tahquitz*, are filled with references to Cahuilla Indian culture that include descriptive texts about its origins and beliefs, and videotaped images of its land in the southern California desert. Through his art, he envisions a reconciliation of long held tribal beliefs central to his Cahuilla heritage, and complex scientific theories about humankind's relationship to the universe, ranging from cosmic strings to fractal geometry. In both perceptions, ancient and modern, the landscape exemplifies a timeless, intricate order within which all of nature's manifestations, animate and inanimate, are interdependent.

As Cahuilla tradition has it, certain areas of the land are the domains of potent spirits, some benign, others fiercely destructive. Their powers are synonymous with nature's unpredictable forces. In his *Landscape as Metaphor* installation, a Cahuilla Indian creation myth about a fearsome ice spirit, Tahquitz, who inhabits a peak in the San

Jacinto Mountains, is metaphorically evoked. Tahquitz (pronounced tah-kwish) feeds on the spirits of humans luckless enough to enter his realm.

Within a somber, blue-lit space, a long, galvanized-steel table supports two huge blocks of ice, which represent the hapless victims of the demi-god. Water from the melting ice drips into two large ceramic ollas beneath the table. The ice blocks are replaced periodically. At opposite ends of the room, videotaped images of the San Jacinto range, including the ominous "Tahquitz" peak, glow on two video monitors. On one monitor, the mountain range appears in "real time," while on the other, it is revealed in a sweeping dawn-to-dusk time-lapse sequence. From speakers installed in various locations, a voice narrates the Tahquitz story in the Cahuilla language. As sound comes from different parts of the room, an invisible narrator seems to be moving restlessly about the space.

2

3

4

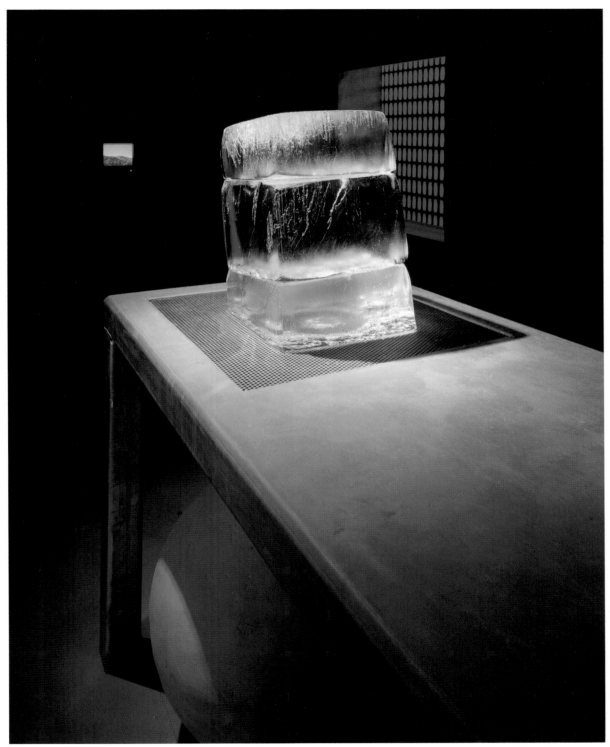

1

RICHARD MISRACH

DESERT CANTO XV THE SALT FLATS

Like so many Richard Misrach photographs, those in his recent Bonneville Salt Flats series are filled with multiple meanings. What at first seems to be a richly detailed photo narrative about high-speed automobile racing takes on troubling historical resonance once we know something of the history of this barren, other-worldly site.

As Misrach points out, few of those participating in the excitement of the car races have any idea that some one hundred and fifty years ago, in this remote place, a far different event involving time and speed—in fact, a tragedy of mythic scale—occurred. On this same patch of desert, the ill-fated, California-bound Donner party was forced to put off its crossing of the Sierra Nevada Mountains. Numbering seventy-eight men, women, and children, these beleaguered pioneers unfortunately delayed their mountain crossing just long enough to encounter the full force of a lethal blizzard, which claimed half their number.

In these desert vistas, Misrach subtly alludes to an older pioneer spirit. Among these images is a gleaming, silver-sided mobile home—a latter-day Conestoga wagon that, unlike its lumbering predecessor, can easily traverse any terrain and cruise the highways at speeds up to ninety miles per hour. In the middle distance of another print, *Danny Boy,* is a low-slung, missile-shaped vehicle capable of accelerating up to six hundred miles per hour. Next to this modern "horse" are two stiffly posed cowboys—the old West meets hi-tech.

In Misrach's ironic view, the Bonneville Salt Flat races could be considered as a present-day expression of the adventurous spirit of Manifest Destiny that inspired nineteenth-century settlers to tame the wilderness. The nomadism of those early days is even recalled in a "setting-up-camp" photograph made near the speedway. Here, instead of the legendary chuck wagon, is a complete chrome and plastic luncheonette, whose

counter, tables, and chairs are neatly, if incongruously, arranged on the desert's white floor.

For his Bonneville photographs, Misrach turns his camera away from the races themselves, preferring instead to record the effects on the landscape of these colorful events. As with his other thematic series using desert imagery, the Bonneville Salt Flats photographs are his archaeological records of man's intervention in nature's timeless order.

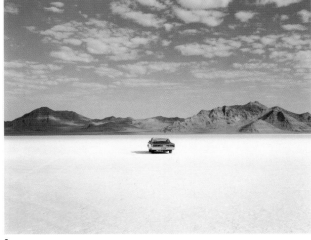

2

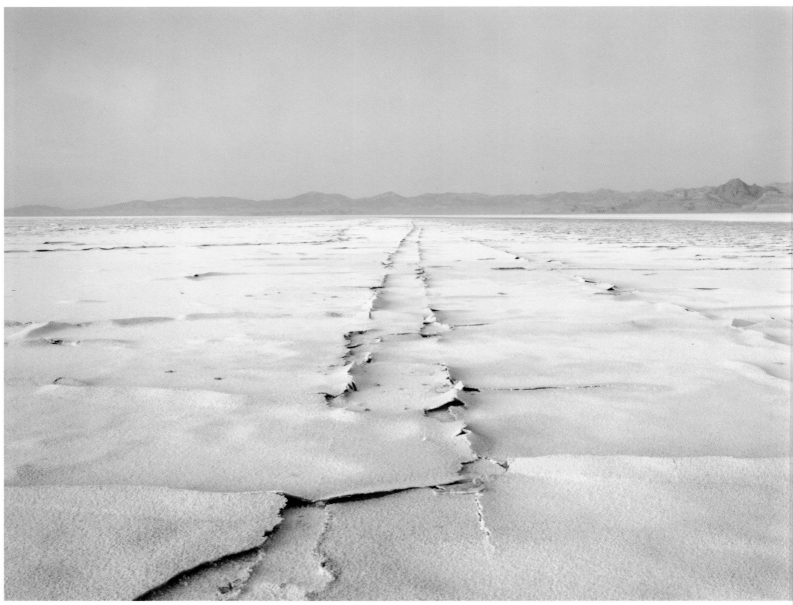

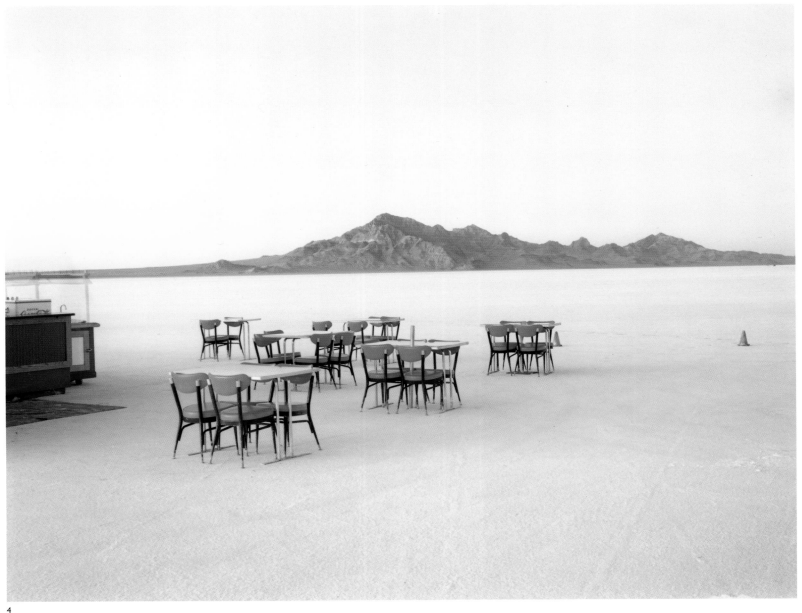

4

MATT MULLICAN FIVE INTO FIVE

The abstract landscapes of Matt Mullican derive from the idiosyncratic, autobiographical philosophy he began diagramming in 1973, as a way of giving symbolic structure to his extremely subjective interpretation of the composition of the world. This approach is predicated on personal experiences and perceptions, as opposed to actual geography. His recent birch plywood floor sculpture *Five into Five*, composed of geometric hollowed and raised elements, is a three-dimensional expression of an imaginary world whose configurations change dramatically as the observer walks around and looks down upon it.

Mullican's maps refer not to actual places but to the indeterminate region between reality and imagination. He thinks of landscape as a simultaneously psychological and physical realm, free of specific time and geographic constraints. In this interpretation, it can be an abstract representation of an ordered universe or a schematic portrait of an architectural system. For example, the stark geometry of his schemes, as exemplified by *Five into Five*, suggests the anonymous, interchangeable character of urban America today.

Since 1973 Mullican has depicted his conceptual landscape in various media, including drawings, rubbings on canvas, banners, posters, incised stone, etched glass, computer-generated video images of fictional cities, and floor plans for exhibitions of his work. Among its recent manifestations are several large-scale floor sculptures, such as *Five into Five*.

1 *Five into Five* under construction at the Denver Art Museum

2 MATT MULLICAN **FIVE INTO FIVE** 1994, sapwood birch, wax, 2 feet 4 ½ inches x 16 x 32 feet; Assistants: Jin Kyo Chung, John Lupe

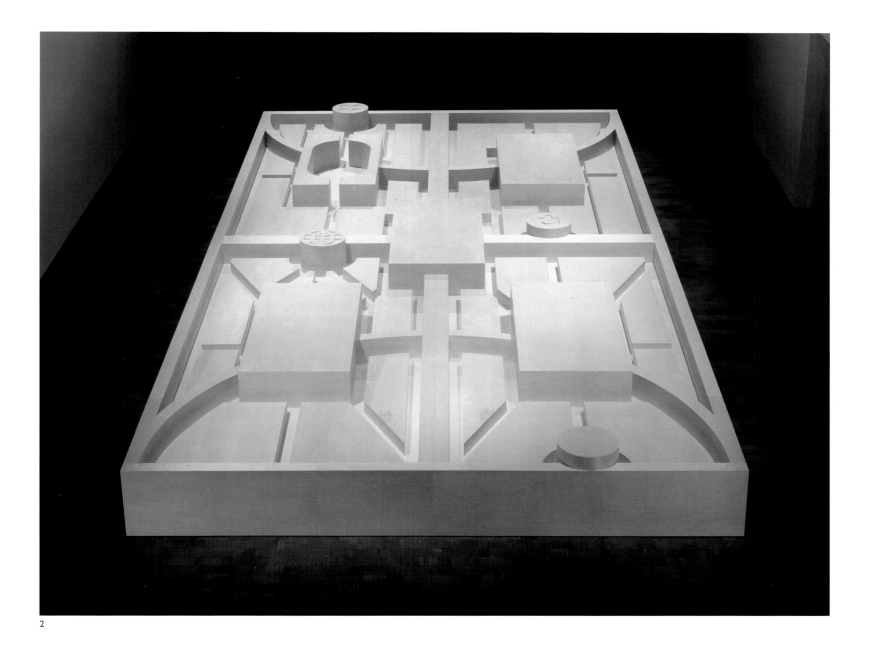

2

3

4

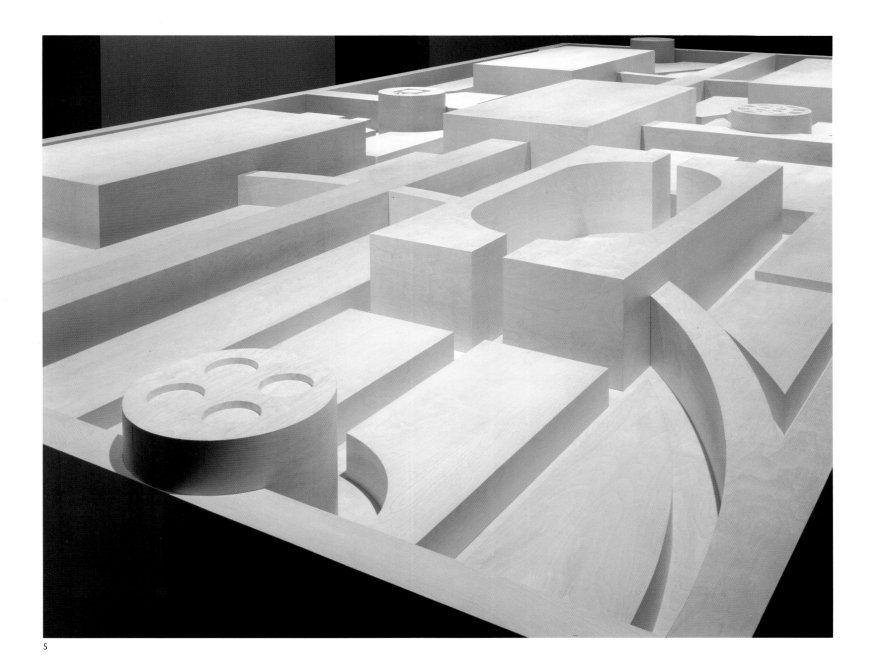

5

JUDY PFAFF CIELO

High over the roof of the Denver Art Museum, from cables attached to the building and castlelike parapet, *Cielo,* Judy Pfaff's vibrant levitating landscape of solid and transparent forms, moves with the wind. Suspended within the three-dimensional calligraphy of its cables and stretched fiberglass filaments are drift nets, plastic netting, lead weights of various sizes and shapes, translucent, thin-walled plastic forms reminiscent of ocean kelp, giant seed pods, and cocoons — plus several Christmas pine trees, whose roots and bare branches have been partially stripped and heavily textured by burning, tarring, and wrapping with wire.

Pfaff thinks of the landscape not only in naturalistic terms but as an extension of her physical being and psychological state, a perception embodied in her sculptures. Giving form to this idea are Pfaff's clusters of seemingly unrelated objects suspended in airy configurations. In her surreal landscapes, improbable exotic forms freely combine with familiar ones.

Pfaff says she arrived at her view of sculpture as a scattering of forms in space after a first-time snorkeling experience in the Caribbean some years ago, where she found herself fascinated by the shifting patterns of underwater vegetation and her ability to move freely among their gently undulating forms. In these unfamiliar surroundings, she recalls, shapes and patterns would appear, dissolve, and reappear in endlessly varied arrangements. Soon after this illuminating experience, her approach to making sculpture was radically transformed; instead of thinking of it conventionally as solid, obdurate mass, she concluded her work could be virtually weightless, ever changing. Her new ideas about the fluidity of form and how shifting patterns of light and shadow could become part of her work became elements of her aesthetic. Because of the increasing scale of her sculptures, she began thinking of herself as both an intruder and participant in them.

Whether projecting from the wall or hung from the ceiling, Pfaff's sculptures are essentially abstract landscapes filled with salvaged man-made objects, those gleaned from nature, and many fashioned by her of

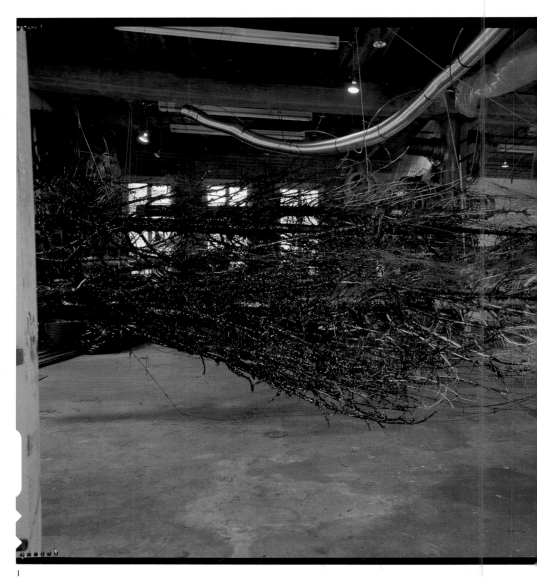

fiberglass, wire, metal, and lead. Their buoyant, gravity-defying elements are in constantly changing relationships to one another.

1 JUDY PFAFF **CIELO** 1994, mixed media, 25 x 100 x 25 feet; Assistants: Heather Moore, Steve Weiss, Sui Zhao; elements of the work in progress at the artist's studio in Brooklyn, New York

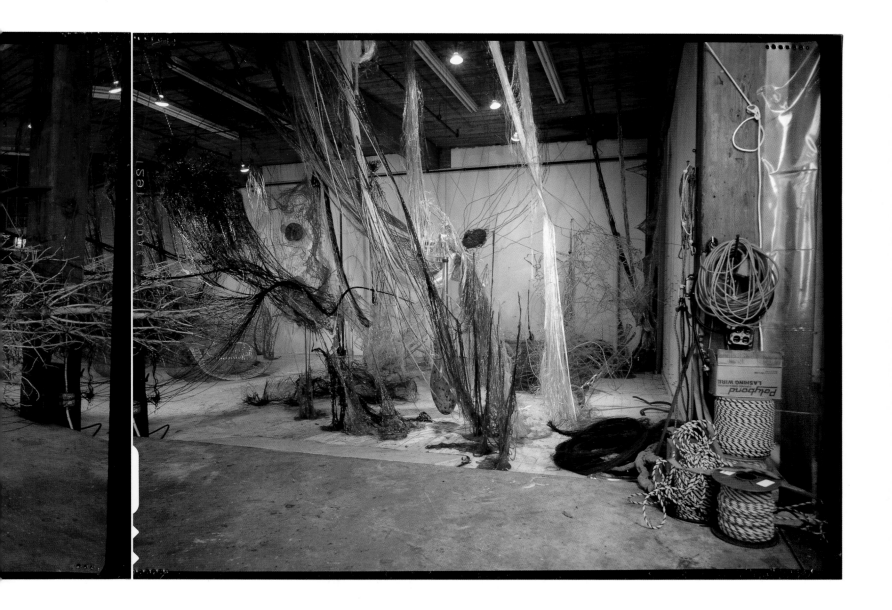

2

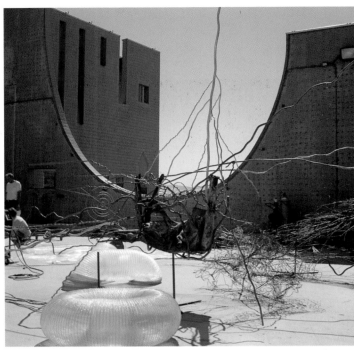

3

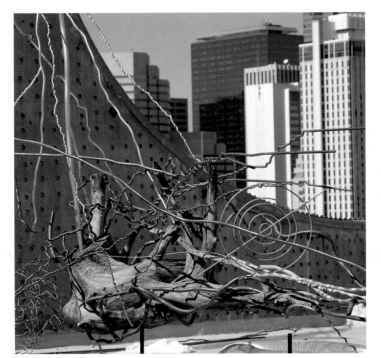

4

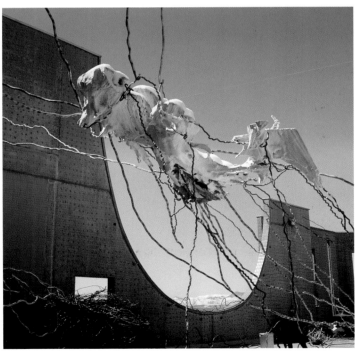

5

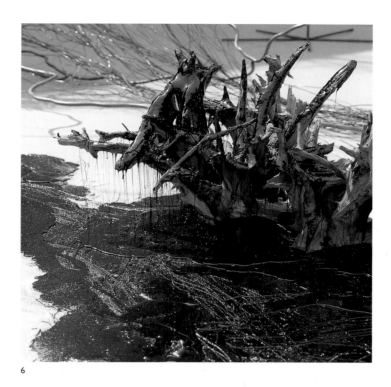

6

7

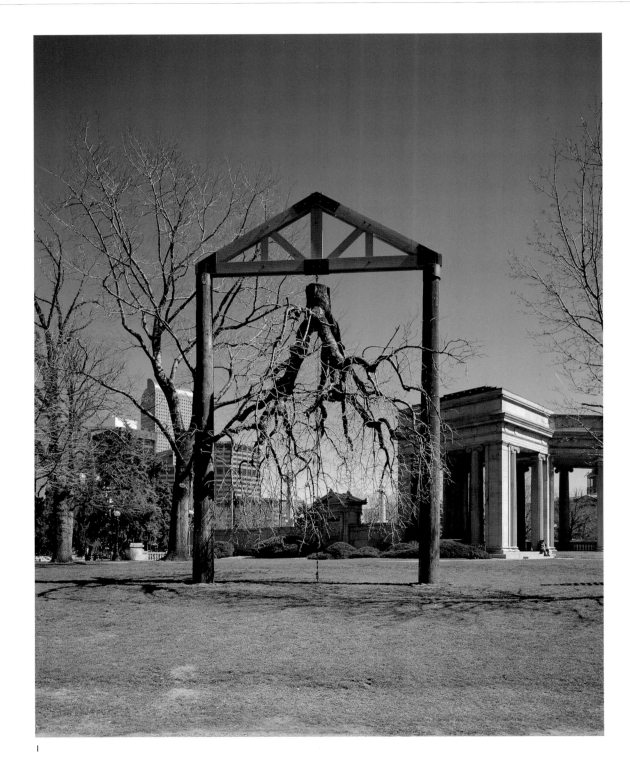

I

MARTIN PURYEAR CAMERA OBSCURA

2

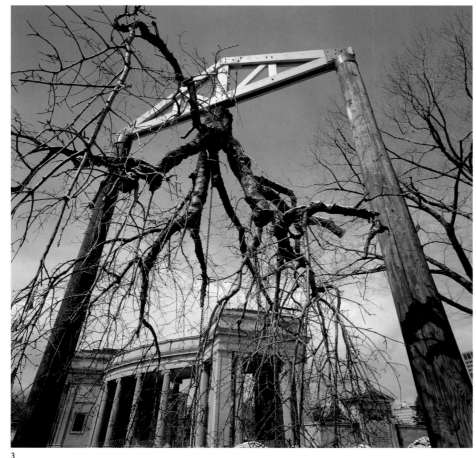

3

Installed on city-owned park land directly across the street from the entrance to the Denver Art Museum is an arresting, improbable image: an upside-down cherry tree. The tree, selected from an abandoned orchard now destined for development as a recreation area in the Colorado Rockies, is some 20 feet in height and suspended from a stout wood gable held aloft by two vertical wood posts. Its trunk has been cut along the line where it met the earth. In place of its vanished roots, inverted branches form a tangled linear mass extending beyond both supporting posts. In this indelible image, the worlds above and below the earth are eerily merged.

Martin Puryear's sly inversion of reality, however, soon takes on unsettling overtones. This felled tree, his somber vision of the late-twentieth-century landscape, differs radically from the generalized organic shapes usually associated with his art. Although those sculptures, too, are strongly associated with nature— their materials and shapes recall seed pods, gourds, and mountains, and a few are stylized portrayals of animals—they offer a far more harmonious view of the world than emanates from this spectral tree.

Indeed, Puryear's deracinated tree can be read as a mournful presence. On one level it is a mythical being whose writhing limbs are a synthesis of human and arboreal forms; on another, its stark clot of branches hanging from a wood truss suggests a doomsday scenario, perhaps an execution. Its enigmatic subtext, especially as the world's great forests are harvested into oblivion, might be the death of nature itself.

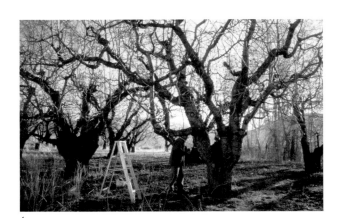

4

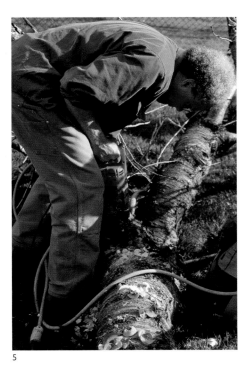

5

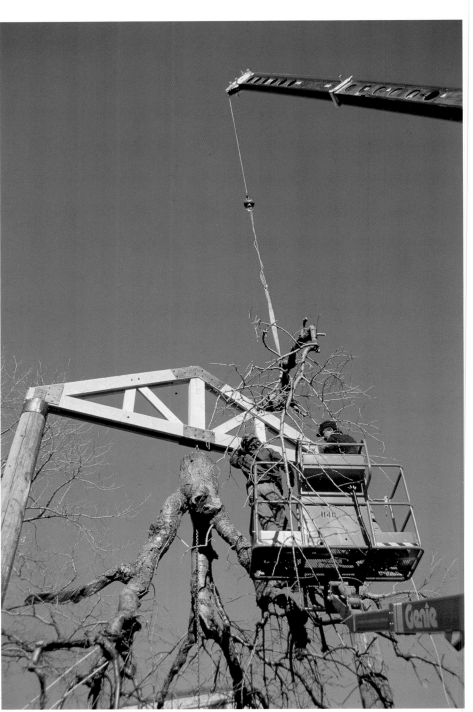

6

7

8

EDWARD RUSCHA

SCRUBSCRATCH

LAND

SAND

Single words and cryptic phrases imposed on sparse landscape have long been components of Ed Ruscha's irony-tinged painted renditions of Americana. Although his earlier desert landscapes were idealized, even confectionery, visions of Western skies and horizons, his recent paintings reveal a mordant, often disquieting edge. In such brooding vistas Ruscha seems to fixate on the dark side of the American dream, a somber, even melancholy, vision of the West that is the antithesis of the into-the-sunset, Hollywoodized interpretation of the frontier.

In three long paintings, each less than two-feet high—one, a twenty-six and a half foot-long diptych, the other two, some thirteen feet in length—the sky, ground, and vegetation share the same dark tonality. Within all three attenuated horizontal formats, a few elemental landscape forms appear as

2

murky silhouettes on low horizons.

Using the principle of anamorphism, by which images can be compressed or expanded—the Cinemascope lens is a good example— Ruscha has created a series of tantalizing visual enigmas based on his desert themes. What at first seem lines of irregular cryptic shapes floating over the pictures' surfaces soon reveal themselves to be words, especially when the canvases are viewed from the side. (He calls these his "rubber-band paintings.") The two-part picture bears the words "Scrub" and "Scratch," while the shorter ones bear the words "Land" and "Sand," respectively. While each canvas is a self-contained composition, when installed on adjacent walls they are, thematically, a continuous whole.

3 EDWARD RUSCHA **LAND** 1994, oil on canvas, 20 × 159

4 *Land* (detail)

3

4

5 EDWARD RUSCHA **SAND** 1994, oil on canvas, 20 × 159

6 *Sand* (detail)

5

6

Ursula von Rydingsvard
Slepa Gienia (Blind Eugenie)

Created for the roof of the Denver Art Museum, a vast platform whose surrounding walls are interrupted by notches and arc-shaped cutouts that reveal the dramatic panorama of the Rockies, Ursula von Rydingsvard's sculpture *Slepa Gienia* (the name derives from a Polish children's game) is a procession of thirteen massive horizontal wood units. These raw-edged floor pieces, each some three-feet high and fourteen-feet long, have generally the same overall elongated form and are deployed, at even intervals, parallel to one another, on the roof's light gray surface.

Like all von Rydingsvard sculptures, these indeterminate shapes bring forth many associations. Constructed of roughly carved lengths of laminated cedar and darkened with graphite, their configurations variously suggest enormous vats, bowls, carts, hospital litters, and spirit boats found in ancient burials. Cryptic anatomical references abound in these works.

Rising from the upper edges of their hollowed masses, for example, are sensuous, rounded shapes, subliminally suggestive of human musculature.

Not the least of these associations is landscape imagery. The contours and textures of these weighty carved and laminated forms suggest primal topography. Their raw, irregular sides, defined in heavy relief, resemble geological formations, cliff walls, and secret caves. When all thirteen components are contemplated, one behind the other—especially with the borrowed view of the Rockies in the far distance—the impression is, at once, of vast terrain, successive layers of jagged horizons, and a bridge leading to the distant mountains.

1 Ursula von Rydingsvard at work building *Slepa Gienia* in her Brooklyn, New York studio

2 **URSULA VON RYDINGSVARD** SLEPA GIENIA (BLIND EUGENIE) 1994, cedar and graphite, thirteen elements: each ca. 3 x 3 feet 4 inches x 14 feet;

overall size: 3 x 14 feet 6 inches x 150 feet; Assistants: Inga Johannsdottir, Bart Karski, Herbert McGilzray, Carmen Olmo, John Townsend

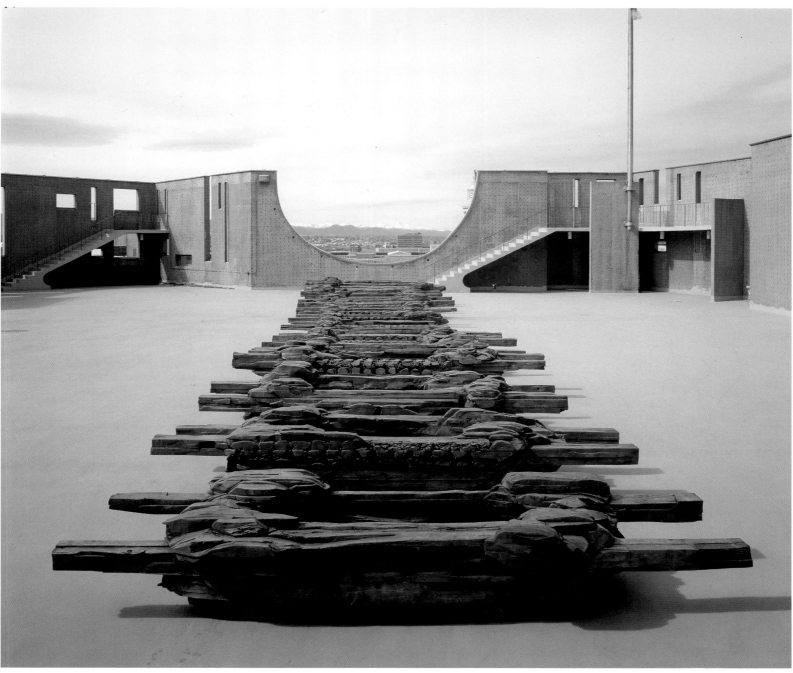

2

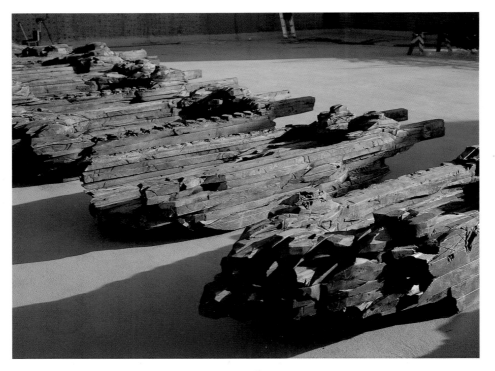

3

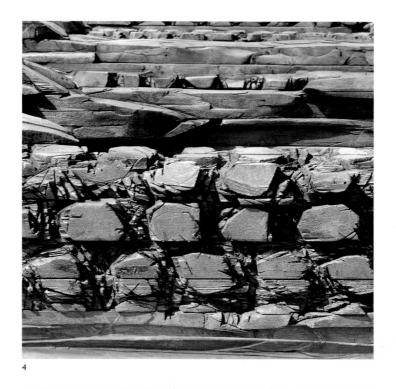

4

5

ALISON SAAR TREE SOULS

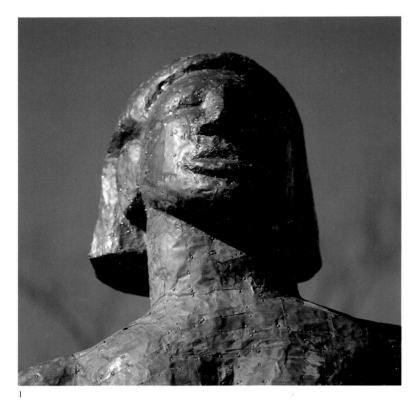

1

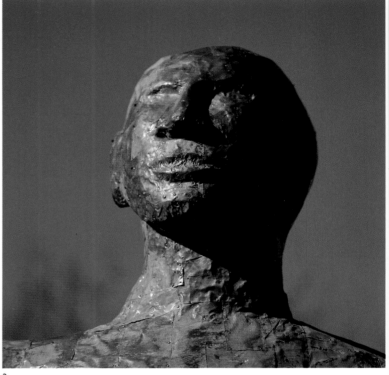

2

The upper bodies of Alison Saar's chain saw-carved, copper-sheathed male and female personages emerge from thick tangles of roots, like burgeoning forms in nature. While these stiffly posed, quasi-abstract magisterial figures reflect Saar's deep interest in manifestations as varied as African tribal art, Afro-Caribbean images, and archaic classical sculpture, their highly individualistic style of carving and overall feeling reflects a decidedly contemporary artistic sensibility.

Raised in a hillside community overlooking Los Angeles, Saar has always thought of the landscape as imbued with history and mythology. So fascinated at an early age was she with the vivid legends and mythologies of indigenous cultures that, she says, "I believed that the trees, stones, and even the hills themselves had a life to them. Each element of nature had a personal memory, a history of what it had experienced, survived and witnessed." And so ingrained in her conscious-ness is this conviction that it continues to strongly affect her approach to making sculpture. Though Saar doesn't use landscape imagery in conventional ways, it is, nevertheless, omnipresent in her sculpture. It is evident in her use of tree forms, which retain their naturalistic quality, even after she cuts and shapes them. Many of the characters in her invented narratives are embodiments of benevolent or demonic natural forces. While some are loosely based on traditional Afro-Caribbean folklore, most derive from her fertile imagination.

The identity of *Tree Souls* giant figures remains ambiguous. When asked for details, Saar charac-terizes them simply as forest spirits. Through such images of invented other-worldly beings, she expresses her ideas about human-kind's interrelation-ship with the landscape and its dependence on the earth for physical and spiritual survival.

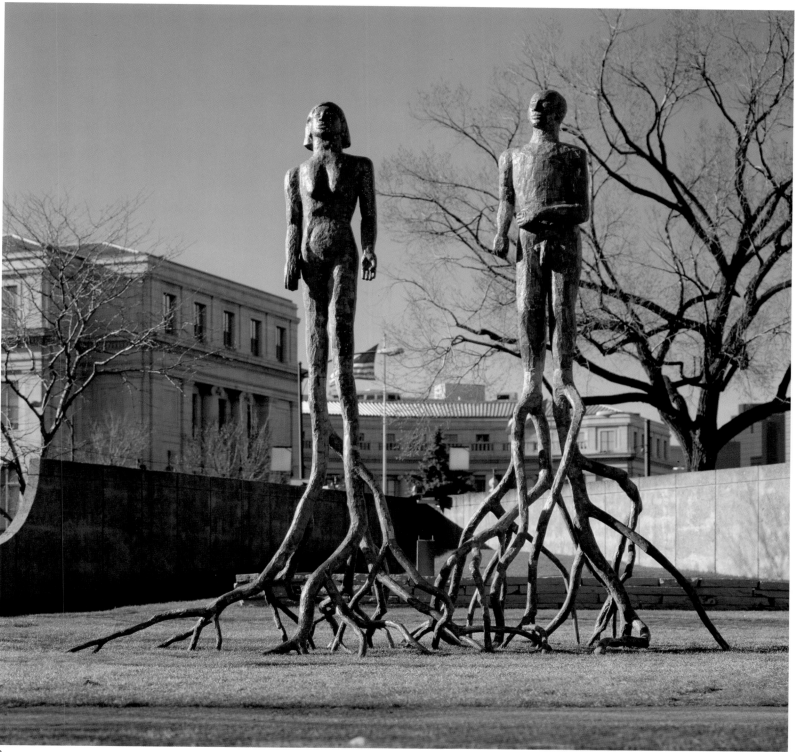

3

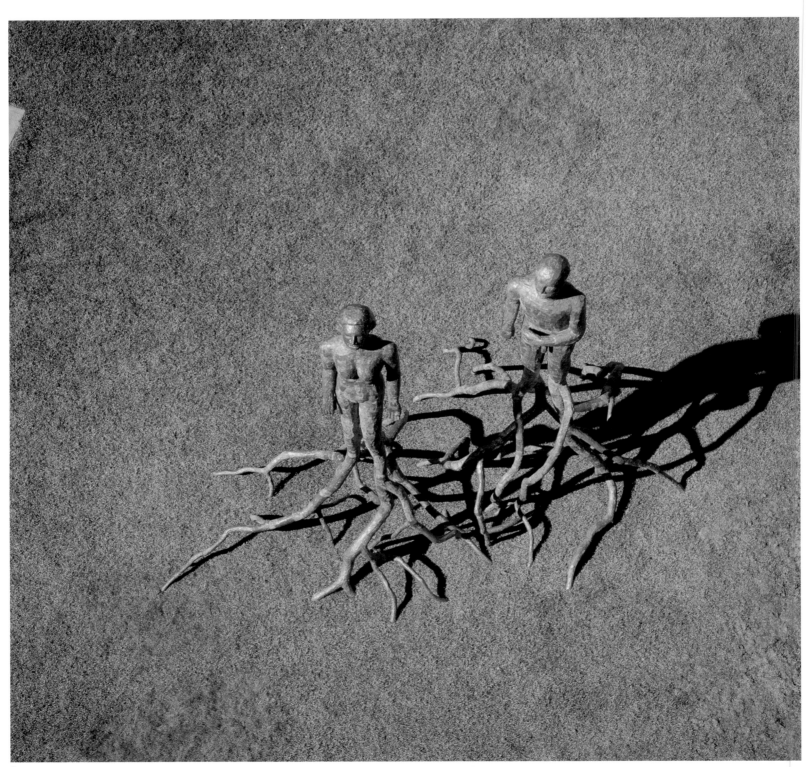

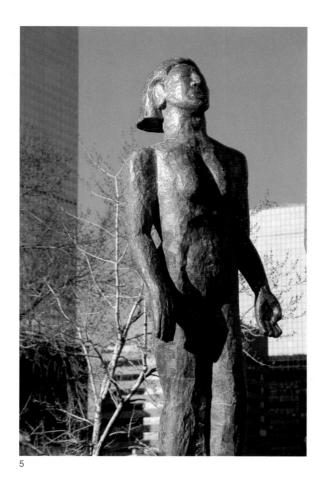

5

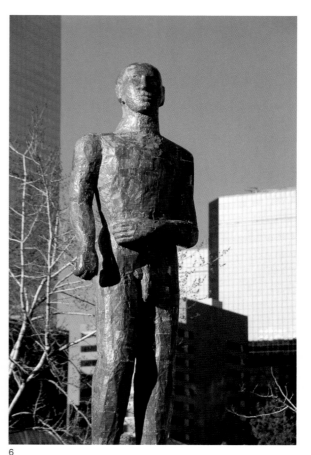

6

MARK TANSEY

LANDSCAPE

WATER LILIES

LIBRARY OF BABYLON

Three radically different views about landscape are posited by Mark Tansey in a trio of large, monochromatic paintings titled *Landscape, Library of Babylon,* and *Water Lilies.* While their factually descriptive style lies somewhere between academic realism and narrative illustration, these are purely fictional vistas.

In the red-toned *Landscape* he conjures up a hallucinatory prospect: a monumental pyramid of fallen stone heads depicting ancient spiritual and political leaders. These battered visages range from those of Egyptian pharoahs and Mayan warrior-kings to heads of more contemporary despots on the world stage, notably Hitler and Stalin. Tansey's mountain of tumbled stone portraits, which press against and abrade one another, can be read as a "text" about the accretions and erosions of power throughout history.

Library of Babylon, the most abstract of the three paintings, is a theoretical vista, a landscape of evolving structures of knowledge. Tansey's point of departure for this work was, ironically, Peter Breughel's mid-sixteenth-century *Tower of Babel,* which also makes its appearance here. Other familiar spiraling forms quoted in this improbable panorama are a Piranesi labyrinth, the spires of a Baroque church, and the circular stairs of a Victorian library. The ultimate library, however, depicted in Tansey's painting, is Watson and Crick's double helix, symbolic of the elaborate complex of genes in which all human attributes are forever encoded.

Based on Monet's celebrated Nymphea series, Tansey's *Water Lilies* is about what the Impressionist master omitted from his canvases. While Monet, concentrating on reflections of light and color, focused on the shimmering surface of his Giverny water garden, Tansey aspires to represent other properties of water, such as its depth, transparency, movement, and variability under changing temperatures. Swiftly rising water spills over the garden's sluice gates, as happened in Giverny during the winter of 1910. In the process, the pond's transition from frozen state to fluid tranquility to turbulence calls attention to its dynamic complexity, the properties of water Monet chose not to depict.

1 MARK TANSEY **STUDY FOR LANDSCAPE** 1994, collage on paper, 11 1/2 x 23 © Mark Tansey, courtesy Curt Marcus Gallery, New York

2 MARK TANSEY **LANDSCAPE** 1994, oil on canvas, 71 1/2 x 144 (work in progress)

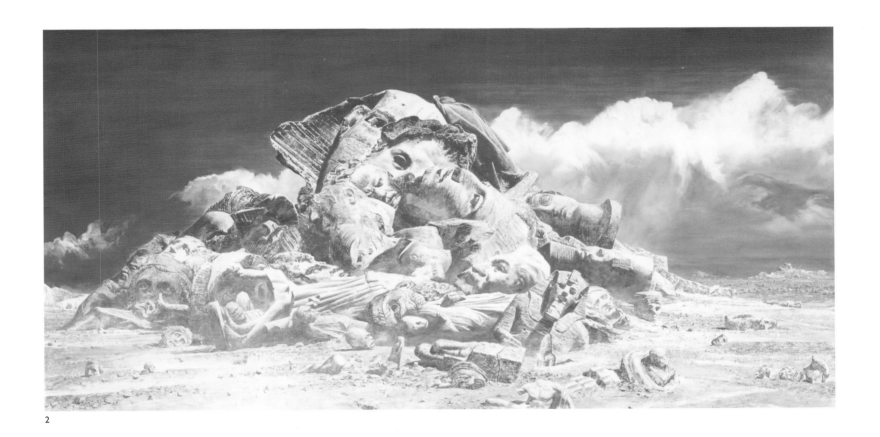

2

3 MARK TANSEY **WATER LILIES** 1994, oil on canvas, diptych, 60 x 192; each panel 60 x 96

4 MARK TANSEY **LIBRARY OF BABYLON** 1994, oil on canvas, diptych, 56 x 192; each panel 56 x 96; Assistant: Iver Flom

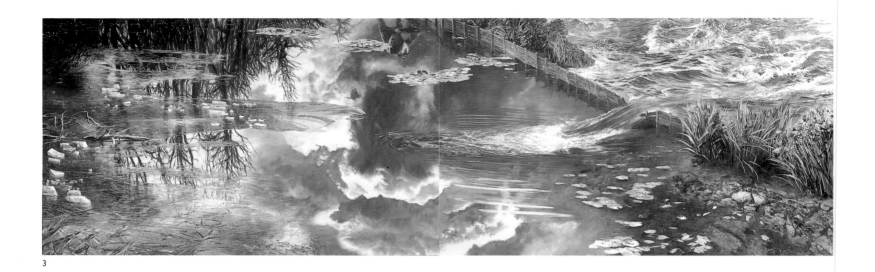

3

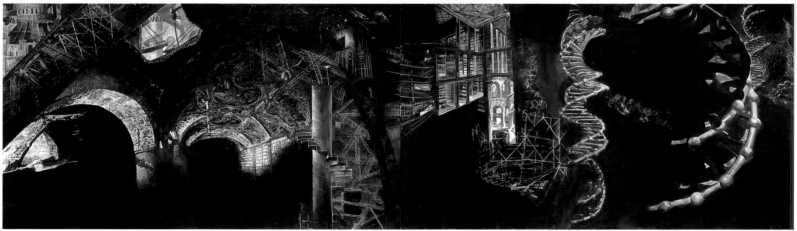

4

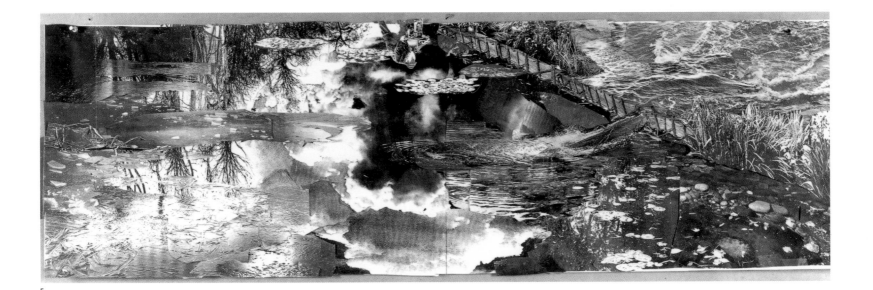

5

JAMES TURRELL TRACE ELEMENTS

1

Of the many interior installations Turrell has made for museums, galleries, and alternative spaces here and abroad, his "aperture pieces," begun in the early 1970s, have been among the most compelling. In these white-walled rooms, viewers are invited to experience the sensuous, spatially disorienting effects of pure light. Though these minimalistic interiors vary in scale and light quality, in every case a large rectangular opening at one end seems to be a luminous membrane in the wall. However, on closer inspection the rectangle becomes an aperture through which the visitor can gaze into light-saturated space of such atmospheric density as to seem both palpable and infinite.

Both sides of the aperture wall are illuminated. In *Trace Elements* the side walls in the viewer's area are dimly lit from ceiling-mounted tungsten units, while the space on the other side of the aperture—the area Turrell calls the "sensing space"—is also dimly lit with ultra-violet and red-toned fluorescent tubes recessed behind the rectangular opening. In these hermetic rooms, whose strictly controlled illumination is as important as their minimalistic architecture, spatial volume is a malleable ingredient. By subtle adjustment of the light's intensity, chromatic quality, and direction on both sides of the aperture wall, he shapes the viewer's perception of space.

As Turrell reminds us, each of us bears within our consciousness countless visions of interior landscapes, assembled over a lifetime of memories, imagination, and dreams, which we can sometimes experience fully illuminated, even through closed eyes. Through the power of art, he observes, we can enter such spaces where interior and exterior visions of the landscape coincide. His aperture installations, such as *Trace Elements*, are such landscapes of the mind, whose darkly luminous spaces viewers are invited to wander.

1, 2 **JAMES TURRELL** TRACE ELEMENTS 1994, ultraviolet, red fluorescent, tungsten light; Room: 13 feet 6 inches x 31 x 45 feet; Aperture: 6 x 15 feet;

Assistant: Michael Bond

2

3 Artist's sketch for *Trace Elements* 1993, outside elevation

4 Artist's sketch for *Trace Elements* 1993, inside elevation showing lighting and dimmer arrangement as seen from inside the installation

3

4

27' 8"

10' 0"

DETAIL #1

6' 11" 13' 10" 6' 11"

5

BILL VIOLA THE CLOUD OF UNKNOWING

Using the sophisticated technology of large-scale video projections, Viola creates moody, room-size installations such as *The Cloud of Unknowing*. Upon entering its darkened space, the visitor is surrounded by a panorama of desert trees and mountains that emerge from, then recede into, a background of grainy projected images that flood the walls. Brief materializations of mysterious room interiors are among the phantom impressions that fill the space. For Viola, these desolate nocturnes are the uncharted primordial topography of a world of menacing dreams and the unconscious. The dark room is his metaphor for the "natural landscape," a psychological as well as physical realm that exists well beneath the world of steel, concrete, and glass. "We cannot be considered distinct and apart from this landscape," he states, "anymore than a living cell can be autonomous from the body of its host."

In Viola's shadowy vistas, boundaries of time and place dissolve. Although the landscape footage for *The Cloud of Unknowing* was shot during his extensive sojourns in the Mojave Desert and other California sites, we are less conscious of an identifiable locale than of being in a generalized, tension-charged atmosphere. These umbrous images, in Viola's interpretation, allude to nature's powerful forces, both threatening and protective, that pervade every aspect of our existence and are part of humanity's collective unconscious. Because this ancestral memory, as exemplified by the primal landscape, is the true subject of Viola's disquieting imagery, some critics have perceptively characterized him as an artist-shaman whose mesmerizing images enable us to gaze deeply into an ancient shared past.

1, 2 BILL VIOLA **THE CLOUD OF UNKNOWING** 1994, four-channel, silent video installation; four black and white video projections: 13 feet 9 inches x

20 x 20 feet (stills)

1

2

3

4

5

6

MEG WEBSTER

ALTERED CONTOURS: ACOMA GARDEN

1

On the quarter-acre grounds at the entrance to the Denver Art Museum, Meg Webster's complex, undulating topography includes an arc of hillocks partially surrounding a low crater containing a pond, the edges of which are lined with marsh grass to prevent evaporation. From this raised area, water flows to a lower pond on the other side of a winding brick path, one of two brick walkways meandering through this heavily planted space. By scooping and mounding large quantities of earth, and employing indigenous grasses, shrubs, sedums, and masses of flowers of varying colors and textures, Webster has created a beguiling micro-landscape of extreme control versus naturalism, a dichotomy that is central to her art.

Altered Contours: Acoma Garden is Webster's response to an embattled parcel of land, currently bordering a massive construction site next to the museum. Prior to its creation, pedestrians making their way from a nearby parking lot to the museum were obliged to traverse an uninviting "demilitarized zone." Now, thanks to Webster, a fairly grim passage has been transformed into an

1 Details of flower varieties in installation of *Altered Contours* at the Denver Art Museum

2 MEG WEBSTER **ALTERED CONTOURS: ACOMA GARDEN** 1994, soil, plants, water, fish, rock, gravel, rubber, pump, pipe, brick, wood, tin, tools, 120 x 160 feet; Assistants: Applewood Seed Company, Nancy Lake Benson, Colorado Pipe, David Dean, James E. Henrich (Director of Horticulture, Denver Botanic Gardens), Richard Hufendick, Allen Keesen Landscaping, David Quinones, Robinson Brick and Tile, Lewis I. Sharp, and US West (work in progress)

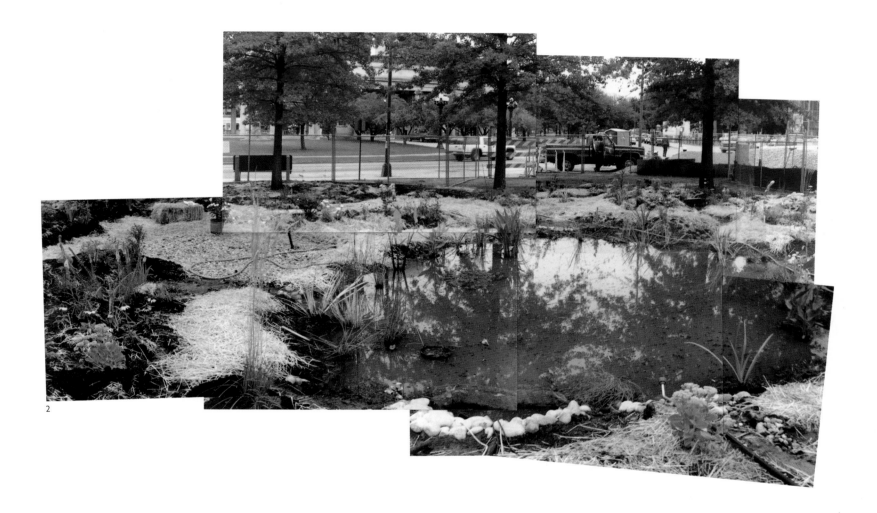

2

enjoyable experience.

Webster regards such large outdoor projects as works in progress, and their continuing development and maintenance, she insists, are as important as their making. A Webster effort of this scale, always

requires a devoted cadre of workers committed to its continuity. Fortunately, her Denver project has attracted several dedicated volunteer gardeners, true believers who have worked with her on this project from its beginning and

whose daily ministrations have been essential to its full realization. According to Webster, they have virtually claimed the garden as their own, even to the extent of appending to its original title *Altered Contours*, the words *Acoma*

Garden, after Acoma Street, located near Webster's project.

Even when utilizing such uncompromisingly fugitive materials as packed earth, salt, and clumps of moss, and poured wax, Webster has always been receptive

to, indeed delighted by, the inevitable organic changes her sculptures undergo. This is especially true of those modifications caused by erosion and growth of vegetation in her large-scale earthworks, such as *Altered Contours*.

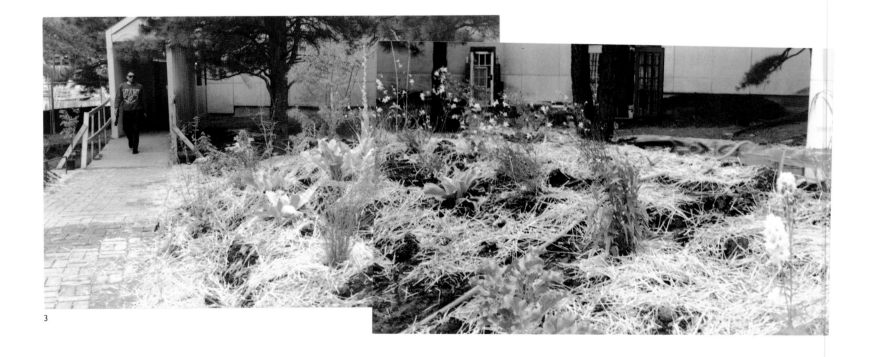

3

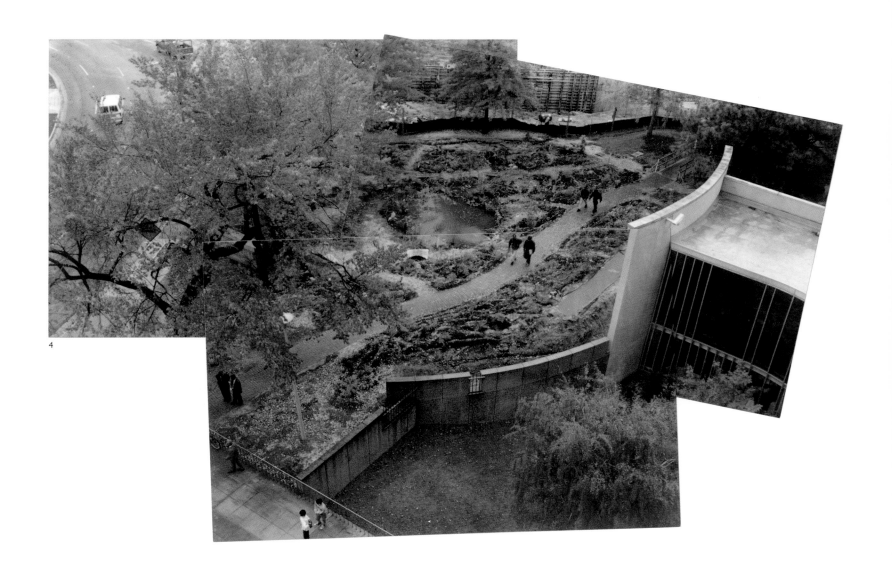

4

GENERAL

Abbey, Edward. *Desert Solitaire*. New York: Simon & Schuster, 1990.

Arthur, John. *Spirit of Place: Contemporary Landscape Painting and the American Tradition*. Boston: Little, Brown, 1990.

Bachelard, Gaston. *The Poetics of Space*. Boston: Beacon Press, 1964.

Beardsley, John. *Probing the Earth: Contemporary Land Projects*. exh. cat. Hirshhorn Museum and Sculpture Garden, Washington, D.C., 1977.

————. *Earthworks and Beyond: Contemporary Art in the Landscape*. New York: Abbeville Press, 1989.

Botkin, Daniel. *Discordant Harmonies: An Ecology for the Twenty-First Century*. New York: Oxford University Press, 1990.

Cameron, Dan. *The Savage Garden: Landscape as Metaphor in Recent American Installations*. exh. cat. Sala de Exposiciones de la Fundación Caja de Pensiones, Madrid, Spain, 1990.

Clark, Kenneth. *Landscape into Art*. New York: Harper Collins, 1991.

Davies, Hugh and Ronald J. Onorato. *Sitings*. exh. cat. La Jolla Museum of Contemporary Art, California, 1986.

Foresta, Merry A., et al. *Between Home and Heaven: Contemporary American Landscape Photography*. exh. cat. Albuquerque, New Mexico and Washington, D.C.: University of New Mexico Press and National Museum of American Art, Smithsonian Institution, 1992.

Friedman, Martin, et al. *Sculpture Inside Outside*. exh. cat. Minneapolis and New York: Walker Art Center and Rizzoli International, 1988.

Gifford, Don. *The Farther Shore: A Natural History of Perception*. New York: Atlantic Monthly Press, 1990.

Griffin, Susan. *Woman and Nature*. New York: Harper & Row, 1980.

————. *A Chorus of Stones: The Private Life of War*. New York: Doubleday, 1992.

Halpern, Daniel, ed. *On Nature: Nature, Landscape, and Natural History*. San Francisco: North Point Press, 1987.

Harris, Neil. *Cultural Excursions: Marketing Appetites and Cultural Tastes in Modern America*. Chicago and London: The University of Chicago Press, 1990.

Havlice, Patricia Pate. *Earth-Scale Art: A Bibliography, Directory of Artists, and Index of Reproductions*. Jefferson, N.C. and London: McFarland and Company, 1984.

Hiss, Tony. *The Experience of Place: A Completely New Way of Looking at and Dealing with Our Radically Changing Cities and Countryside*. New York: Alfred A. Knopf, 1990.

Jackson, J. B. *The Necessity for Ruins: and other topics*. Amherst: University of Massachusetts Press, 1980.

————. "Urban Circumstances." *Design Quarterly* 128, Minneapolis, MN and Cambridge, MA: Walker Art Center and The MIT Press, 1985.

Jussim, Estelle and Elizabeth Lindquist-Cock. *Landscape as Photograph*. New Haven: Yale University Press, 1985.

Lewis, R.W.B. *The American Adam: Innocence, Tragedy, and Tradition in the Nineteenth Century*. Chicago: University of Chicago Press, 1964.

Lippard, Lucy R. *Overlay: Contemporary Art and the Art of Prehistory*. New York: Pantheon Books, 1983.

Marx, Leo. *The Machine in the Garden: Technology and the Pastoral Ideal in America*. New York: Oxford University Press, 1964.

Matilsky, Barbara C. *Fragile Ecologies: Contemporary Artists' Interpretations and Solutions*. New York: Rizzoli International, 1992.

McShine, Kynaston, ed. *The Natural Paradise: Painting in America, 1800-1950*. exh. cat. The Museum of Modern Art, New York, 1976.

Mitchell, John Hanson. *Living at the End of Time*. Boston: Houghton Mifflin, 1990.

Nash, Roderick. *Wilderness and the American Mind*. New Haven: Yale University Press, 1973.

Novak, Barbara. *Nature and Culture: American Landscape and Painting, 1825-1875*. New York: Oxford University Press, 1980.

Rosenblum, Robert, et al. *The Landscape in Twentieth Century Art: Selections from the Metropolitan Museum of Art*. New York: Rizzoli, 1991.

Shepard, Paul. *Man in the Landscape*. College Station: Texas A & M University Press, 1991.

Smith, Henry Nash. *Virgin Land: The American West as Symbol and Myth*. Cambridge, MA: Harvard University Press, 1981.

Sorkin, Michael, ed. *Variations on a Theme Park: The New American City and the End of Public Space*. New York: Noonday Press, 1992.

Stilgoe, John R. *Common Landscape of America, 1580 to 1845*. New Haven: Yale University Press, 1982.

Thompson, William Irwin, ed. *Gaia, A Way of Knowing: Political Implications of the New Ecology*. Great Barrington, MA: Lindisfarne Press, 1987.

Thoreau, Henry David. *Walking*. Bedford, MA: Applewood Books, 1992.

Tompkins, Jane. *West of Everything: The Inner Life of Westerns*. New York: Oxford University Press, 1992.

Turner, Frederick Jackson. *Rediscovering America: John Muir in His Time and Ours*. New York: Viking, 1985.

Van Valkenburgh, Michael R. "The Flower Gardens of Gertrude Jekyll and Their Twentieth-Century Transformations." *Design Quarterly* 137, Minneapolis, MN and Cambridge, MA: Walker Art Center and The MIT Press, 1987.

Whyte, William H. *The Last Landscape*. Garden City, NY: Anchor, 1968.

Wilson, Alexander. *The Culture of Nature: North American Landscape from Disney to the Exxon Valdez*. Cambridge, MA and Oxford, England: Blackwell, 1992.

Winsor, Justin, ed. *Narrative and Critical History of America*. 8 vols. New York: Houghton Mifflin, 1889.

Wolf, Daniel. *The American Space: Meaning in Nineteenth-Century Landscape*. Middletown, CT: Wesleyan University Press, 1983.

Woodward, David, ed. *Art and Cartography: Six Historical Essays*. Chicago: University of Chicago Press, 1987.

Wrede, Stuart and William Howard Adams, eds. *Denatured Visions: Landscape and Culture in the Twentieth Century*. New York: The Museum of Modern Art, 1991.

Zukin, Sharon. *Landscapes of Power: From Detroit to Disney World*. Berekely, CA: University of California Press, 1991.

MEL CHIN

Boswell, Peter. *Viewpoints: Mel Chin*. exh. cat. Walker Art Center, Minneapolis, 1990.

Cameron, Dan. "Opening Salvos, Part Two." *Arts Magazine*, February 1988.

Cembalest, Robin. "The Ecological Art Explosion." *ARTnews*, Summer 1991.

Chan, Evans. "Combining the Essence of Chinese and Western Mythologies: A Sculptural Recreation of the Solar System's Nine Planets." *China Daily News*, 4 January 1988.

Chin, Mel. "Degrees of Paradise" and "Revival Field" in *Art for a Natural and Artificial Environment*. Zoetermeer, the Netherlands: Florida Foundation, 1992.

———. *The Operation of the Sum through the Cult of the Hand*, New York: Loughelton Gallery, 1987.

Gambrel, Jamey. "Art Capital of the Third Coast." *Art in America*, April 1987.

Heartney, Eleanor. "Skeptics in Utopia," *Art in America*, July 1992.

Henry, Gerrit. "Mel Chin: Surveying Heaven and Earth." *Sculpture* 10, January–February 1991.

Hill, Ed and Suzanne Bloom. Review. *Artforum*, January 1986.

Kastner, Jeffrey. "Mel Chin." *Artforum*, March 1991.

Lippard, Lucy. "Texas Red Hots." *Art in America*, July–August 1979.

Matilsky, Barbara C. "Art and Ecology." *Museum News*, March/April 1992.

McBride, Elizabeth. "Mel Chin: Dialectic Materials." *Artspace*, Fall 1991.

McCormick, Carlo. Review. *Artforum*, March 1988.

Rifkin, Ned. *Directions: Mel Chin*. exh. cat. Hirshhorn Museum and Sculpture Garden, Washington, D. C., 1989.

Saussy, Haun. "Mel Chin." *Arts Magazine*, March 1989.

Tanner, Marcia. "A Conversation with Mel Chin." *Artweek*, 18 June 1992.

Tennant, Donna. Review. *ARTnews*, January 1986.

LEWIS DESOTO

Bellon, Linda. "Some Stimulus Complexity." *Artweek*, Vol. 14, No.34, 15 October 1983.

Bellon-Fisher, Linda. "The Concept of Landscapes." *Artweek*, Vol. 16, No. 1, 5 January 1985.

Biren, Jordan. "Before Thought." *Reflex*, July/August 1989.

Bonetti, David. "The Way To San Jose." *San Francisco Examiner*, 31 May 1991.

Cohn, Terri. "Interior Destinations." *Artweek*, 30 August 1990.

Cubbs, Joanne, *Visual Paradox*. John Michael Kohler Arts Center, Sheboygan, WI, 1988.

Curtis, Cathy. "Overview: A Model for Conferences." *Artweek*, Vol. 14, No. 34, 19 November 1983.

Davis, Keith. *Night Light. A Survey of 20th Century Night Photography*, exh. cat. Hallmark Photographic Collection, 1989.

Earle, Edward W. *Biennial I*, exh. cat. California Museum of Photography, October 1989.

Featherstone, David. *Commitment to Vision*, exh. cat. University of Oregon, 1986.

Gragg, Randy. "Heroes, Monuments and the Creative Impulse." *Reflex*, November/December 1987.

Hemmerdinger, William. *35 x 35*, exh. cat. Riverside Art Museum, California, 1982.

International Triennial of Photography, exh. cat. Museum of Art and History, Fribourg, Switzerland, 1985.

Knaff, Devorah. "Through The Eyes Of Others." *Artweek*, 7 March 1991.

Mahaffey, Patrick and Rebecca Solnit. *Pé Túkmiyat, Pé Túkmiyat (Darkness, Darkness)*. exh. cat. San Jose Museum of Art, California, 1991.

Read, Tory. "Heaven and Earth." *Friends of Photography Newsletter*, Vol. 8, No. 1, March 1985.

Reed, Jim. *Natural Selection: The Terrain of Southern California*. Riverside Art Museum, California, 1988.

Rinder, Lawrence. *MATRIX 144/Lewis deSoto*, exh. cat. University Art Museum, Berkeley, California, 1991.

Ross, Ann. "Lewis deSoto: Nature and Transformation." *9-1-1: Hotline to Contemporary Culture*, May/June 1986.

Slemmons, Rod. *Photographic Memory*. exh. cat. Seattle Art Museum, Washington, 1988.

RICHARD MISRACH

Foresta, Merry A., et al. *Between Home and Heaven: Contemporary American Landscape Photography*. exh. cat. University of New Mexico Press and National Museum of American Art, Smithsonian Institution, 1992.

Gauss, Kathleen McCarthy. *New American Photography*. exh. cat. Los Angeles County Museum of Art, 1985.

Jenkins, Steven. "A Conversation with Richard Misrach." *Artweek*, 4 February 1993.

Katzman, Louise. *Photography in California, 1945-1980*. exh. cat. New York and San Francisco: Hudson Hills Press and San Francisco Museum of Modern Art, 1984.

Kozloff, Max. "Ghostly news from epic landscapes." *American Art*, Smithsonian Institution, winter/spring 1991.

Misrach, Richard. *Telegraph 3 A.M.: The Street People of Telegraph Avenue, Berkeley, California*. Berkeley, CA: Cornucopia Press, 1974.

———. "The Illusion of Fact." *Aperture*, Spring 1985.

———. *Desert Cantos*. Albuquerque, NM: University of New Mexico Press, 1987.

———. *Richard Misrach, Photographs 1975-1987*. exh. cat. Gallery Min, Tokyo, Japan, 1988.

Misrach, Richard and Myriam Weisang Misrach. *Bravo 20: The Bombing of the American West*, Baltimore, MD: Johns Hopkins University Press, 1990.

Misrach, Richard and Susan Sontag. *Violent Legacies: Three Cantos*. New York: Aperture, 1992.

Richardson, Nan. "The Fruited plain (rural America)." *Aperture*, Spring 1992.

Solnit, Rebecca. "The Tainted Wilderness." *Artweek*. 6 May 1989.

———. "Reclaiming History: Richard Misrach and the Politics of Landscape Photography." *Aperture*, Late Summer 1990.

MATT MULLICAN

Alexander, Max. "Art in the Underground." *Art in America*, December 1989.

Brenson, Michael. "Matt Mullican." *The New York Times*, 14 December 1984.

Celant, Germano. "Between Atlas and Sisyphus." *Artforum*, November 1985.

Clothier, Peter. "Sign Language." *ARTnews*, Summer 1989.

Concentrations 15: Matt Mullican. Dallas Museum of Art, Winter bulletin, 1986–87.

Cotter, Holland. "Matt Mullican" Public Paradise," in *Banners, Monuments and the City*. exh. cat. Moore College of Art, Philadelphia, 1987.

Doll, Nancy. *Matt Mullican*. exh. cat. Santa Barbara Museum of Art, California, 1992.

Geerling, Let. "Mullican Life-Mullican Death-Mullican World." *Archis* (Amsterdam), February 1991.

Graze, Sue, *Matt Mullican*. exh. cat. Dallas Museum of Art, 1987.

Groot, Paul. "Matt Mullican." *Parkett* No. 17, 1988.

Heartney, Eleanor. "Matt Mullican." *ARTnews*, March 1993.

Kimmelman, Michael. "Synopsizing the Graphic Fabric of Modern Life." *The New York Times*, 12 August 1988.

Kuspit, Donald, Max Weschler, Dan Cameron, Pier Juigi Tazzi, and Ingrid Rein. "The Critics Way." *Artforum*, September 1987.

O'Dell, Kathy. "Through the Image Maze." *Art in America*, January 1988.

Princenthal, Nancy. "Matt Mullican's Etchings: Rereading The Looking Glass." *The Print Collectors Newsletter*, November–December 1989.

Rifkin, Ned. *Matt Mullican Works*. exh. cat. Hirshhorn Museum and Sculpture Garden, Washington, D. C., 1989.

Tarantino, Michael. "Mullican: L'Organisation De L'Histoire." *L'Inventaire*, June 1988.

————, et al. *Matt Mullican. The M.I.T. Project*, exh. cat. List Visual Arts Center, M.I.T., Cambridge, MA.1990.

Wallis, Brian. *Art After Modernism: Rethinking Representation*. New York: The New Museum of Contemporary Art, 1984.

Weber, John and Prudence Roberts. *Matt Mullican*. Western Gallery, exh. cat. Western Washington State University, 1989.

Wells, Jennifer. *Projects: Matt Mullican*. exh. cat. The Museum of Modern Art, New York, 1989.

Westfall, Stephen. *American Art Today: Surface Tension*. exh. cat. The Art Museum at Florida International University, Miami, 1992.

JUDY PFAFF

Armstrong, Richard. "Judy Pfaff." *LAICA Journal/Art Rite*, Summer 1978.

Auping, Michael. "Judy Pfaff: Turning Landscape Inside Out." *Arts*, September 1982.

Floss, Michael M. and Anastasia D. Shartin, "Embracing Ambiguity." *Artweek*, 9 July 1992.

Gardner, Paul. "Do Titles Really Matter?" *ARTnews*, February 1992.

Gill, Susan. "Beyond the Perimeters: the Eccentric Humanism of Judy Pfaff." *Arts Magazine*, October 1986.

Handy, Ellen. "Installations and History." *Arts Magazine*, February 1989.

Hughes, Robert. "Navigating a Cultural Tough." *Time*, 11 May 1987.

Larson, Kay. "An Alternative (Not an Echo)." *The Village Voice*, 8 October 1979.

McGill Douglas C. "Pfaff's Riotous Calm Hits the Holly Solomon." *The New York Times*, 16 May 1986.

Ratcliffe, Carter. "Portrait of the Artist as a Survivor." *New York Magazine*, 27 November 1978.

Rickey, Carrie. "Curatorial Conceptions: The Biennial's Latest Sampler." *Artforum*, April 1981.

Rosen, Carol. "10,000 Things I Know About Her: Judy Pfaff's Recent Work." *Arts Magazine*, March 1989.

Russell, John. "It's Not 'Women's Art' It's Good Art." *The New York Times*, 24 July 1983.

Saunders, Wade. "Judy Pfaff at Holly Solomon."

Art in America, November 1980.

Shore, Michael. "How Does It Look, How Does It Sound?" *ARTnews*, November 1980.

Smith, Roberta. "For Judy Pfaff, Moderation at Last." *The New York Times*, 28 September 1990.

Tucker, Marcia. "An Iconography of Recent Figurative Painting, Sex, Death, Violence and the Apocalypse." *Artforum*, September 1982.

"Who Are the Artists to Watch?" (Judy Pfaff cover) *ARTnews*, May 1981.

Yau, John. "Art on Location." *Artforum*, Summer 1986.

————. "Judy Pfaff, Holly Solomon Gallery." *Artforum*, March 1989.

MARTIN PURYEAR

Benezra, Neal and Robert Storr. *Martin Puryear*. exh. cat. Chicago, IL and New York: The Art Institute of Chicago and Thames and Hudson, 1991.

Berkowitz, Marc. "São Paulo Biennale: No Hidden Corners." *Artnews*. February 1990.

Brenson, Michael. "Doors of Art Opening." *The New York Times*. 16 October 1989.

————. "Shaping the Dialogue of Mind and Matter." *The New York Times*. 22 November 1987.

Calo, Carole Gold. "Martin Puryear: Private Objects, Evocative Visions." *Arts Magazine*. February 1988.

Crary, Jonathan. "Martin Puryear's Sculpture." *Artforum*, October 1979.

Flam, Jack. "The View from the Cutting Edge." *The Wall Street Journal*, 10 May 1989.

Friedman, Martin. "Growing the Garden." *Design Quarterly* 141, Walker Art Center and MIT Press, Fall 1988.

————, et al. *Sculpture Inside Outside*. exh. cat. Minneapolis and New York: Walker Art Center and Rizzoli, International, 1988.

Golden, Deven K. et al. *Martin Puryear: Public and Personal*. exh. cat. Chicago Public Library Cultural Center, 1987.

Jones, Kellie. *Martin Puryear*. exh. cat. 20th International São Paulo Bienal and Jamaica Arts Center, Jamaica, NY, 1989.

Kimmelman, Michael. "Martin Puryear, The Brooklyn Museum." *The New York Times*. 2 December 1988.

King, Elaine. *Martin Puryear: Sculpture and Works on Paper.* exh. bro. Pittsburgh, Carnegie Mellon University, Hewlett Art Gallery, 1987.

Lautman, Victoria. "Martin Puryear: Chicago Public Library Cultural Center." *Sculpture.* July/August 1987.

Lewallen, Constance. *Martin Puryear: Matrix/Berkeley 86.* exh. cat. University Art Museum, Berkeley, California, 1985.

Plagens, Peter. "Sculpture Like It Oughta Be." *Newsweek.* 11 November 1991.

Swift, Mary and Clarissa Wittenberg. "An Interview with Martin Puryear." *The Washington Review*, October/November 1978.

Teltsch, Kathleen. "MacArthur Foundation Honors Achievement." *The New York Times*. 18 July 1989.

Tomkins, Calvin. "Perception at All Levels." *The New Yorker*. 3 December 1984.

EDWARD RUSCHA

Berkson, Bill. "Sweet Logos." *Artforum*, January 1987.

Bois, Yves-Alain. *Edward Ruscha: Romance with Liquids.* exh. cat. New York: Rizzoli International and Gagosian Gallery, 1993.

de Groot, Elbrig, et al. *Edward Ruscha Paintings.* exh. cat. Museum Boymans-van Beuningen, Rotterdam, The Netherlands, 1990.

Failing, Patricia. "Ed Ruscha, Young Artist: Dead Serious About Being Nonsensical." *Artnews*, April 1982.

Fehlau, Fred. "Ed Ruscha: An Interview." *Flash Art*, January-February 1988.

Hickey, Dave, et al. *The Works of Edward Ruscha.* exh. cat. San Francisco Museum of Modern Art, 1982.

————. "Edward Ruscha." *Parkett.* No. 25, December 1988.

————. "Ed Ruscha/The song of the giant egress." *Artspace*, Albuquerque, New Mexico, Vol. 15, No. 1, November/December 1990

Kuspit, Donald. "Edward Ruscha." *Artforum*, February 1988.

Larson, Kay. "Billboards Against the Sunset." *New York Magazine*, 26 July 1982.

Rickey, Carrie. "Ed Ruscha Geographer." *Art in America*, October 1982.

Ruscha, Edward. *Twenty Six Gasoline Stations*, 1962.

————. *Various Small Fires and Milk*, 1964.

————. *Some Los Angeles Apartments*, 1965.

————. *Every Building on the Sunset Strip*, 1966.

————. *Thirty Four Parking Lots in Los Angeles*, 1967.

————, et al. *Royal Road Test*, 1967.

————. *Nine Swimming Pools and a Broken Glass*, 1968.

————. *Babycakes*. New York: Multiples, 1970.

————. *Real Estate Opportunities*, 1970.

————. *A Few Palm Trees.* Hollywood: Heavy Industry Publications, 1971.

————. *Records.* Hollywood: Heavy Industry Publications, 1971.

————. *Dutch Details.* exh. cat. Deventer, The Netherlands: Octopus Foundation for Sonsbeek '71, 1971.

————. *Edward Ruscha.* exh. cat. Minneapolis Institute of Arts, 1972.

————. *Guacamole Airlines.* New York: Harry N. Abrams, 1980.

————. *Edward Ruscha Stains 1971 to 1975.* exh. cat. Robert Miller Gallery, New York, 1992.

URSULA VON RYDINGSVARD

Alloway, Lawrence. *Ursula von Rydingsvard.* exh. bro. Bette Stoler Gallery, New York, 1984.

Berman, Avis. "Ursula von Rydingsvard: Life Under Siege." *ARTnews*, December 1988.

Brenson, Michael. "Shaping a New Consciousness in Sculpture." *The New York Times*, 12 July 1987.

Degener, Patricia. "Mystery, Familiarity In Work of Ursula von Rydingsvard." *St. Louis Post-Dispatch*, 27 March 1988.

Glueck, Grace. "New Sculpture Under the Sun, From Staten Island to the Bronx." *The New York Times*, 3 August 1979.

Kimmelman, Michael. "Intimations in Wood of Ritual and Refugee Camps." *The New York Times*, 17 July 1992.

Larson, Kay. ". . . In New Sculpture, Ursula von Rydingsvard Has Created A Sense of the Tragic" *New York*, 9 May 1988.

Lippard, Lucy. "WOOD at the Nassau County Museum." *Art in America*, November 1977.

Megerian, Maureen and Michael Brenson. *Ursula von Rydingsvard: Sculpture.* exh. cat. Storm King Art Center, Mountainville, NY, 1992.

Onorato, Ronald J. and Nancy Princenthal. *Ursula von Rydingsvard and Vito Acconci: Sculpture at Laumeier.* exh. cat. Laumeier Sculpture Park, St. Louis, MI, 1990.

Osterow, Saul. *Ursula von Rydingsvard.* exh. bro. Lorence Monk Gallery, New York, 1990.

Princenthal, Nancy. "6 Sculptors." *ARTnews*, September 1983.

Russell, John. "Art for Public Places Captured in Photos." *The New York Times*, 28 August 1980.

Sheppard, Ileen. *Sculpture of the Eighties.* exh. cat. Queens Museum, New York, 1987

Strauss, David Levi. "Sculpture as Refuge: Ursula von Rydingsvard." *Art in America*, February 1993.

von Rydingsvard, Ursula. "Thoughts About My Work." *Issue #6, A Journal for Artists*, Spring 1986.

Yau, John. *Ursula von Rydingsvard.* exh. cat. Exit Art, New York, 1988.

ALISON SAAR

Adams, Brooks. "Alison Saar." *Art in America*, December 1992.

Alison Saar: Soul Service Station, exh. cat. Roswell Museum and Art Center, Roswell, N.M., 1986.

Brenson, Michael. "Examining the Role of the Blues." *The New York Times*, 26 September 1989.

Cook, Katherine. "Mother and child reunion: Betye and Alison Saar: Oakland Museum, California, exhibit." *Artweek*, 15 August 1991.

Directions: Alison Saar. exh. bro. Hirshhorn Museum and Sculpture Garden, Washington, D.C., 1993.

Enigmatic Inquiry, exh. cat. Gray Art Gallery, New York and East Carolina University, Greenville, N. C., 1988.

Hewitt, Mary Jane. "Alison Saar: The Persistence of the Figure." *International Review of African American Art*, No. 9 (No. 2, 1990).

Jones, Kellie. "New Visions and Continuing Traditions." *New Visions*. exh. cat. The Queens County Art and Cultural Center, New York, 1988.

Kuspit, Donald. "Alison Saar (Monique Knowlton Gallery)" *Artforum*, April 1986.

Marks, Ben. "Heredity and Environments: The Artistic Visions of Betye and Alison Saar." *Los Angeles Magazine*, 1990.

Muchnic, Suzanne. "Big Folks." *Los Angeles Institute of Contemporary Art Journal*, September–October 1983.

Powell, Richard J. *The Blues Aesthetic: Black Culture and Modernism*. exh. cat. Washington Project for the Arts, Washington, D. C., 1989.

Roswell Museum and Art Center. *Soul Service Station*. exh. cat. Roswell Museum and Art Center, Roswell, NM, 1986.

Secrets, Dialogues, Revelations: The Art of Betye and Alison Saar. exh. cat. Wight Art Gallery, University of California, Los Angeles, 1990.

Smith, Roberta. "Recent Met Acquisitions Survey Works of 80's." *The New York Times*, 15 April 1988.

The Art Gallery, Cleveland State University. *Acts of Faith: Politics and the Spirit*. exh. cat. Cleveland, Ohio, 1988.

Word, Terrance. "Figures and Frescoes: Alison Saar (Jan Baum Gallery)" *Visions*, Summer 1987.

MARK TANSEY

Armstrong, Richard. "Mark Tansey." *Artforum*, February 1983.

Blau, Douglas. "Where the Telephone Never Rings: Tansey's *Conversation, 1986*." *Parkett*, No. 13, 1987.

Cameron, Dan. "Report from the Front." *Arts Magazine*. summer 1986.

Cooke, Lynne. "Fictions." *Artscribe*, summer 1988.

Danto, Arthur C. *Mark Tansey: Visions and Revisions*. New York: Harry N. Abrams, 1992.

————. "The State of the Art World: The Nineties Begin." *Nation*, 9 July 1990.

Freeman, Judi, et al. *Mark Tansey*. Los Angeles and San Francisco, C.A.: Los Angeles County Museum of Art and Chronicle Books, 1993.

Friedman, Jon R. "Mark Tansey." *Arts Magazine*, January 1983.

Friedman, K. S., and Peter Frank. "Art Futures." *Art Economist 2*, 28 February 1982.

Grundberg, Andy. "Attacking Not Only Masters but Mastery as Well." *The New York Times*, 23 November 1990.

Heartney, Eleanor. "Mark Tansey." *ArtNews*, October 1986.

Joselit, David. "Wrinkles in Time." *Art in America*, July 1987.

Kandel, Susan, and Elizabeth Hayt-Atkins. "Mark Tansey." *ArtNews*, January 1988.

Kuspit, Donald. "Mark Tansey." *Artforum*, September 1986.

Linker, Kate. "Multiple Choice." *Artforum*, September 1983.

Mahoney, Robert. "New York in Review." *Arts Magazine*, summer 1990.

Martin, Richard. "Cèzanne's Doubt and Mark Tansey's Certainty on Considering *Mont Sainte-Victoire*." *Arts Magazine*, November 1987.

McCormick, Carlo. "Fracts of Life." *Artforum*, January 1987.

Owens, Craig. "Mark Tansey." *Art in America*, February 1983.

Phillips, Deborah C. "Mark Tansey." *Art News*, January 1983.

Pincus-Witten, Robert. "Entries: Concentrated Juice & Kitschy Kitschy Koons." *Arts Magazine*, February 1989.

Russell, John. "Mark Tansey." *The New York Times*, 2 May 1986.

Sims, Patterson. *Mark Tansey*. exh. cat. Seattle Art Museum, Seattle, Washington, 1990.

Smith, Roberta. "The Library." *The New York Times*, 14 June 1991.

JAMES TURRELL

Adcock, Craig E. *James Turrell*. exh. cat. University of Arizona Museum of Art, Tucson, AZ, 1986.

————. *James Turrell*. exh. cat. Florida State University Gallery & Museum, Tallahassee, FL, 1989.

————, et al. *Mapping Spaces: A Topological Survey of the Work of James Turrell*. New York: Peter Blum Edition, 1987.

Andrews, Richard. "Interview." *James Turrell, Four Light Installations*. exh. cat. Center on Contemporary Art, Seattle, Washington, 1982.

Brown, Julia, ed. *Occluded Front James Turrell*. exh. cat. Museum of Contemporary Art and Lapis Press, Los Angeles, CA, 1985.

Castle, Frederick T. "The Irish Sky Garden of James Turrell." *Parkett*, No. 25, September 1990.

Failing, Patricia. "James Turrell's New Light on the Universe." *Artnews*, April 1985.

Flood, Richard and Carl Stigliano. "Interview with James Turrell." *Parkett*, No. 25, September 1990.

Garrels, Gary. "Disarming Perception." *Parkett*, No. 25, September 1990.

Gopnik, Adam. "Blue Skies." *The New Yorker*, 30 July 1990.

Helfenstein, Josef et al. *James Turrell: First Light*. exh. cat. Kunstmuseum Bern and Edition Cantz, Bern, Switzerland, 1991.

House, Dorothy A. *Roden Crater*. exh. cat. Museum of Northern Arizona, Flagstaff, AZ, 1988.

Hughes, Robert. "Poetry Out of Emptiness." *Time*, 5 January 1981.

Larson, Kay. "Dividing the Light from the Darkness." *Artforum*, January 1981.

Light Projections and Light Spaces. exh. cat. Stedelijk Museum, Amsterdam, The Netherlands, 1976.

Smith, Richard. "Out on the Rim: Celestial Vaulting at Roden Crater, Arizona." *Artweek*, 23 April 1992.

Waterman, Daniel. "James Turrell." *Artnews*, November 1990.

Wortz, Melinda et al. *James Turrell: Light and Space*. exh. cat. Whitney Museum of Art, New York, 1980.

BILL VIOLA

Bellour, Raymond. "An Interview with Bill Viola." *October*, Fall 1985.

Duguet, Anne-Marie. "Les Videos de Bill Viola: une poetic de l'espacetemps." *Parachute*, December 1986-February 1987.

Haynes, Deborah J. "Ultimate Questions." *Artweek*, 21 May 1992.

London, Barbara, ed. *Bill Viola, Installations and Videotapes*. The Museum of Modern Art, New York, 1987.

Minkowsky, John. "Bill Viola's Video Vision." *Video 81*, Fall 1981.

Nash, Michael. "Eye and I: Bill Viola's Double Vision." *Parkett 20*, 1989.

Nicastro, Nicholas. "The Passing." *Film Comment*, January/February 1993.

Richardson, Nan. "The Past Becoming Future." *Aperture*, Summer 1990.

Richmond, Wendy. "Beyond the Video Screen." *Communication Arts Magazine*, November 1992.

Ross, David. "The Success of the Failure of Video Art." *Videography*, May 1985.

Sturken, Marita. "Temporal Interventions." *Afterimage*, Summer 1982.

Viola, Bill. "The European Scene and Other Observations." in Ira Schneider and Beryl Korot, eds. *Video Art*, New York, 1976.

————. "Will There Be Condominiums in Data Space?" *Video 80*, Fall 1982.

————. "History, 10 Years, and the Dreamtime." in *Video: A Retrospective 1974–1984*, Kathy Rae Huffman, ed., Long Beach Museum of Art, Long Beach, CA, 1984.

————. "The Sound of One Line Scanning." in *Sound by Artists*, Dan Lander and Micah Lexier, eds., exh. cat. Art Metropole, Toronto and Walter Phillips Gallery, Banff, 1990.

————. "Video Black-The Mortality of the Image." in *Illuminating Video: An Essential Guide to Video Art*, Doug Hall and Sally Jo Fifer, eds. New York: Aperture/Bay Area Video Coalition, 1990.

————. "Perception, Technology, Imagination, and the Landscape." *Enclitic*, July 1992.

MEG WEBSTER

Baker, Kenneth. "Meg Webster and James Turrell at the Mattress Factory." *Art in America*, May 1985.

Brenson, Michael. "Meg Webster." *The New York Times*, 13 May 1988.

————. "A Show's Instructive Provocation." *The New York Times*, 17 March, 1989.

————. "Sculpture Shows at Two Branches of the Whitney." *The New York Times*, 22 December 1989.

Fairbrother, Trevor, et al. *The BiNATIONAL: American Art of the Late 80s*. Institute of Contemporary Art and Museum of Fine Arts, Boston, MA, 1988.

Gerstler, Amy. "Meg Webster, Stuart Regen Gallery." *Artforum*, February 1991.

Gookin, Kirby. "Meg Webster." *Artforum*, December 1992.

Gutterman, Scott. "Natural and Unnatural Causes." *Art International*, Autumn 1990.

Hess, Alan. "Technology Exposed: Toward a New Aesthetic for Technology in the Landscape." *Landscape Architecture*, May 1992.

Jameson, Frederic. *Utopia Post Utopia*. Boston: Massachusetts: Institute of Contemporary Art, 1988.

Melrod, George. "Meg Webster." *Art in America*, February 1993.

Princenthal, Nancy. "Meg Webster at Art Galaxy." *Art in America*, November 1986.

Richardson, Trevor. *Meg Webster: Sculpture Projects*. Weatherspoon Art Gallery, University of North Carolina at Greensboro, NC, 1992.

Smith, Roberta. "Art that Hails from the Land of Deja Vu." *The New York Times*, 4 June 1989.

Sobel, Dean. *Currents 17: Meg Webster*. exh. bro. Milwaukee Art Museum, 1990.

Spector, Nancy. "Meg Webster." *Contemporanea*, September 1990.

Stapen, Nancy. "'Our Land': Artists with Social Consciences." *Boston Herald*, 10 January 1990.

Von Kunstadt, Theodor. "Spotlight: The 1989 Whitney Biennial." *Flash Art*, Summer 1989.

ACKNOWLEDGMENTS

It was at the invitation of Henry Pillsbury, Executive Director of the American Center, Paris, that I proposed the exhibition *Landscape as Metaphor* as the inaugural event for Frank Gehry's American Center building in Paris. In anticipation of that occasion, thirteen American artists were asked to explore the theme of landscape at the end of this century. One factor in selecting this approach was Europe's enduring fascination with the American frontier—not just its legendary history but its seemingly limitless physical expanse. For the French public in particular, the phrase "le Far West" retains its magic. Another, even more compelling factor, was that many American artists are increasingly attracted to landscape, not solely for aesthetic reasons but also for its social, psychological, and ecological implications.

Although recent economic conditions have prevented the American Center from presenting *Landscape as Metaphor,* an alternative plan for its realization was soon developed. The exhibition's original schedule had called for it to be shown at the Denver Art Museum and the Columbus Museum of Art following its Paris premiere. Since early discussions of its American tour, the directors of both institutions, Lewis Sharp and Merribell Parsons, had been steadfast in their commitment to its presentation. Thus, when the American Center was unable to proceed, both American directors immediately stepped forward, agreeing to assume joint administrative and financial responsibility for its presentation in their respective museums.

The seamless transfer of responsibility could not have occurred without the understanding and generosity of the initial sponsoring organizations, specifically the Lila Wallace-Reader's Digest Fund, the Rockefeller Foundation, and the Graham Foundation for Advanced Studies in the Fine Arts. Joining them soon in providing major support was the Bohen Foundation.

In particular, thanks are due the artists represented in *Landscape as Metaphor*. Throughout the exhibition's lengthy planning process they have been accommodating and shown admirable forbearance in submitting to lengthy interviews about their working methods and artistic philosophies. Their good humor, especially during the exhibition's difficult transition days, was an inspiration to all involved in organizing the exhibition. The depth of their respective commitments to the exhibition's premise is evident in the ambitious works each created for it. These commissioned works were especially made for spaces within and surrounding the Denver Art Museum and the Columbus Museum of Art.

It is a pleasure to thank the many authors who wrote so persuasively for this publication. Their observations extend from provocative meditations on the significance of landscape imagery in late twentieth-century American art to astute commentaries on the imagery of each artist in this exhibition.

On page 254, the many talented individuals who contributed to this effort are recognized, as are the creative staffs of the Denver and Columbus museums who participated. I am indebted to them all.

MARTIN FRIEDMAN
Curator of the Exhibition

ILLUSTRATION CREDITS

(Credits not listed here occur with the images.)

p. 34 (no. 1): Graydon Wood

p. 37 (no. 3): copyright © Gianfranco Gorgoni, 1990, Contact Press Images

p. 44 (no. 10): copyright © Ana Mendieta

p. 47 (no. 12): John Cliett, copyright © Dia Center for the Arts, New York

p. 50 (no. 13): Howard Nathanson

p. 53 (nos. 1, 2): copyright © Babette Mangolte

p. 73 (no. 1): Lynn G. Harrison

p. 110 (no. 5): courtesy Galerie Lelong, New York

p. 112 (no. 11): Michael Harms

p. 114 (no. 12): Ben Blackwell

p. 120 (no. 2): Paul Hester

pp. 121 (no. 3), 187 (no. 2): courtesy Walker Art Center

pp. 122 (nos. 4–6), 124 (no. 1): Dennis Crowley

p. 124 (nos. 1–4): courtesy Christopher Grimes Gallery, Santa Monica, California

p. 143 (no. 2): Julius Kozlowski

p. 146 (no. 6): courtesy Max Protetch Gallery, New York

p. 147 (no. 7): courtesy Holly Solomon Gallery, New York

pp. 148 (no. 1), 151 (no. 3), 152 (no. 5), 153 (no. 6): courtesy Donald Young Gallery, Seattle, Washington

p. 151 (no. 4): copyright © 1994 Wayne Cozzolino, PAV-T00516

p. 155 (no. 1): Dorothy Zeidman

pp. 155 (no. 2), 156 (no. 3): Paul Ruscha

pp. 158 (no. 1), 159 (no. 3): Jerry L. Thompson

pp. 159 (no. 2), 160 (no. 4), 163 (no. 6): David Allison

p. 162 (no. 5): Larry La Me

p. 165 (no. 1): courtesy Art Resources Transfer, Inc.

p. 166 (nos. 5, 6): courtesy Jan Baum Gallery, Los Angeles, California

pp. 169 (nos. 1,2), 170 (no. 3), 171(nos. 4, 5), 172 (no. 6): courtesy Curt Marcus Gallery, New York

p. 176 (no. 2): courtesy The Mattress Factory, Pittsburgh, Pennsylvania

p. 177 (no. 3): Richard Nicol

p. 174 (no. 1): Dick Busher

pp. 181 (nos. 1, 2), 182 (nos. 3, 4): Kira Perov

p. 183 (nos. 5–10): Kira Perov and Squidds & Nunn

p. 188 (no. 4): Patricia Layman Bazelon

pp. 192 (nos. 1–3), 194 (no. 7), 195 (nos. 8–10), 196 (no. 1), 197 (no. 2), 199 (nos. 4, 5), 205 (no. 2), 206 (nos. 3, 4), 207 (no. 5), 210 (nos. 2–5), 211 (nos. 6, 7), 212 (no. 1), 213 (no. 3), 214 (nos. 5, 6), 215 (nos. 7, 8), 221–224 (nos. 2–5), 224–227 (nos. 1–6), 232 (nos. 1, 2): James Milmoe

p. 193 (nos. 4–6): Doug Warnock

pp. 195 (no. 11), 198 (no. 3): Julia Shepherd

pp. 200–203 (nos. 1–4): Richard Misrach

p. 204 (no. 1): Bill O'Connor

pp. 208, 209 (no. 1): Vincente Dente

p. 213 (no. 2): Julia Miller

p. 214 (no. 4): Steve Osborne

p. 220 (no. 1): John Townsend

pp. 216–219 (nos. 1–6): Paul Ruscha

pp. 228–231 (nos. 1–5): Bill Orcutt

pp. 237–239 (nos. 1–6): Kira Perov

pp. 240–243 (nos. 1–4): Meg Webster

COLOPHON

The text of this book was set in the special VAL PostScript version of Baskerville and Gill Sans digitized from hot metal Monotype casting by Stamperia Valdonega in Verona. Image reproduction and printing were also carried out by Stamperia Valdonega. The paper is PhoenoMatt from Scheufelen, the cloth is Cialux, the binding was made by Torriani.